COUNTRYFILE

A PICTURE OF BRITAIN

JOHN CRAVEN
& MATT BAKER

WILLIAM
COLLINS

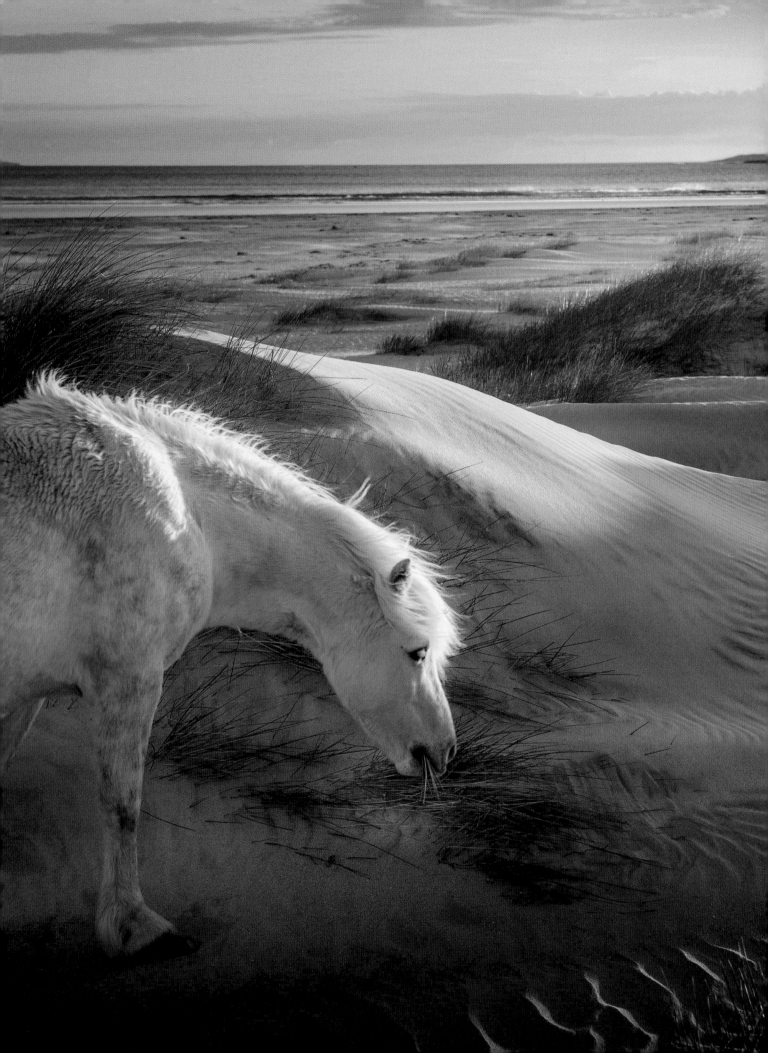

CONTENTS

INTRODUCTION *John Craven* 5

JANUARY *John Craven* 25

FEBRUARY *Matt Baker* 45

MARCH *John Craven* 65

APRIL *Matt Baker* 83

MAY *Matt Baker* 101

JUNE *John Craven* 119

JULY *Matt Baker* 141

AUGUST *John Craven* 161

SEPTEMBER *Matt Baker* 179

OCTOBER *John Craven* 197

NOVEMBER *Matt Baker* 219

DECEMBER *John Craven* 235

COUNTRY**FILE** *Calendars (2003–20)* 253

Opposite: **June 2020** – Dune Drifter, Luskentyre Beach, Isle of Harris. **Judges' Favourite**. (David Brown)

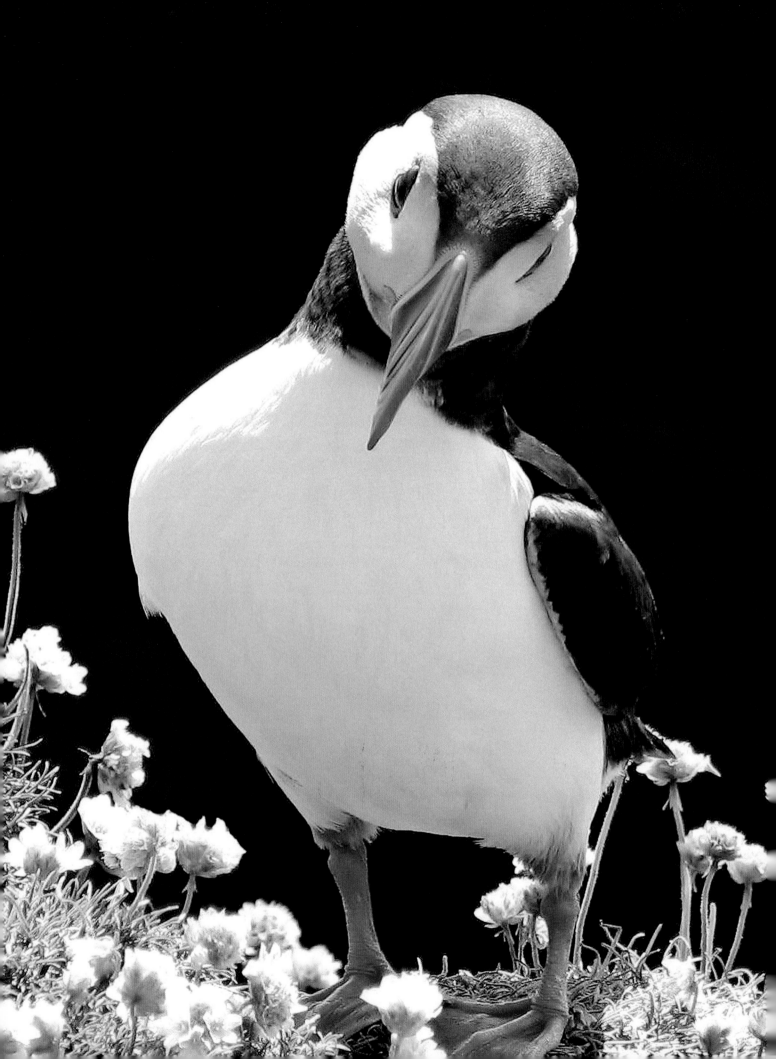

INTRODUCTION
JOHN CRAVEN

What's not to love about heading out into the countryside with camera at the ready hoping to capture an image that will forever remind you of how fortunate we are to live in, or close by, the rich and diverse rural landscapes of the United Kingdom? For several hundred people the satisfaction of actually doing that was then topped – when their special photograph was selected to appear in one of the nation's best-loved calendars and helped raise millions of pounds for a children's charity.

The calendar in question is the one that has been compiled for more than 20 years by the BBC's *Countryfile* programme from pictures submitted by viewers who enter our annual photographic competition. I'm sure you don't need me to tell you that *Countryfile* is the UK's leading rural affairs programme and goes out every Sunday evening of the year on BBC One. Its family of presenters cover everything from farming issues to wildlife, country crafts to social isolation and it is regularly the most popular weekly factual show on UK television.

When *Countryfile* first invited its viewers to take part in a competition that would showcase the best of our countryside, it attracted just a few thousand entries. For the 2020 calendar the judges faced the daunting task of choosing from more than 40,000 – a staggering response! That calendar raised £2.5 million for the BBC's Children in Need appeal and the grand total has now reached around £20 million.

Opposite: **May 2008**
Shetland Puffin.
(George Turnbull)

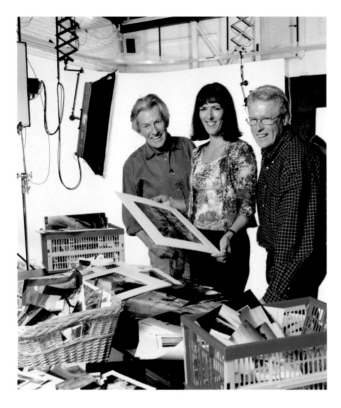

Judging 2003 Patrick Lichfield, *Radio Times* editor Gill Hudson and I sift through entries in Patrick's London studio. (BBC Countryfile)

Countryfile calendars brighten countless kitchen and office walls with their kaleidoscope of rural images taken across every season and in every weather condition. But, because of their very purpose, come the end of December they get taken down and often binned to be replaced by another collection of stunning pictures.

Yet surely those winning photos are just too good to be forgotten – so why not give them a new lease of life and let them raise even more money for BBC Children in Need? That is the reasoning behind this book. For the very first time, pictures from the past two decades have been gathered together. Hopefully, they will now have a much longer life than in a calendar and be a lasting tribute to the skills and patience of the amateur photographers who take up *Countryfile*'s challenge.

Turning these pages and admiring all the talent on display just confirms how hard it has been for the judges over the years to pick the top twelve – one for each month – and the best of the rest. For me it also brings back many happy memories because I'm privileged to have chaired every one of those judging panels since the competition began.

Along the way I have been joined by a long list of really talented people with a passion for photography: top professionals like Patrick Lichfield and Charlie Waite, television wildlife experts and cameramen like Chris Packham and Simon King, and keen amateur snappers such as writer Janet Street-Porter, Deborah Meaden (not nearly as dragonish as she is in the Den) singer/broadcaster Cerys Matthews and the comedians Bill Bailey and Jo Brand. "It's my favourite day of the year," said Jo, "except of course when I get to lie in bed all day."

Chris Packham commented: "Photo competitions are like a lucky dip. It's great when you turn 50 standard photos over and then see a unique, spectacular photo which makes it all worthwhile. It's best when they're really simple, as you think: 'I could have done that, if only I'd thought of it.'"

Deborah Meaden, no stranger to making difficult choices, admitted in 2016: "It was incredibly hard to decide which ones would grace the pages of the nation's favourite calendar. When I looked at the chosen images, from the beautiful to the fun, the poignant to the comic, all skilfully executed, I could see the calendar was going to be very special. I'm in!"

The big question that has forever faced our judges is: "What makes a really good photograph that we are happy to look at every day for a whole month?" Searching for the answer has led to hours of lively debate, with each of us offering differing views and pitching strongly for our favourites. We want photos that leap out at us because of their composition, technical mastery, originality and not least their commercial appeal – there's no point in producing a calendar if it doesn't sell because its contents are not attractive.

In fact, we could produce a dozen different calendars every year from the shortlist of around 1,000 photos. That list is handed to us by a team of volunteers, made up of previous winners and finalists and more recently of local independent photographers, who've completed the mammoth task of sifting through every entry.

Over the years the competition has given viewers and judges specific themes to work on – among those that spring to mind are The Four Seasons, Wild and Wonderful, All Creatures Great and Small, Animals in Action, From Dawn Till Dusk, Beauty and the Beasts and some 'pinched' from song titles like River Deep, Mountain High and Seasons in the Sun. They've all left plenty of room for interpretation when the shutters start to click but as guidelines the judges bear them very much in mind on the day we meet to decide the winners.

And we've met in some pretty impressive surroundings, from the headquarters of the Household Cavalry to the Royal Observatory at Greenwich, the medieval splendours of Eltham

Judging 2005 Absorbing as a game of chess – Chris Packham and Jo Brand join me for a break from judging in Berkshire. (BBC Countryfile)

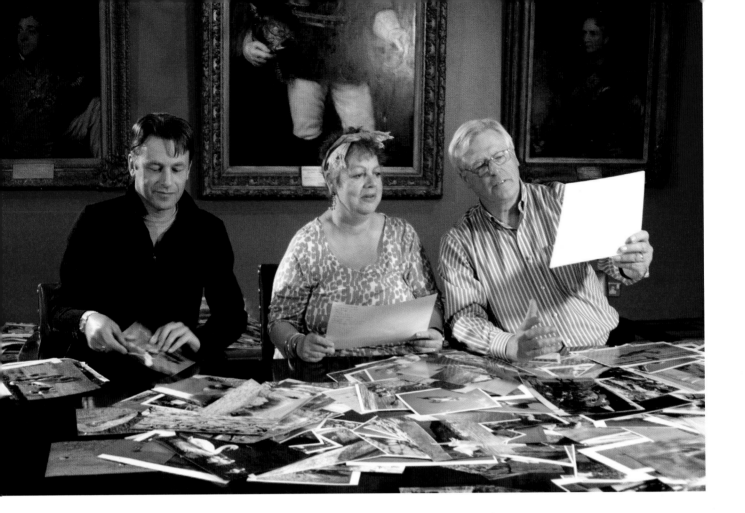

Palace and the fine library of the Linnean Society in London, where Charles Darwin's theories on evolution were first presented.

For the 2020 calendar our setting was the magnificent gardens of Woburn Abbey on one of the hottest days of the year and the current judging team of Simon, Cerys and I literally sweated over the choices we had to make.

Every year, we are staggered by the sheer quality of the entries. As Simon remarked: "Another extraordinary year, with the standard of imagery up there with the best. I was particularly thrilled to see so many people interpreting the world from their own, unique perspective and sharing that with us. It was a real treat to see natural beauty and the challenges faced by the wild world in their eyes."

And Cerys added: "It's a total joy to look through the photographs – the range and imagination behind this year's entries was absolutely stand-out, so thank you all round."

As ever, compromises were made, some personal favourites jettisoned and eventually we came to an agreement on the final twelve. I'm happy to report that over the years, without exception, every judge has been delighted with the result when we've assembled those images on a large table and given ourselves the first

impression of what the new calendar will look like. Then it's over to the designers to work their magic and create the finished product.

For the rest of us, boggle-eyed after hours of closely examining so many photos which we would have been more than proud to have taken ourselves, it's time perhaps to sit back and ponder on the wonder of the camera. It has the unique ability to create in one single image a specific moment that will last for eternity. One of our judges, Charlie Waite, who is renowned for his landscape pictures, put it like this:

"From the moment of photography's birth it's diverse evolution has been astonishingly rapid. Through television and cinema and our own 'home movies' moving film has permeated into all of our worlds, yet the still image, the 'photograph', remains mysteriously sacred.

"The pursuit of the single image still captivates us with its power to move and affect us. The single image was after all Mother Photography's 'first-born' and it has earned a certain reverence as a result. Photography is easily accessible to all of us and this competition makes it abundantly clear that the people of this small nation of ours rejoice in its landscape and revere its staggering diversity.

Judging 2010
Maybe not one for the calendar, Jo? (BBC Countryfile)

"With just one press of the shutter release we are hoping that we may be able to convey our wonder (both spiritual and aesthetic) of the world around us. If our photography can do that successfully, then I say: 'Long live photography'."

Every year a fine crop of favourite subjects emerges – robins, red squirrels, puffins, deer, poppies and lambs, to name just a few. But in many cases the photographer has added her or his unique perspective to the shot and made it memorable. That's what the judges are looking for – an image that instantly stands out from the rest and can propel a photo of a squirrel or a puffin from amid hundreds of others into the final. When we judges spot such an image it makes the heart soar. We always wonder and worry whether we will find a dozen show-stopping pictures, and we always do.

Looking back, I remember that the 2001 competition was unique in two ways – it was the only year when our theme focussed specifically on rural people and it was also the only year when taking photos was made extremely difficult for our viewers because for many months the countryside was virtually a no-go area due to the disastrous outbreak of foot and mouth disease. When we launched the theme we had no idea the disease would spread so rapidly but despite the odds we still received thousands of great photos – and there were few images of despair. Instead what we saw was pride and perseverance and hope for the future.

Judging 2011
Still a long way to go – the final judging in its early stages. (BBC Countryfile)

The cover of the 2002 calendar (for the most obvious reason, the calendar is always one year behind the competition) featured a brilliant black-and-white study of a couple of gnarled old Yorkshire farmers having a good laugh while leaning on a gate. It made me smile every time I saw it. Another memorable shot was taken by one of our youngest-ever winners Harriet Spiers, who was aged six at the time. Harriet captured the look of absolute frustration on her dad's face when his combine broke down at harvest-time.

Another very popular theme, for the 2007 calendar, was the weather – after all, the weather forecast for the week ahead is one of the most anticipated sections of our TV show. The judges sifted through images of the elements in all their moods, from ice melting on slopes of Kinder Scout to a very misty, miserable picnic on Bridlington Beach.

One entry was simply a sheet of blue – no clouds, no birds, just nothing but blue sky… a great example of the many head-scratchingly quirky photos that get sent in. In recent years we have used the two penultimate pages of the calendar to showcase a selection of some of the funnier and sometimes poignant entries that didn't make it

Judging 2012
A new judge joins for this year – writer and country-lover Janet Street-Porter casts her expert eye over the entries.
(BBC Countryfile)

Judging 2014
The paintings on the
walls of the grand
National Trust house
Hinton Ampler,
in Hampshire are
pretty impressive
but so too are
the hundreds of
photographs we
have to choose from.
(BBC Countryfile)

onto the main pages: a hen climbing a ladder, a pheasant examining a warning notice about shooting, a seagull apparently out-flying the Red Arrows. Some of the images didn't merit a whole page and others were technically poor, but they deserved their place in the calendar.

Now let me take you back to how the competition all started. After *Countryfile* first hit the airwaves in the late 1980s, the team was delighted to receive, unsolicited, in the post a trickle of photographs taken by our viewers of their favourite rural spots or encounters with wildlife, often with a little story to explain them.

What they did was to underline one of the founding concepts of the programme which still holds good to this day: to portray our stunning countryside at its visual best. We have achieved this by recruiting skilled cameramen to work with directors who have great vision. Those photos which arrived in the office were proof positive that our audience was totally in step with us.

By 1991 that trickle of photos had turned into quite a stream and our Editor at the time, the late John King – who was the father of current judge Simon, a happy connection – decided we should do something about it, by making our audience's enthusiasm for photography a key element of the programme. We were seeing, he said, just a glimpse of the great passion for rural Britain shared by a large section of the population and we must harness that.

So it came to pass that the *Countryfile* annual photo competition was born and it became such a success that (and I didn't discover this until many years later) it helped to secure the future of the programme, which had been threatened with the axe.

According to Tim Manning, who worked closely with John King when he oversaw *Countryfile*, at that point there was a great deal of pressure from BBC bosses in London to take it off the air and it needed to find ways to build a broader connection with viewers.

Tim told me: "I will be forever proud of what we as a production team achieved in saving *Countryfile* from being decommissioned and in securing the importance of the representation of everyday life in rural Britain on mainstream television."

Part of the early success of the competition was getting *Radio Times*, which in those days belonged to the BBC's commercial wing, to sponsor it and provide big prizes, often holidays to faraway places. That, along with persuading famous photographers like Fay Godwin and Lord Lichfield to join the judging panel, gave the programme extra prestige and a higher profile.

"The competition became much more successful than we had imagined," said Tim. "Successive channel controllers were always tempted to reduce the run of *Countryfile*,

Judging 2015
We arrived at Petworth House in style. Comedian, and ace photographer, Bill Bailey and wildlife presenter Charlotte Uhlenbroek are newcomers this year. (BBC Countryfile)

and the budget, but proving it had a commercial value to the BBC and a profile beyond the channel was another way of discouraging them from doing that."

The stream of viewers' photos arriving in the office turned into a torrent after we launched the competition – so many, in fact, that it was decided to split them into categories for future years: rural landscape, waterways, British flora, working landscape, and animals and wildlife.

Then John King had another brainwave – to reveal the winners every year in a live edition of *Countryfile*, with viewers phoning in to choose their favourites. The finalists from all corners of the UK and the judges joined me in the studio and the voting closed just before I handed over to the weather forecast. Our team had just three minutes to work out the winners while the forecaster told the nation what to expect in the week ahead.

For me it was a nerve-wracking time as thousands of calls were analysed – after all, this was a live show with very little time to do the sums so what if something went wrong? Don't forget this was in the early days of viewer voting, long before it became fine-tuned on shows like *The X Factor* and *Strictly Come Dancing*.

Fortunately, I always got the result in my earpiece with a couple of minutes to spare before the closing titles began to run. The category winners received their Golden Butterfly awards and the overall winner got the star prize, such as a trip for two to Barbados. We could be generous with prizes in those days because, as the photo competition was co-produced with Radio Times, it was the magazine not the licence payers that provided the funds for them.

Though the live show always ran smoothly, there was one year when it didn't happen at all. Britain was in the grip of a terrible snowstorm and though everyone – finalists, judges, studio crew and me – tried to battle our way to our base at the Pebble Mill studios in Birmingham, hardly anyone made it.

I had to abandon my car on the A5 and trudge for what seemed like miles until finding shelter in a motel already packed with refugees from the snow. The BBC had no alternative but to cancel the programme and, in its place, show a repeat of an earlier *Countryfile* with the promise that all being well the results would be revealed the following Sunday. Which is what happened – the snow crisis was over and our winners got their Golden Butterflies a week late.

From the very start, we were immensely proud to reveal the talents of *Countryfile* viewers who carried their cameras at the ready as they trekked across fields and

fells, along riverbanks and byways hoping to capture in their lenses a winning photo. Some of our winning photographers spent hours, even days, in search of their special pictures, while others were just plain lucky.

Retired policeman Frank Hill strolled to the bottom of his garden in East Sussex to take his prize-winner in 1997. The River Brede runs past and as Frank recalled: "There was a heavy hoar frost, the mist was beginning to burn off and a couple of anglers were setting up on the banks. Ten minutes later and the entire atmosphere would have gone."

Frank received his award at Wimpole Hall, the largest country house in Cambridgeshire, which was hosting our live show that year – and, as he was to discover, his picture would also make a little bit of history.

Such was the popularity of the competition our production team had decided that the best photos should not simply vanish into the ether once the programme had ended. So a selection of the photos, including the final ones and the best of the rest, were enlarged, mounted on boards and shown at special exhibitions around the country. Frank Hill's evocative river shot would take pride of place in the 1998 tour.

Judging 2016
Bill Bailey and I are joined by wildlife star from children's television Naomi Wilkinson to pick the winners, at Stowe School in Buckinghamshire. (BBC Countryfile)

Judging 2017

Not a dragons' den, but the ruined Old Wardour Castle in Salisbury, is our judging venue as I welcome Deborah Meaden and Simon King to the panel. (BBC Countryfile)

But something else was afoot. Together with the BBC's Children in Need appeal (which I had been involved in from its beginnings in 1980), *Countryfile* wanted to give our viewers the chance to display the top photos in their own homes so they could admire them all the year round. What better way to do that than in the form of a calendar? As an experiment, the 1998 *Countryfile* calendar was launched in rather low-key fashion in November 1997 with Frank's photo on the cover. If it wasn't a success the idea could be quietly forgotten.

No one need have worried because it sold reasonably well and though this was an entirely new concept for *Countryfile*, Radio Times and BBC Children in Need, we were pleased how well the photos had transferred. The decision was made that it would not be a 'one-off' and fingers were crossed that the idea would really catch on with viewers and boost the funds of the charity.

The live results show was dropped and priority was given to filming the judging sessions and promoting the calendar. How could anyone – least of all me – possibly have believed that it would develop into one of the nation's best-loved, best-selling calendars? In 2002 there were 10,000 entries – by 2019 the figure had more than

quadrupled. We were thrilled when the 2005 calendar raised £220,000 for BBC Children in Need – imagine our reaction when the 2020 edition total was more than ten times that and broke all our records!

Over the three decades that *Countryfile* viewers have been sending in their pictures there has been one dramatic change which has transformed photography and it's summed up in one word: digital. In the early days the photos were taken on 35mm film using SLR or instamatic cameras but the advent of digital cameras made it easier and cheaper for a much larger number of people to join in.

One of our judges, Lord Lichfield, who was famed for his portraits of world-famous models as well as his studies of nature, told me he was the first leading photographer in the UK to go completely digital and it saved him many thousands of pounds a year in film stock. To this day many really keen amateur photographers use expensive cameras and impressive lenses to capture their entries but some of the best 'moment in time' pictures have come from far less costly digital cameras and smart phones.

This has, of course, influenced the way the judges now examine the entries. For many years all the photos arrived by post either as prints (huge mailbags of them took over a corner of the *Countryfile* office) or slides. For the 2019 judging there was a smattering of prints and no slides – everything was sent to us online.

As always, the overall winner is chosen by our viewers in a public vote and the prize is £1,000 worth of photographic equipment plus the honour of having her or his photo on the cover. But no glamorous holiday abroad any more because since 2003 broadcasting regulations have prevented *Radio Times* from sponsoring programmes. The judges also choose their joint favourite and whoever took that picture receives a voucher for £500 worth of photographic equipment.

One of my all-time top photos (it was both the overall winner and the judges' favourite, which doesn't happen all that often) was taken by David White. He's a retired food inspector from Budleigh Salterton in Devon – a dedicated amateur photographer and wonderful country character. While strolling in one of his favourite local spots he heard animal noises in the undergrowth which he didn't recognise and went, as he told me, on Red Alert.

David put on the camouflage he often wears to disguise himself on his wildlife camera shoots and waited where he thought the creatures would emerge. "Suddenly there were eyes and ears and noses everywhere as out popped, of all things, a family

Judging 2018
Every year a panel of previous finalists sift through every single entry and compile a shortlist for the judges. What a task – but they love it!
(BBC Countryfile)

of five polecats," he said. "It was a chance sighting and it would have been so easy to panic but I kept on clicking the shutter.

"The best moment for me was seeing Simon King – someone I really respect – holding up my picture on TV and saying: 'But no one actually sees polecats!' He's been everywhere and seen everything but I don't think he'd seen a family of polecats.

"Before I entered the competition I read that the judges were looking for originality and I mulled over that for some time. How on earth do you get a cow, a sheep, a robin or a bluetit to be original? But when I showed my polecat photo to people I got talking to as I was taking shots, they all said: 'Wow. Fabulous. Fantastic', so then I knew it had to be the one that I entered.

"My conclusion is that just ordinary people – if they have enthusiasm, knowledge and genuine interest – can win such a competition. So now I'm going around encouraging more people to take part." Since winning, and becoming something of a local celebrity, David has given talks which raised several hundred pounds for Devon Wildlife Trust and spoken to pupils at local schools about his love of photography and wildlife.

I met him, with a *Countryfile* camera crew in tow, on the banks of the River Otter – a favourite location of his. David was taken totally by surprise when I broke the news that he was the overall winner and then produced from my rucksack a prototype of the calendar with his polecats on the cover. But that ruse didn't work quite as well the following year when I showed Michelle Howell her winning cover as we walked along the beach at Robin Hood's Bay in North Yorkshire.

She used to be a police detective and, though of course she was delighted, she had her suspicions that something was about to happen. "You weren't carrying your rucksack before," Michelle told me later, "and I was wondering: 'Why has he suddenly picked up that bag and what's he got in there?'" Once a detective always a detective – and I'll have to find somewhere else to hide the calendar in future!

So how do you turn winning photos into an eye-grabbing calendar? For many years that challenge has been taken on by an expert team at The Art of Design Ltd, headed by directors Tim Boxall and Paul Hughes. There is always a friendly battle within the team to be awarded the task. "The kudos of having your own design selected for the calendar is something we all secretly desire," says Paul, "and even when the design is a combination of ideas we all stake a claim!"

Let me take you 'behind the scenes' towards the end of judging day when the final photos have been chosen and the cameras have stopped rolling. In step Tim and Paul to give their verdict – not on the subject matter of the photos but on whether they will transfer successfully onto the pages of the calendar.

This vital element is what makes our competition so different from others because the winning photos won't just end up in frames on their owners' walls. They will also be displayed on thousands of other walls, having been bought by fans of the calendar – many of whom repeat their order year after year to support BBC Children in Need – and they have to look perfect.

There are times when I have seen frowns on their normally contented faces as Tim and Paul come across an entry which for some technical reason they think may not fit the criteria. It could well signal that a favourite picture of mine has to be eliminated – Tim and Paul will take it back to their studios at Ashford in Kent for further checks.

One such picture showed a swan tending her eggs on a nest she had built from disgusting plastic waste – a poignant reminder of the dangers to nature created by the thoughtless acts of we humans. Goodness knows what happened to the cygnets when they hatched amid that filthy, harmful debris. The verdict from the designers

was that the quality wasn't good enough to reproduce as a full page but it had such an emotional impact on us all that we didn't want to let it go. It was given space on the back pages – a decision widely praised by purchasers of the calendar, who were as shocked as we were.

The designers have always had challenges to deal with. Until quite recently nearly all the entries were prints so the chosen ones were professionally scanned by the team. "The quality of those prints had to be as good as possible but each scanned image would still need colour correcting and some enhancements to make sure the colours matched the entry photograph as closely as possible," says Tim.

"In the early days of Photoshop, high resolution images would take an absolute age to render. And just to test us further we often had to deal with beautiful but glossy photos that were printed using a very different method from the techniques required for printing the calendar. Reproducing such vibrancy and colour depth was an almost impossible task.

"We remember a particular photograph from the 2004 calendar that featured a sunset behind a winter tree. The glossy print sent in was stunning, the sunset so vibrant it looked like the sun was on fire. However, as soon as the photo was scanned and converted, the depth and vibrancy disappeared. We enhanced the colours as much as possible but still couldn't match the sheer vividness of the original photo." Nevertheless, that photo, taken by Lorraine Harvey from Cheshire, was the overall winner.

With the photo competition now very much part of the digital age, the judges no longer have to delve into vast mounds of prints. Instead a huge database automatically collates the submitted digital photographs and we can view and share the shortlist on mobile tablets.

Going digital has required a rethink of some of the competition conditions. For instance, new smart phone cameras have incredible filters and excellent resolution so a certain amount of colour enhancement has to be allowed. But the golden rule has always been that a photograph must stay faithful to the spirit of the competition and not deceive the viewer or misrepresent the aspect of nature it is portraying.

Composite images, where photographers will try to enhance their work by combining a number of pictures using programmes like Photoshop, are strictly banned.

"Spotting them these days is becoming more and more difficult," admits Paul, "but we always have ways of detecting them. In the first instance, *Countryfile* researchers

will ask for supporting pictures – since when did a photographer ever take just one shot! Failure to supply these will inevitably rule out that entry.

"The second step for our 'digital detectives' is carried out in our studios. With the images enlarged on screen we will get to see all the details, and by using numerous filters and settings we can determine any pixel inconsistencies and evidence of retouching. There have been some truly audacious attempts in the past – some poorly executed and some very well done, works of art in themselves!

"The favourite and easiest composite of all to spot is the addition of a new, dramatic sky. If the original photo has a clear, uncluttered horizon, adding an alternative sky is relatively straightforward and can transform a mediocre picture. The giveaway clues are usually differences in natural light and reflections, as well as poor masking where the two pictures meet. We've seen animals, mountains, skies and entire backgrounds added but they always get found out."

Some things never change for the design team. They still spend many hours colour testing and sorting out every detail before going to print with the calendar, often making last-minute tweaks.

Judging 2019
Keeping up with the times – new judge Cerys Matthews, Simon and I pick the winners using the screens of our tablets.
(BBC Countryfile)

Judging 2020 A shaded corner of Woburn Abbey on a gorgeous summer day provides the perfect setting as we head towards our final twelve. (BBC Countryfile)

Paul and Tim have to be satisfied that every page is of the standard everyone expects. Says Paul: "The poor printer must dread our annual visit. We are the fussiest people he has ever met. Then, when we've given the green light, we wait to see the first sheets coming off the press. It's a thrill we never tire of.

"The calendar has always been designed to be used. The layout must show the finalists' pictures in all their glory while retaining the practical and functional requirements of a calendar. Maybe a bit old school, but in today's high-tech society, the fact that the calendar's sales keep breaking records proves that the demand is still there for something so traditional."

Perhaps half a million images have been submitted to the competition over its long history and they have formed a fantastic window onto our countryside and everything that lives within it. They have shown in profusion and in every weather glorious landscapes, all aspects of rural life, the world of animals both working and wild, and

the joys to be found as we spend our leisure time in unbeatable surroundings. All of which underlines my long-held belief that there is no better place on Earth.

Each year, after the television cameras have looked over our shoulders during the judging process and viewers have seen our selections and rejections, people come up to me and ask why I ignored ones they particularly liked. Choosing just twelve from so many is such a subjective exercise and in the long run what the judges do, hopefully, is to home in on those which we think the vast majority of you who buy the calendar will enjoy as you turn the pages.

It's worked well so far and now, in this book, you have the opportunity to compare the winning entries over the years and choose your all-time favourites. They are here because of the skill, enthusiasm, competitiveness and co-operation of everyone who has stepped out into the countryside with their camera and snapped an image which they thought was worthy of our consideration.

To each and every one of you we say a heartfelt thank you – the competition, the calendar, this book and the £20 million (and still counting) to BBC Children in Need would not have been possible without you. Keep those shutters clicking!

June 2020

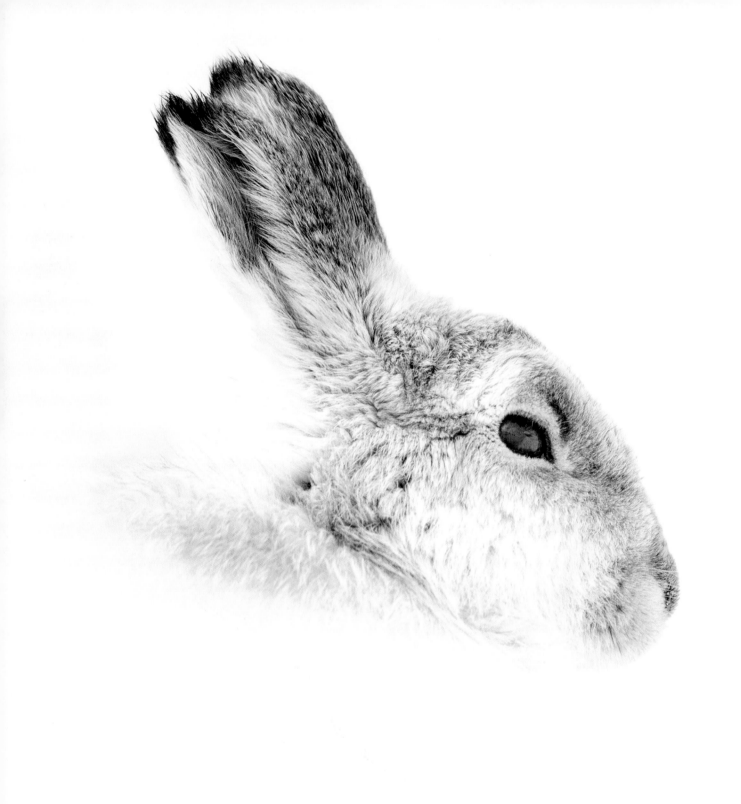

January

John Craven

We have Julius Caesar, the Roman emperor, to thank for the year starting with the month of January. He sorted out the calendar in 46 BCE and the first month was named after Janus, a god with two faces who could look back to the past year and forward to the new one, so a most suitable choice.

January is the month of new beginnings, of making resolutions, of hoar frosts and snowscapes and sales bargains and cold noses. The renowned American writer John Updike summed it up in this poem: "The days are short, the sun a spark, hung thin between the dark and dark. Fat snowy footsteps track the floor, milk bottles burst outside the door. The river is a frozen place, held still between the trees of lace. The sky is low, the wind is grey, the radiator purrs all day."

Over the years our *Countryfile* viewers have ventured with their cameras into wintery landscapes, and returned with images which vividly illustrate Updike's words – apart from the milk bottles and radiator. In our selection for January you can almost feel a chill wind blowing from the pages.

Among my favourites is the squirrel leaning against a snowy tree stump, almost as though it was ordering at the bar of the local pub. The walkers and their dogs on a mountain top remind me of the time I clambered 1,200 m through the snow to the weather station at the summit of Cairn Gorm in the Highlands. Just like the team in the photo, when I got there the view was worth all the effort. Sadly though, unlike John Evans, whose picture starts off our January section, I didn't spot a mountain hare.

We get very few monochrome entries in the competition but a group of deer striding past some bare-boned trees makes a perfect black-and-white study, while, in complete contrast, colour bursts through the columns of Hastings Pier as the winter sun sets over the sea.

January is often the coldest, bleakest month but, as you can see on the following pages, it is also a month which, with its clear air and sharp light, provides many diverse opportunities for the keen amateur photographer willing to brave whatever January has to throw at them.

Opposite: **2017** – Morning Mountain Hare, Cairngorms. (John Evans)

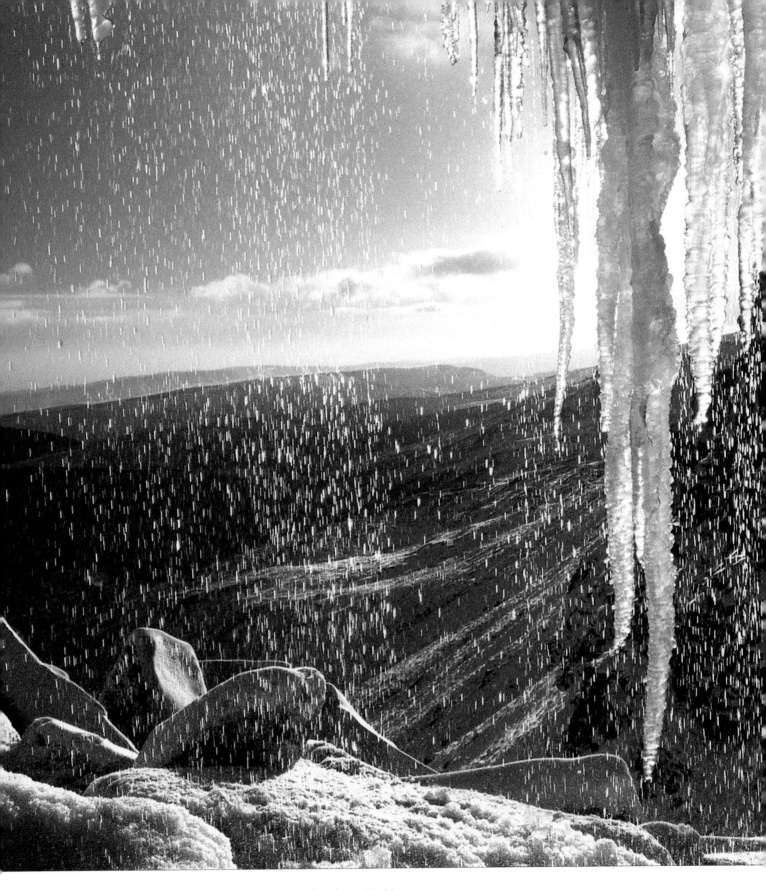

Above: 2007 – Melting Ice, on Kinder Scout. (Anthony Pioli)

Opposite top: 2005 – Fledgling. (Edwina Dickinson, Hereford)

Opposite bottom: 2015 – Sunlit Sheep. (Luke Oyston)

Following spread: 2010 – Golden Dawn. (Robert Fulton)

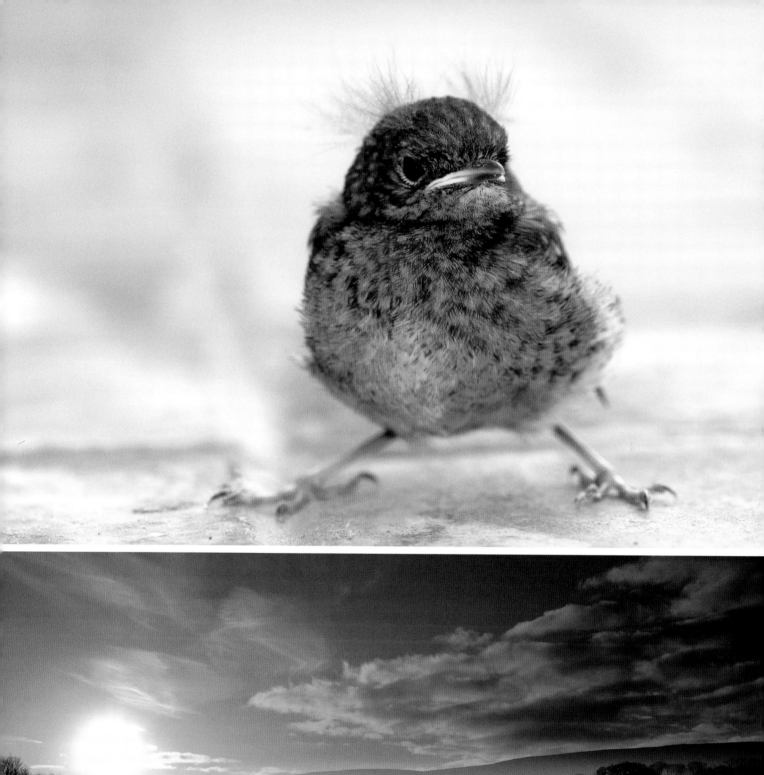
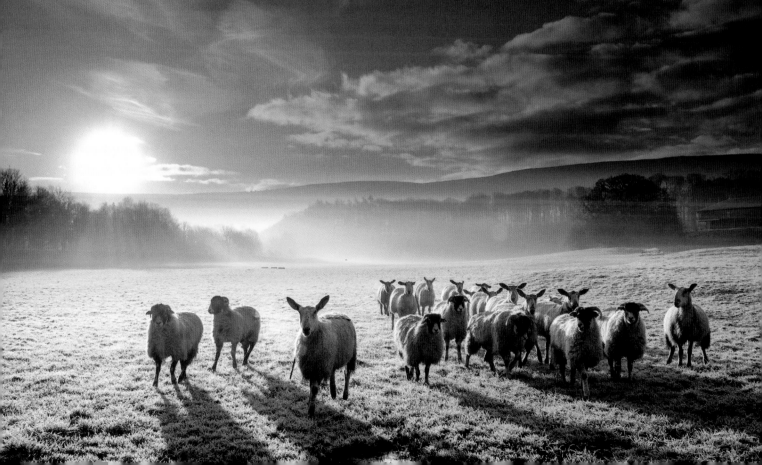

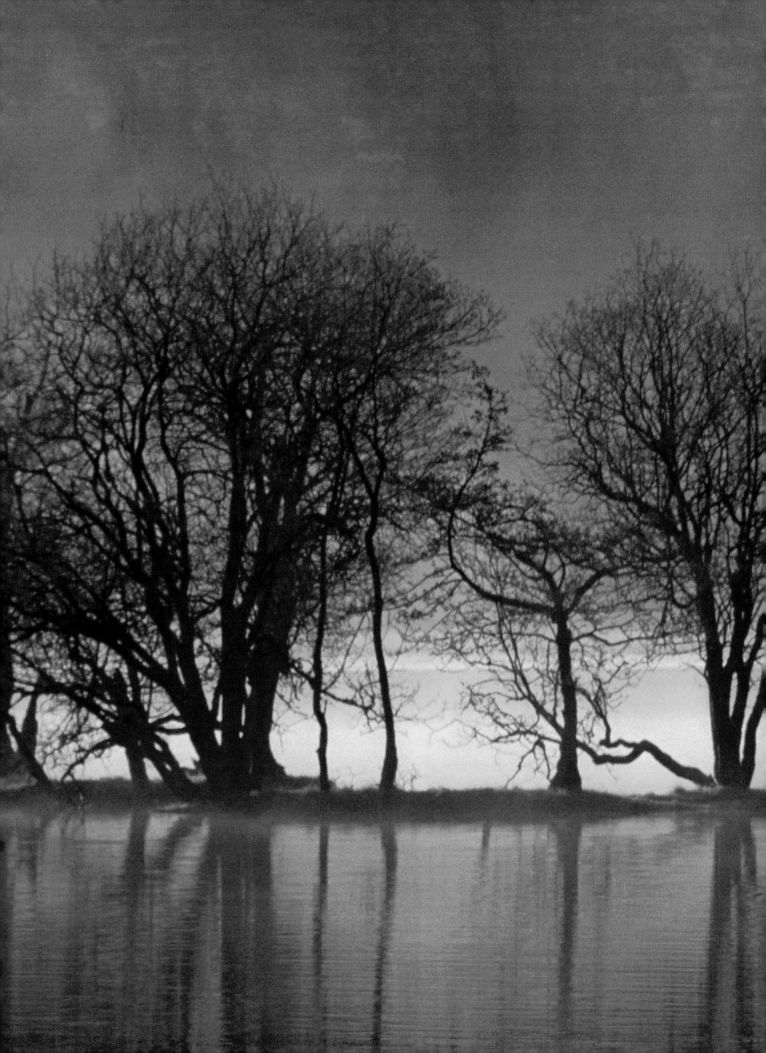

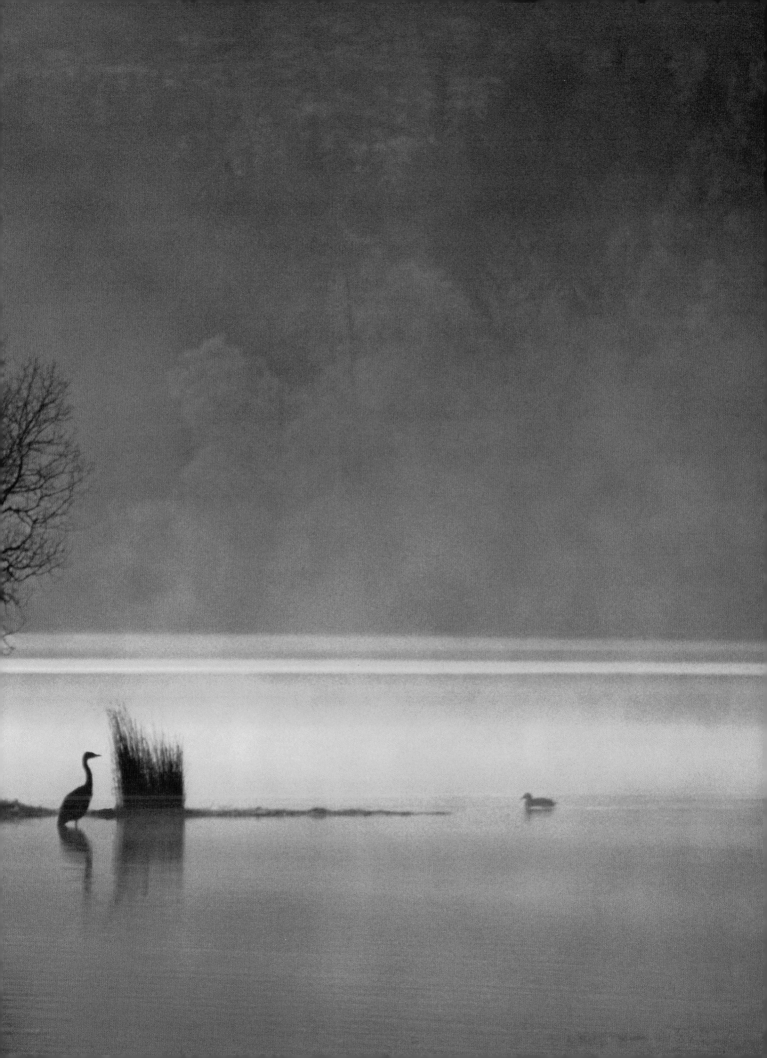

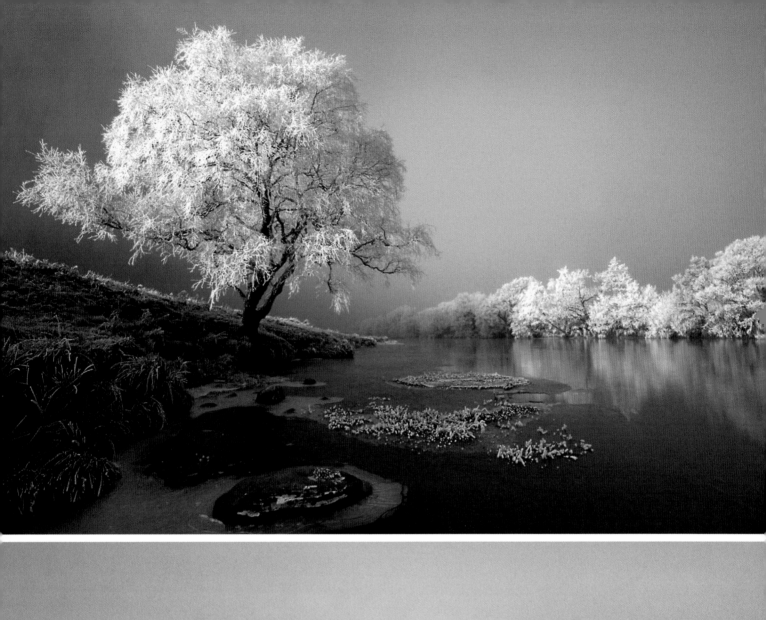

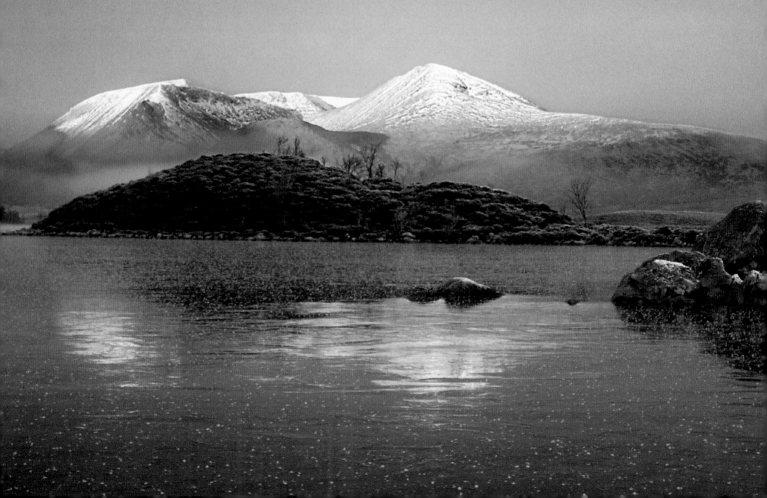

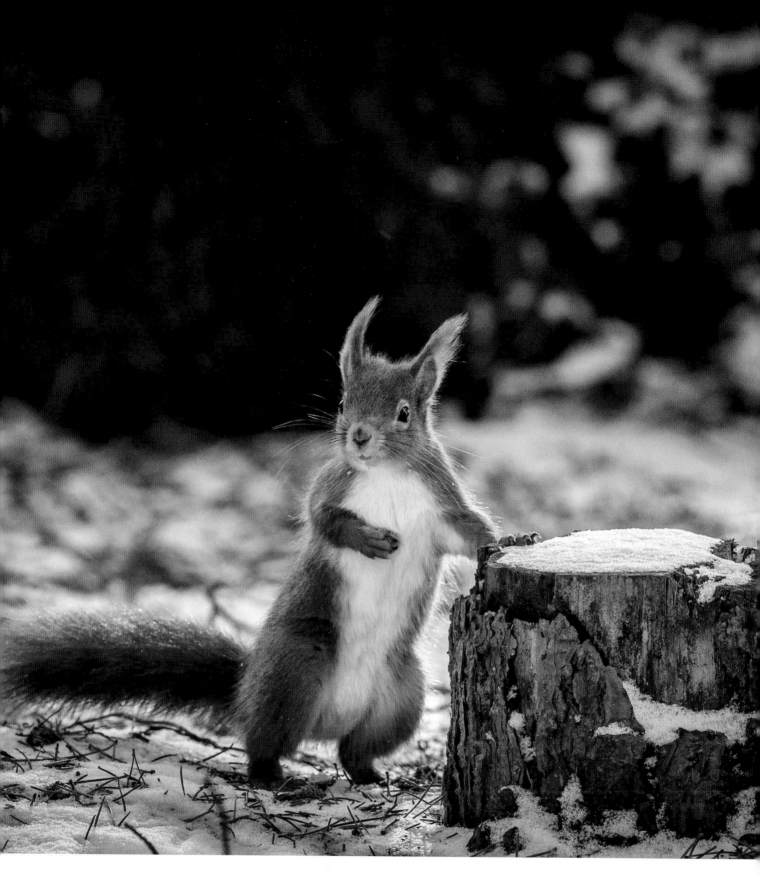

Above: **2016** – Stumped Squirrel. (Walter Bulmer)

Opposite top: **2003** – Hoar Frost on Trees, Crianlarich, Scotland. **Judges' Favourite** and **Overall Winner**. (Robert Fulton)

Opposite bottom: **2006** – Frozen Loch. (Robert Fulton)

Following spread: **2013** – Winter Wanderers. (John Gregson)

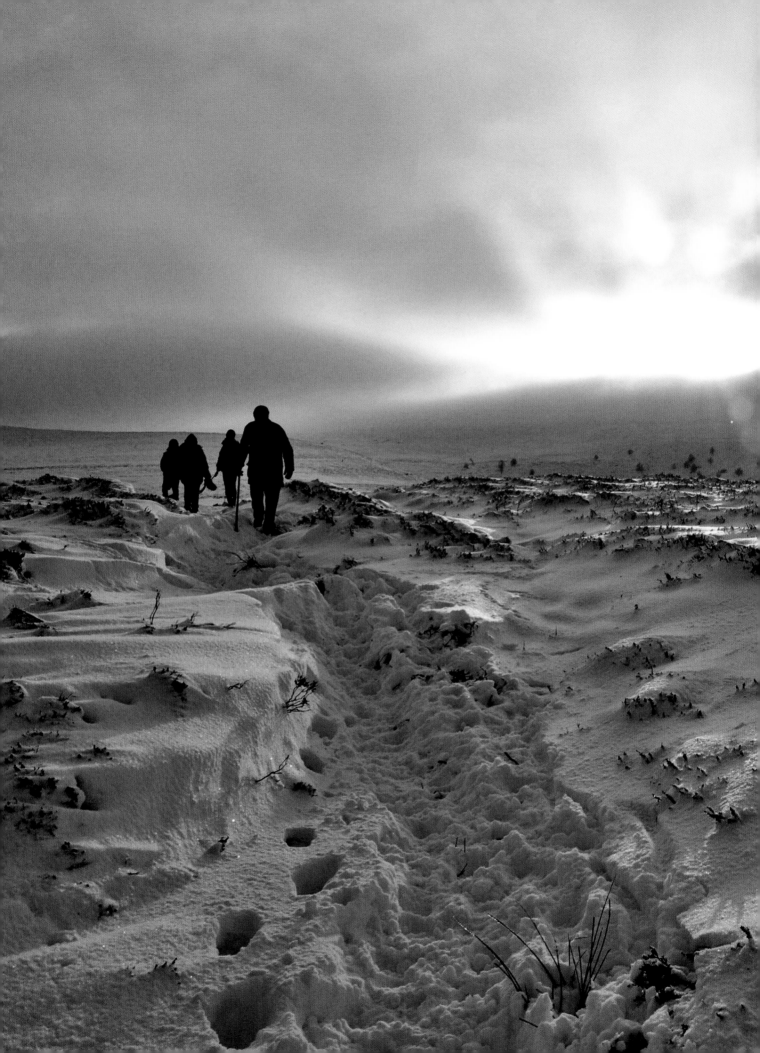

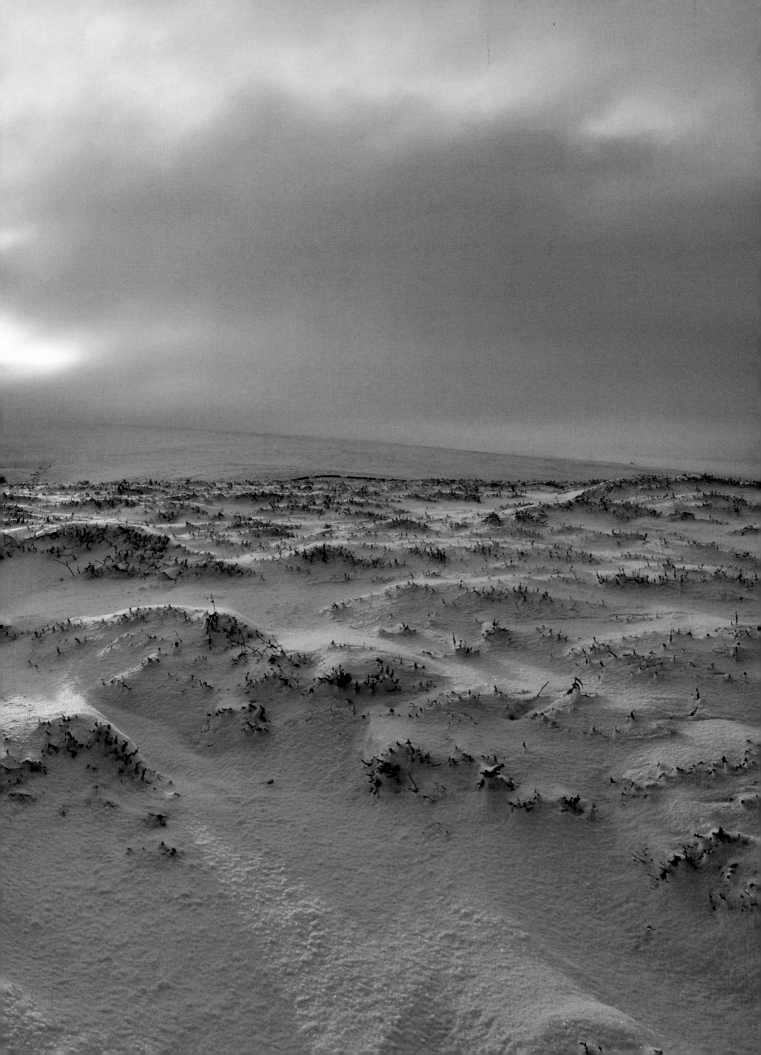

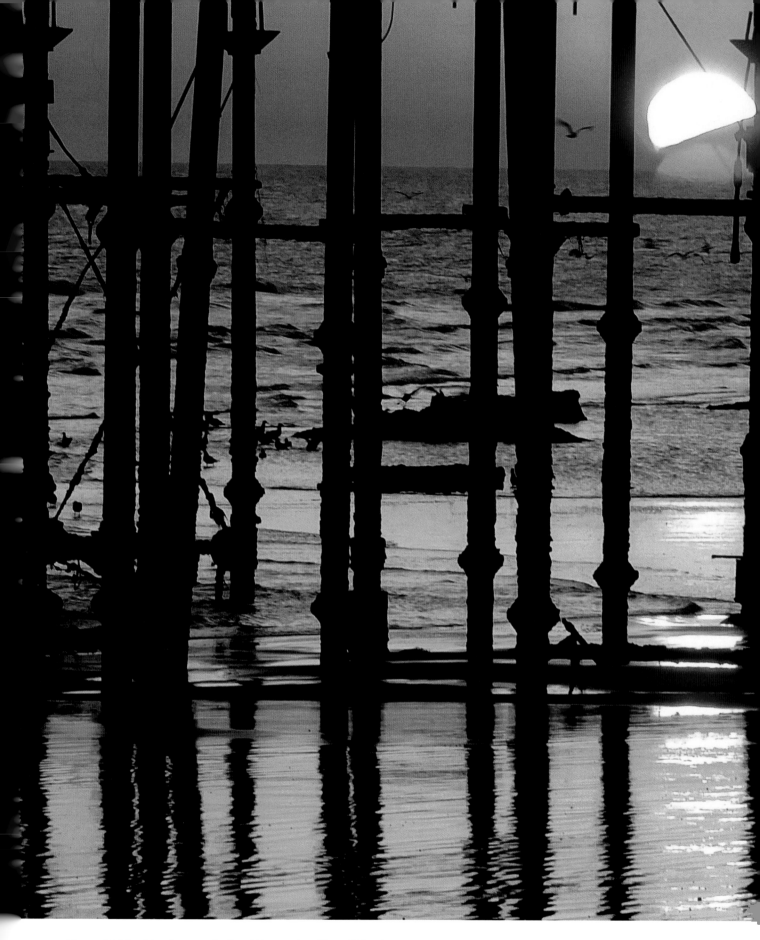

Above: **2014** – Pier Sunset. **Judges' Favourite**. (Tim Clifton)

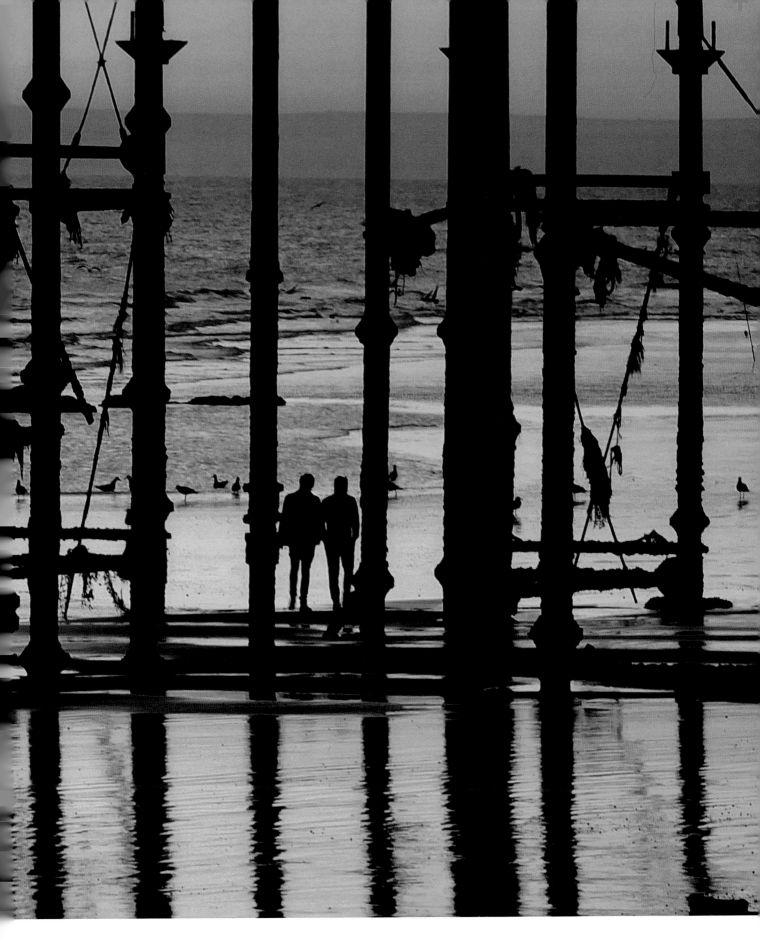

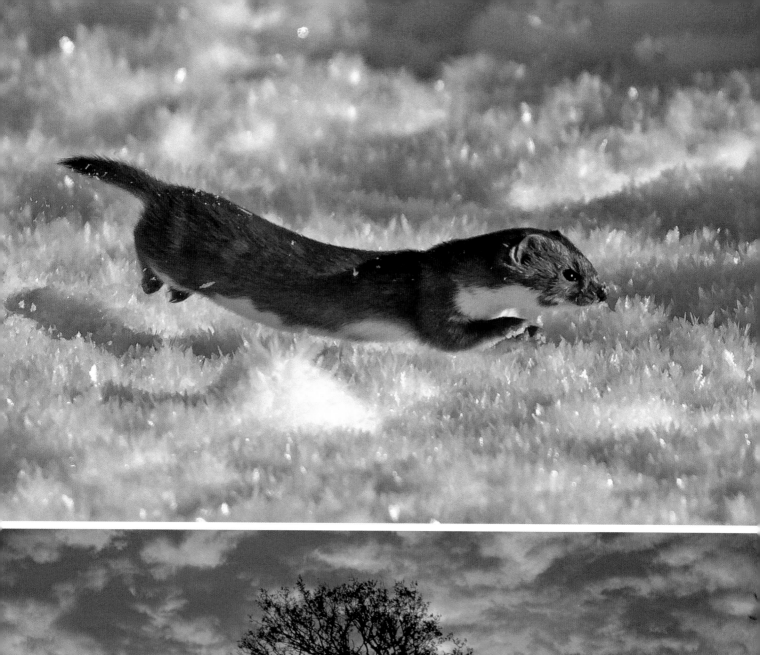
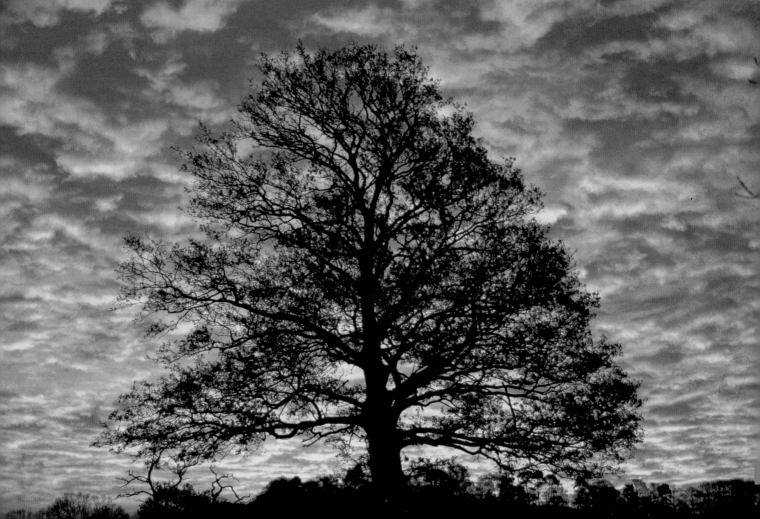

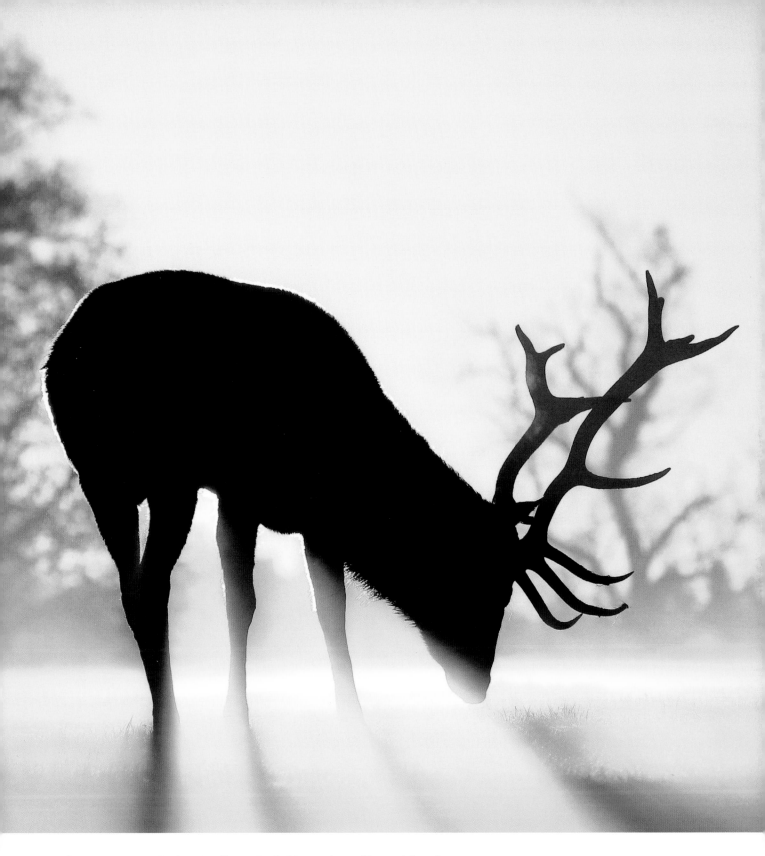

Above: **2019** – Sunlit Stag, Wollaton Park, Nottingham. (Steve Adams)

Opposite top: **2012** – Winter Weasel. (Mark Blake)

Opposite bottom: **2004** – Winter Sundown. **Overall Winner**. (Lorraine Harvey, Broxton, Cheshire)

Following spread: **2020** – Pony Trek, Beachy Head, East Sussex. (Ashley Hemsley)

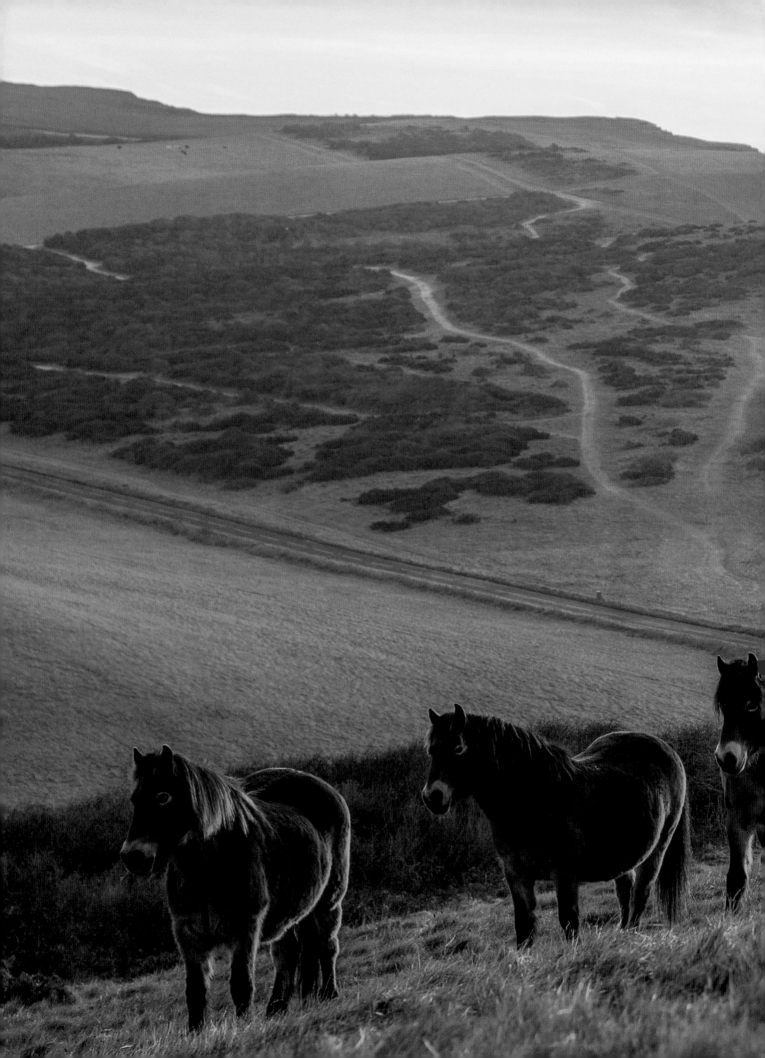

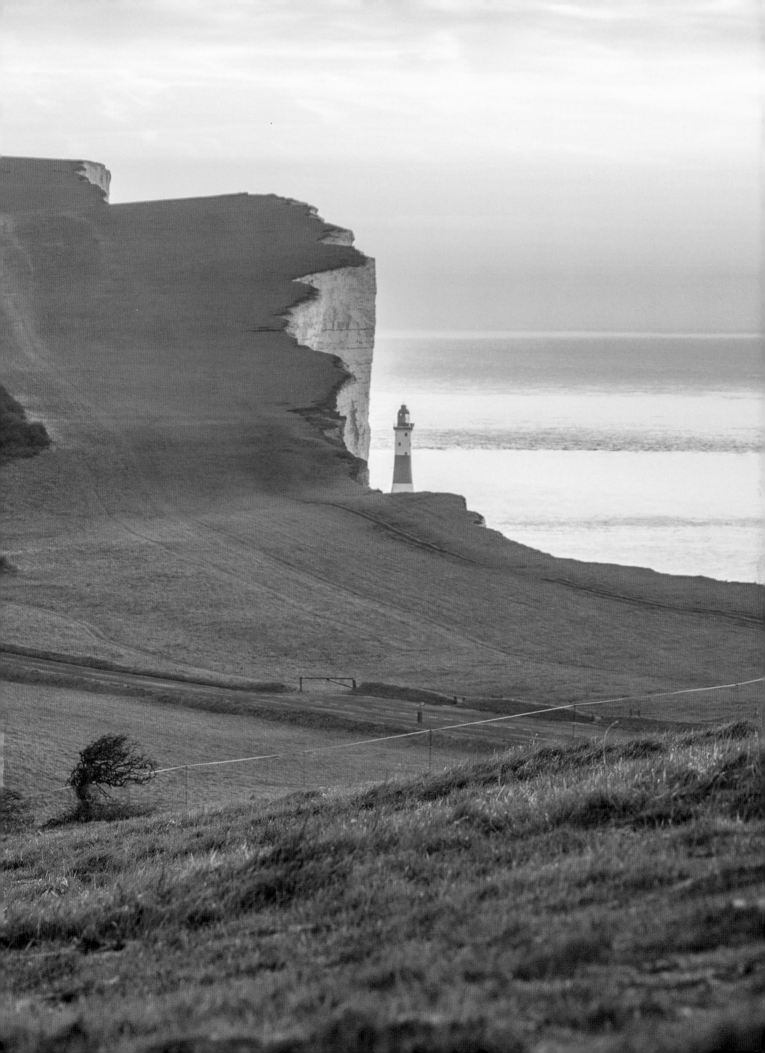

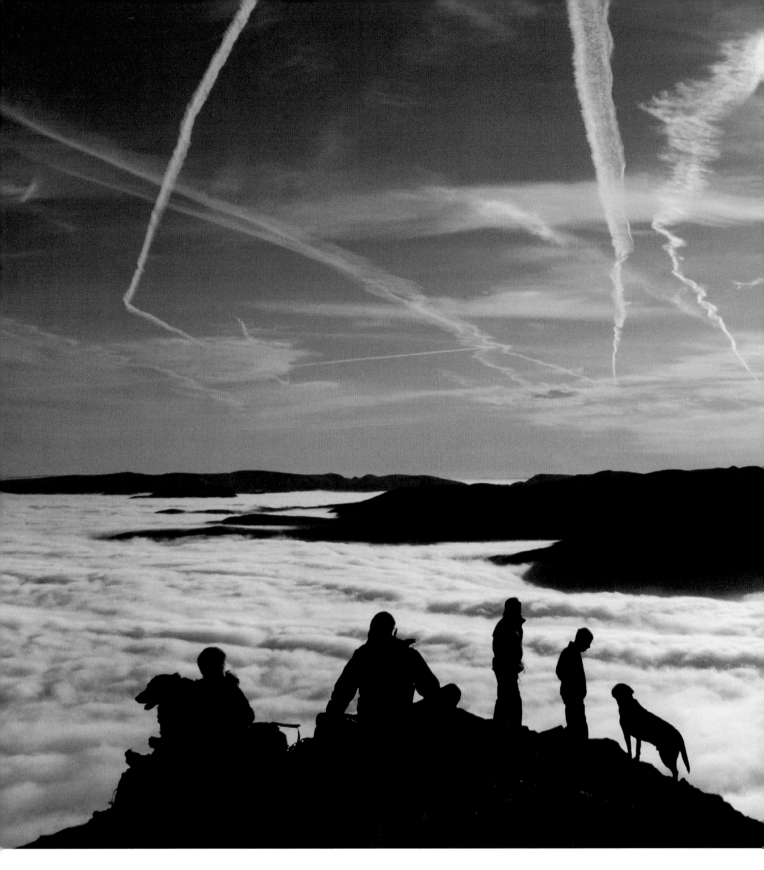

Above: **2011** – Mountain High. (Brian Hancox)

Opposite top: **2008** – Speedy Squirrel. (Tom Bold)

Opposite bottom: **2009** – Winter Hares. (Steve Barker)

Following spread: **2018** – Winter Wanderers, Stainborough Park. **Judges' Favourite**. (Kevin Dolby)

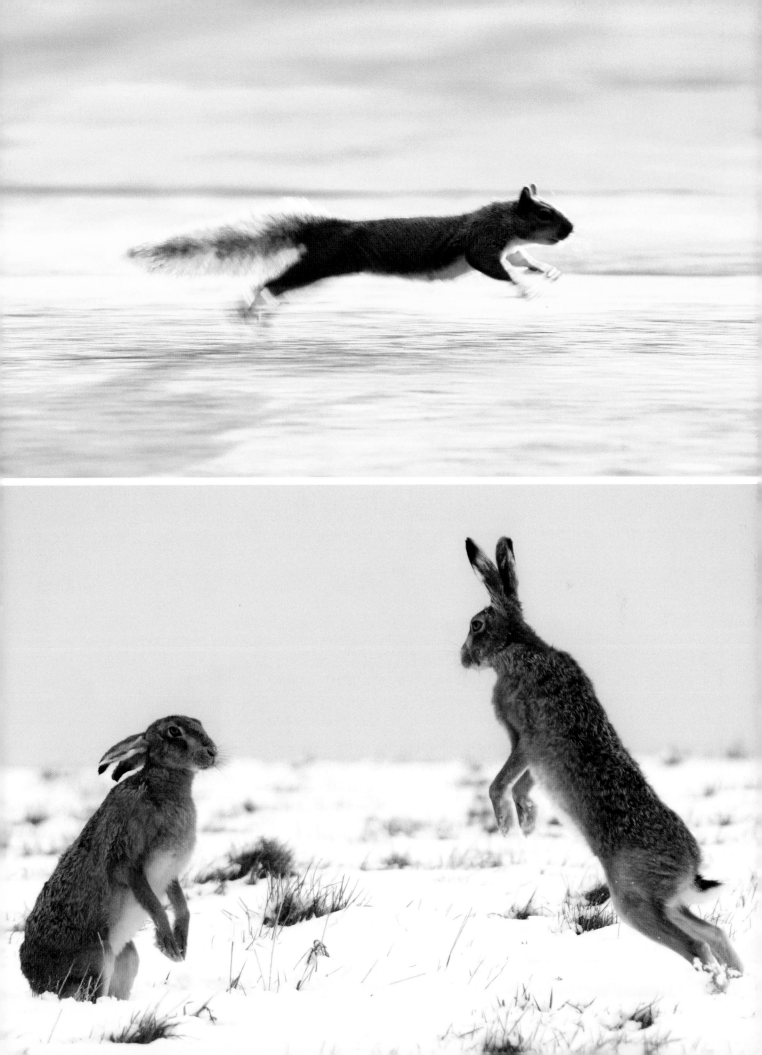

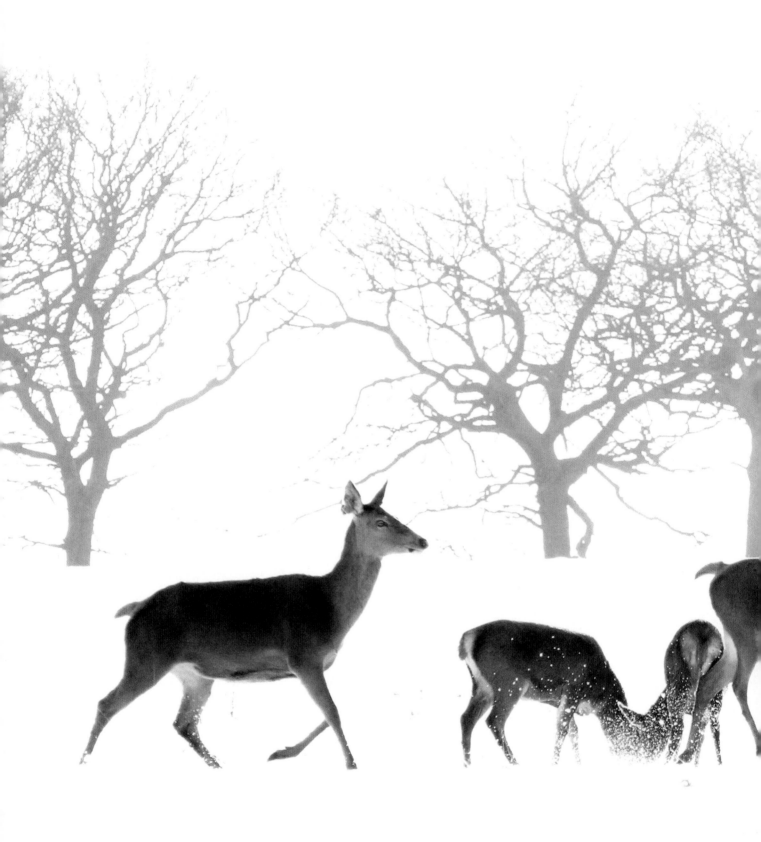

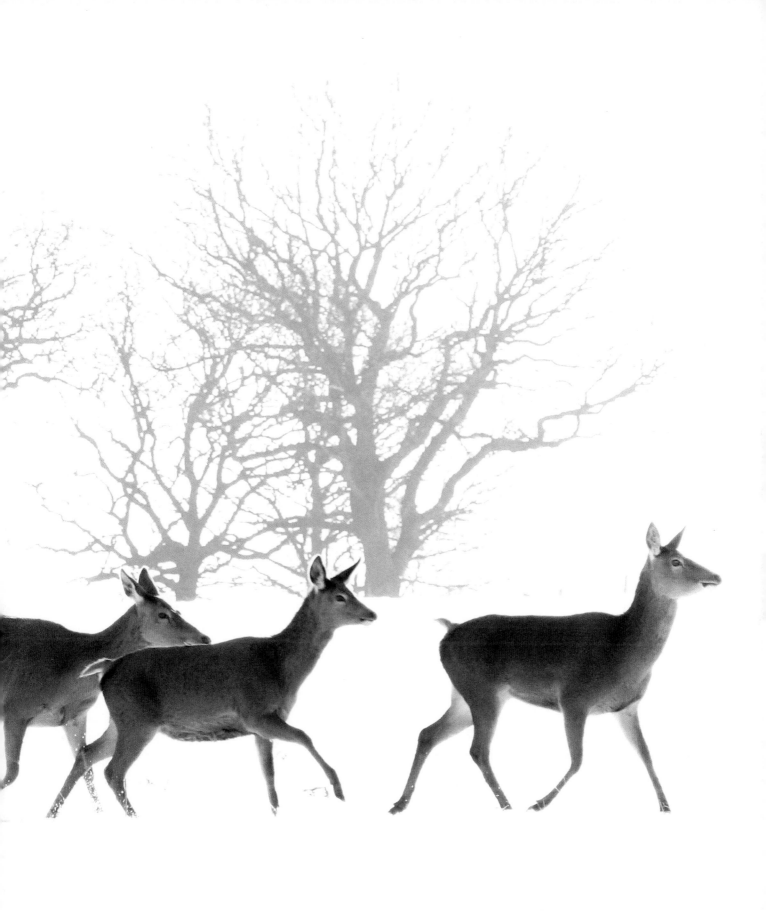

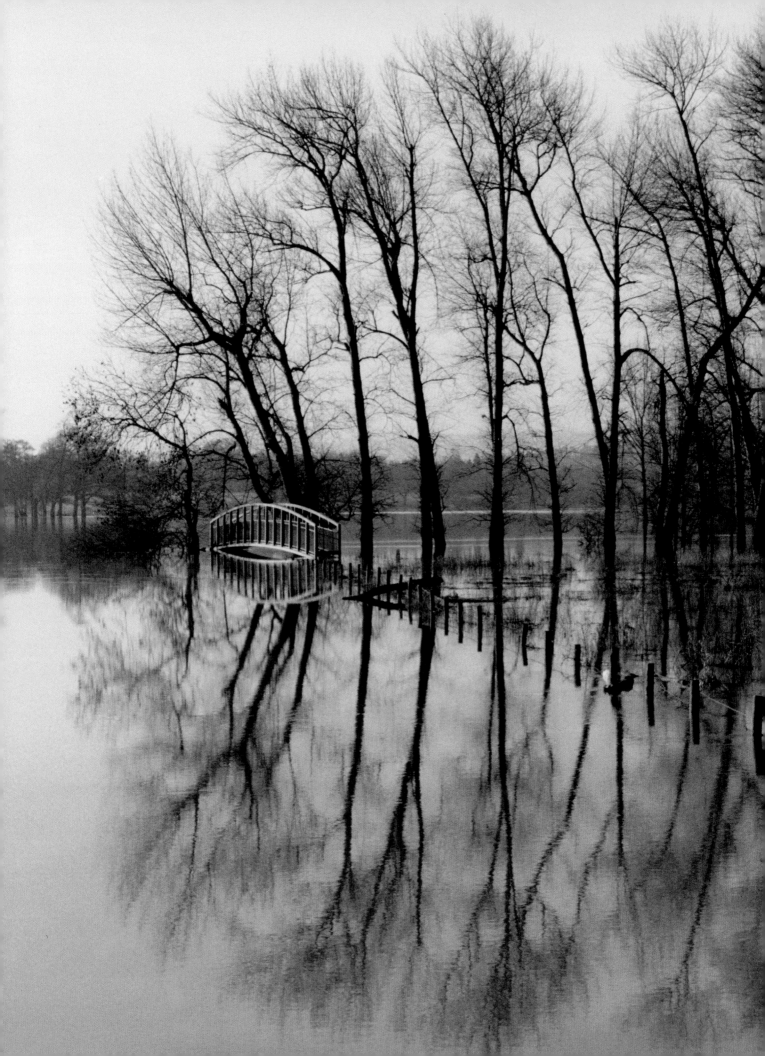

February

Matt Baker

February is a quirky month, for us, as my Mum is a leap-year baby so we only get to celebrate properly once every four years. As John said, Julius Caesar commissioned a sun-based calendar, similar to what the Egyptians used, which is more or less what we have today. The time it takes for the Earth to orbit the Sun is around 365.25 days. It might not seem a lot, but that extra quarter every year really adds up over time, so we need that extra day to keep in sync with the seasons. Historically, in the various Roman calendars February always had the fewest days, which is why the 'extra' day is added to the month in a leap year.

These days it seems the overriding feel of February is one of it always being wet, cold and relentless. Heavy black clouds demonstrating a sky full of rain. I feel sorry for the land, covered and smothered by water, and it never ceases to amaze me how nature bounces back.

On the farm we're getting ready for the busy months – fencing, fixing gates, repairing the ancient drystone walls and clearing fallen branches before the grass begins to grow, hiding them from view. It's a last chance to sort things before the rapid acceleration of nature in springtime.

Blue tits and great tits begin searching for the perfect site to build their nests – a much-needed dash of colour and energy in a bleak month. Carpets of beautiful white snowdrops also bring a very welcome sign of life. It is still bitterly cold, with plenty of frosty mornings. One of February's images shows a blanket of frosted leaves, looking as though they're doing what they can to try and protect the earth.

One of my favourite shots from this month is the lone tree on a limestone pavement. I took my old Blue Peter dog Meg there while filming many years ago. I remember her hobbling along trying to navigate the deep cracks. She was so desperate to follow me, it was all I could do to stop her falling down any of the crevices. The tree itself represents an image of the impossible for me. Thriving on its own within a landscape of challenges.

Opposite:
2003 – Floods at Pulborough. (Janet Cook, Petworth, West Sussex)

Following spread:
2004 – Frosted Leaves. (Ian Gregory, Gorse Covert, Warrington)

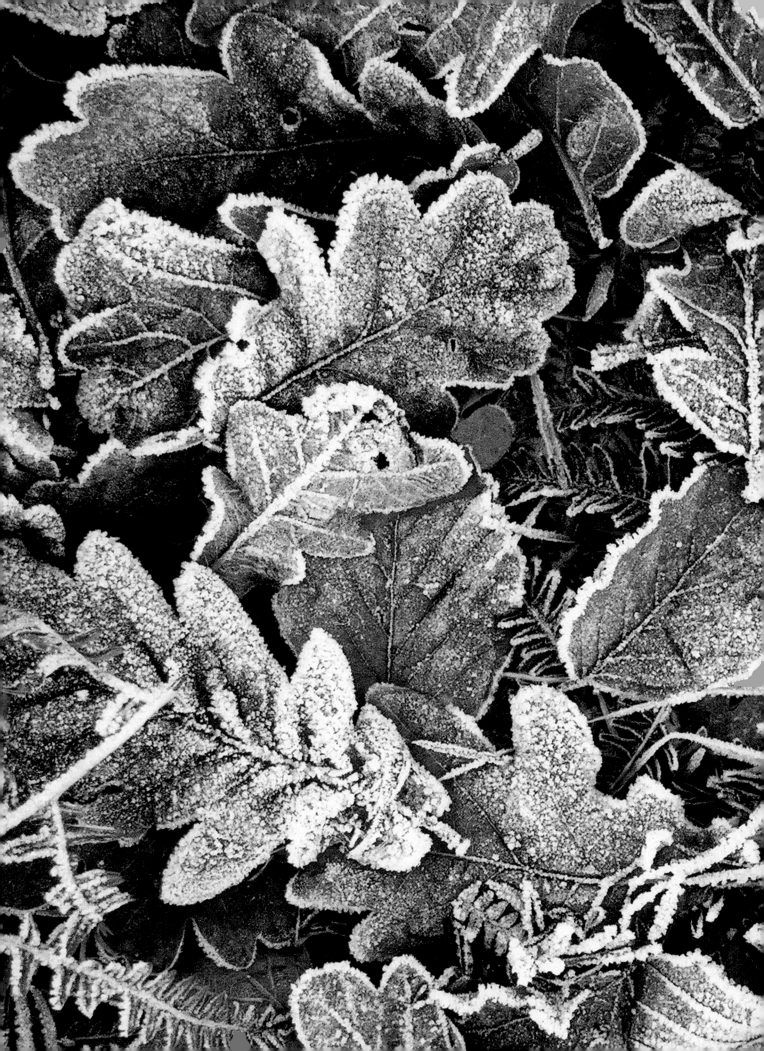

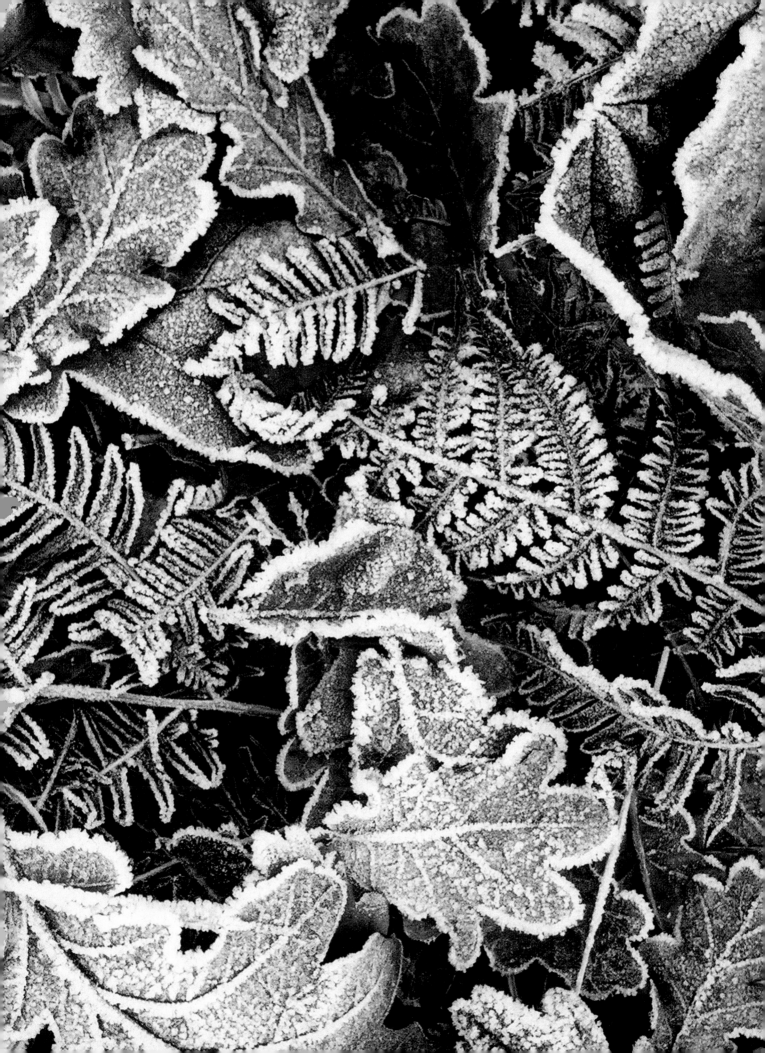

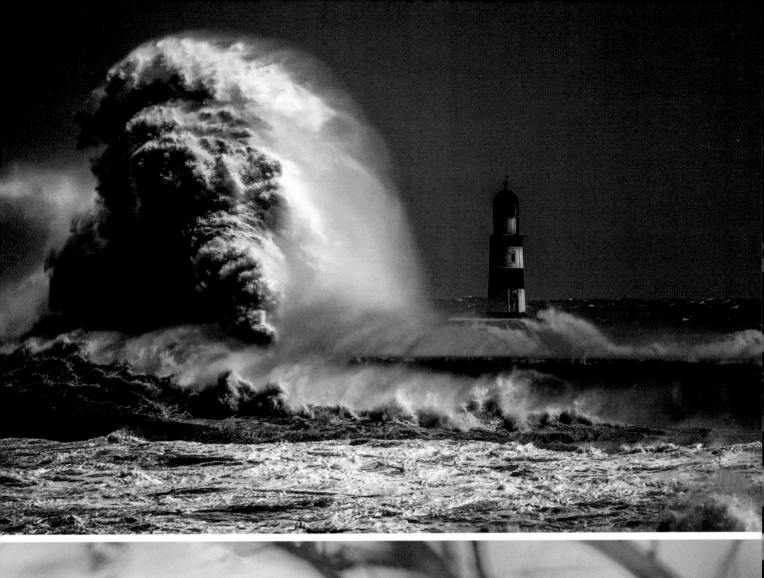
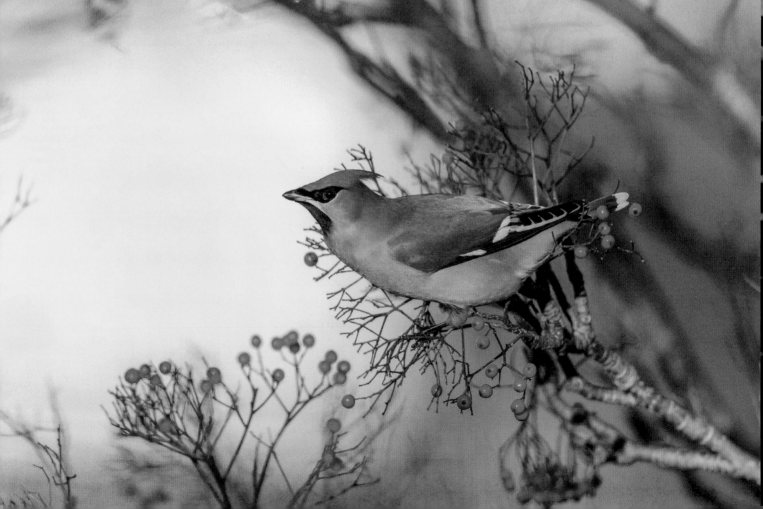

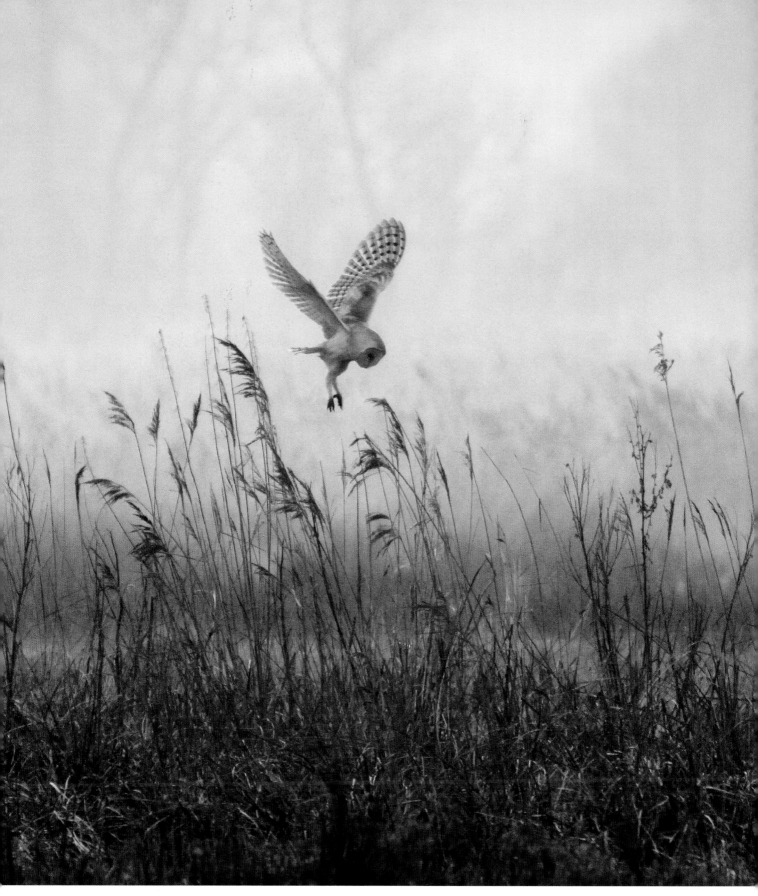

Above: **2017** – Twilight Hunter, Barn Owl, Norfolk. **Judges' Favourite**. (Tony Howes)

Opposite top: **2020** – The Tide is High, Seaham Harbour, County Durham. (Neil Rutherford)

Opposite bottom: **2019** – Waxwing Lyrical, Hessle, East Yorkshire. (David Higgins)

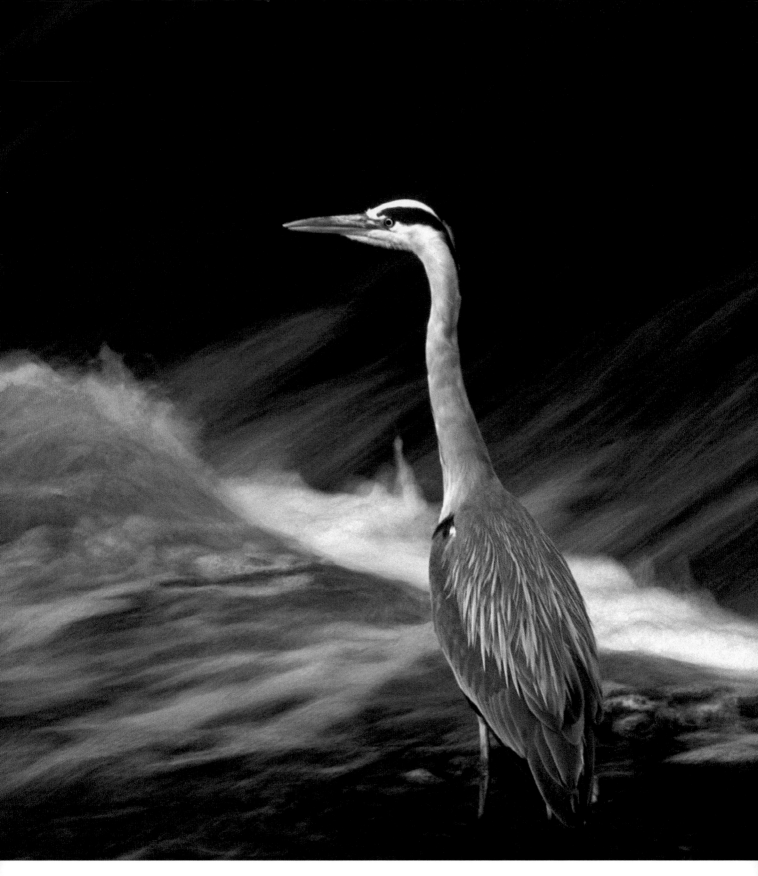

Above: **2006** – Heron. **Overall Winner**. (Mike Cruise)

Opposite top: **2004** – Love on the Rocks. (Isabelle Fudge)

Opposite bottom: **2015** – Swan Sweethearts. (Diana Grant)

Following spread: **2010** – Lone Tree. (David Stephenson)

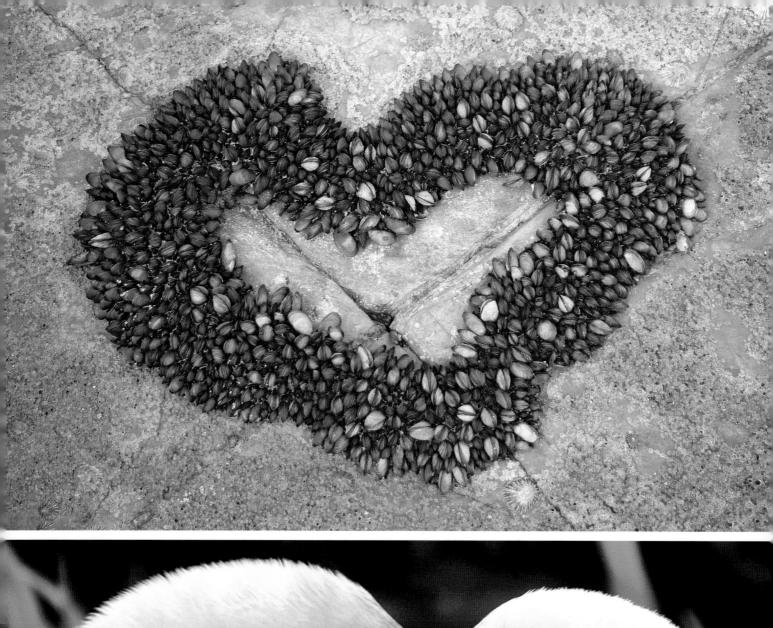
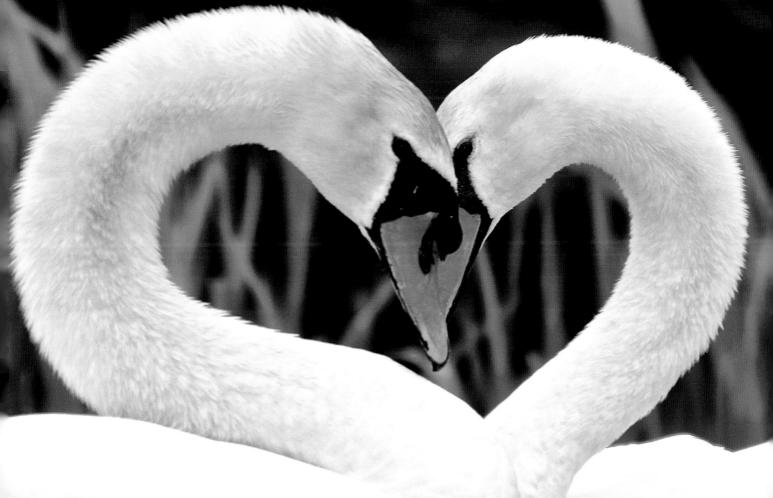

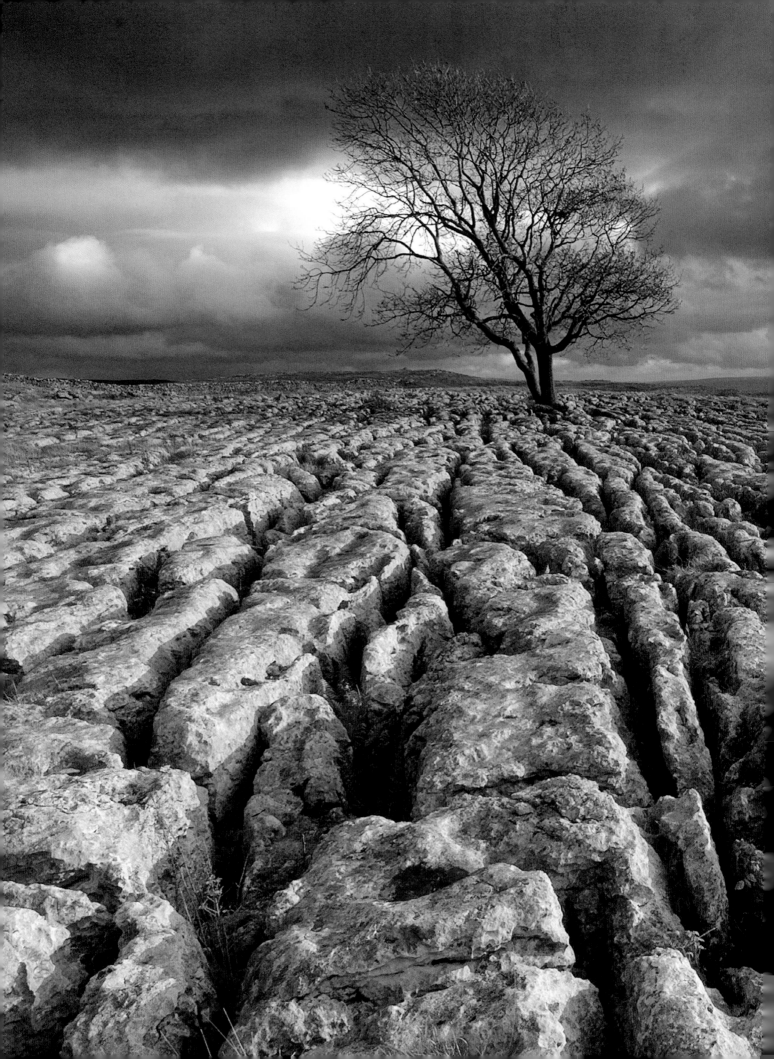

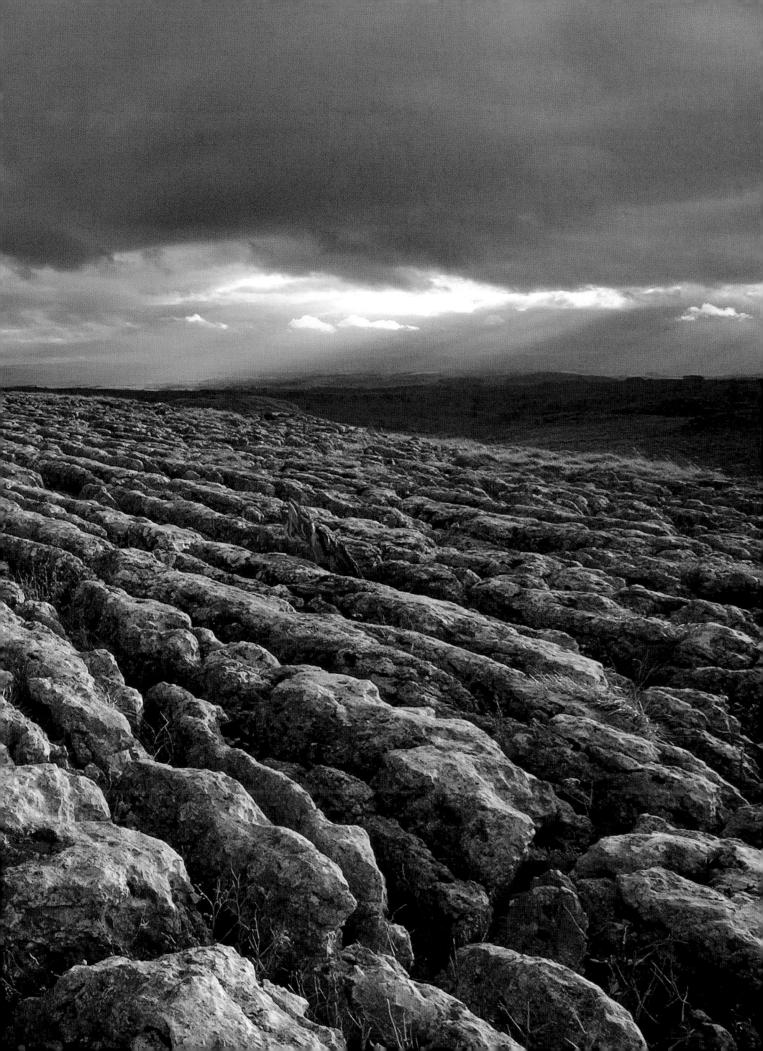

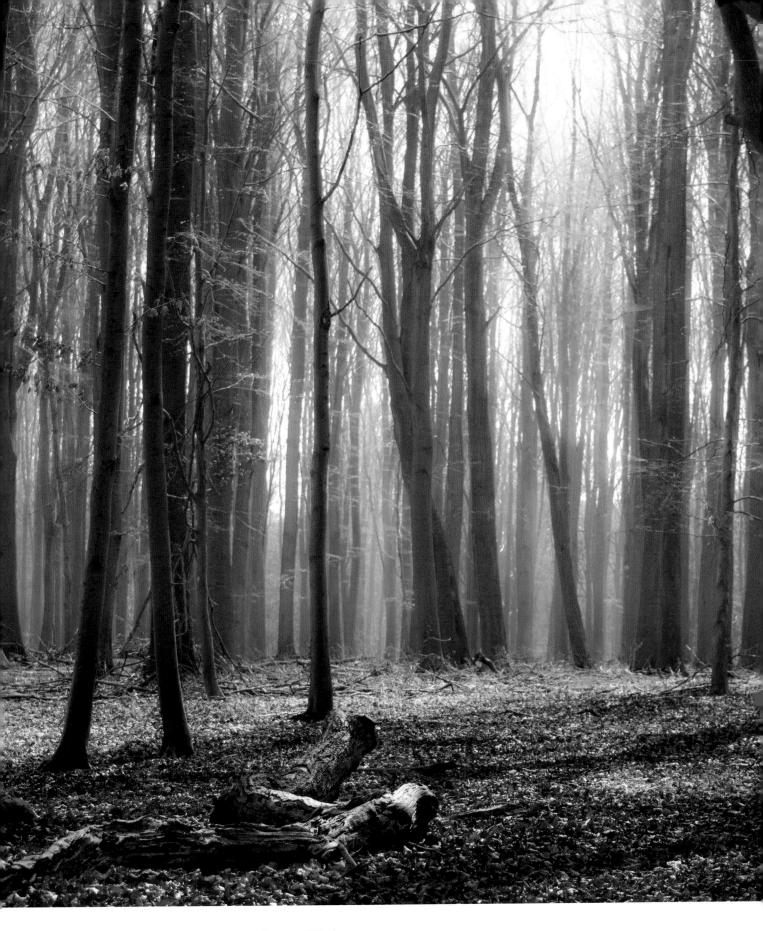

***Above:* 2016** – Magical Mist Trees. (Dianne Giles)

***Opposite top:* 2009** – Sea Horses. (Jeffrey Warren)

***Opposite bottom:* 2014** – Feeding Frenzy. (Andy Colbourne)

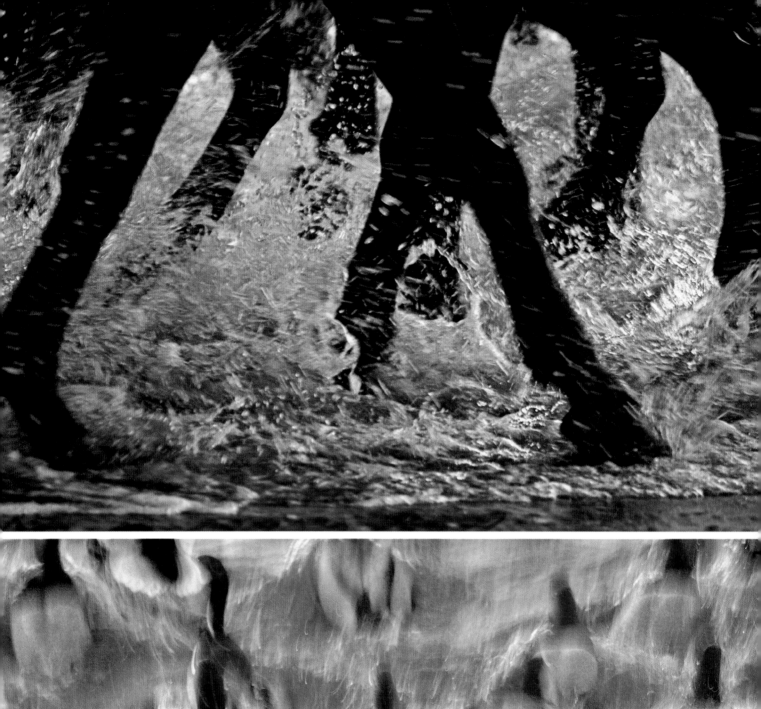
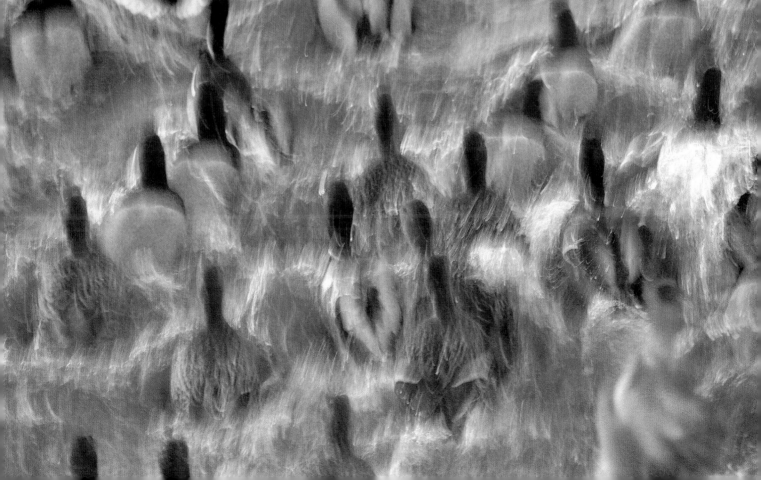

***Above:* 2011** – Sun Down. (Mark Catanach)

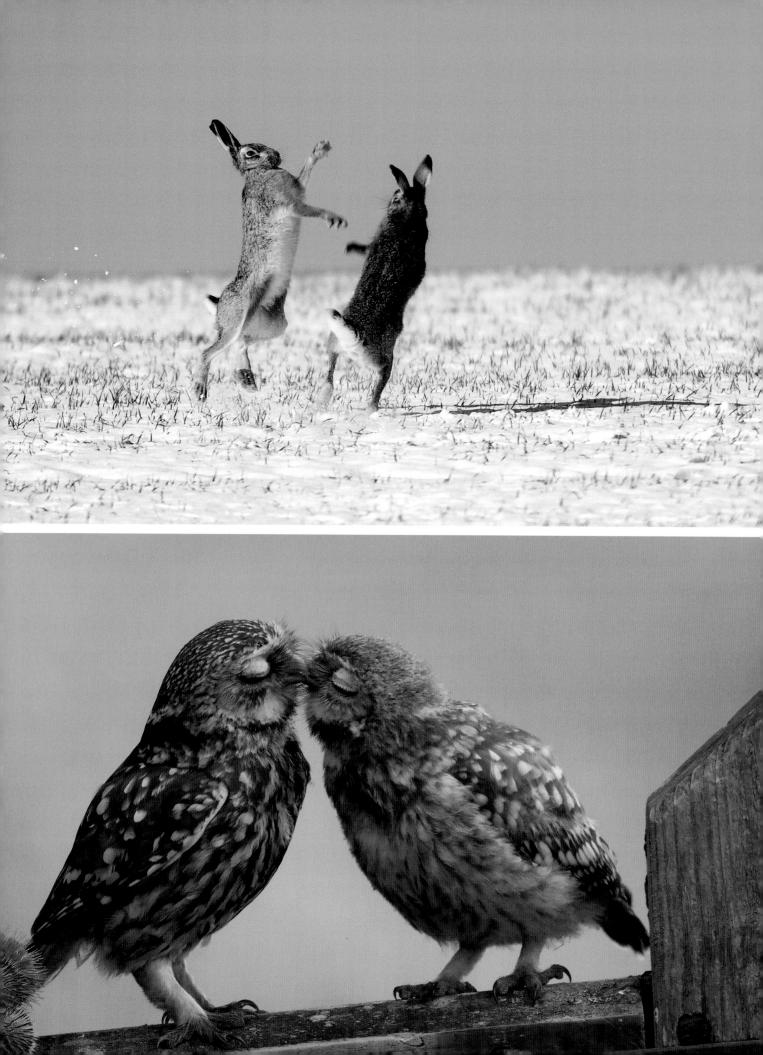

***Above:* 2012** – Best of Friends. (Kevin Stock)

***Opposite top:* 2005** – Boxing Hares. (Andy Darrington, Bedfordshire)

***Opposite bottom:* 2018** – A Little Love, York. (John Pate)

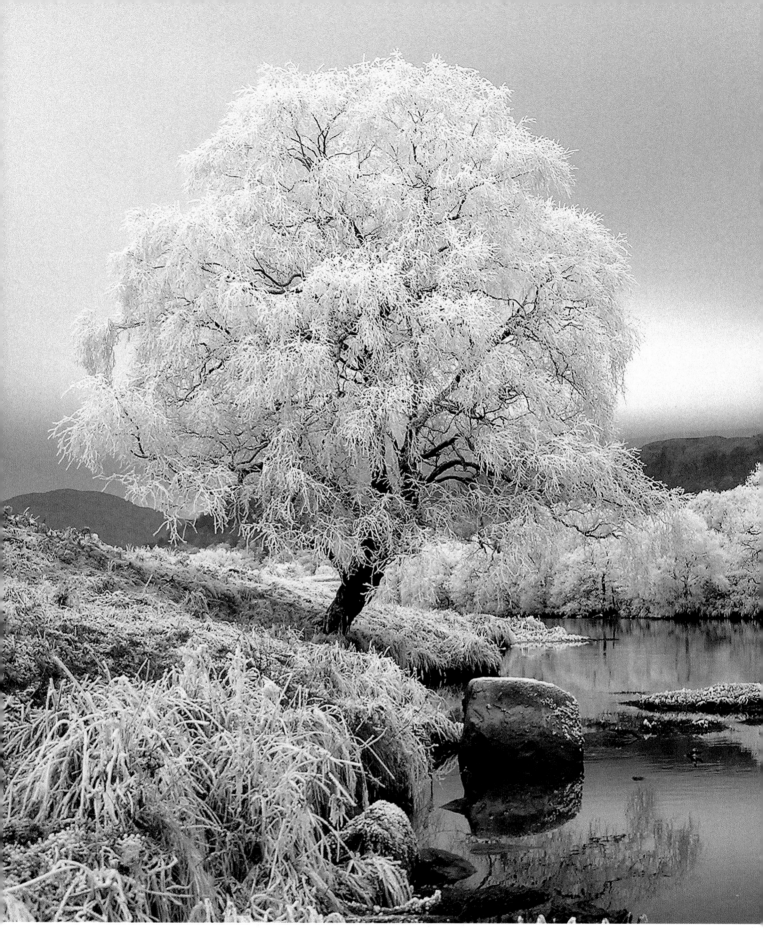

***Above:* 2007** – Hoar Frost, Glen Dochart. (Louise McGilviray)

***Following spread:* 2008** – Eye to Eye. (David Baker)

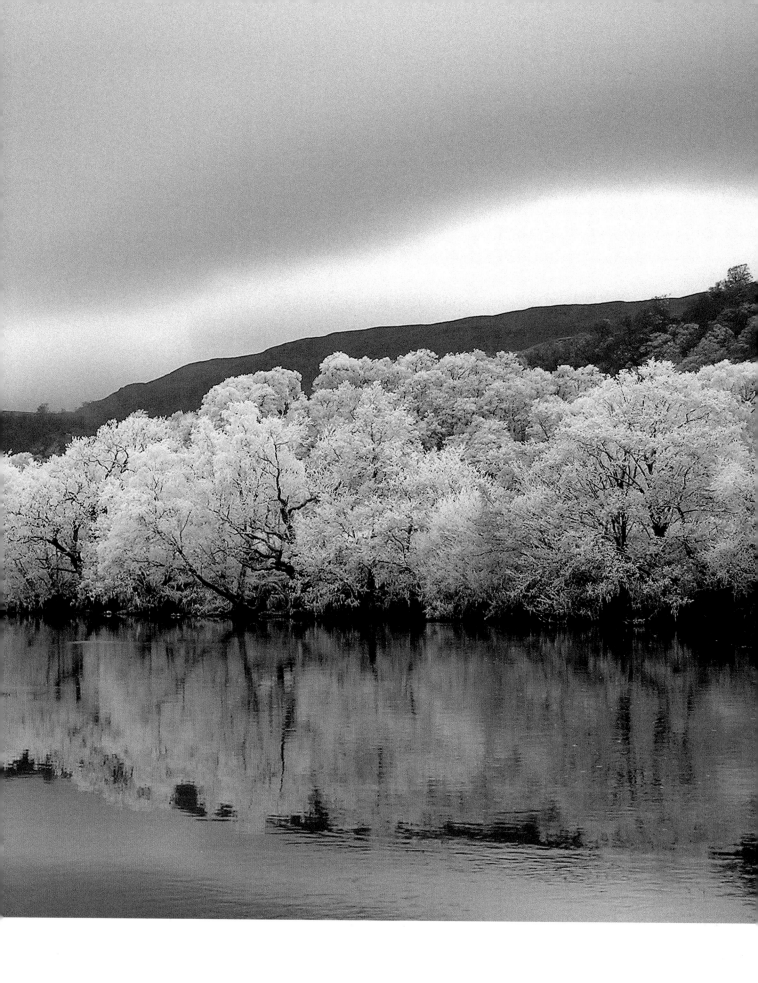

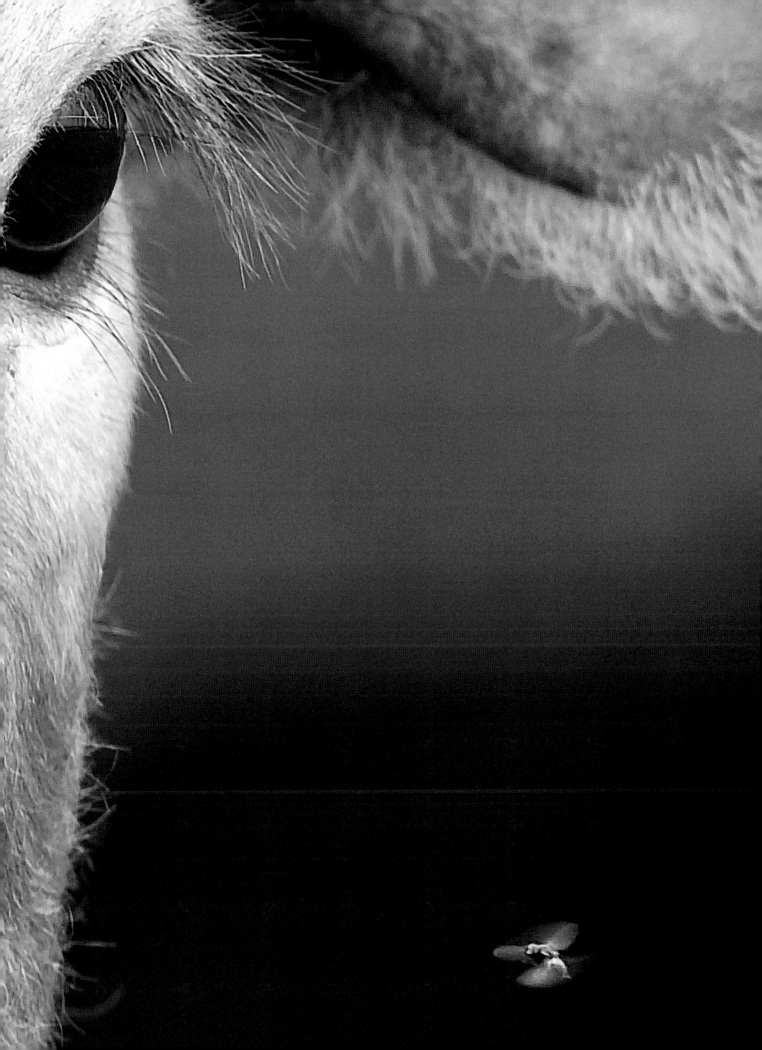

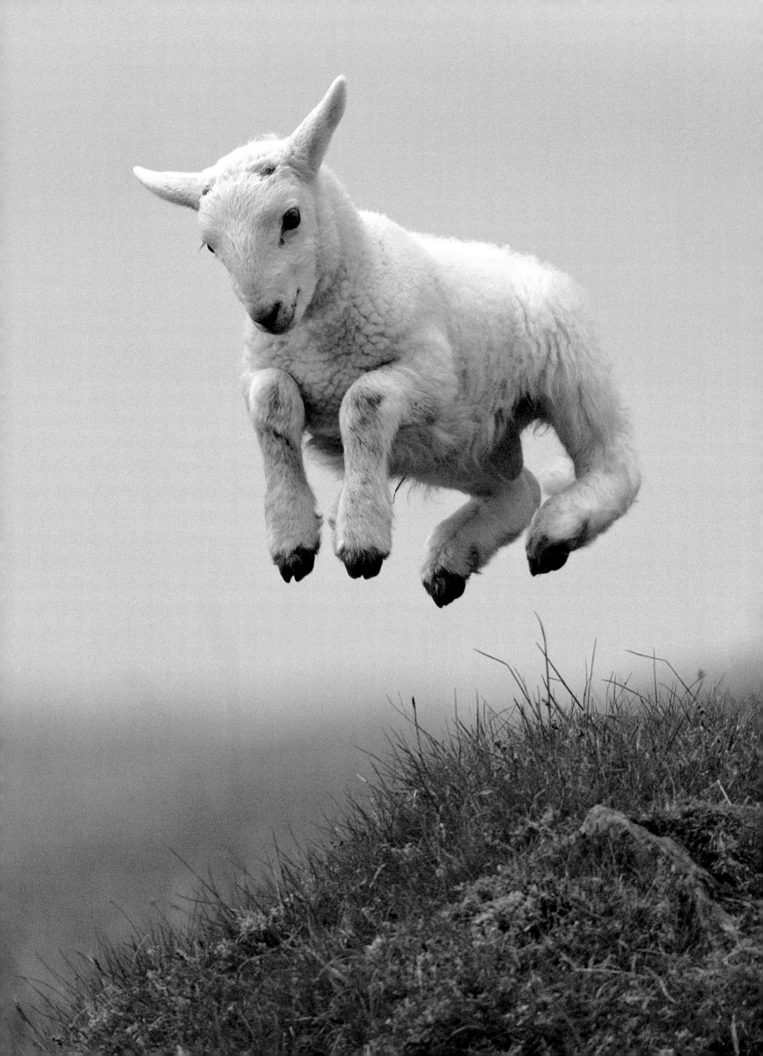

March

John Craven

We all know the old saying that when March comes in like a lion it goes out like a lamb, and as with so many proverbs there is much truth in those few words. John Clare, the farm labourer's son whose poems depicted 19th-century rural life, began his observation of this month with these words:

March month of 'many weathers' wildly comes/In hail and snow and rain and threatening hums/And floods. While often at his cottage door/The shepherd stands to hear the distant roar/Loosed from the rushing mills and river locks/ Wi thundering sound and overpowering shocks

That is March, roaring in lion-style. But as the month softens and gentler, lamb-like days take over, Clare, who was known as the 'peasant poet', notes that 'love-teazd maidens' meet their 'swains' (boyfriends): 'To talk about spring pleasures hoveing nigh/And happy rambles when the roads get dry'. Some things never change!

March happens to be a good month for Saints – David (Wales) on the 1st, Piran (Cornwall) on the 5th and Patrick (Ireland) on the 17th. And in case you hadn't noticed, it is the only month with three consecutive consonants!

With stark, sharp light and bleak landscapes, this is a perfect time of year for one of my favourite photographic themes – a lone object, catching the eye in a wide-open vista. Often a sentinel of our rural past, which enhances the present-day view. We have some fine examples in our winning entries for March: a ruined chapel in a scree-splattered Welsh valley; a distant castle watching over a deserted lake. The single tree, emerging from the shallows of a misty Buttermere, transforms what could be a rather standard shot into something special.

Bird life is bountiful in March and that's reflected here by a remarkable shot of a brave female mallard seeing off an osprey, as well as images of ducklings, swans, a colourful coot and a sky-full of linnets. We don't get too many pictures of frogs and spiders sent in but you will see both on these pages, proving that nothing in nature escapes our viewers when they are out with their cameras.

Opposite: **2008** – Spring Lamb. **Overall Winner**. (Richard Peters)

Following spread: **2005** – Welsh Landscape. (Rory Trappe, Blaenau Ffestiniog)

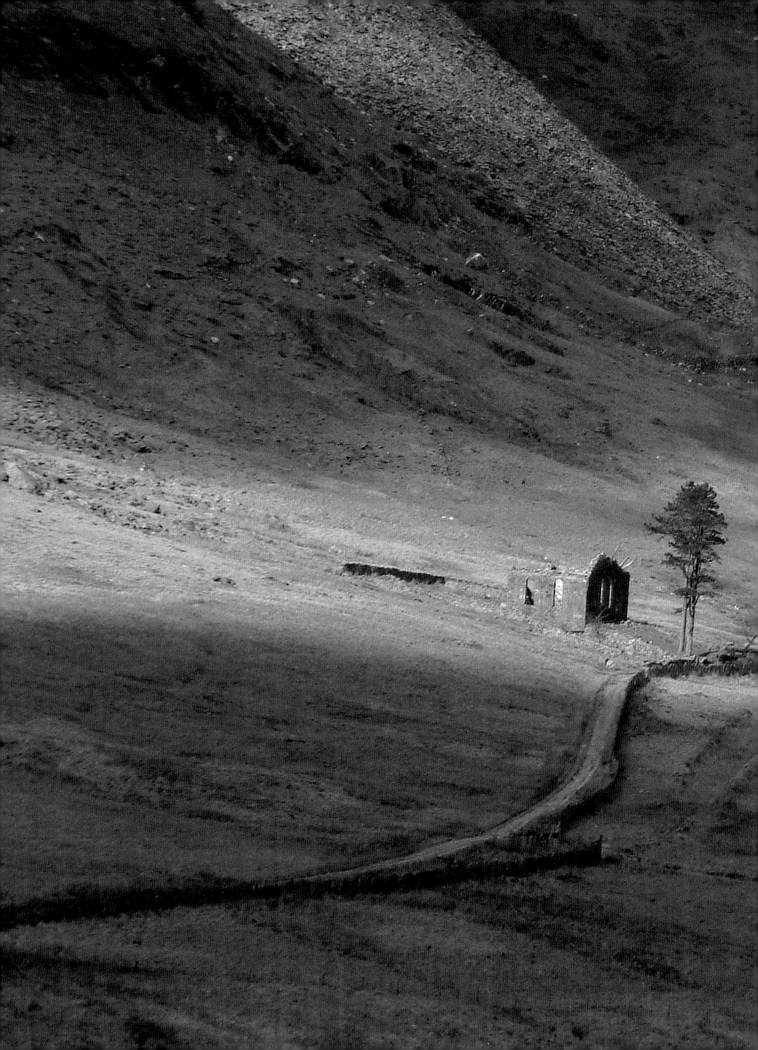

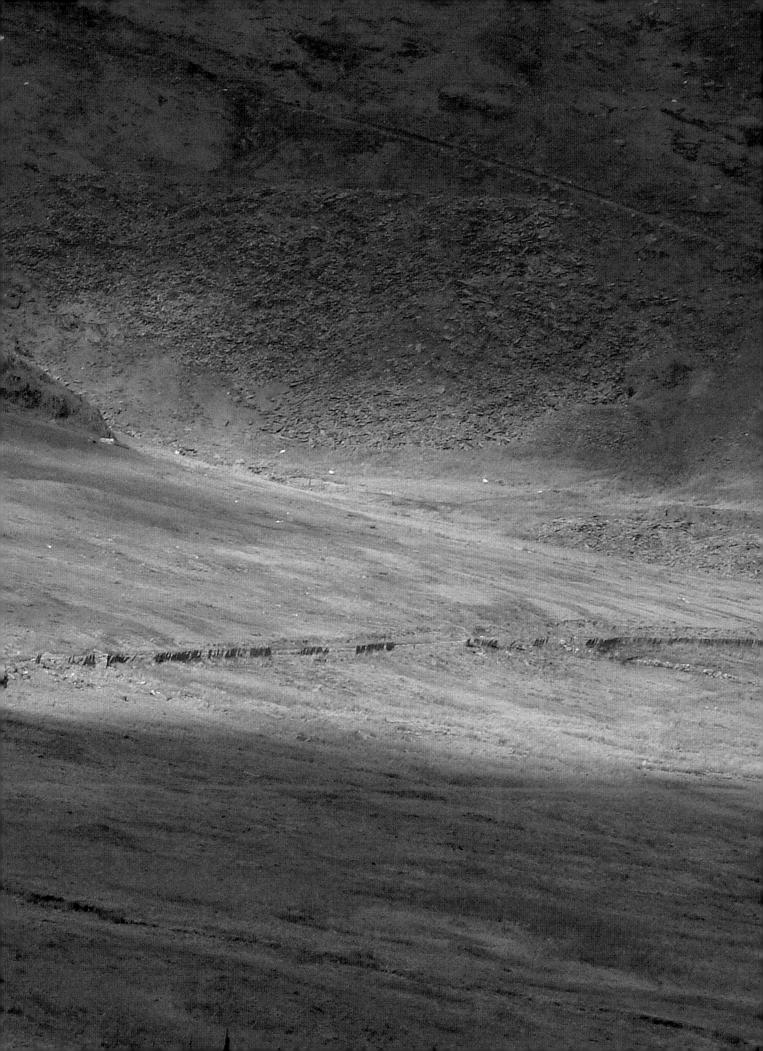

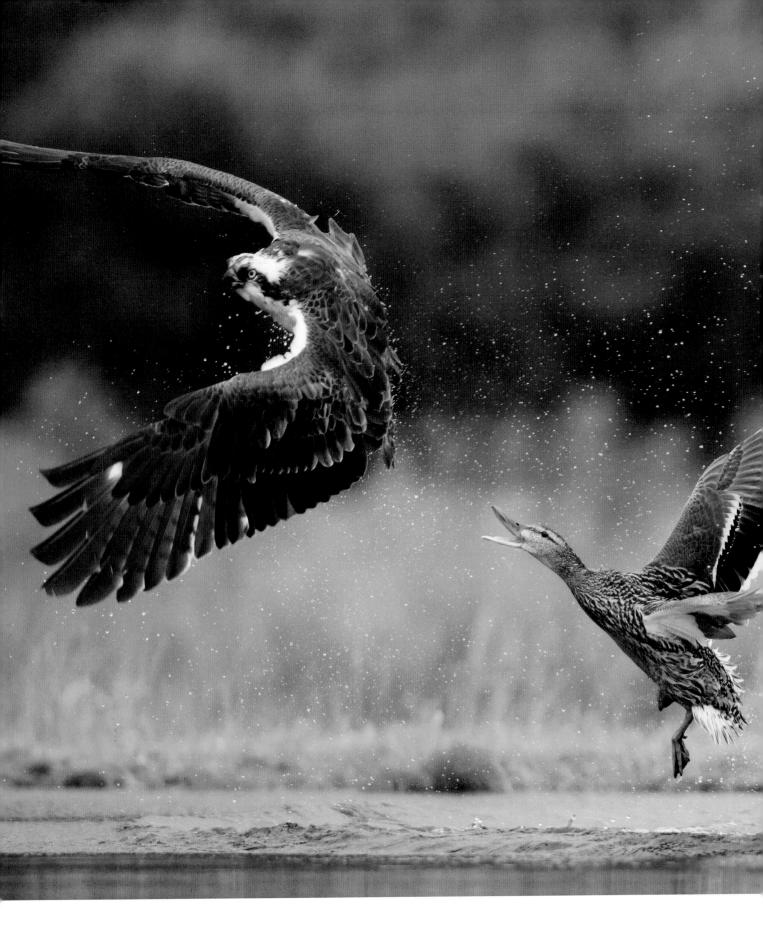

Above: **2014** – When Feathers Fly. (Jerome Murray)

Opposite: **2015** – Linnets Aloft. (James Fisher)

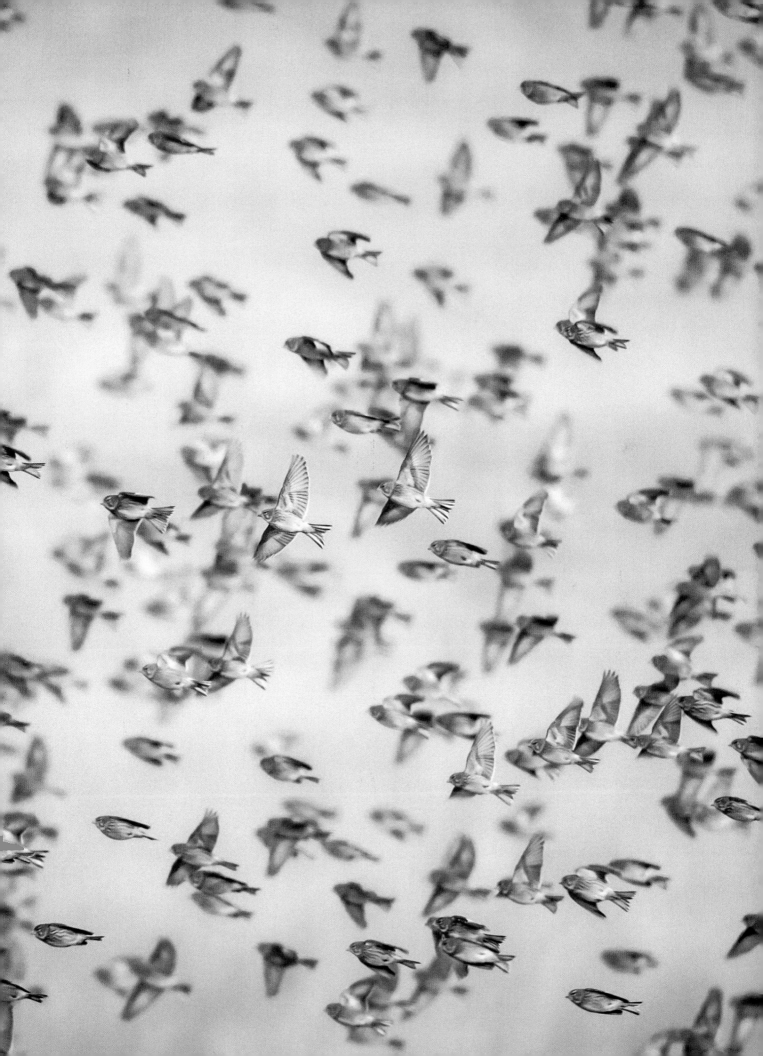

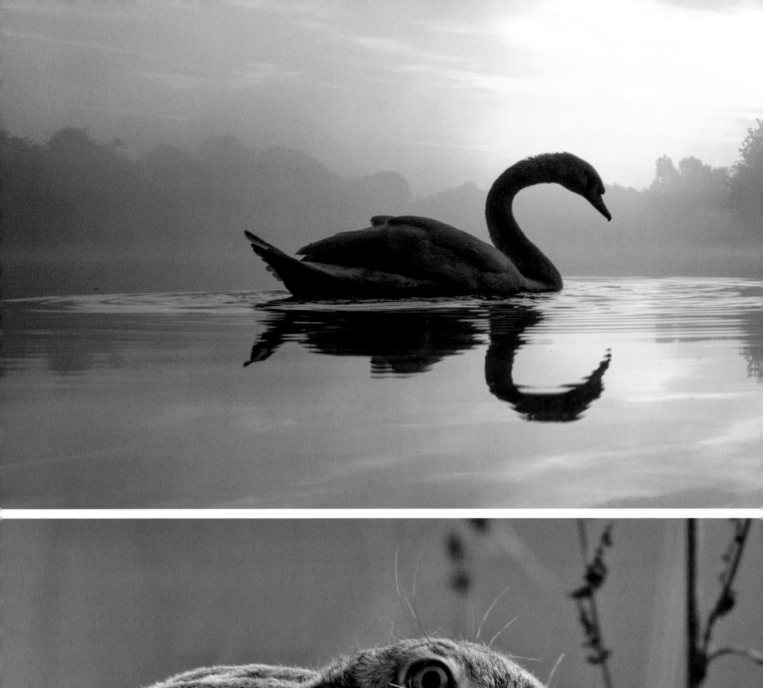
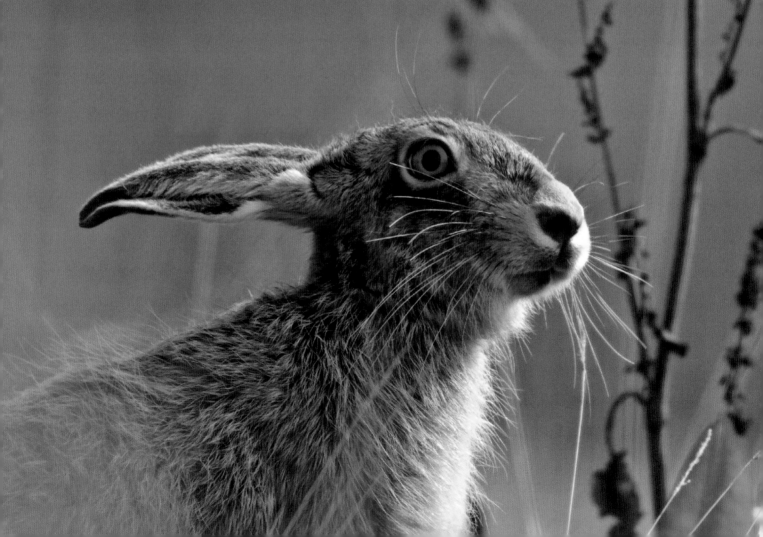

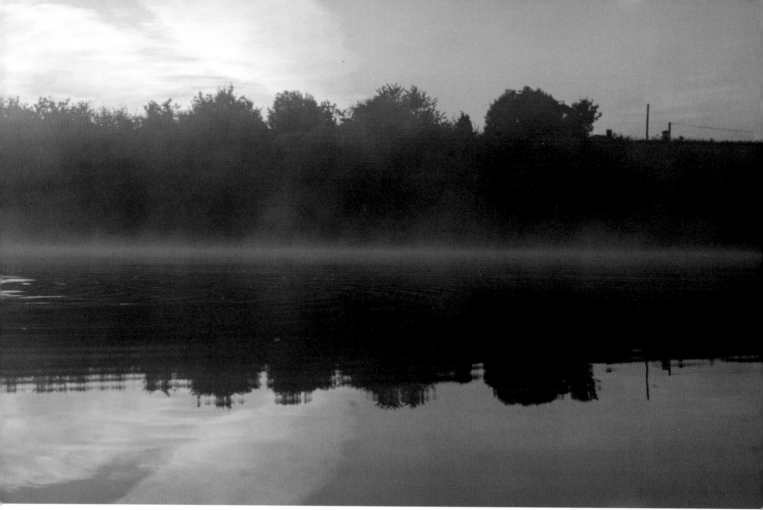

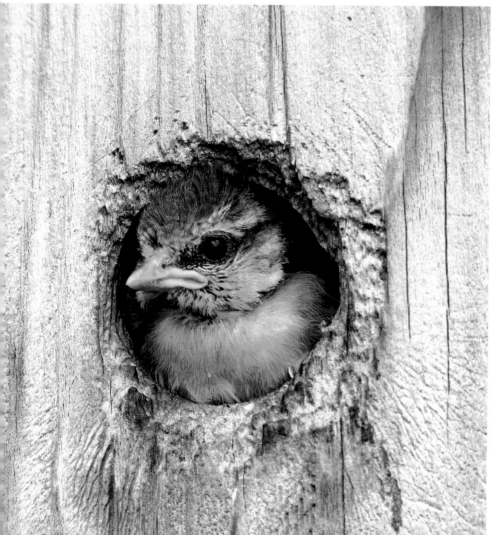

Above: 2019 – Swan Lake,
Crime Lake, Oldham.
(Mark Buchan Jones)

Left: 2012 – Baby Blue Tit.
(Mike Sibley)

Far left: 2010 – March Hare.
(Laurence Watton)

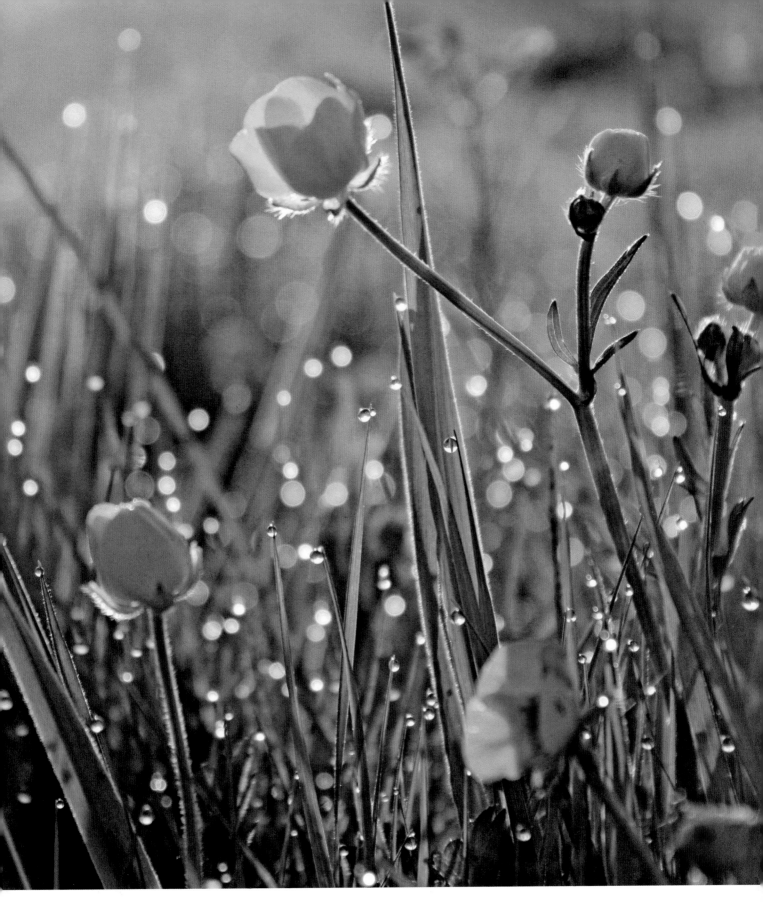

Above: 2013 – Diamonds at Dawn. (Mandy Elizabeth Rush)

Opposite top: 2017 – Buck Up, Roe Buck, Norfolk. (Jo Soanes)

Opposite bottom: 2016 – Colourful Coot. (Susie Scofield)

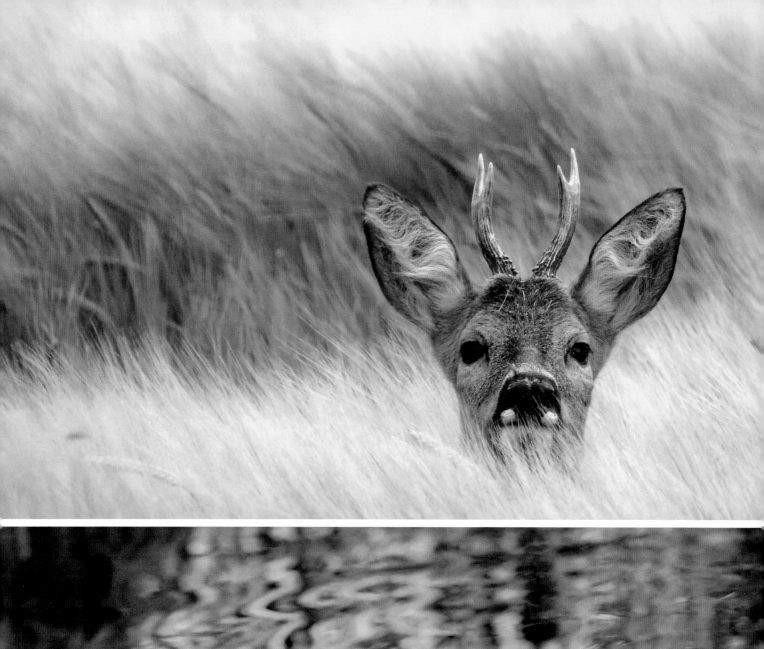
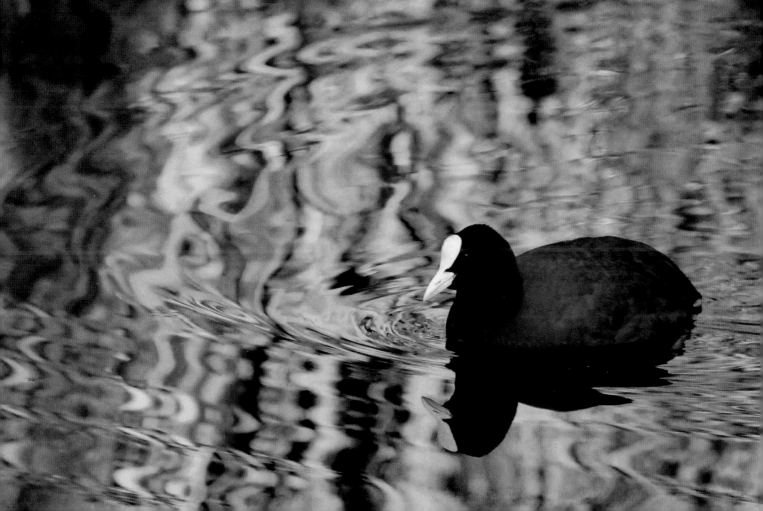

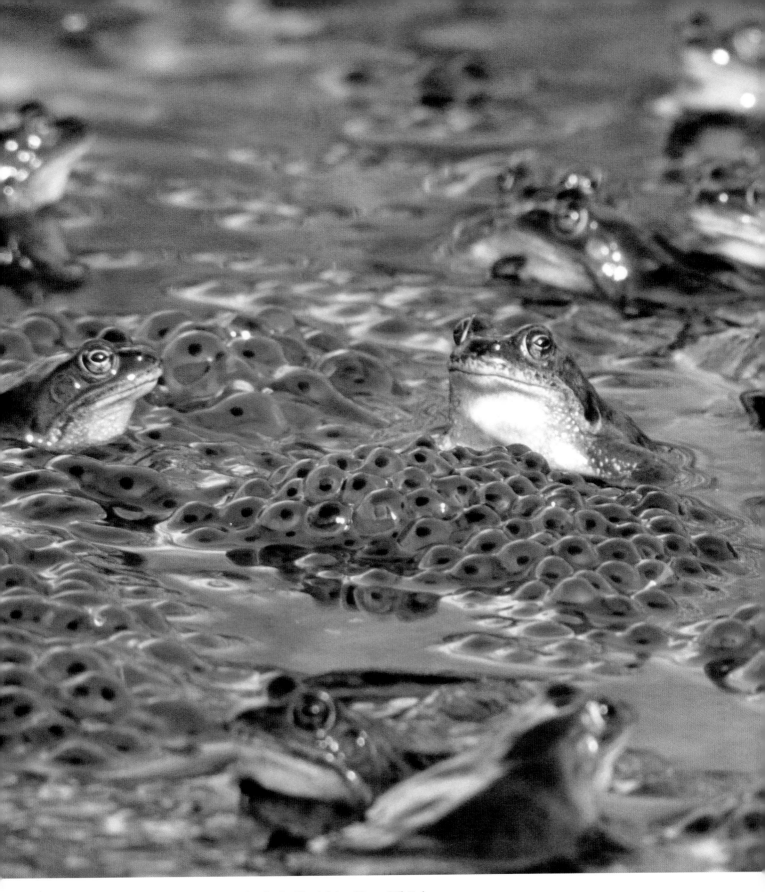

Above: **2004** – Spawning Frogs, Leek, Staffordshire. (Dave White)

Opposite top: **2020** – Hare Today, Gone Tomorrow, Croston, Lancashire. (Bernard Noblett)

Opposite bottom: **2009** – Swan Lake. (Terry Slater)

Following spread: **2018** – Solitude, Buttermere. (Adrian Harrison)

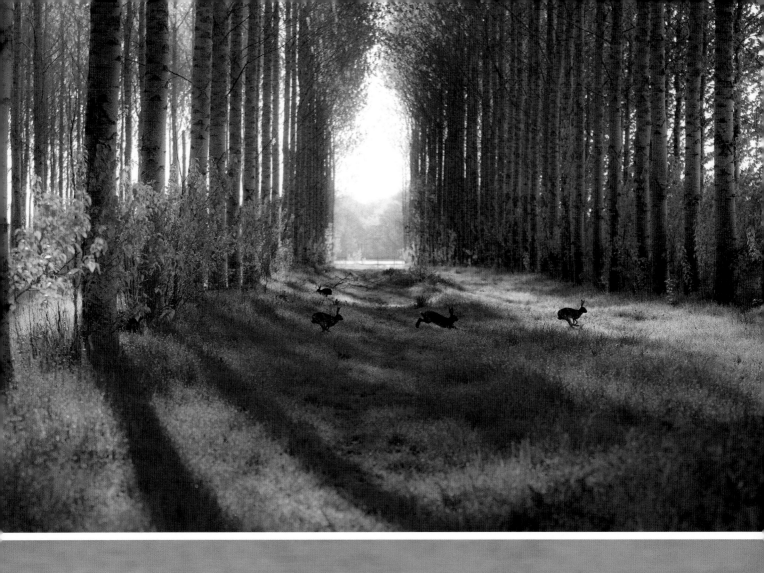

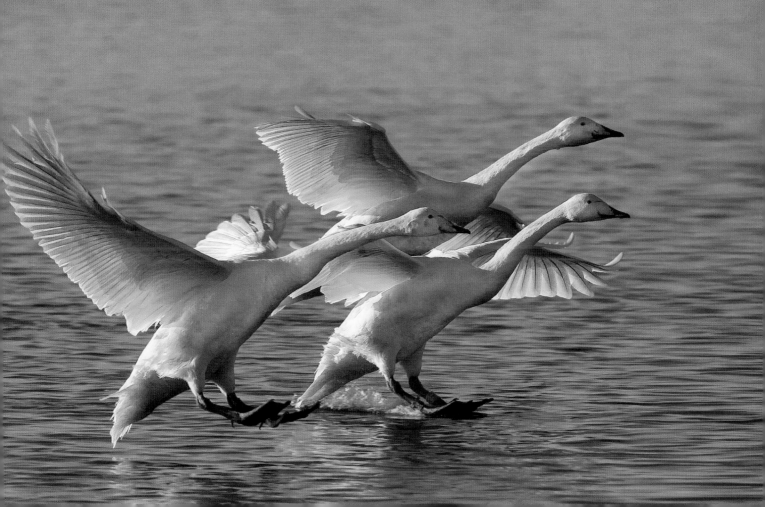

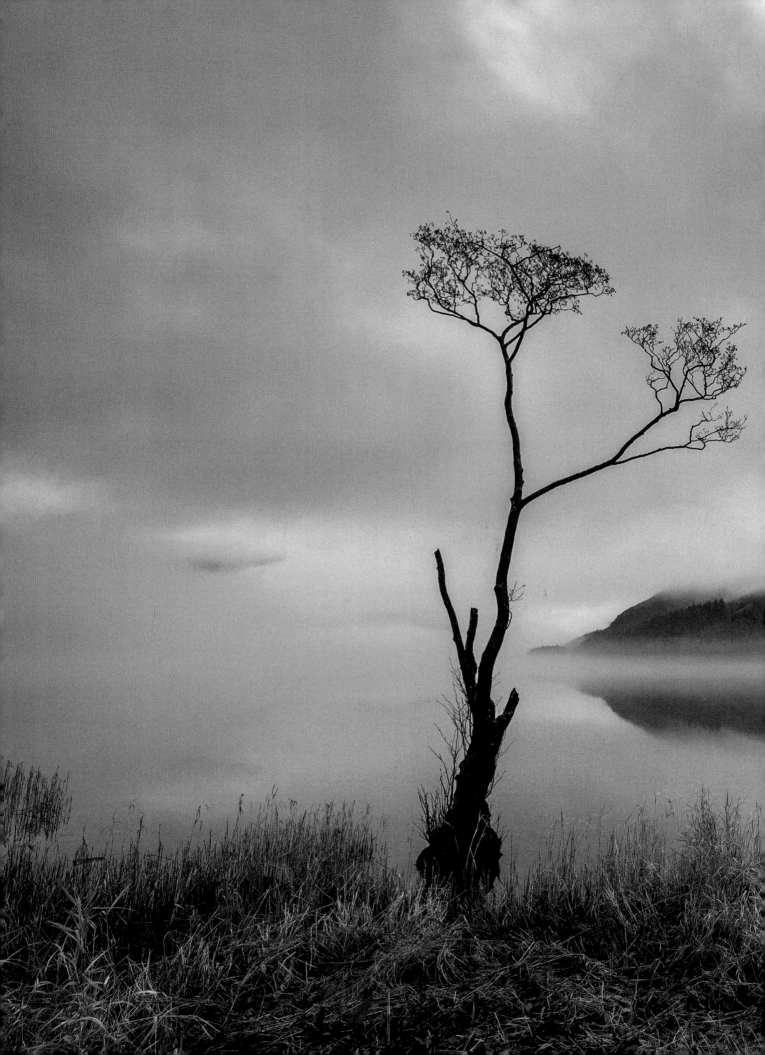

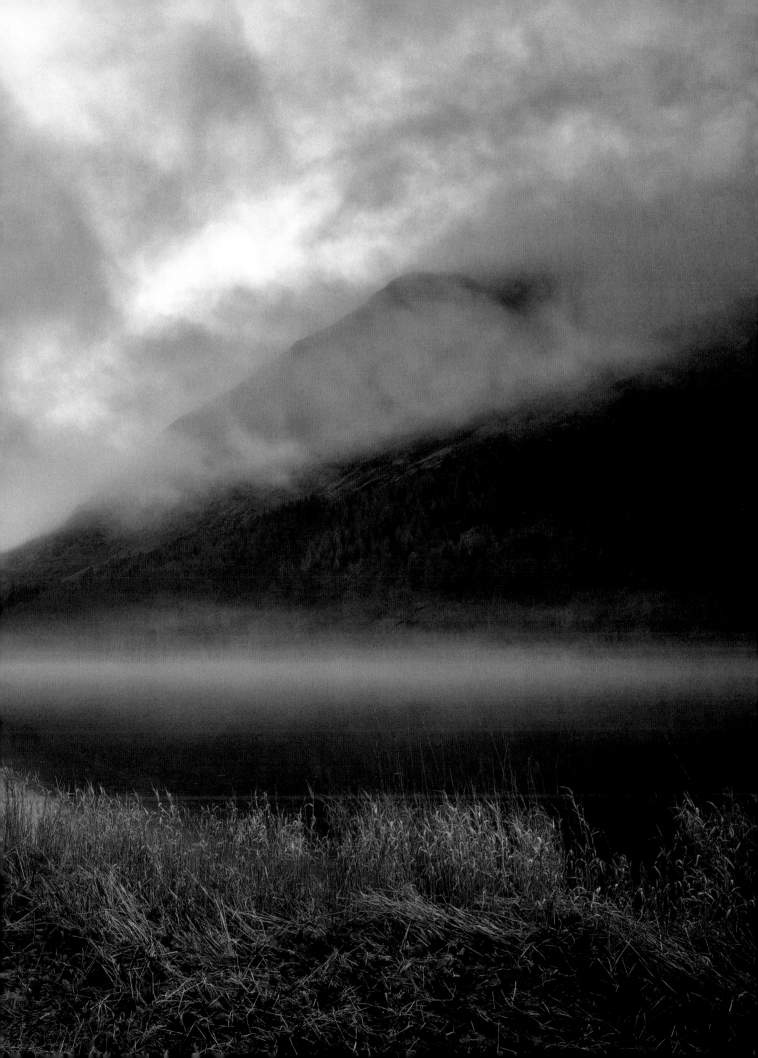

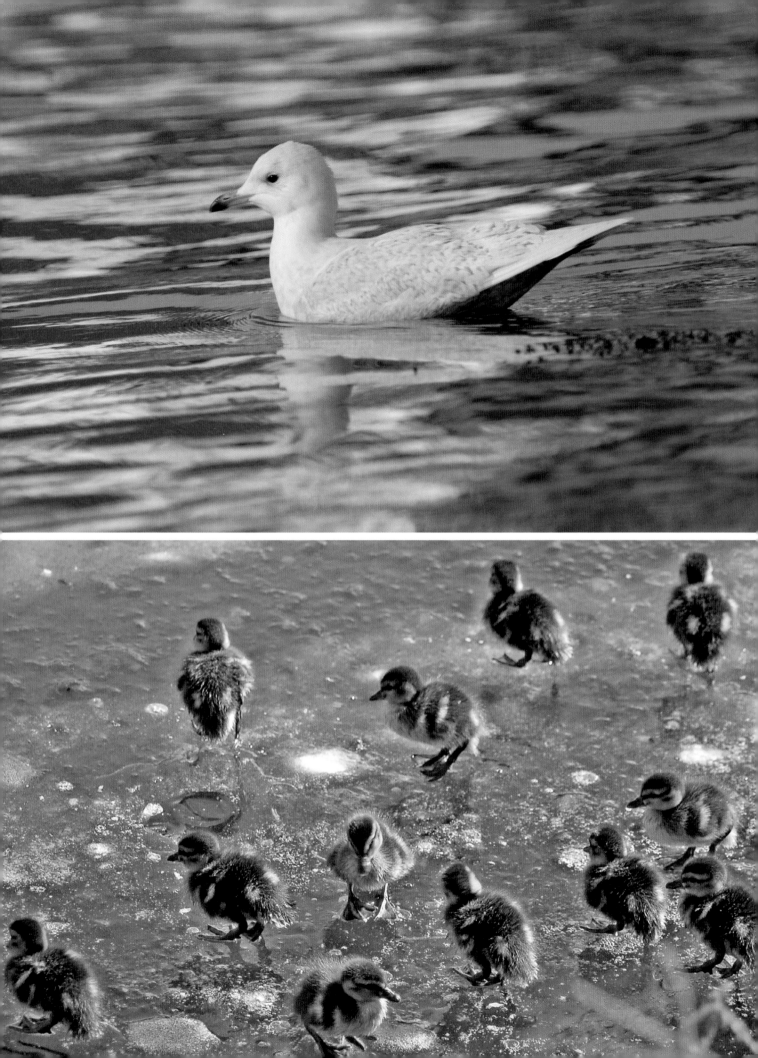

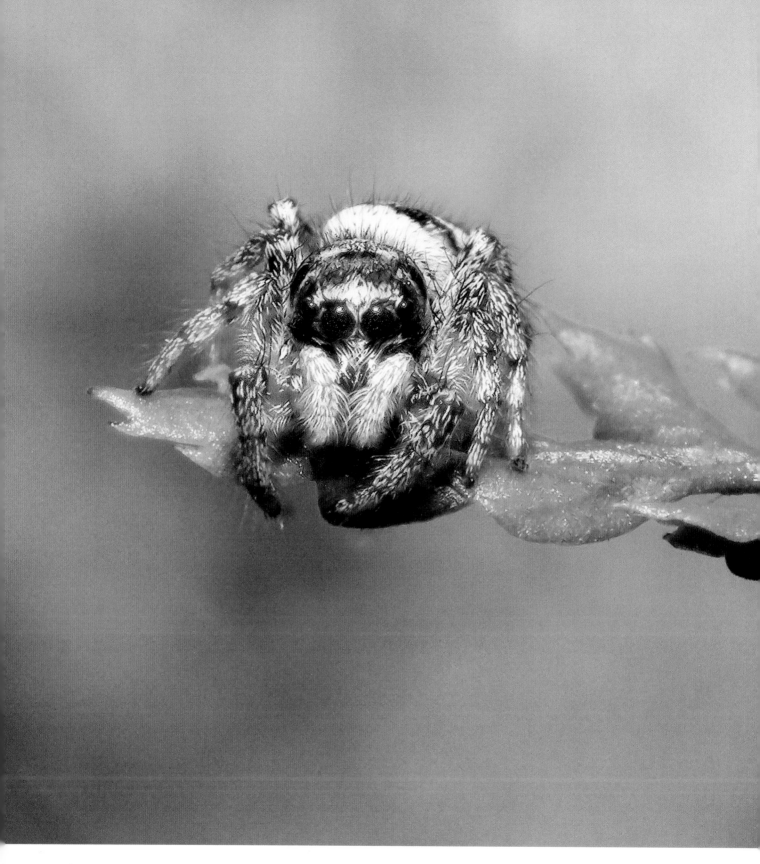

Above: **2011** – Incy Wincy. (Michael J. Butler)

Opposite top: **2006** – Young Gull. (Adrian Davey)

Opposite bottom: **2007** – Ducklings, West Yorkshire. (Beatrice Myers)

Following spread: **2003** – Castle Stalker from Appin, West Scotland. (Simon Booth)

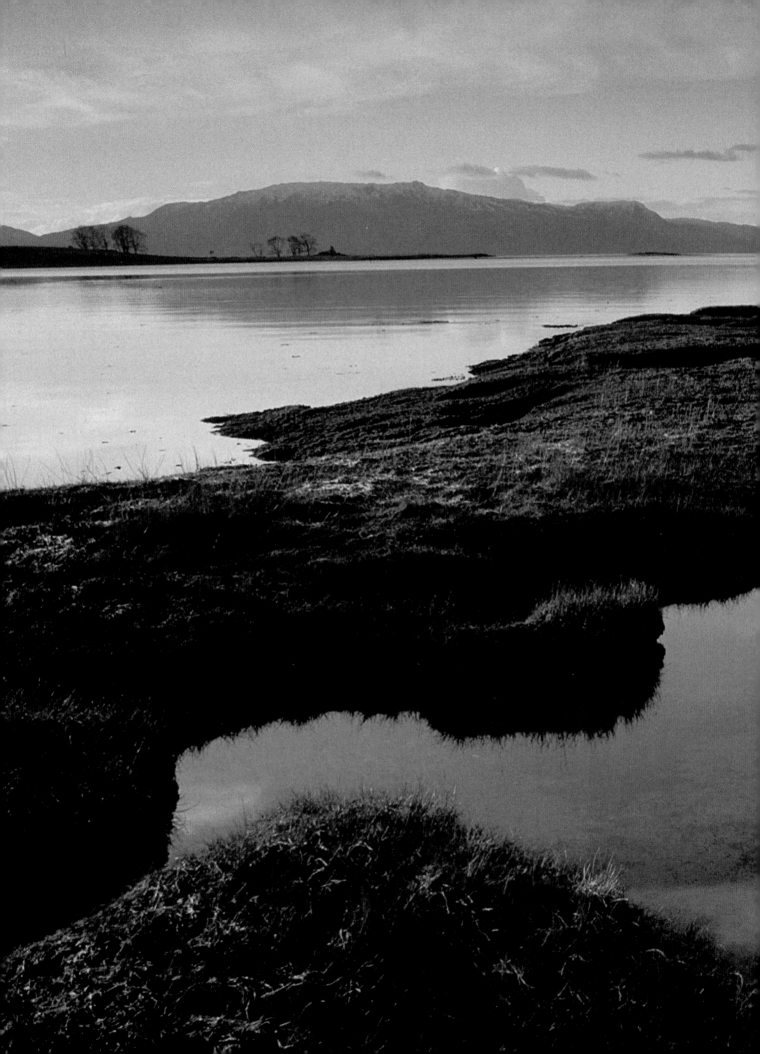

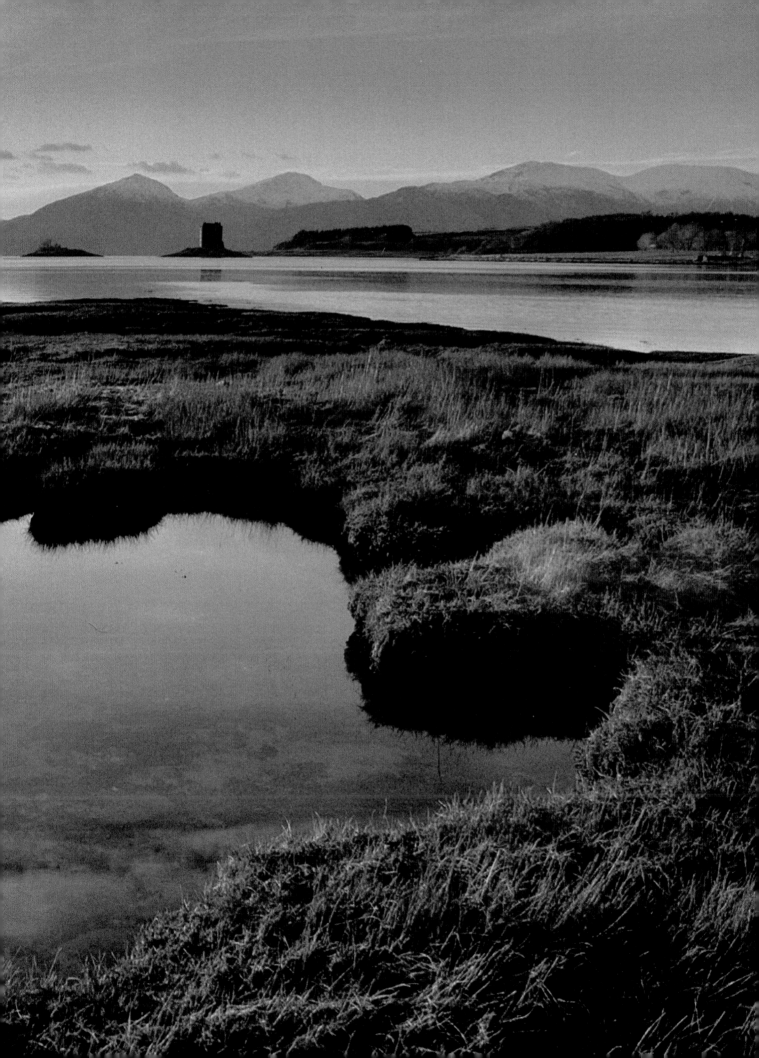

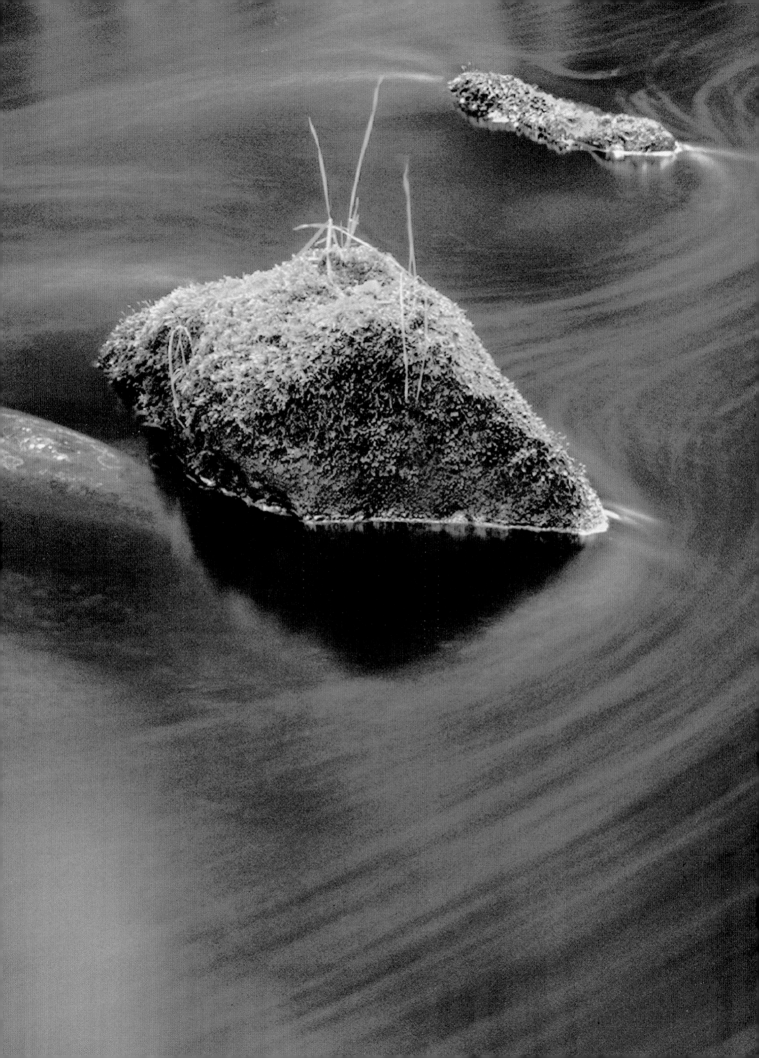

April

Matt Baker

In early April the swallows and house martins arrive along with the warblers and redstarts, followed closely by the flycatchers. It's around this time of year you often hear your first cuckoo calling – the sound of spring. Hedgehogs and ladybirds begin to make themselves seen, signalling winter is over. Two of my favourite flowers are in abundance in April too: carpets of bluebells in the dappled woodlands; and the fascinating snake's-head fritillaries in the damper areas. You may see the early butterflies flitting around in the warm spring sunshine – brimstone, orange tips, peacocks and small tortoiseshells. In late April, moths begin to emerge, which can only mean one thing – bats. Emerging from their winter dens after hibernation, they start to feed most nights, hungry after their winter sleep. We're lucky enough to have a few visit us at home and it's exciting to watch them swooping, darting above our heads at dusk in search of food. An adult bat can eat thousands of insects a night so it's just as well that insect numbers are beginning to increase at this time of year.

On the farm it's a celebratory time. It's certainly a busy time, with lambing in full swing. Our Hebridean sheep are hardy and lamb outside in sheltered woodland. We bring our Hampshires in to lamb in the polytunnel before they're turned out again into the now lush fields when the lambs are strong enough. It's one of those months that goes by in a blur, sometimes barely noticing as nature begins to grow and flourish.

April really does signal new life and new beginnings, the promise of things to come. Young badgers begin to venture out of their setts, the fox cub season continues and the watery ecosystems burst into life. April brings colour with its vibrant greens, as the grass and trees burst into life. Spring bulbs and flowers make an appearance, adding to the vibrant palette which is a feast for our eyes. Our fruit orchards begin to blossom too and we all wonder if this year will be a good one with an abundance of fruit.

I love the photo of the goat kid and its mother as it reminds me of growing up. We always had goats and I'd have goat's milk on my cornflakes in the morning or Mum would make cheese out of it – a taste of my childhood.

Opposite: **2003** – Golspie Burn, Sutherland. (Andrew Linscott, Ripon, North Yorkshire)

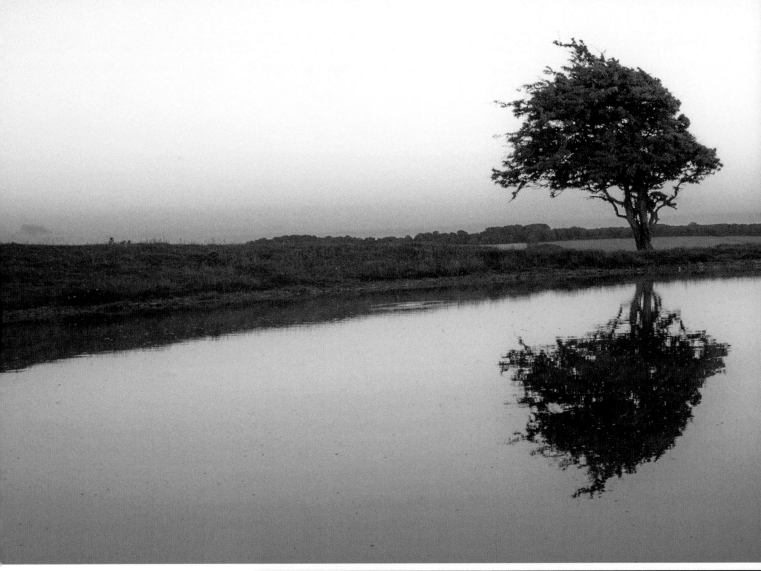

Above: **2017** – On Reflection, Ditchling Beacon, Sussex. (Duncan Innes)

Right: **2008** – Damselfly. (John Bogle)

Far right: **2004** – Magnolias. (Susan Stevens, Nottingham)

Following spread: **2019** – Easter Bunnies, Staffordshire. (Lyndon Hill)

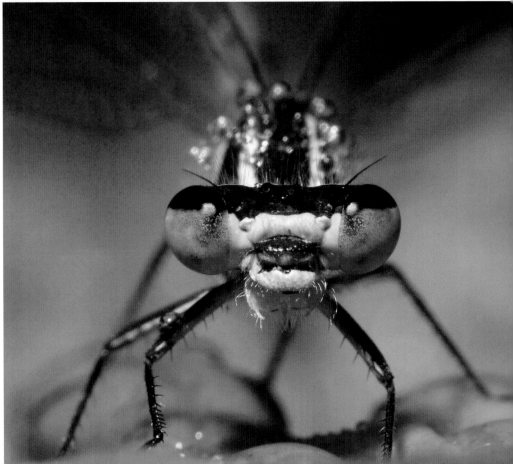

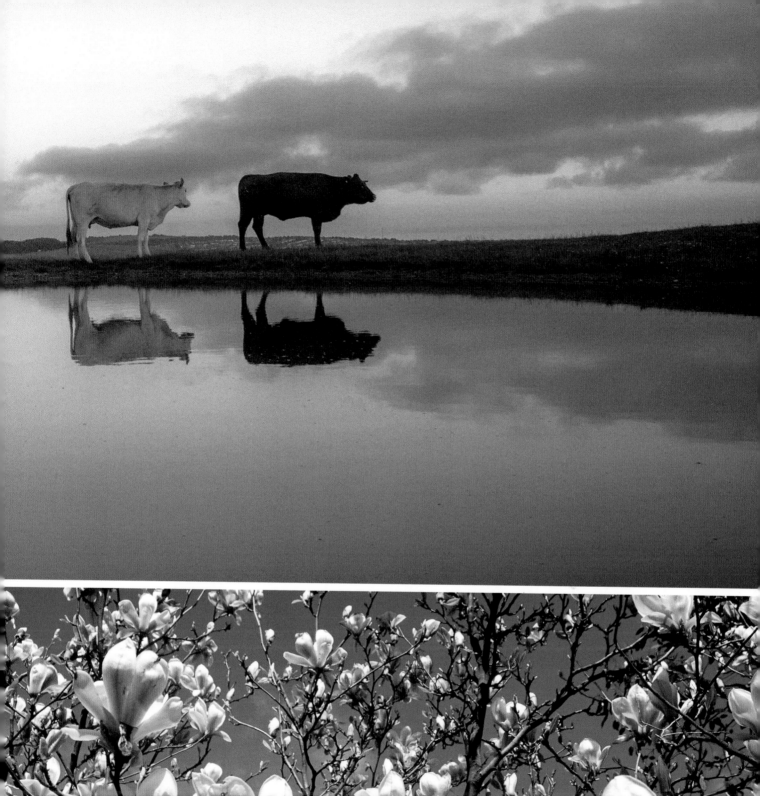
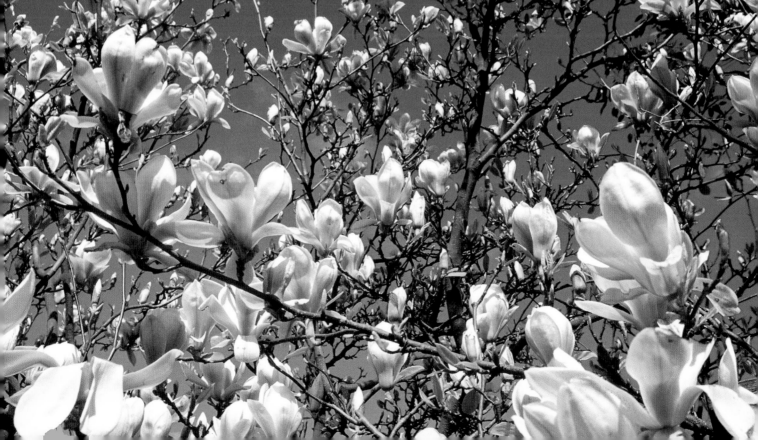

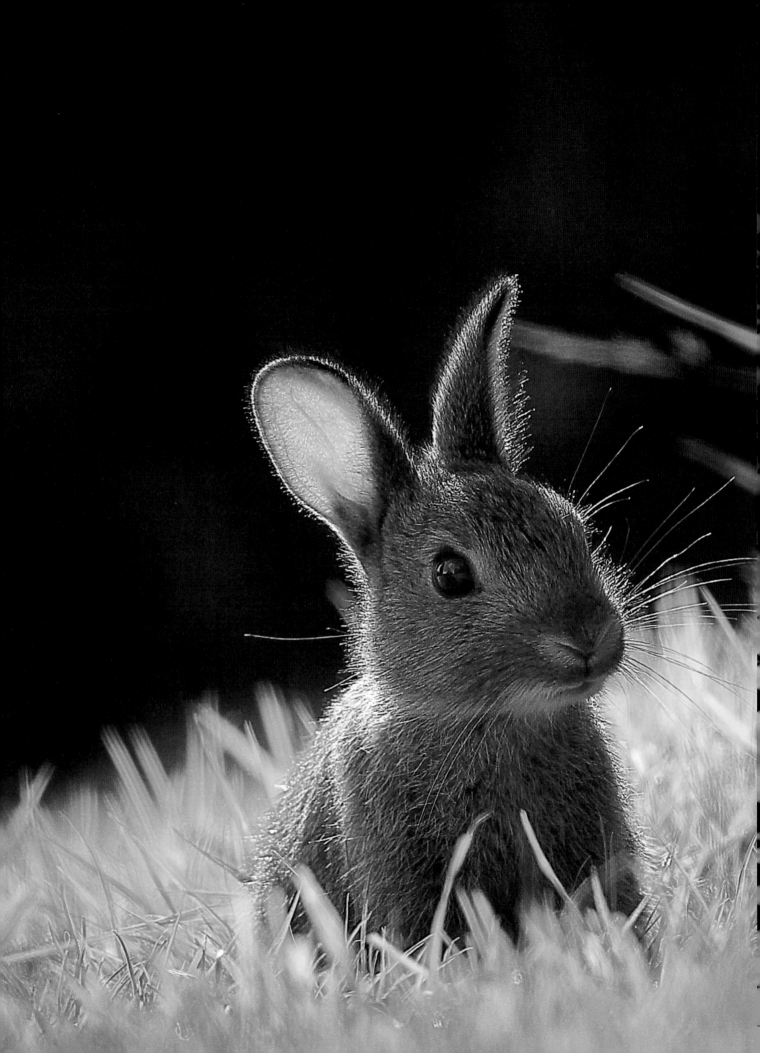

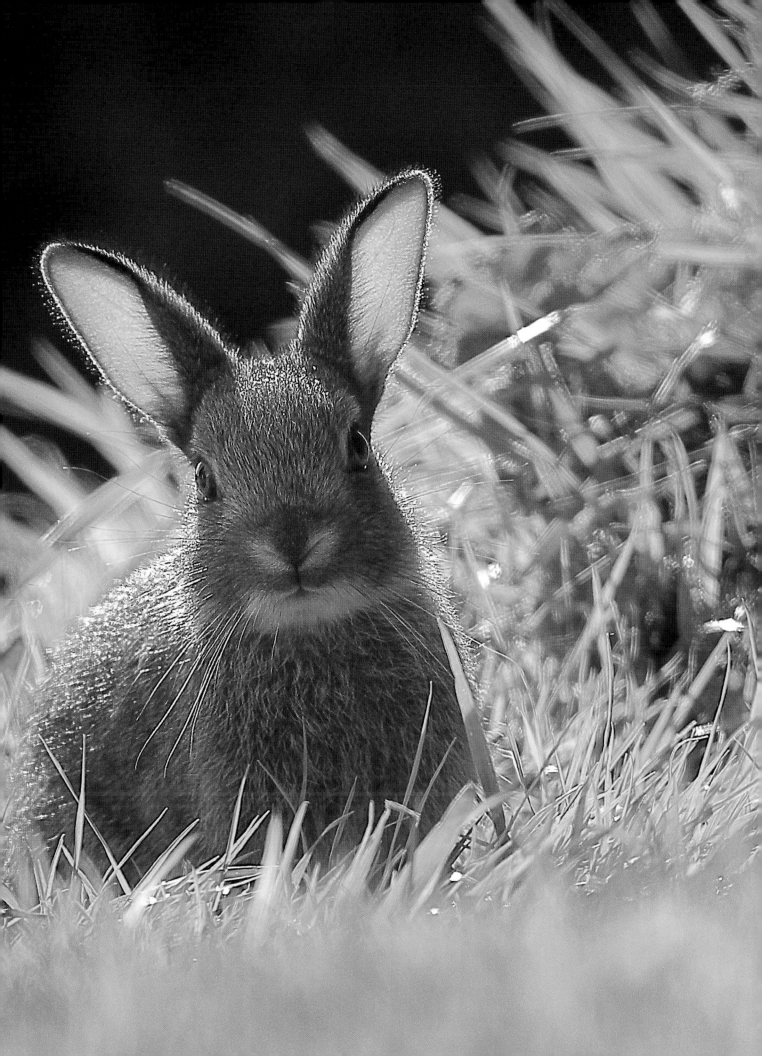

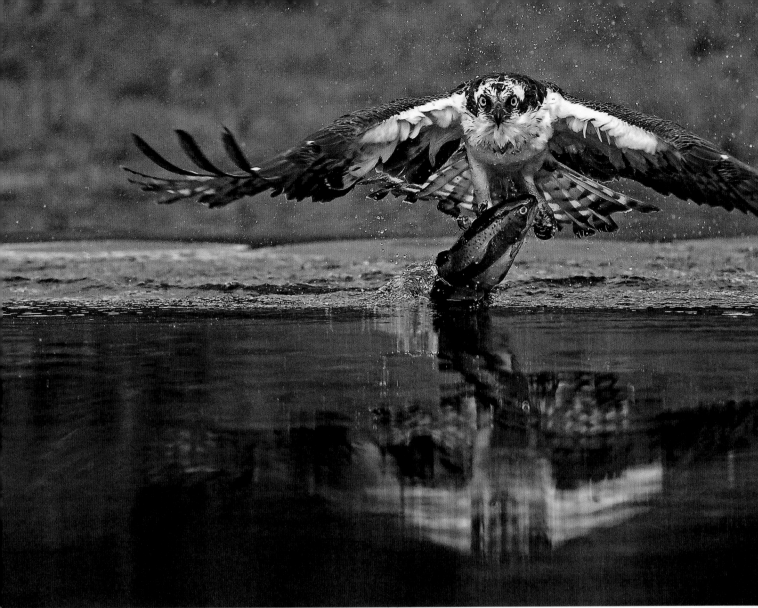

Above: **2011** – Dish of the Day. (Lee Fisher)

Opposite top: **2012** – Lone Ladybird. (Neil Maughan)

Right: **2014** – The Dell. **Overall Winner**. (Bill Robins)

Far right: **2010** – Perfect Poise. (Nick Mckeown)

Following spread: **2005** – Swans. (Peter Karry, Surrey)

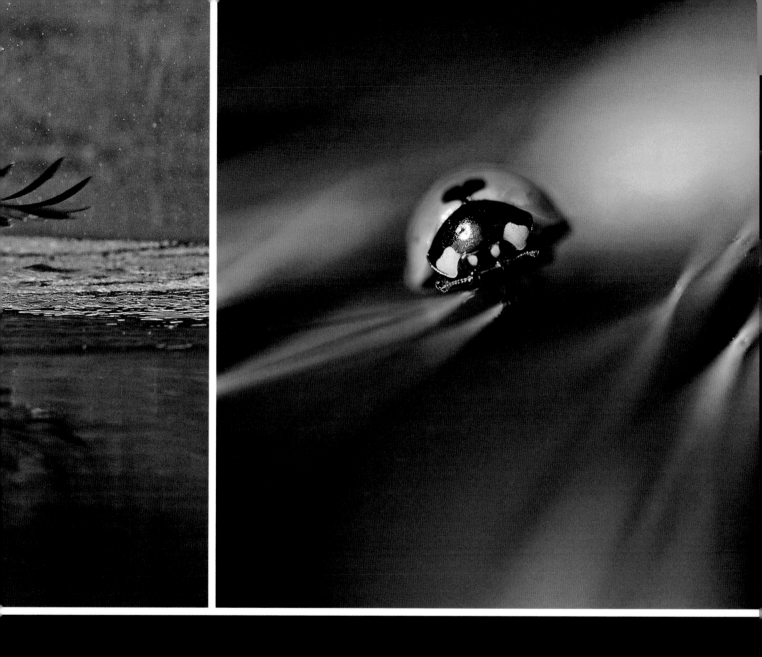
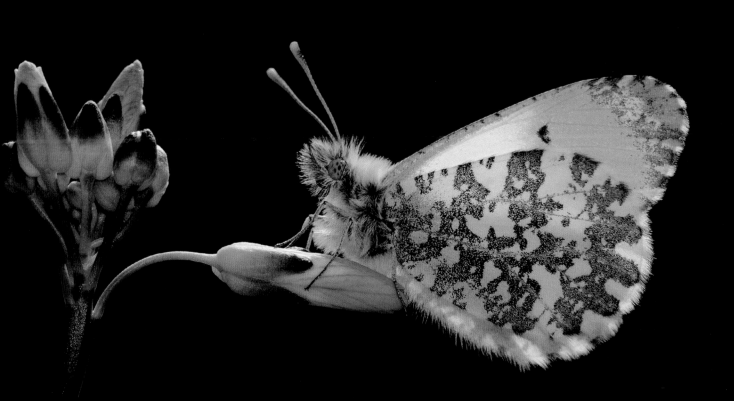

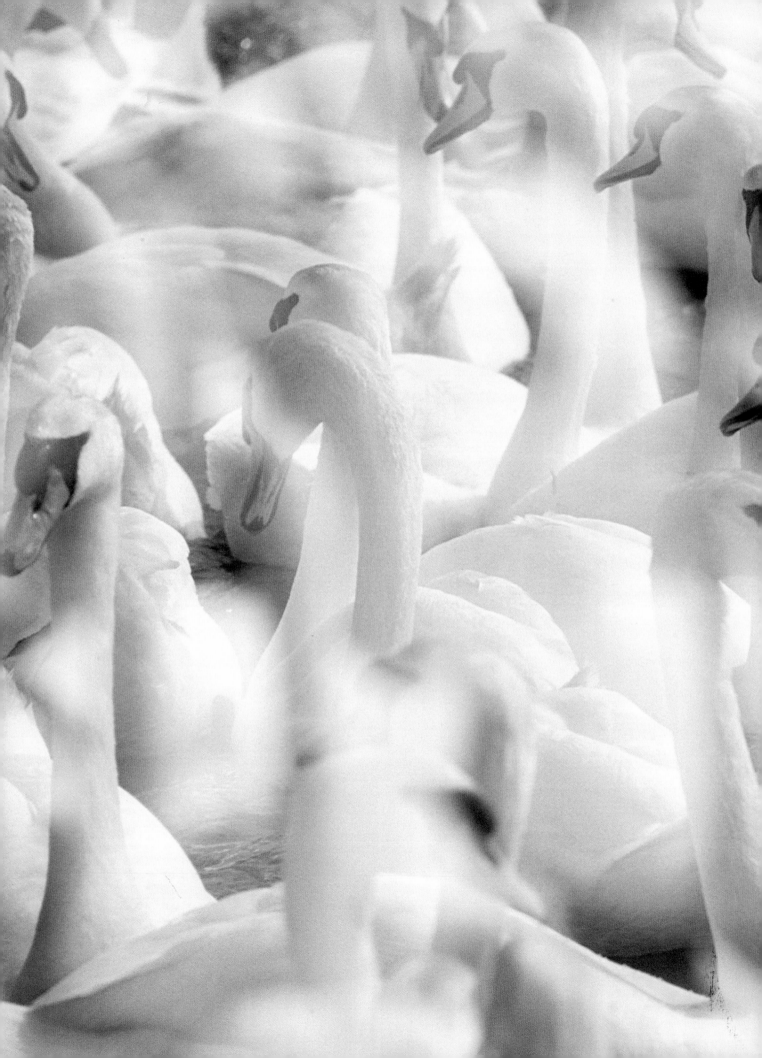

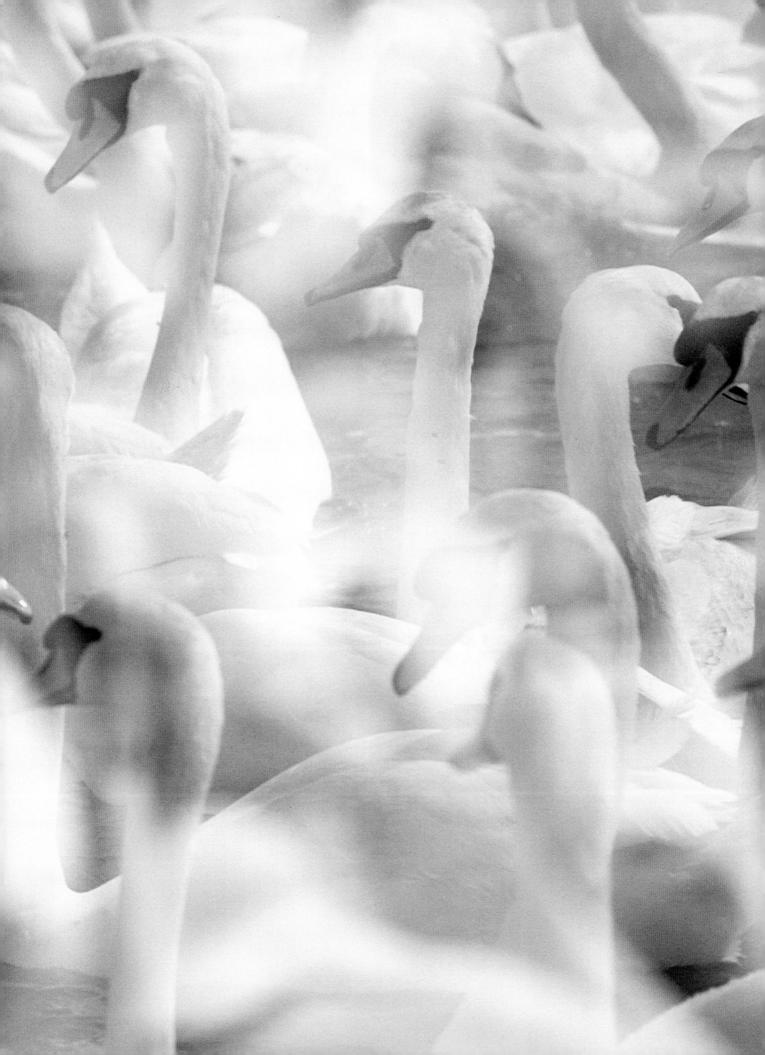

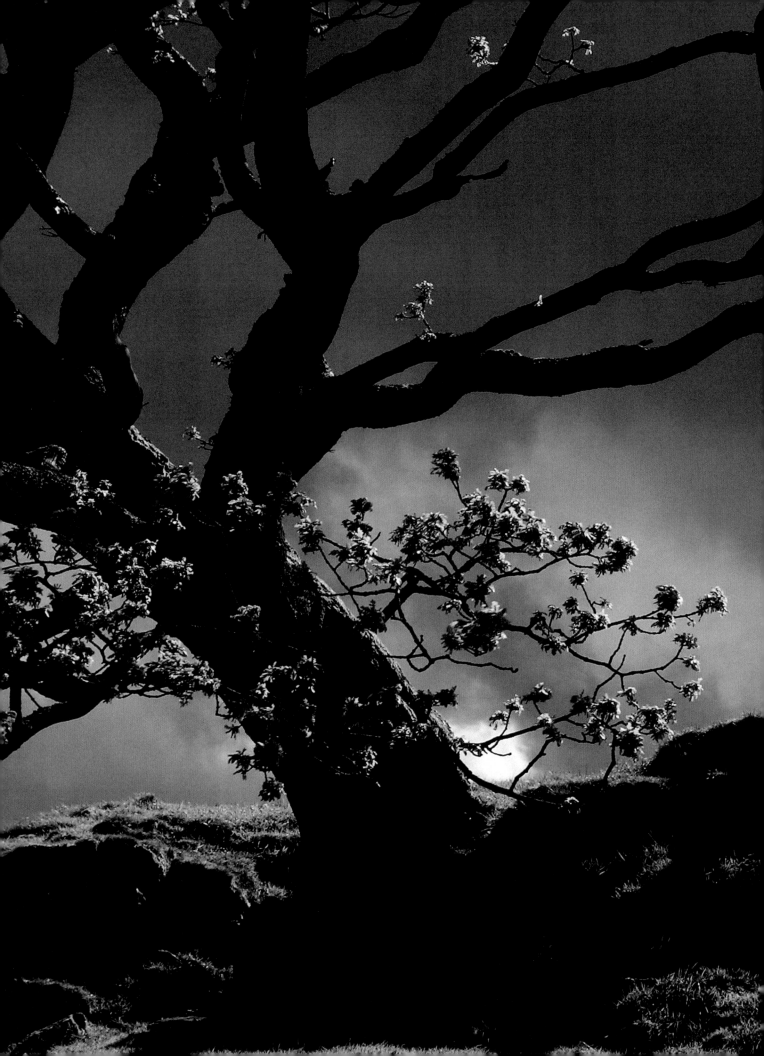

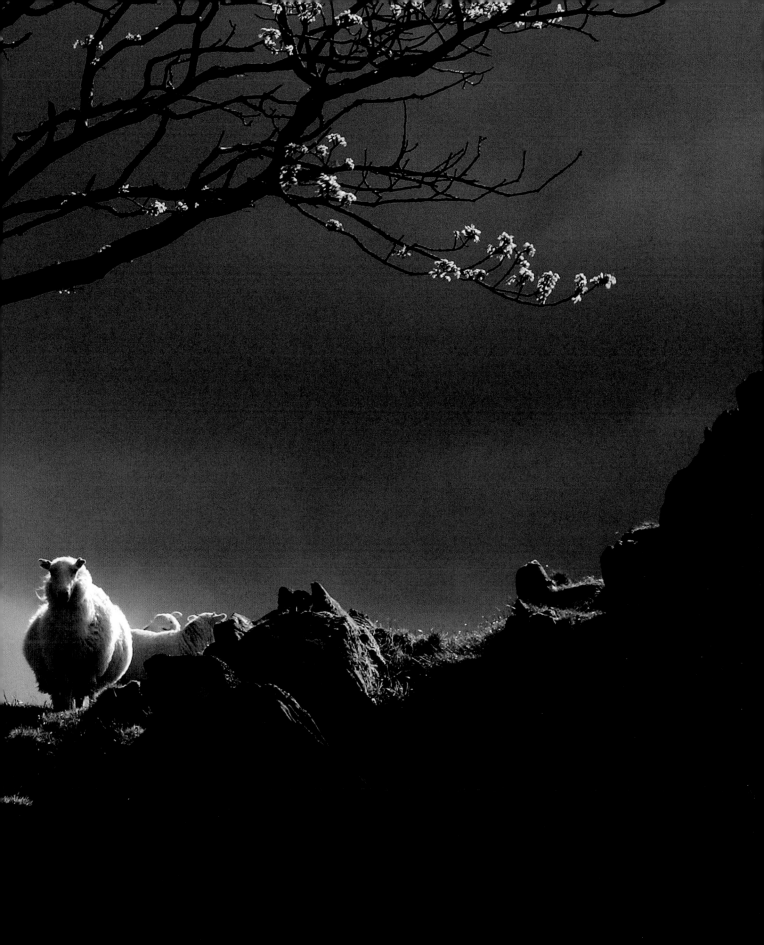

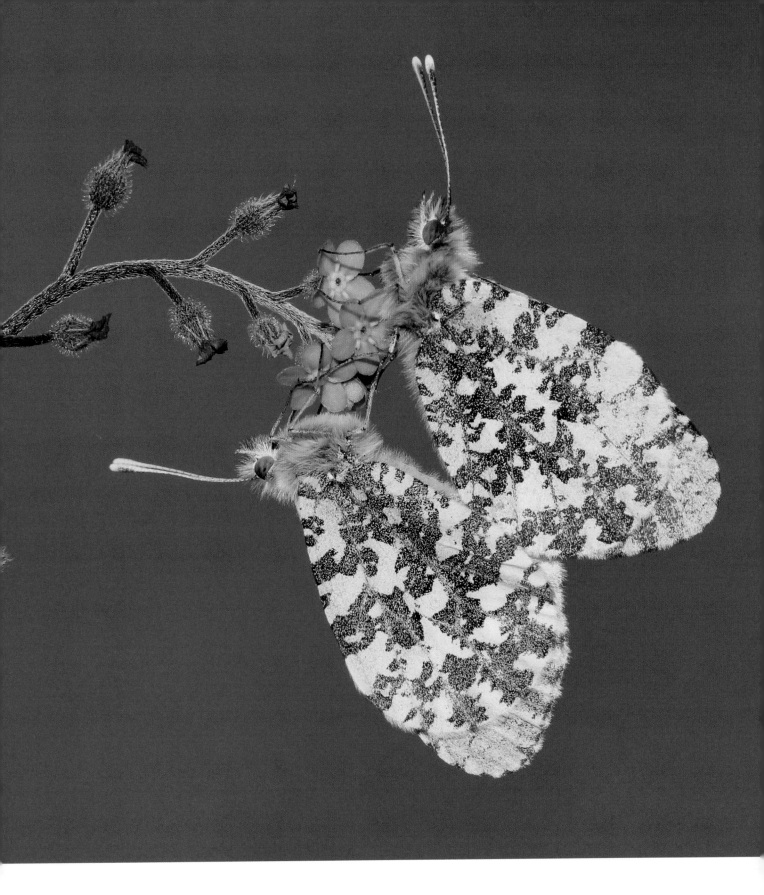

Previous spread: **2007** – Sheep in Spring, Snowdonia. **Overall Winner.** (Claudia Wass)

Above: **2015** – Forget Me Not. (Craig Richardson)

Opposite top: **2020** – Here's Looking at You, Temple Newsam Farm, Leeds. (Laura Ellis)

Opposite bottom: **2009** – Hungry Chicks. (Graham Johnson)

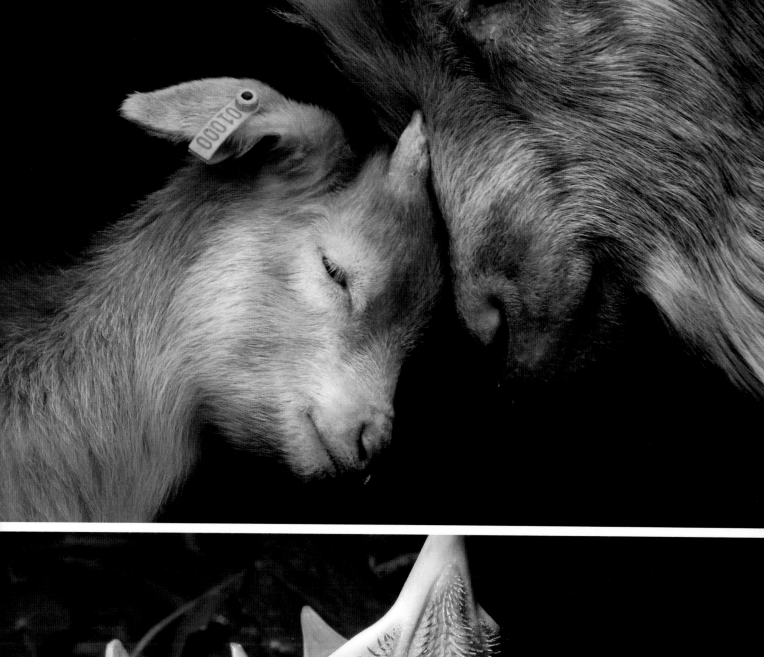
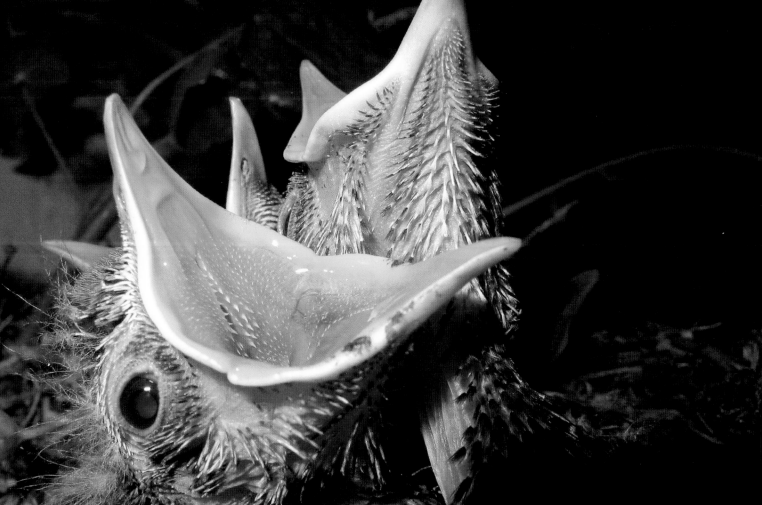

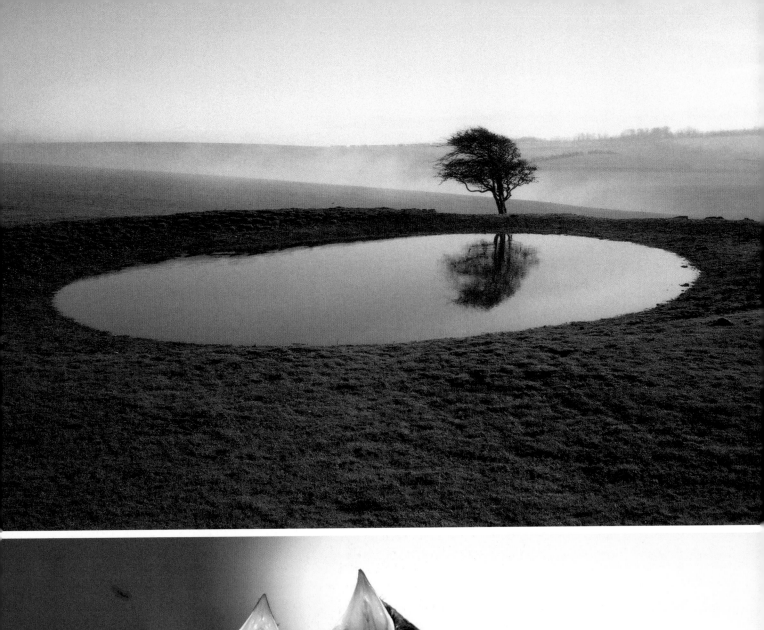
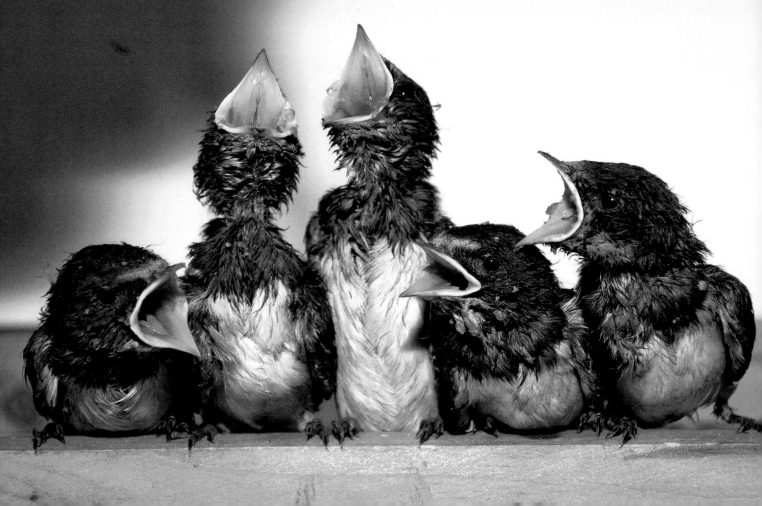

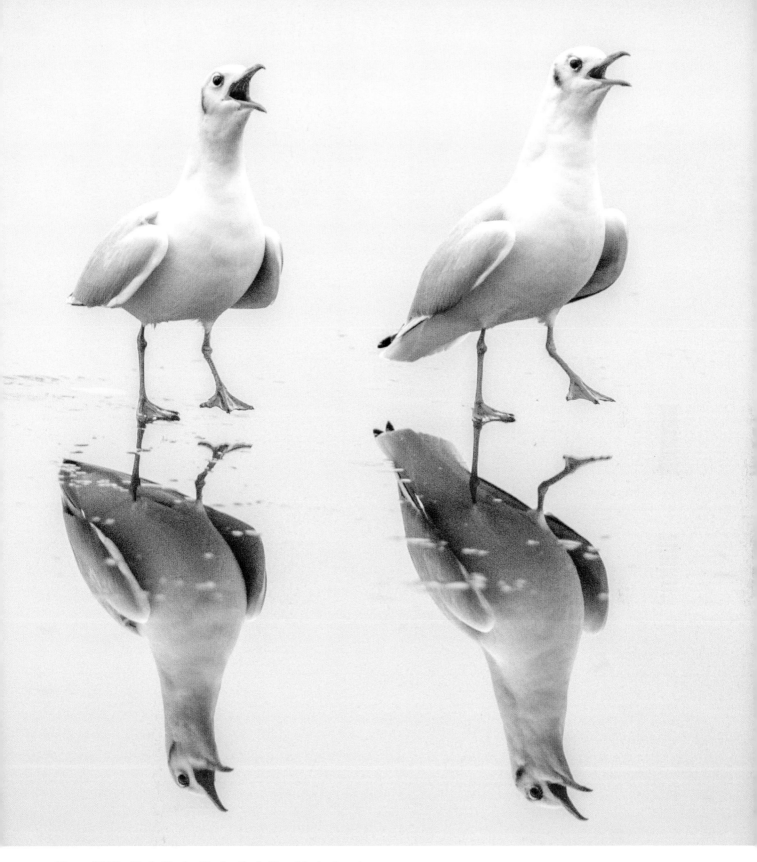

Above: **2018** – Twin Beaks, Bushy Park. (Sue Lindenberg)

Opposite top: **2006** – Lone Tree. (Richard Price)

Opposite bottom: **2013** – Feed Me! (Jimmy Robson)

Following spread: **2016** – Sunrise Silhouette. (Stephen Hembery)

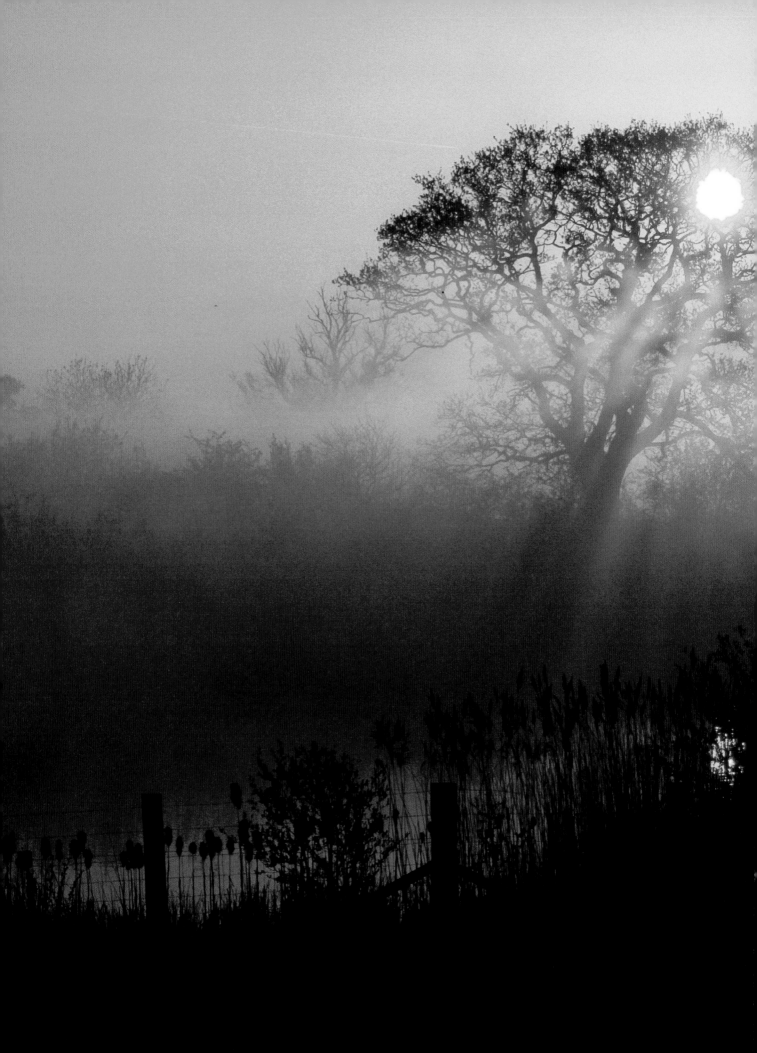

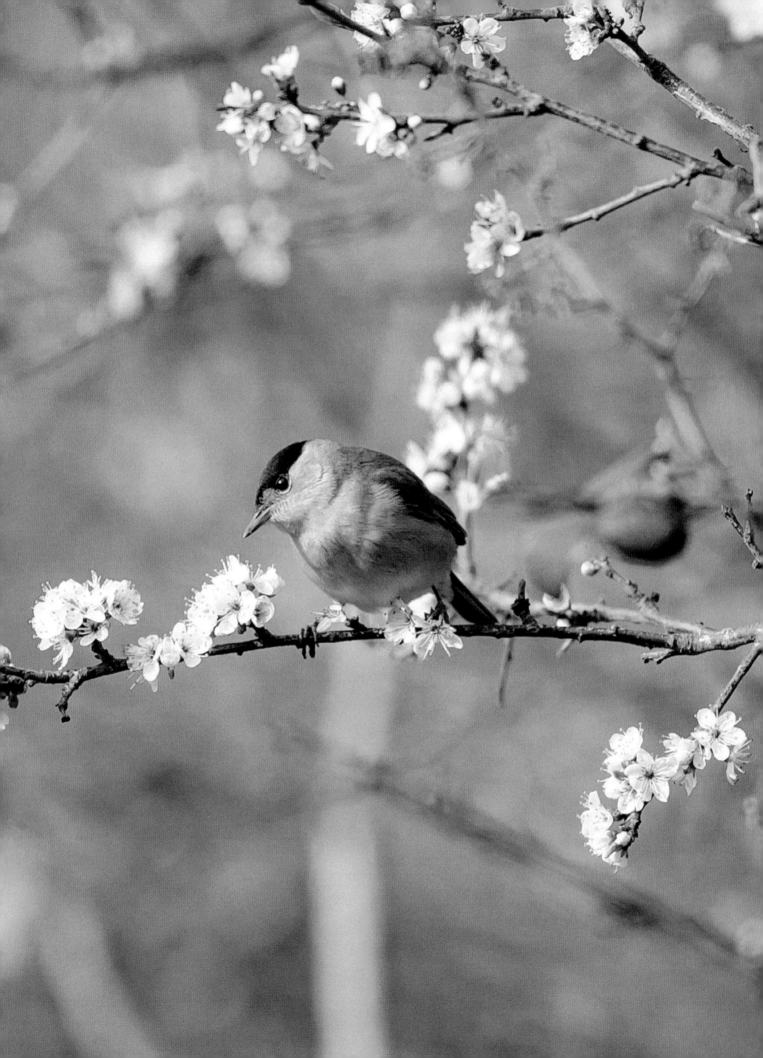

May

Matt Baker

To me, the images for May say 'discovery' and 'exploring our countryside'. The badger sums up the feeling I have when returning home after a *Countryfile* shoot having explored our landscape in great detail. The seaweed on the pebbles are a vivd reminder of being battered by sea breezes.

The North East coast was a brilliant place to explore as a young nature lover. We'd make the most of trips to the Farne Islands at this time of year as over 100,000 seabirds make it their home: terns, kittiwakes, gannets, razorbills, guillemots and my childhood favourite – the puffin. Puffins are unmistakeable, and May and June are peak breeding season for them. They're only on land between April and July each year to breed and raise their young, the rest of the year is spent out at sea on the water. In May the swifts also make an appearance after their long journey from Africa to Britain, travelling non-stop, feeding and sleeping on the wing.

'M' is not just for May, but for mice as well – there's a lot around at this time. Dormice (which aren't actually mice) wake up from hibernation in May. In Britain there are two species of dormice. The 'edible' dormouse, which is non-native and found mainly in the Chilterns, is considered a bit of a pest with its night-time shenanigans and a love of cables in walls and lofts. The second species, the native 'hazel' dormouse, rarely comes down to the ground and loves a hazelnut. It will have to eat plenty over the summer as up to half of dormice die during hibernation.

May has always been a time of the turning out of animals onto the fresh grass. The fields are filled with the energy of gambolling lambs and their bleating is one of my favourite sounds. It's a month of fun and celebration too, with plenty of villages marking May Day. The festivities' roots are based in ancient ritual, celebrating the return of spring and of summer being just around the corner. Village greens see dancing around the maypole, Morris dancers and the picking of a May queen. It's strange to think that maypoles were banned in the 1600s and if it wasn't for Charles II bringing them back, our traditional May Day quirks would probably be long forgotten.

Opposite: **2015** – Blackthorn Blackcap. (Michael Cunningham)

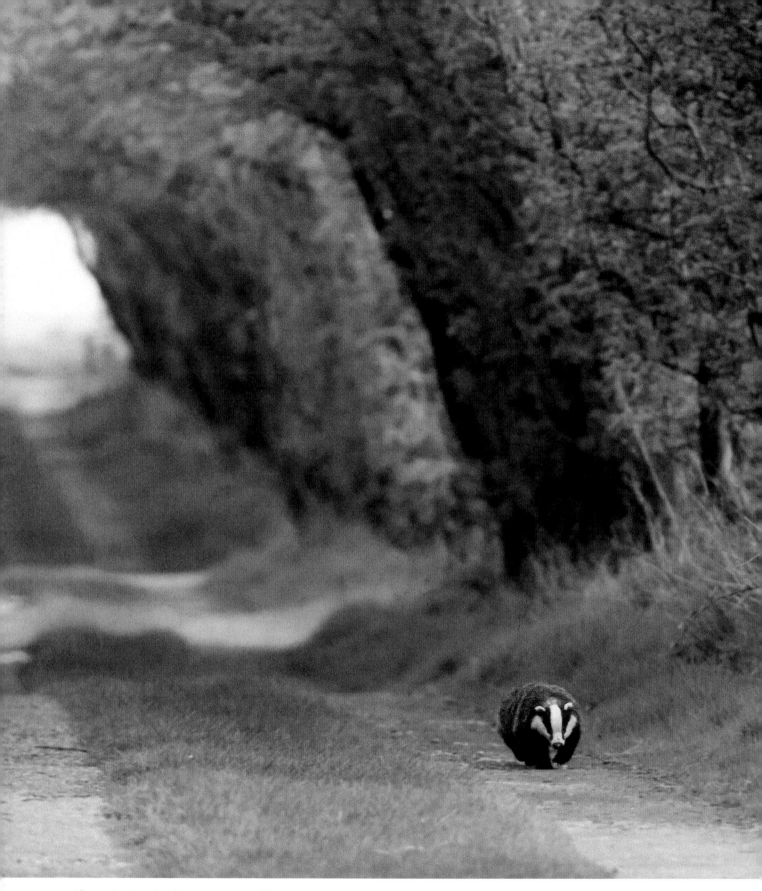

Above: **2013** – On the Move. **Overall Winner**. (Dave Foker)

Opposite top: **2017** – Spring in Their Step, Morris Dancers, Worcestershire. (Paul Shutler)

Opposite bottom: **2014** – Guardian Angel. (John Lockyer)

Following spread: **2012** – On the Seashore. (Molly Hemingbrough)

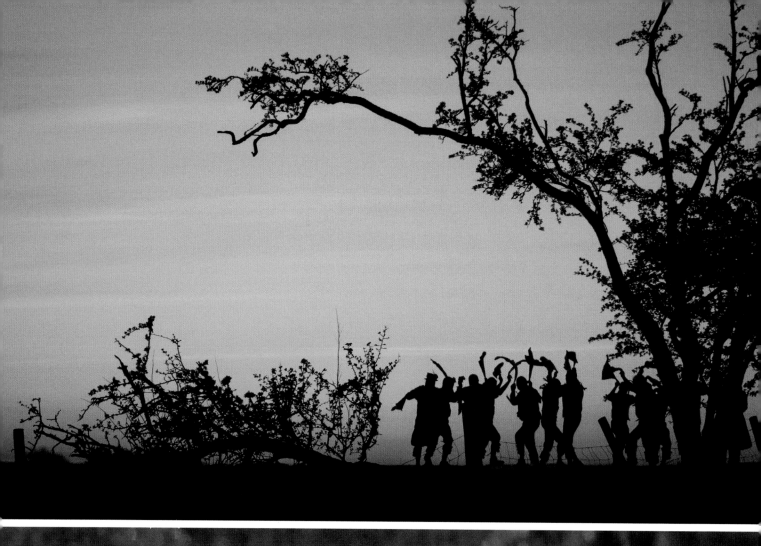
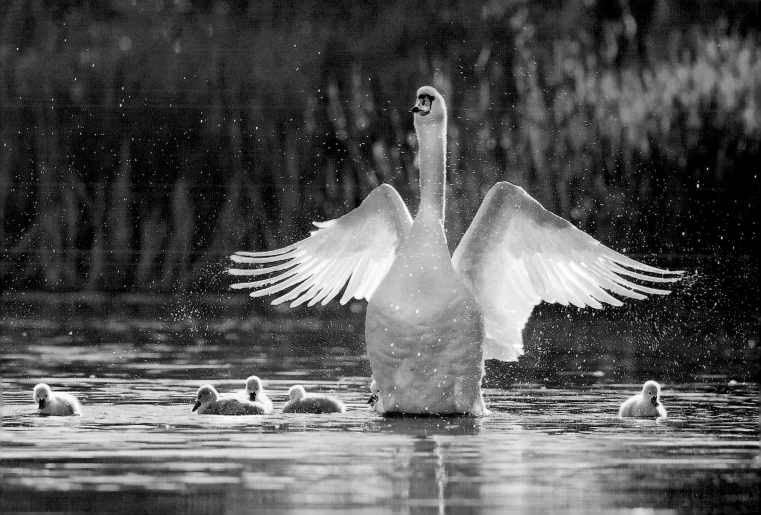

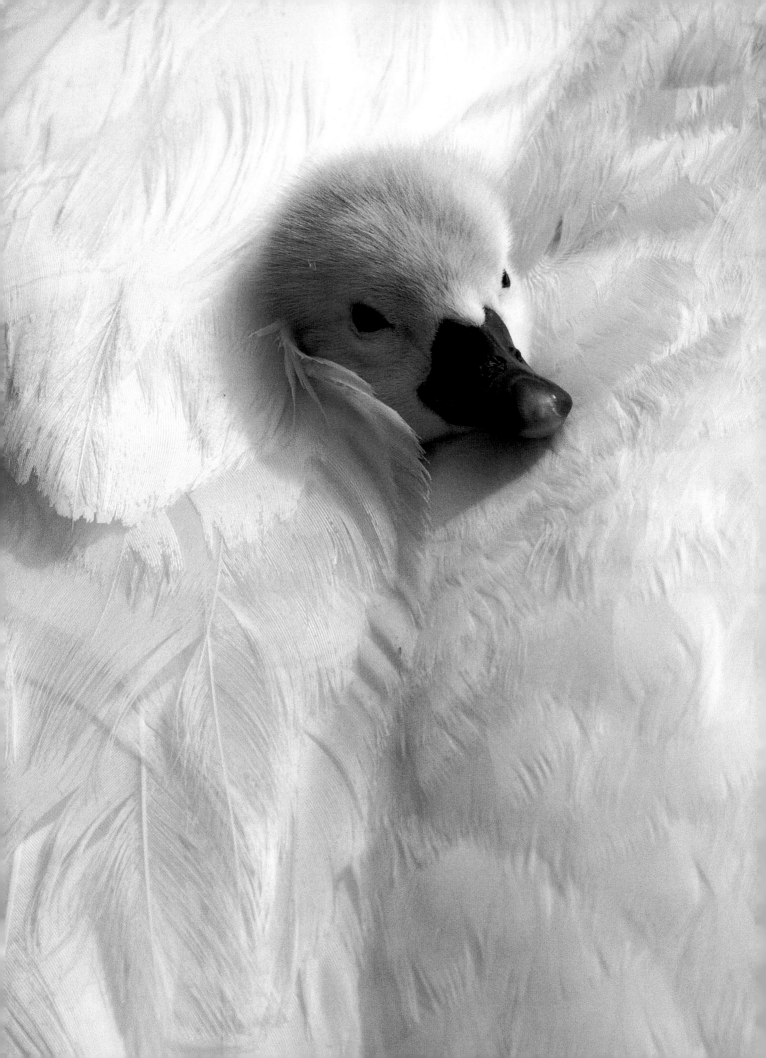

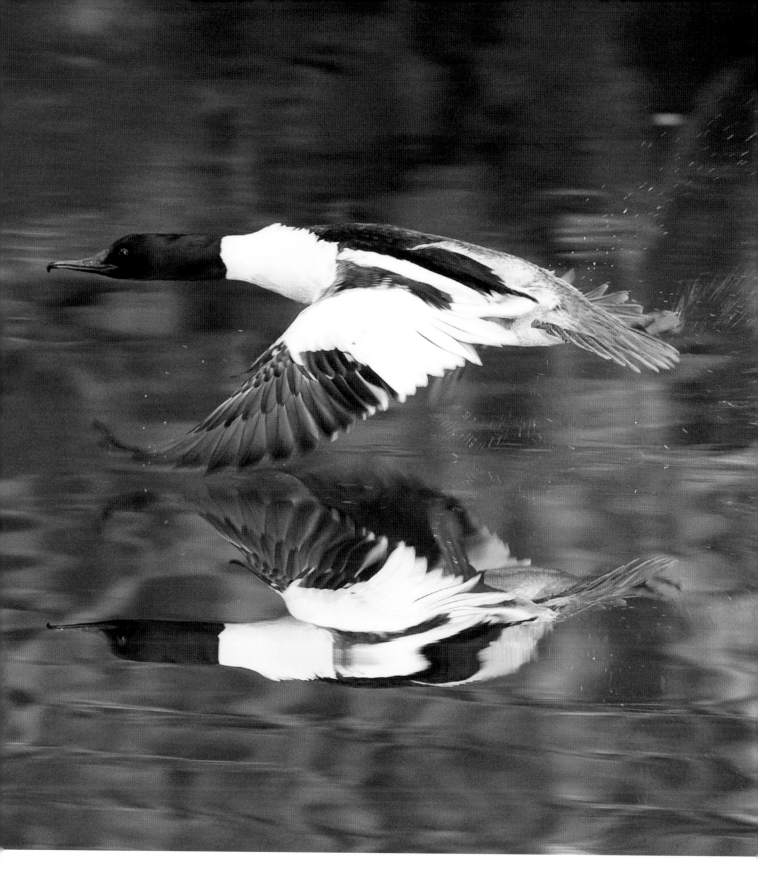

Above: **2010** – Reflected Glory. (Keith Prescott)

Opposite: **2018** – Down Time, Warwickshire. (Colin Powell)

Following spread: **2003** – Glen Affric, Inverness. (Michael Cruise, Newmilns, Scotland)

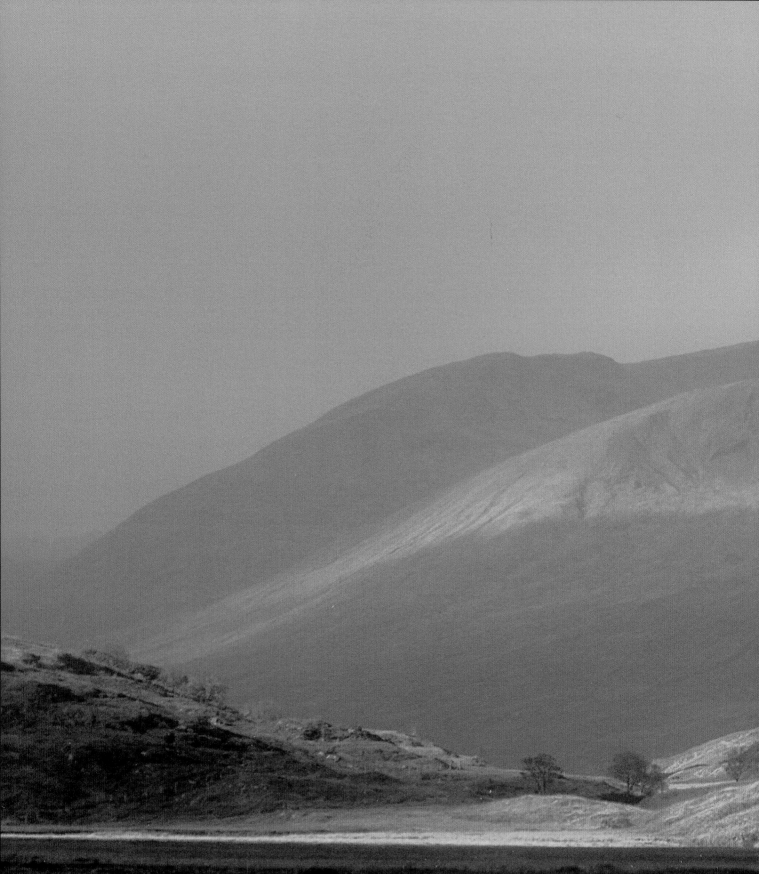

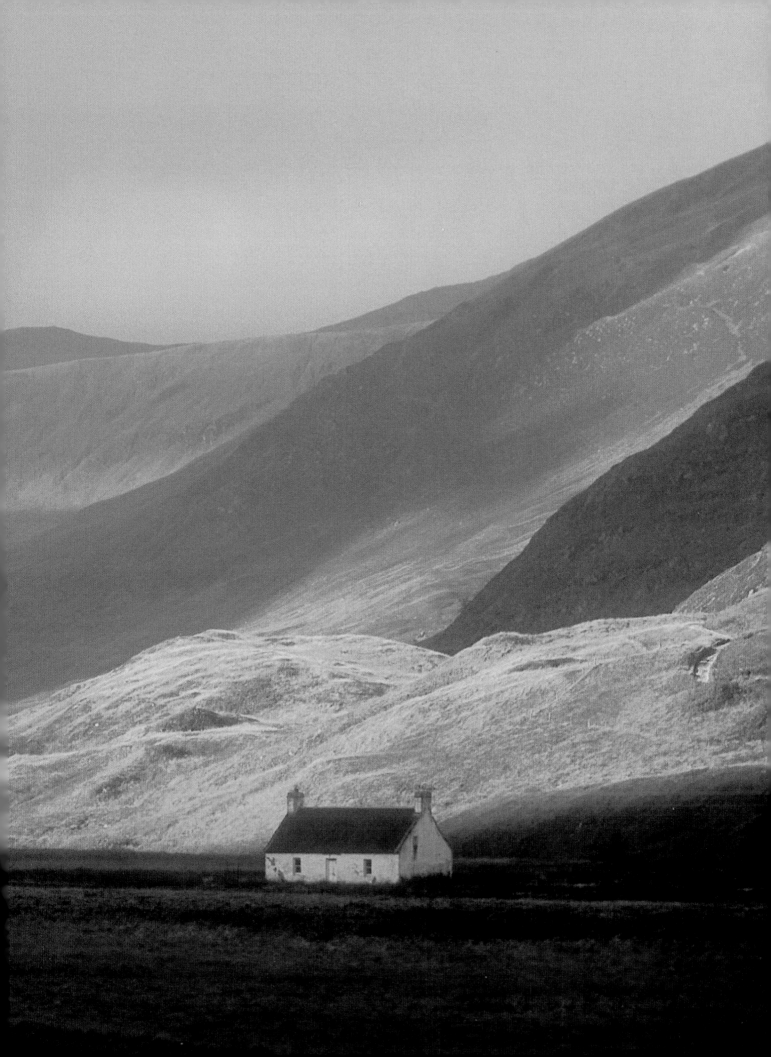

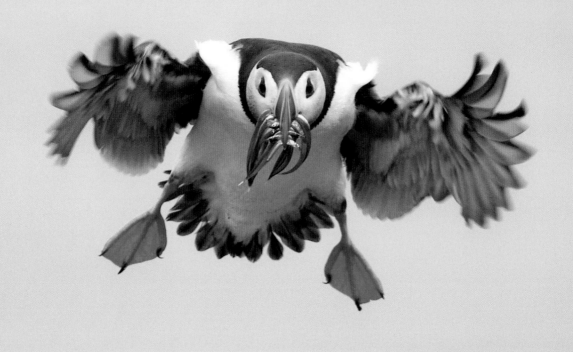

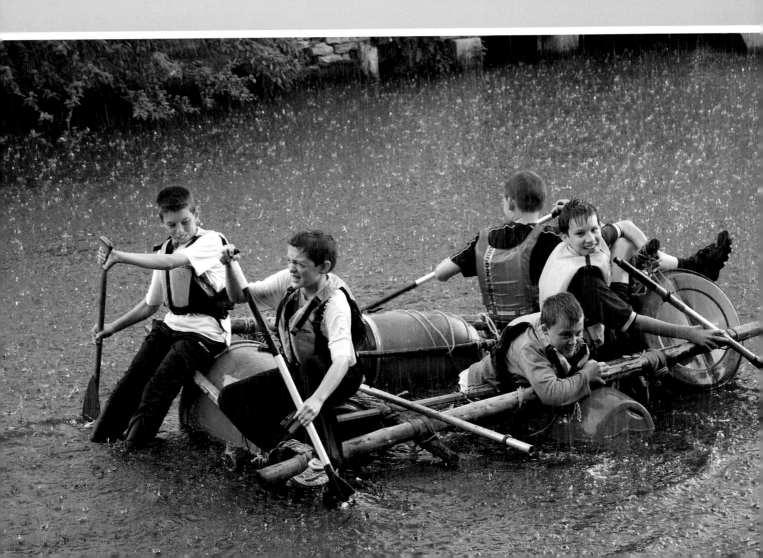

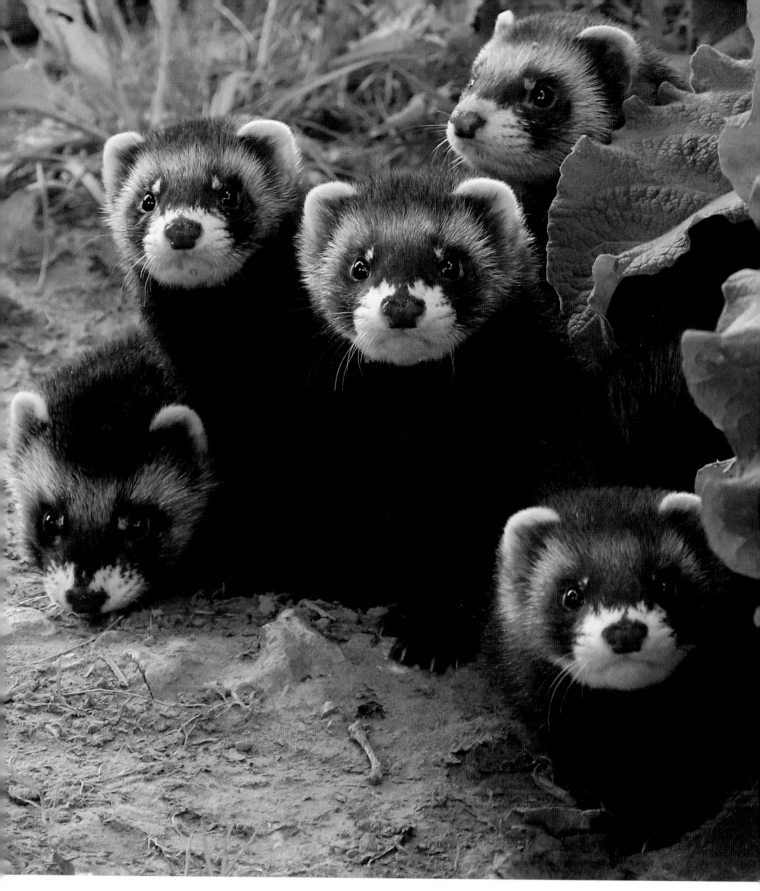

Above: **2019** – Pole Position, East Budleigh, Devon. **Judges' Favourite** and **Overall Winner**. (David White)

Opposite top: **2009** – In-flight Meal. **Overall Winner**. (Richard Steel)

Opposite bottom: **2007** – River Rafting, River Lee, Hertfordshire. (Mike Hawes)

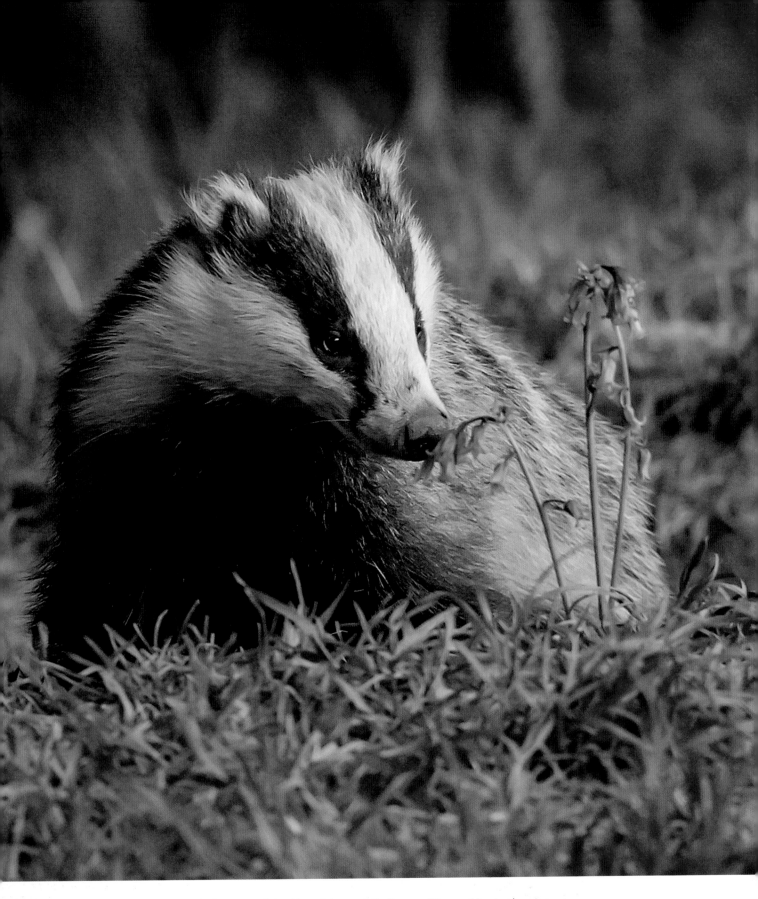

Above: **2020** – Brock and Blue, Dumfries, Dumfries and Galloway. (Trevor Hupton)

Opposite top: **2008** – Shetland Puffin. (George Turnbull)

Opposite bottom: **2011** – Flutter By. (Coral Robinson)

Following spread: **2016** – Follow Me. (Tony Howes)

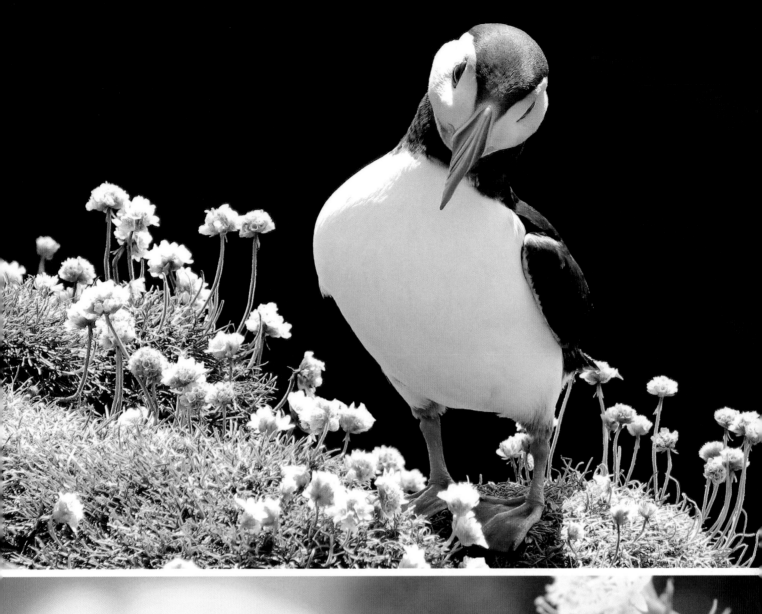

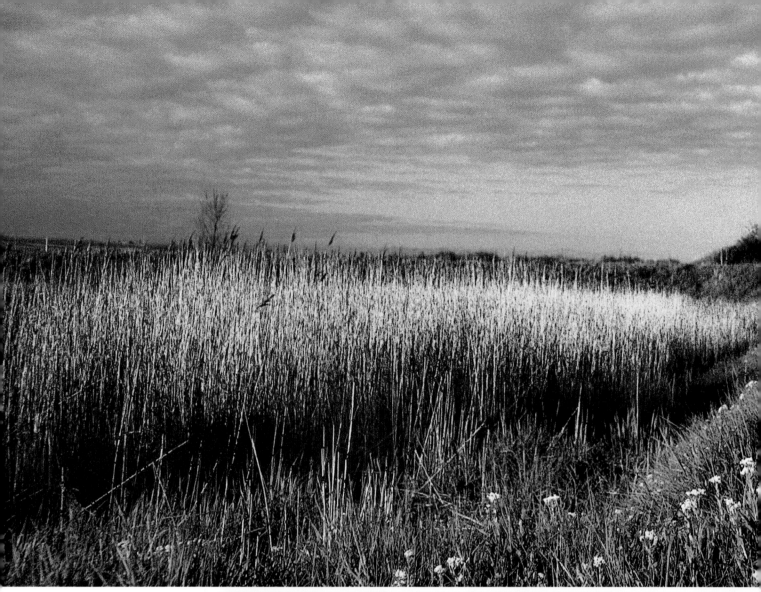

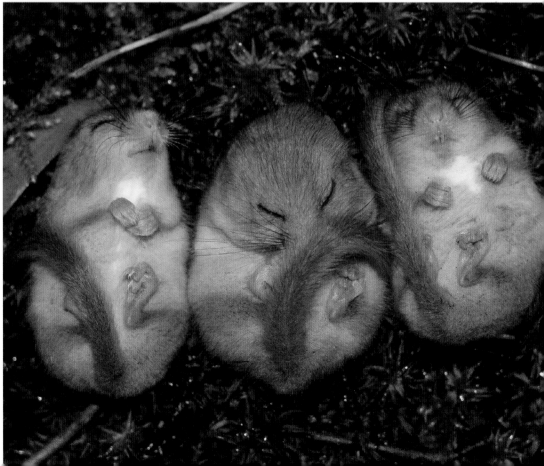

Above: **2004** – Crayford Marshes. (Adrian Campfield, Slade Green, Kent)

Right: **2005** – Three Dormice. (Steven Robinson, West Sussex)

Far right: **2006** – Cygnets. (Donald Hooper)

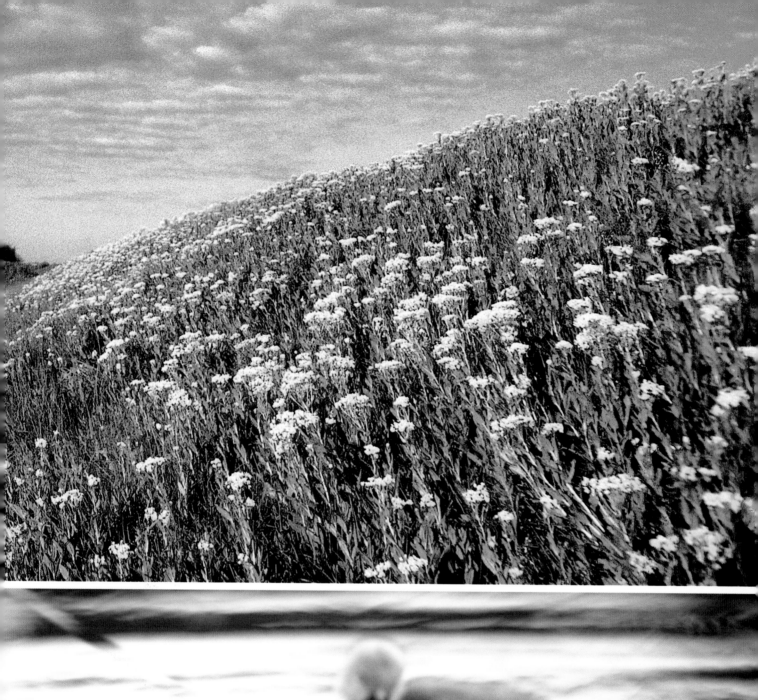

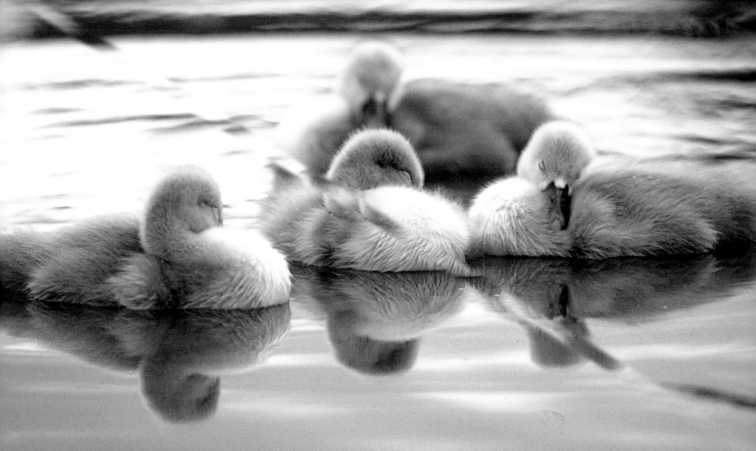

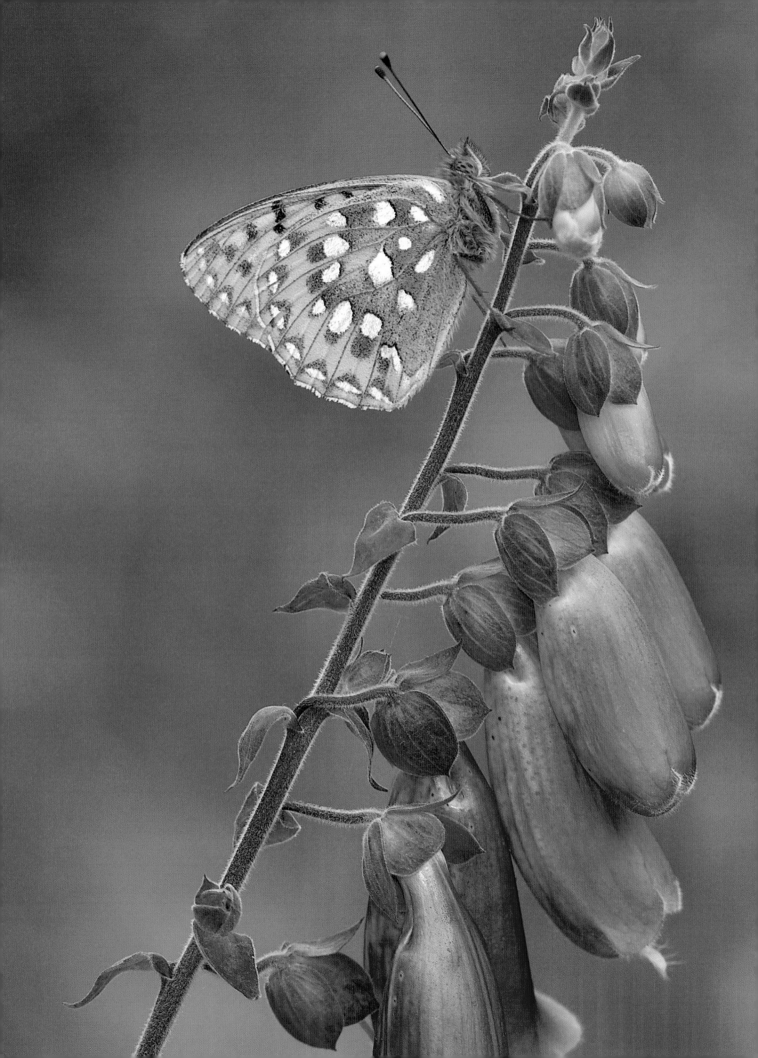

June

John Craven

June is a month of plenty when the glorious sights and scents of summer begin revealing themselves. Honeysuckle, poppy, lupin, lavender and rose are in bloom, grassland is cut for sileage and new potatoes, broad beans and peas are ready for harvest. In that great musical *Carousel*, Richard Rogers penned: "You can see it in the trees, you can smell it in the breeze … June is busting out all over, all over the meadow and the hill."

He was right – June doesn't just happen, it bursts into warm, colourful life with promises of happy times ahead. Three weeks into the month comes solstice day when the sun travels its longest and highest path through the sky and gives us the most hours of sunlight and the shortest night and we know summer really has started.

We have a floral profusion in our images for June, dominated by the poppy. It's by far the favourite flower of viewers entering our competition and over the years they have found many inventive ways of picturing this most symbolic of blooms.

Of the 'non-flowery' pictures this month, I'd like to mention two which demonstrate what every snapper needs – luck. Holidaymaker David Brown had bucketloads of patience as he waited one June evening to capture the perfect image of a pony snacking on dune grass on the Isle of Harris in the Outer Hebrides.

"The low evening sun on the dunes enhanced the ripples in the sand and with the sea in the distance it made a wonderful backdrop," says David. "Two ponies roam free there and they can be elusive. So I got ahead of them, sat still and hoped they'd walk past me through the scene. One of them came close and the symmetry of the warm light on its neck and on the sand dunes really made it a magical moment."

Victoria Boobyer had amazing luck when, walking on her own on Pen y Fan, the highest peak in the Brecon Beacons, very early one morning, she witnessed that rarest of sights, a phenomenon known as Brocken Spectre. It happened as the rising sun behind her cast a massive shadow of Victoria on the mist below. She says: "I had no idea this was going to happen – I've never seen anything like it before or since – so I just put my camera on automatic and hoped for the best."

Opposite: **2005** – Butterfly on Foxglove. (Peter Entwistle, Cumbria)

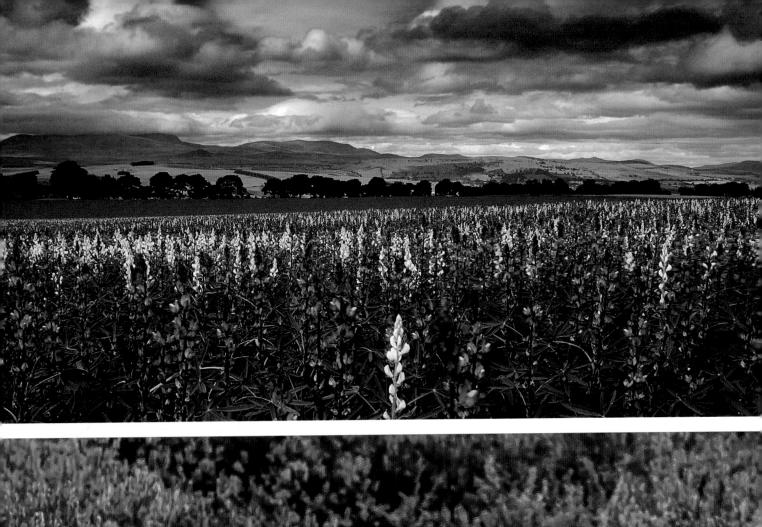

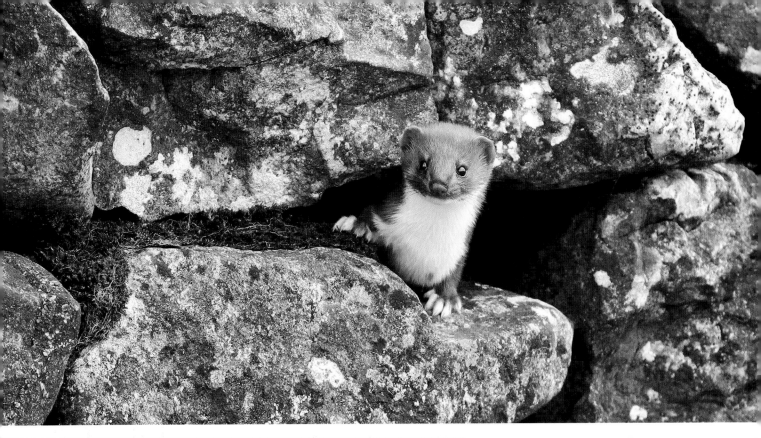

Above: **2013** – Lone Stoat. (Andy Hold)

Opposite top: **2007** – Lupin Fields, Ben Wyvis. (Colin Campbell)

Left: **2016** – Sheep Purple. (Tony Raine)

Following spread: **2020** – Dune Drifter, Luskentyre Beach, Isle of Harris.
Judges' Favourite. (David Brown)

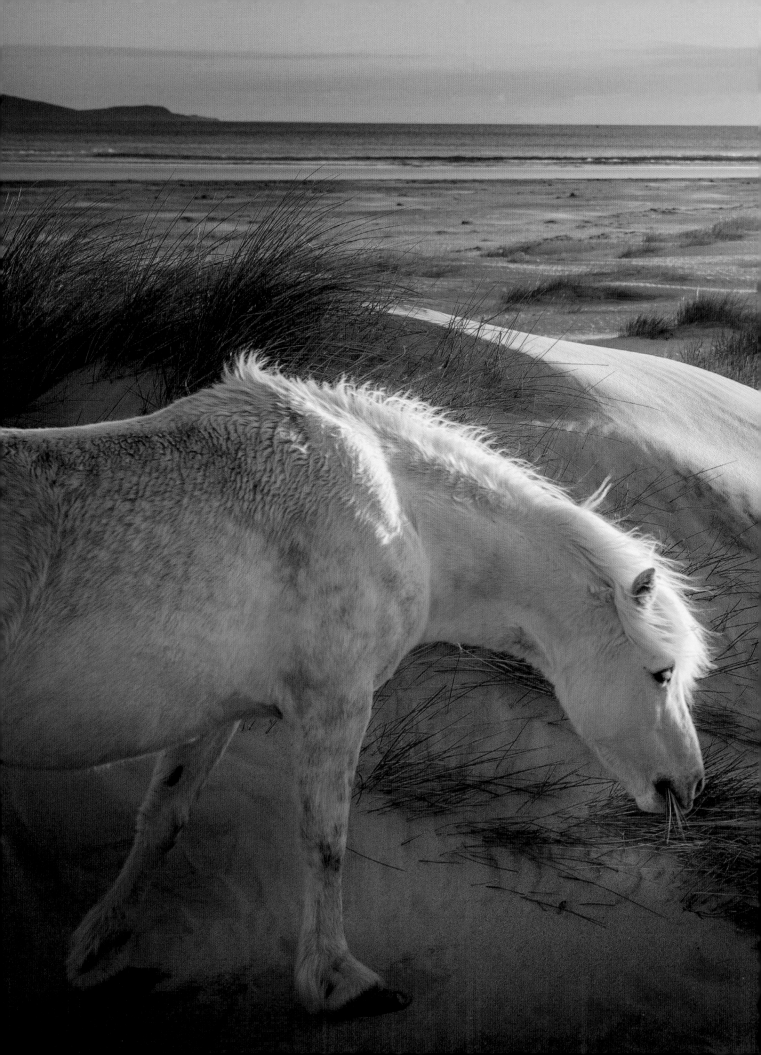

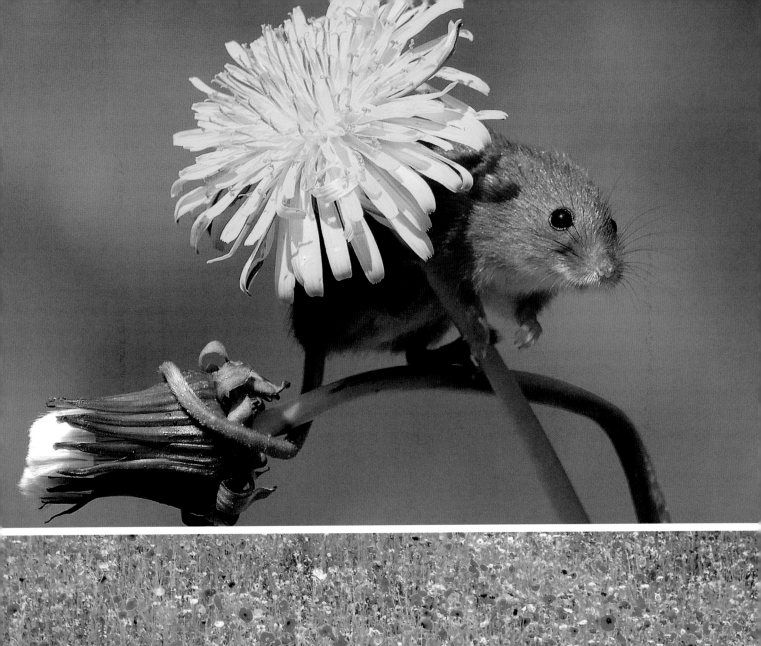

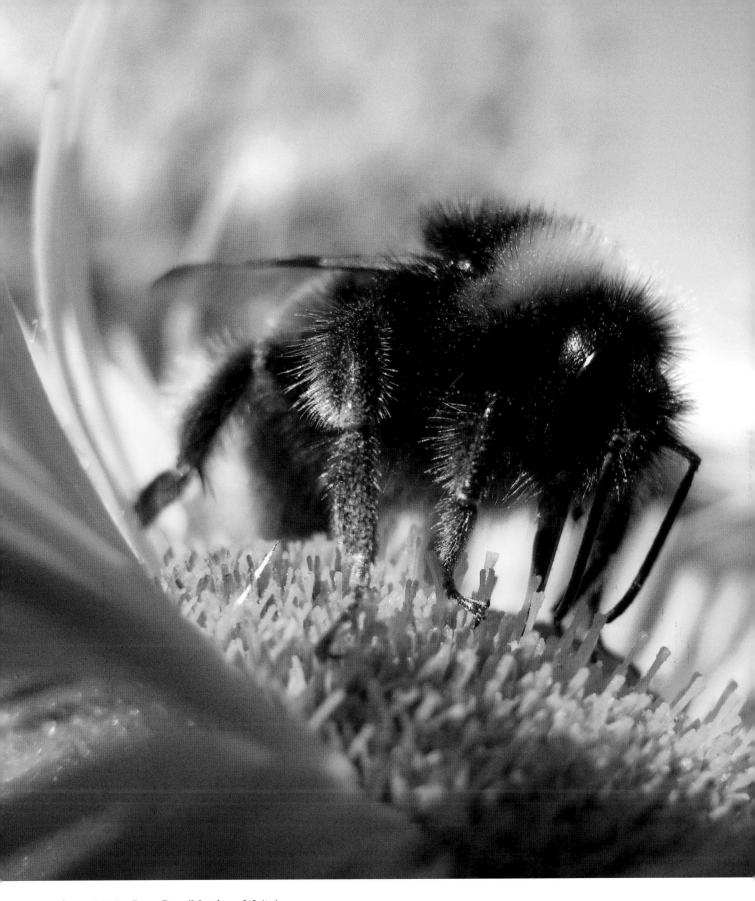

Above: **2009** – Busy Bee. (Matthew Waite)

Opposite top: **2018** – Dandelion King, Preston. (Phillip Green)

Opposite bottom: **2010** – Flower Power. **Judges' Favourite**. (Gary Gray)

Following spread: **2019** – Reflected Glory, Fairy Glen, Near Betws-y-Coed. (Ian Wright)

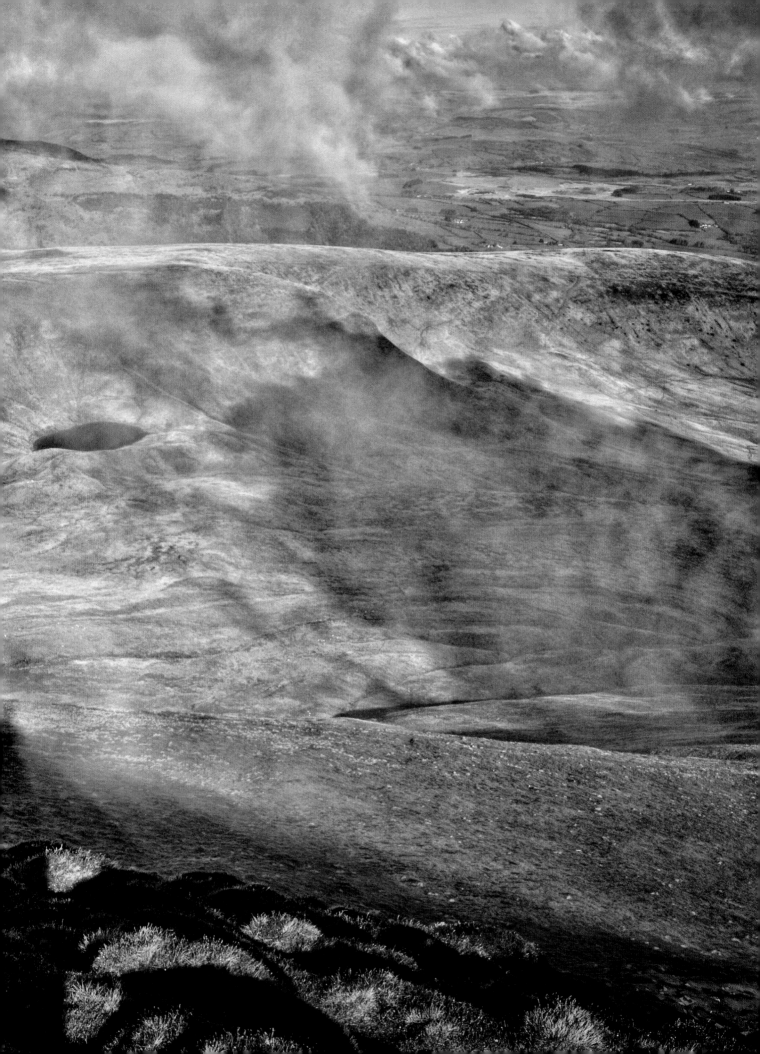

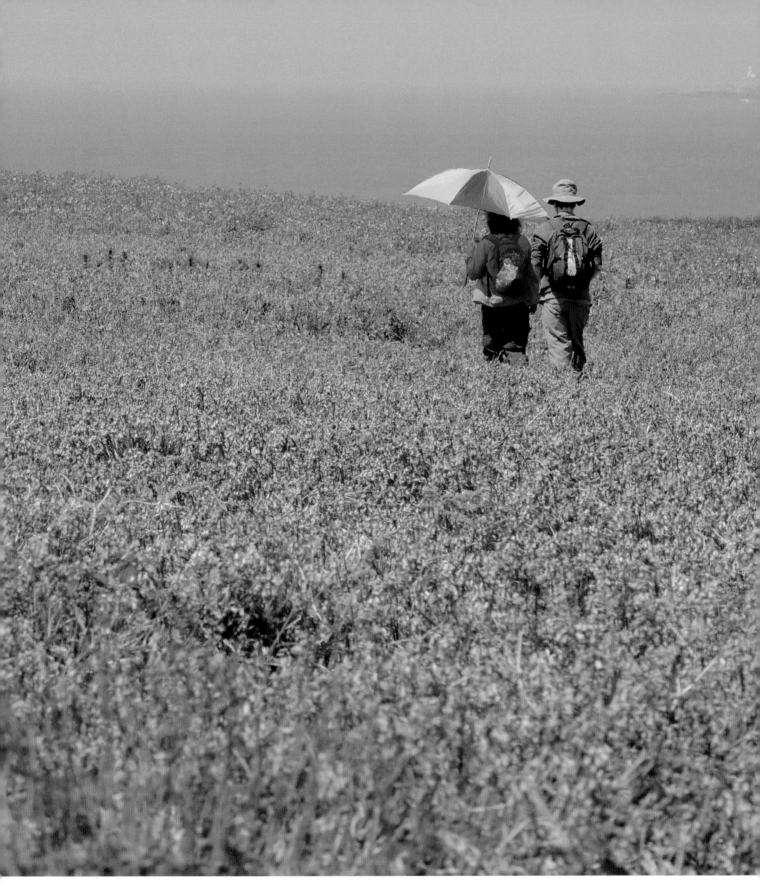

Above: **2014** – Meadow Meander. (Robert Stewart)

Opposite: **2011** – Head's Up. (Jamie Brockbank)

Following spread: **2004** – Poppies. (David Railton, Blyth, Northumberland)

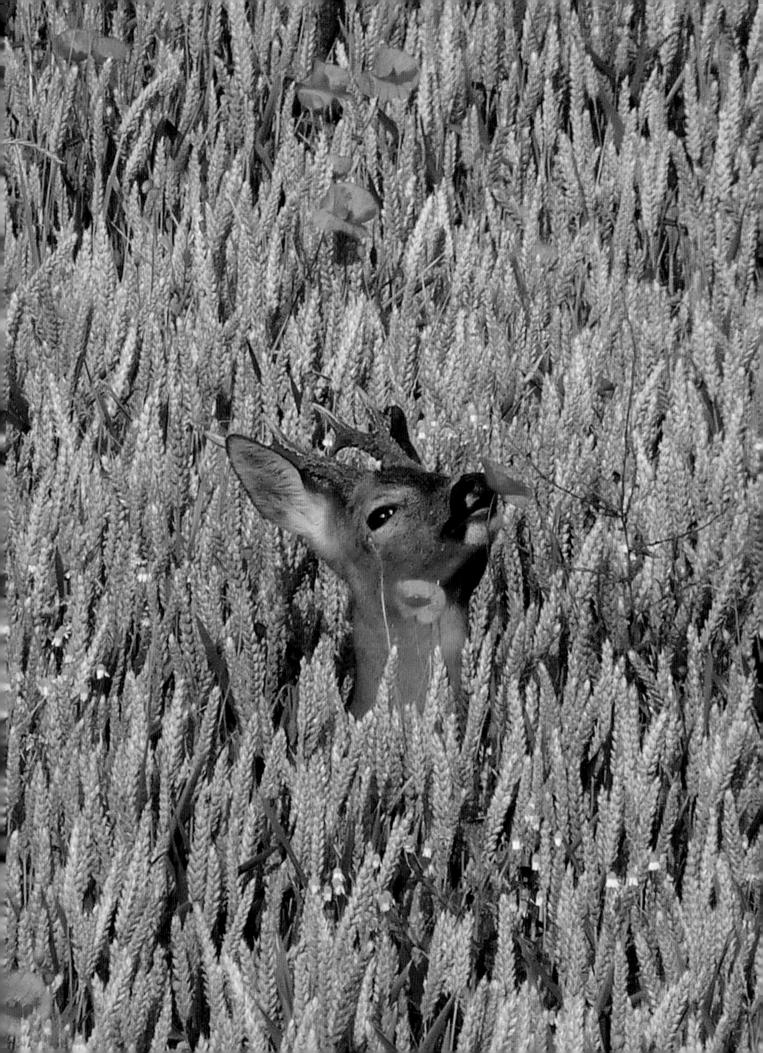

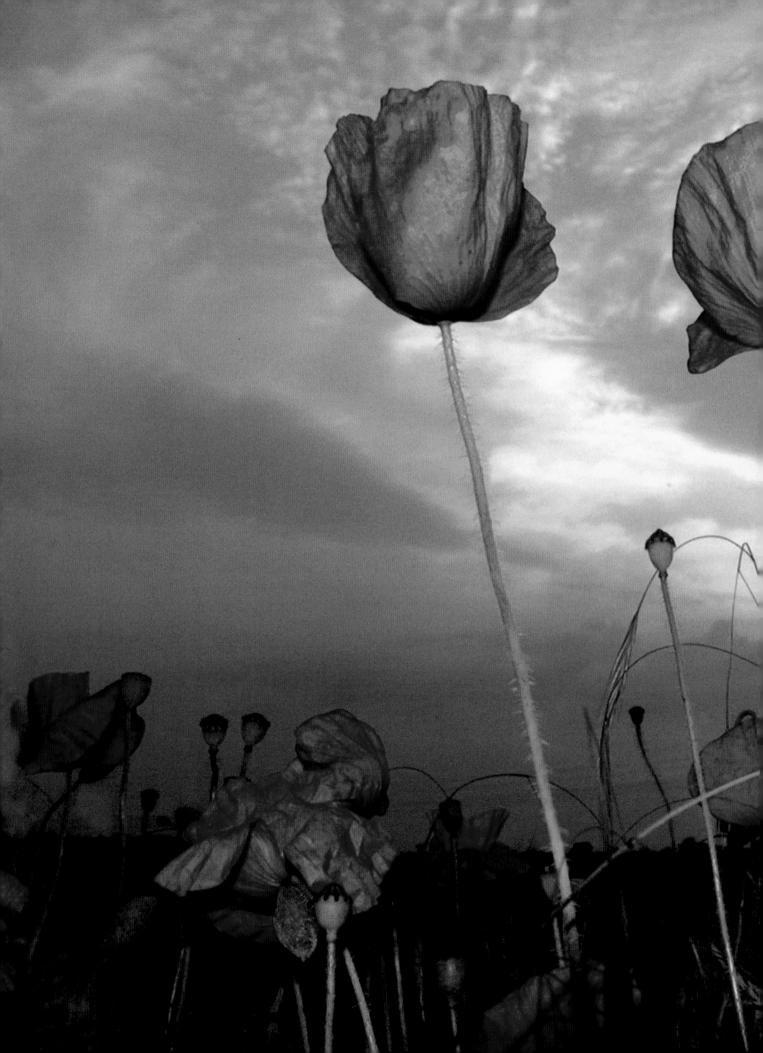

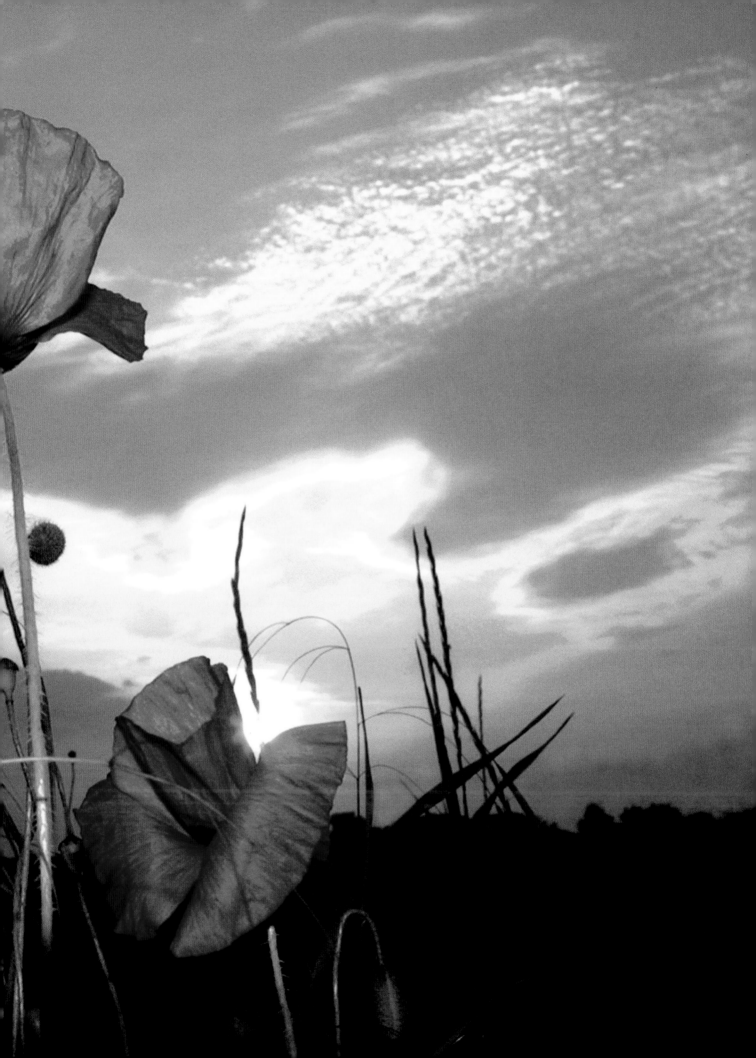

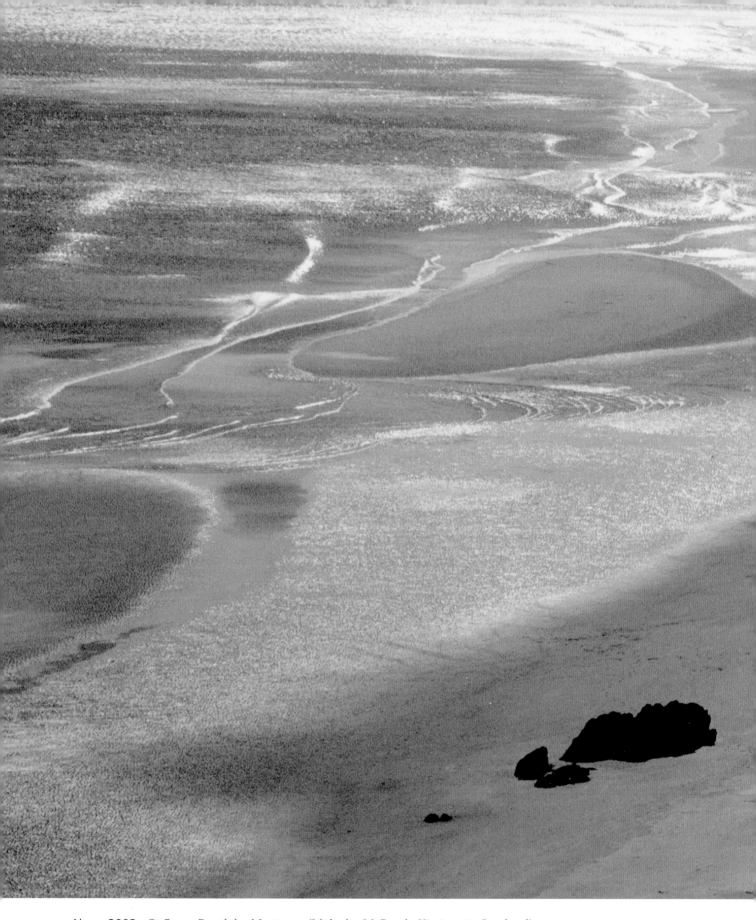

Above: **2003** – St Cyrus Beach by Montrose. (Malcolm McBeath, Kirriemuir, Scotland)

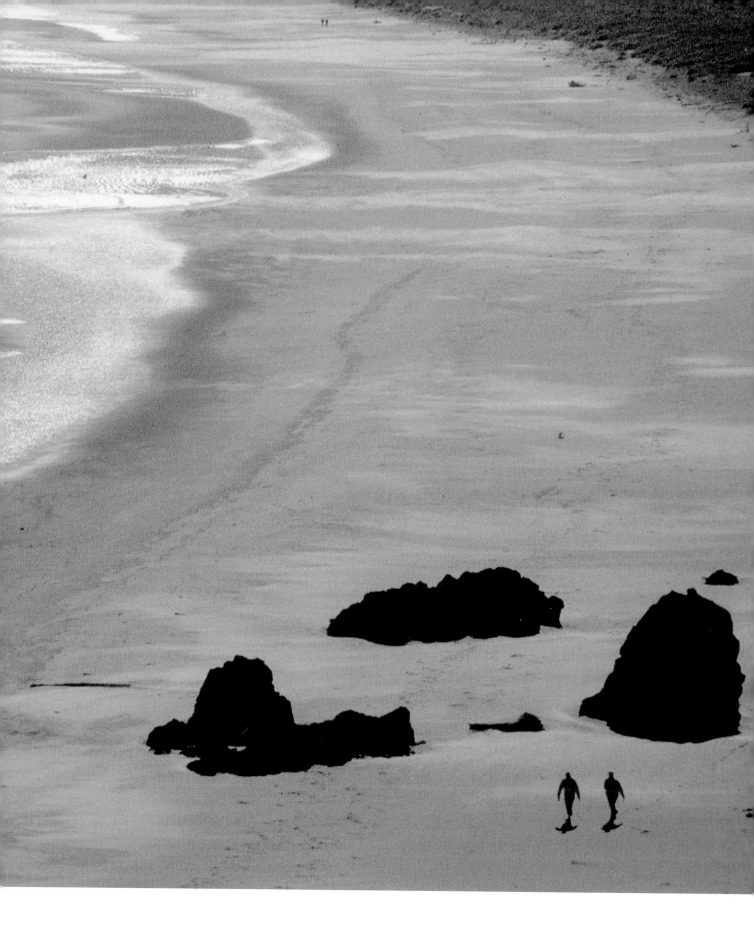

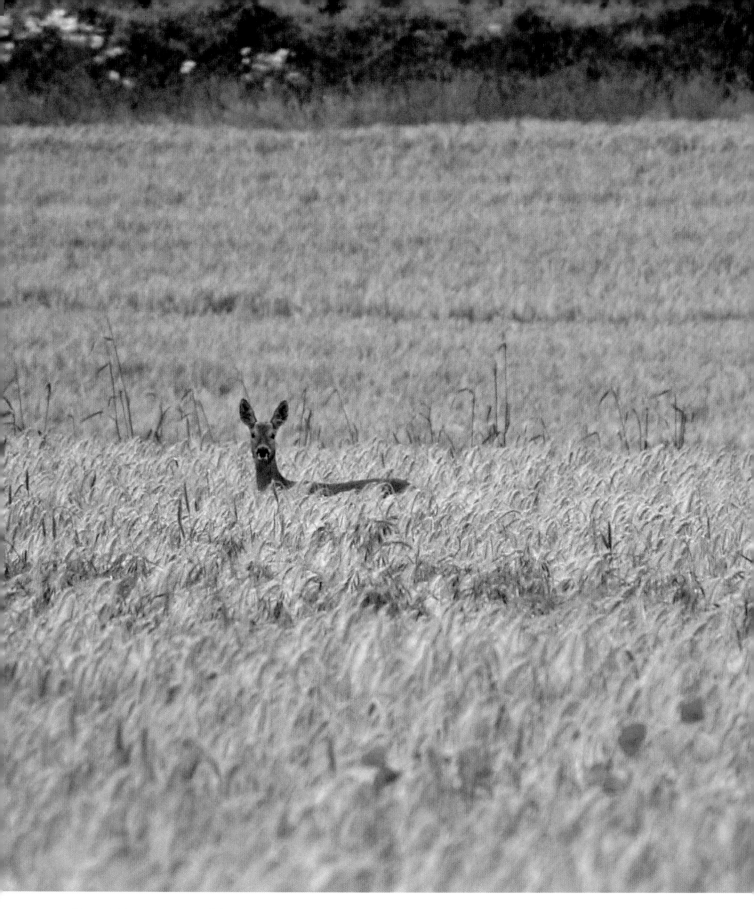

Above: **2008** – Lone Deer. (Sharon Ayres)

Opposite top: **2015** – Fox Love. (Lawrie Brailey)

Opposite bottom: **2006** – Seascape. (Stephen Ellis)

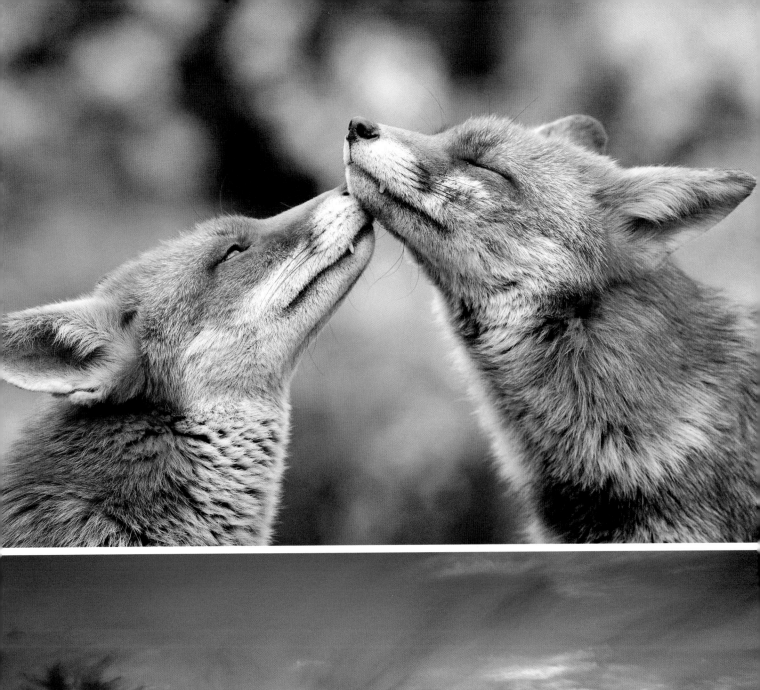
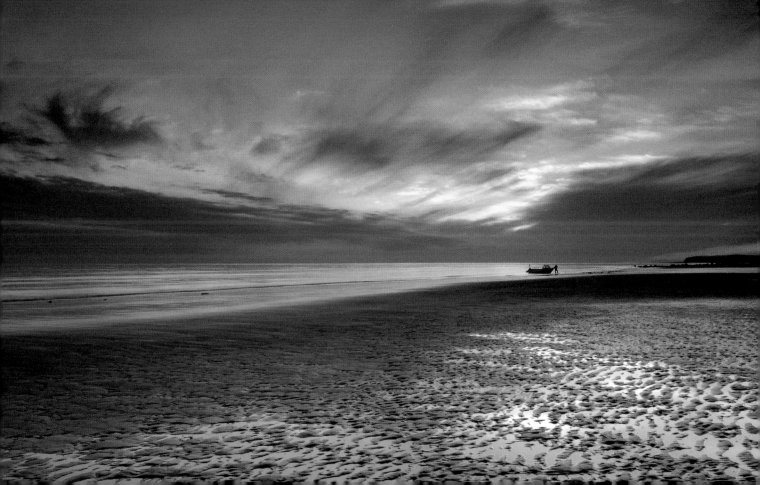

***Above:* 2012** – Magical Meadow. (Chris Eaves)

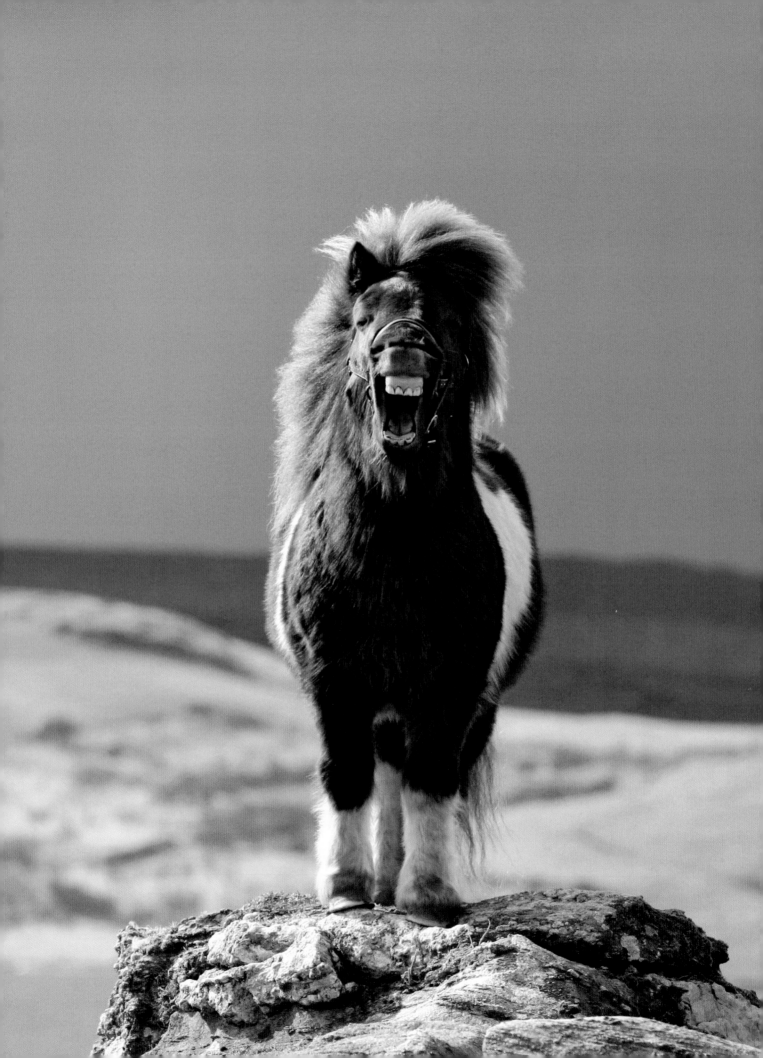

July

Matt Baker

July means long hot days and summer holidays. It's sunshine, ice cream and being outside all day. I love long evening walks in July and sometimes it almost feels like you get an extra day within a day because it's light for so long. If we're lucky we grab an odd night away in the campervan. Our countryside is beautiful at this time of year – why would we want to go anywhere else?

It's also the time where you'll see grass collected in the fields for winter feed. I love the feeling of preserving the summer goodness ready to be cracked open in the depths of winter. There's nothing quite like the feeling on a cold, wet morning when you open a bale and your senses are hit with the smell of summer. You're immediately transported back to the days of shandy and crisps on the bale trailer.

There are ancient hay meadows on the farm and the collection of grass and rich meadow species we now have is testament to the effort that's gone into them over the years. We leave our hay until the end of July when the seed heads from the flowers have fallen to encourage even more the following year. It also gives the curlews that nest in the long grass a chance to fully fledge their young. Curlews are on the 'Red List', meaning they are of the highest conservation status, so it feels good to know we're doing our bit to help them.

In our gardens there's a sense that everything needs to be watered, and water is a very important commodity in July. A theme of some of this month's photos is the cooling element of water, replenishing nature on hot days. July is peak season for dragonflies and the image of one alongside a lily pond sums that up beautifully.

Farmers will also begin combining cereal crops this month. It's amazing how the technology of harvest has changed over the years. I remember smothering myself in sun cream in July, as I would sit for hours on open-top tractors, which these days would be classed as vintage! Summer Shows have always been a big part of this month for us. All the vintage farm machinery from my youth is usually on display, alongside the most up-to-date versions. I love the shot of the crooks with rosettes as, for me, it's a image that sums up a wonderful way to celebrate a year of hard work.

Opposite: **2017** – Shetland Smiler, Shetland Pony, Shetland. (Elaine Tait)

Following spread: **2013** – High Flier. (Irene McIlvenny)

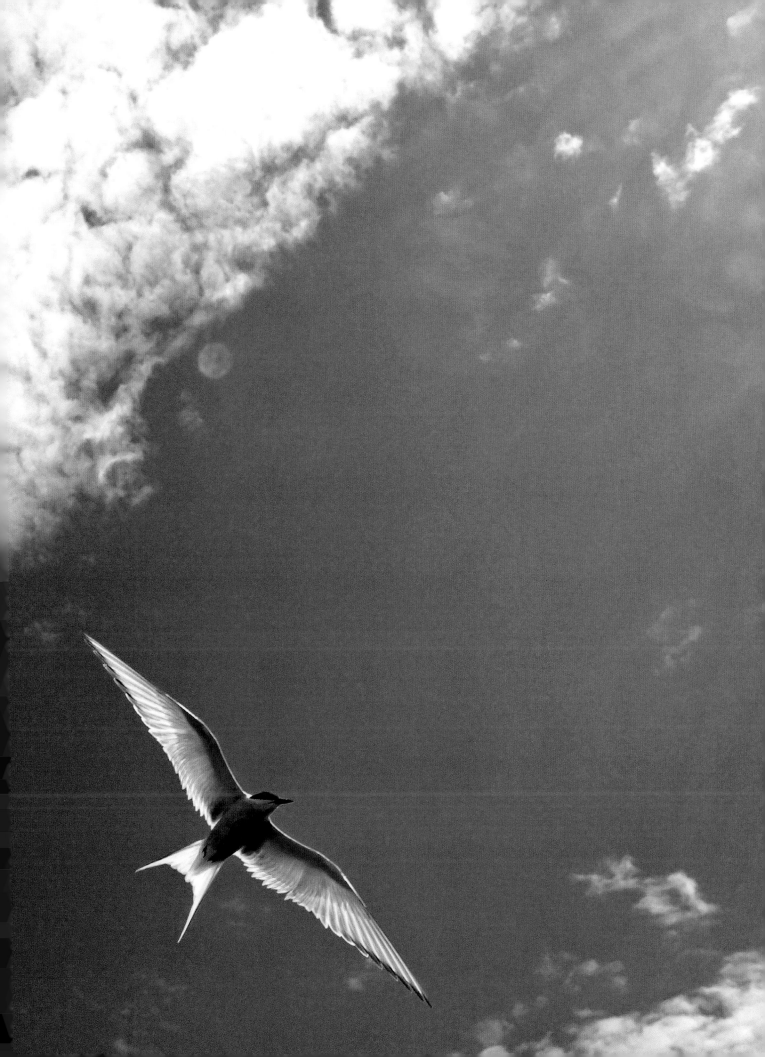

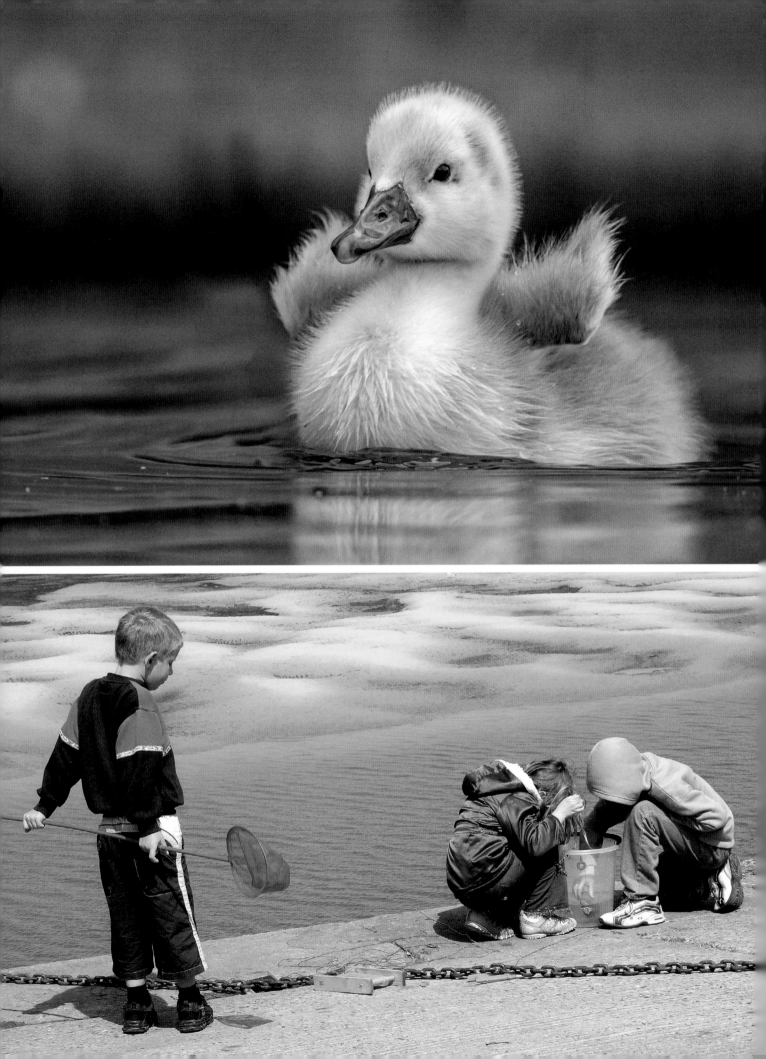

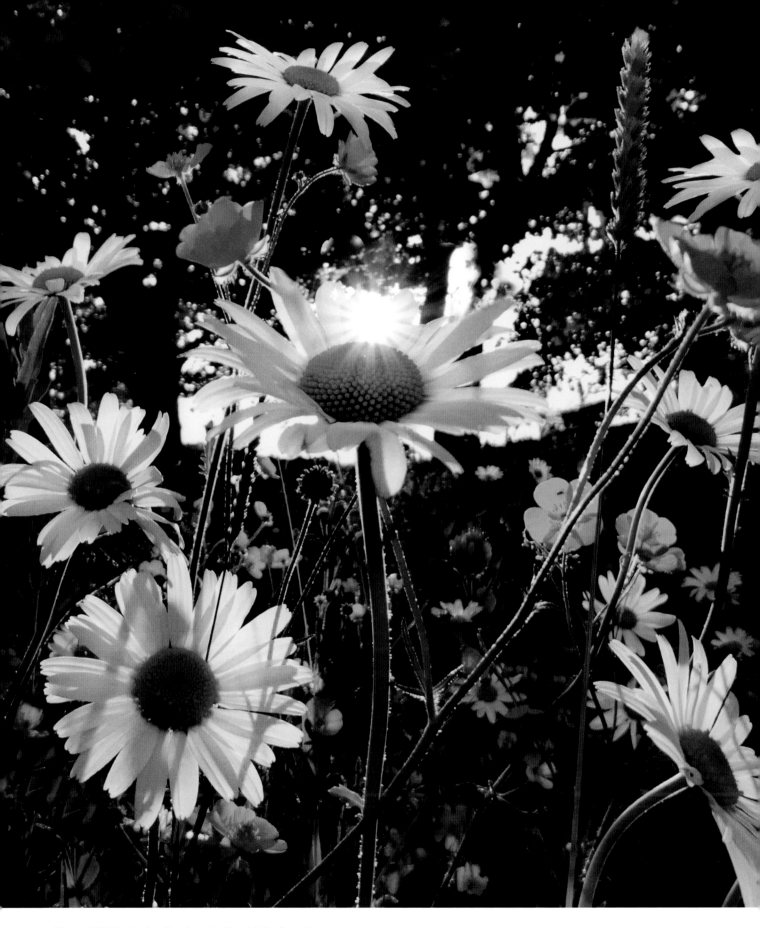

Above: **2014** – Daisy Sunburst. (David Jackson)

Opposite top: **2019** – Little Wings, Kensington Gardens, London. (Barry Jones)

Opposite bottom: **2006** – Children Crabbing. (Christopher Kislingbury)

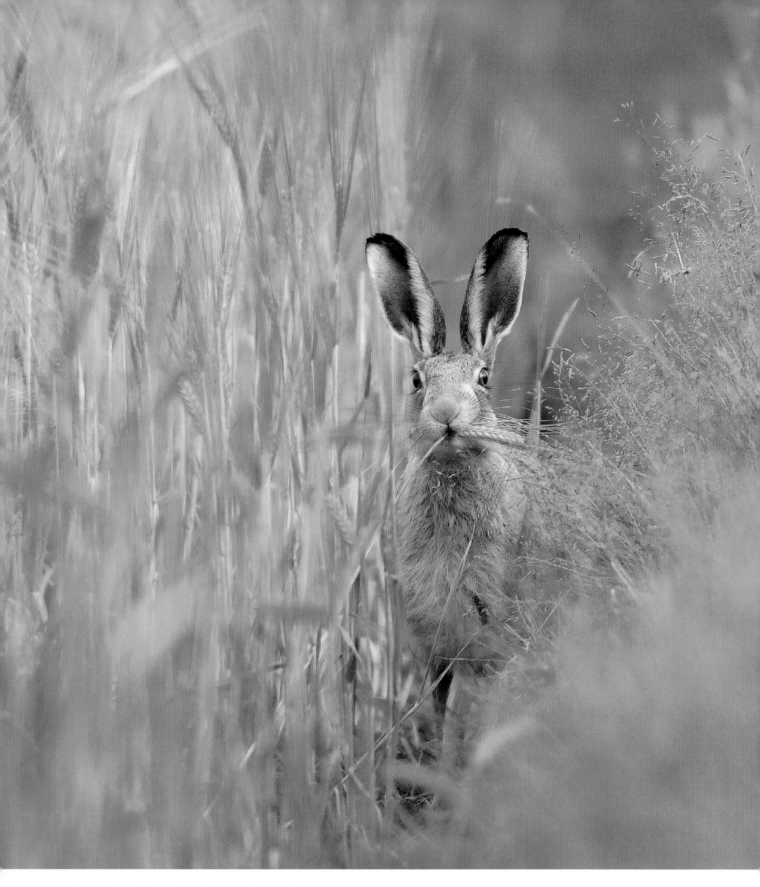

Above: **2016** – All Ears. (Andrew Stewart)

Opposite: **2018** – First Flight, Bushy Park. **Overall Winner.** (Jarek Kurek)

Following spread: **2003** – Wasdale and Wastwater from Great Gable. (Julie Fryer, Wigton, Cumbria)

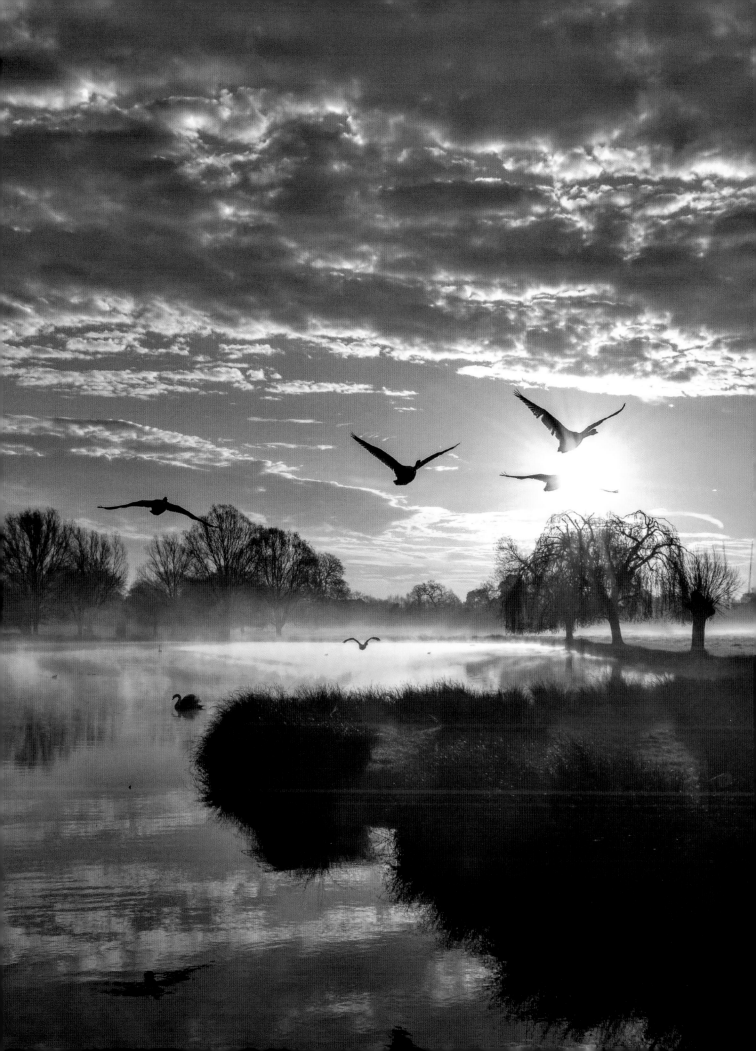

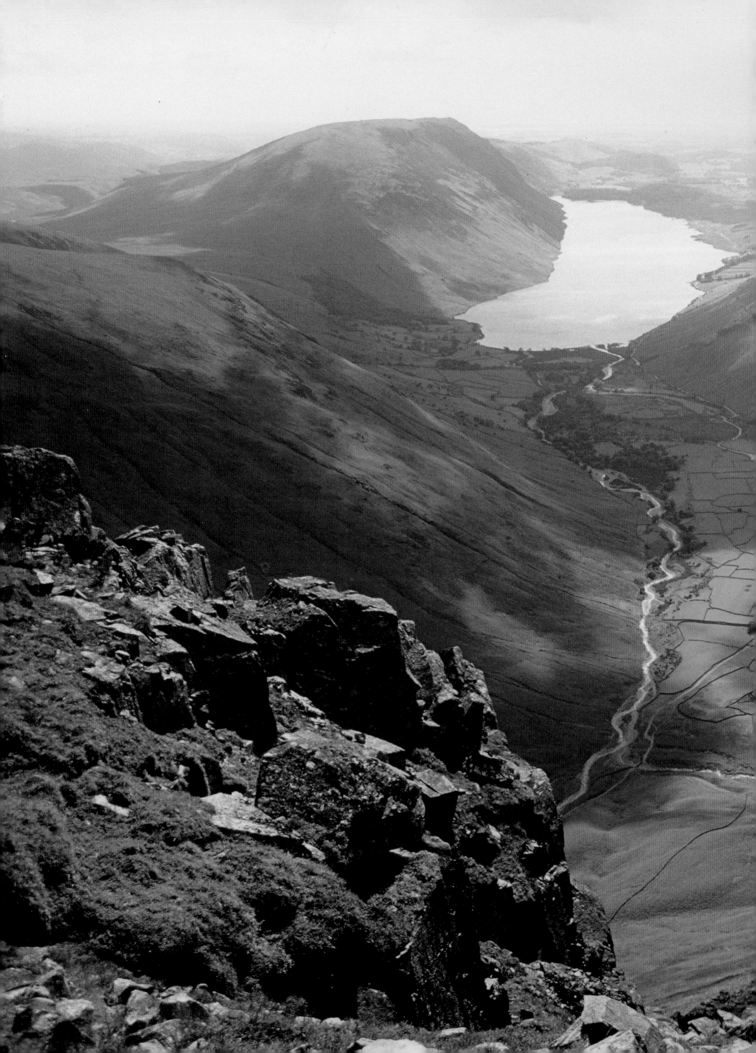

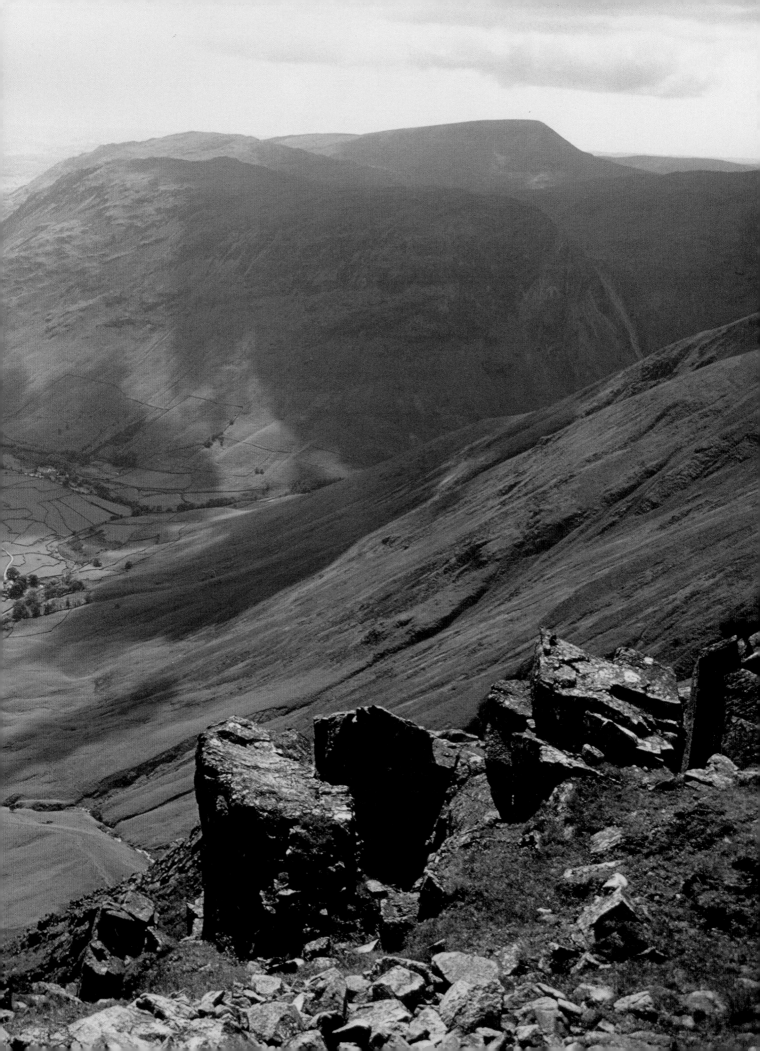

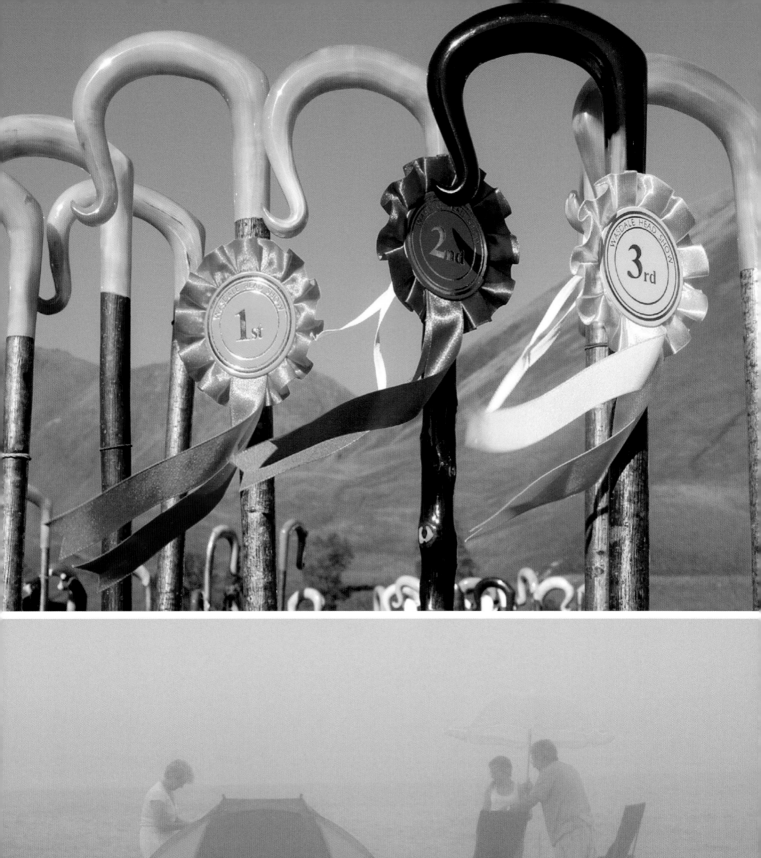

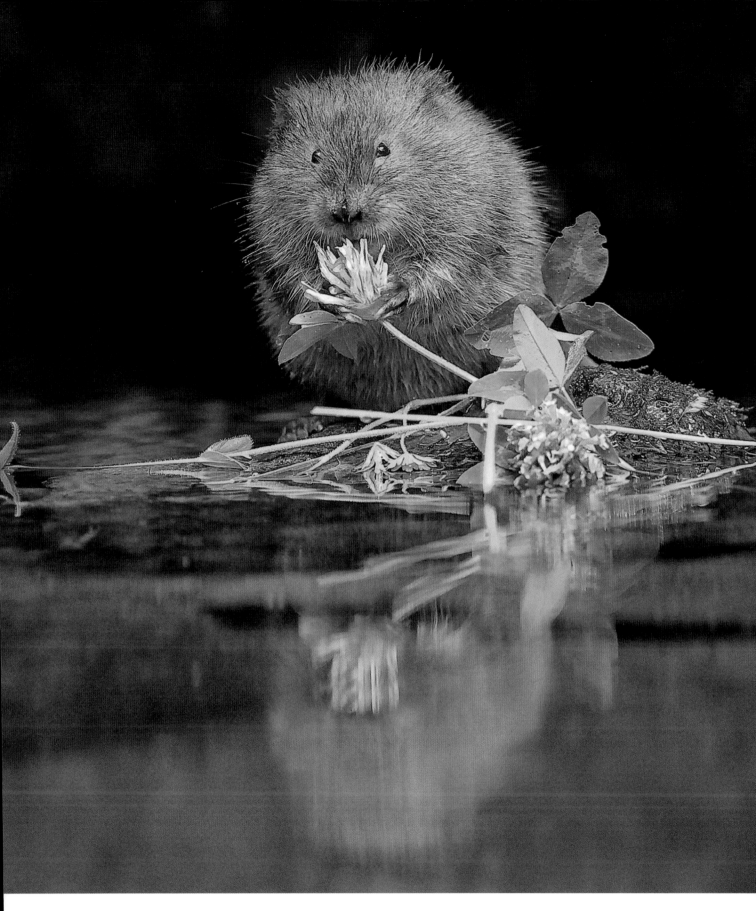

Above: **2011** – In the Clover. (Sue North)

Opposite top: **2012** – By Hook, or By Crook. **Judges' Favourite**. (Derrick Young)

Opposite bottom: **2007** – Misty Picnic, Bridlington Beach. **Judges' Favourite**. (Paul Arro)

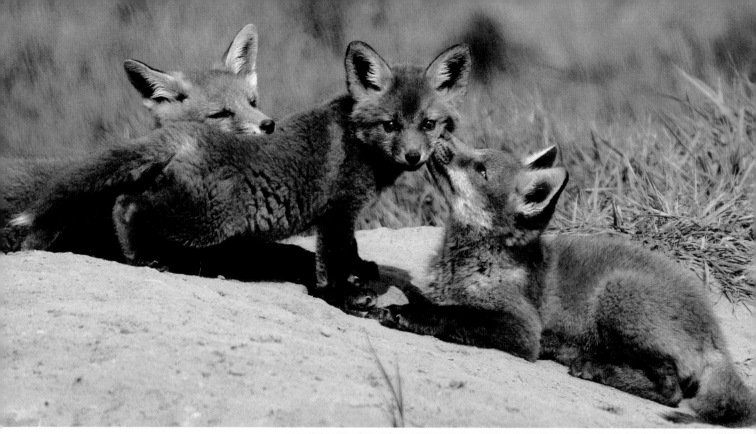

Above: 2008 – Fox Cubs.
(Sheila Blamire)

Opposite top: 2020 – Damsel in the Dew, Scorton, North Yorkshire.
(David Lain)

Right: 2009 – Dolphins on Display.
(Peter Evans)

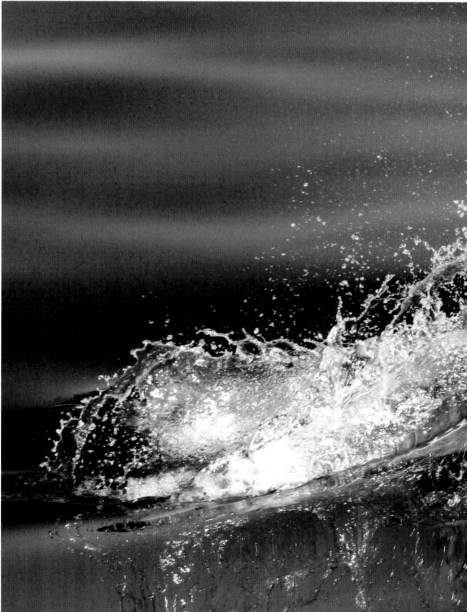

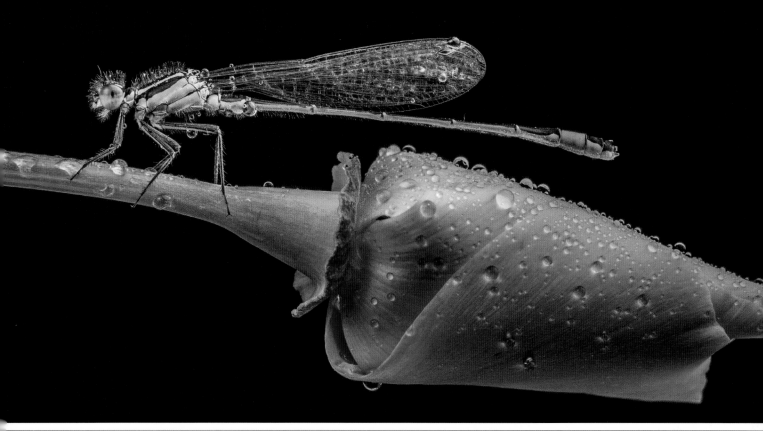
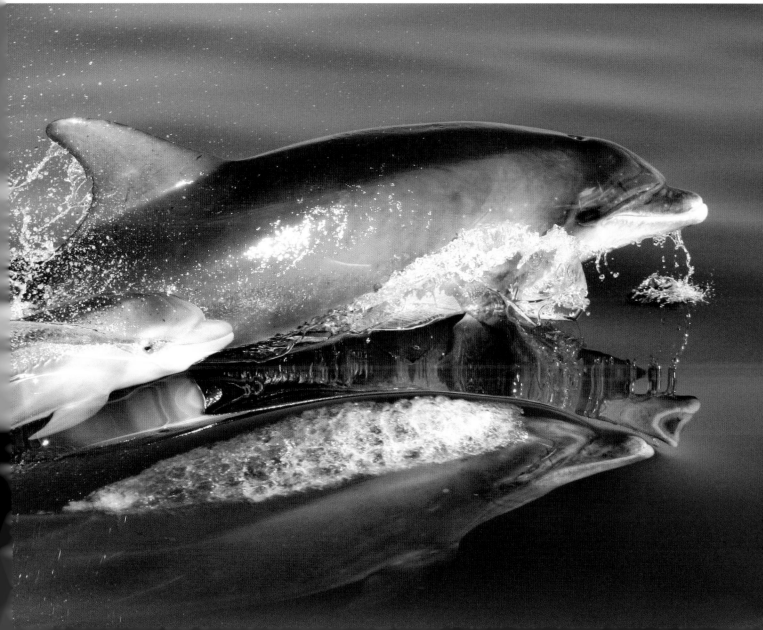

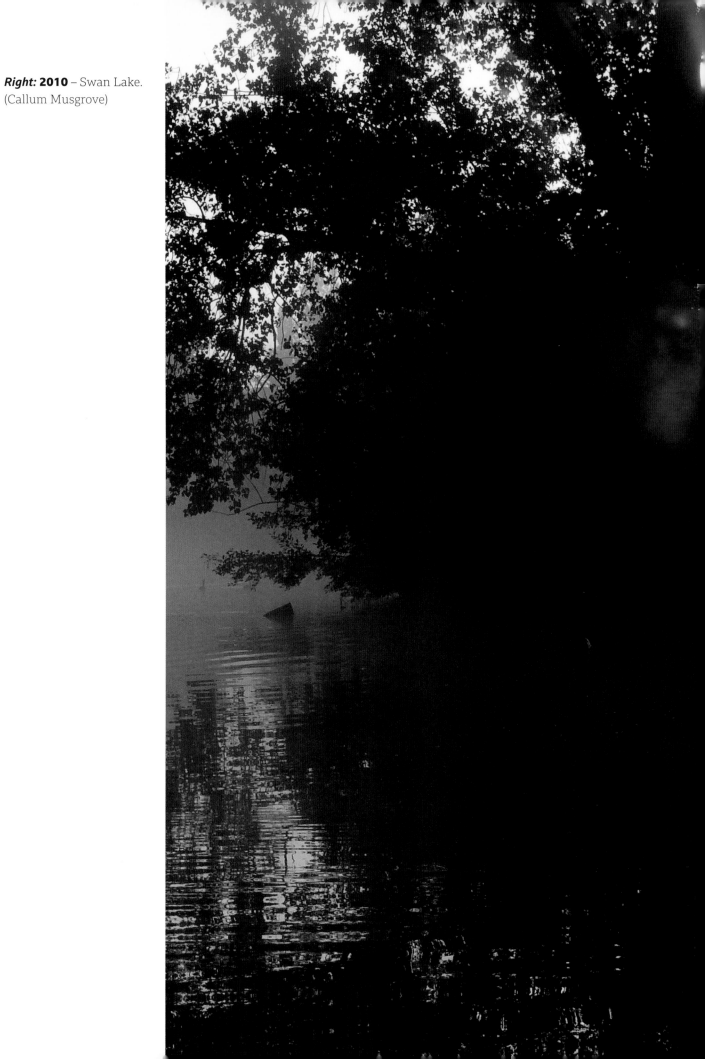

Right: **2010** – Swan Lake.
(Callum Musgrove)

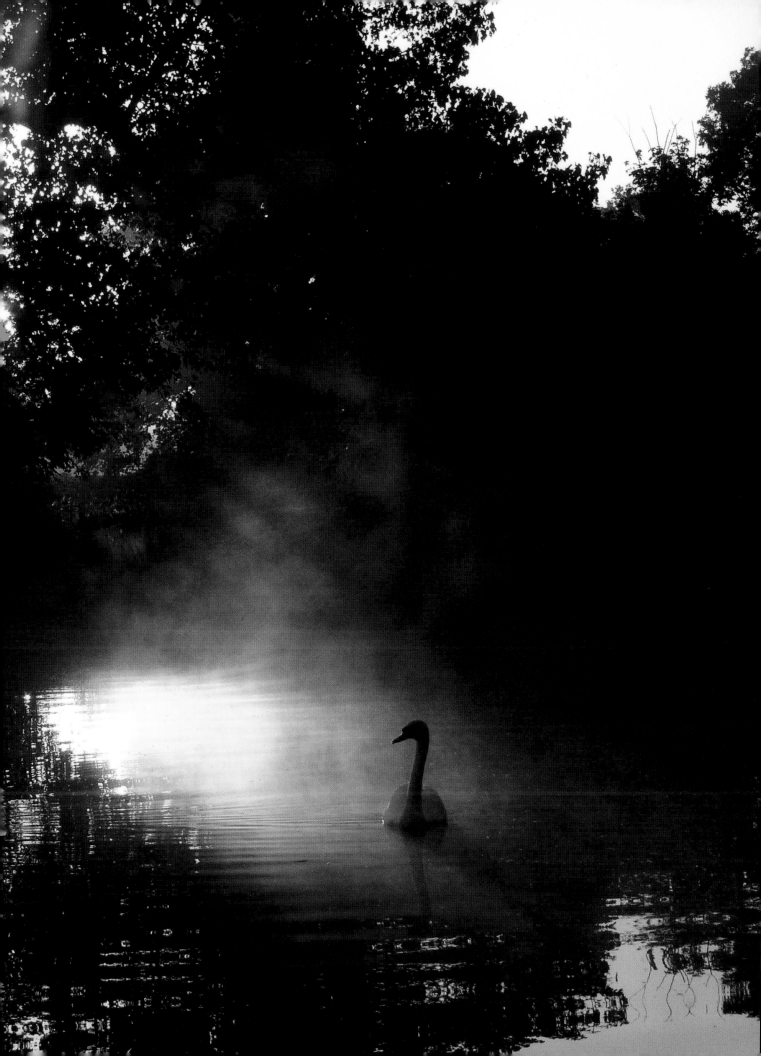

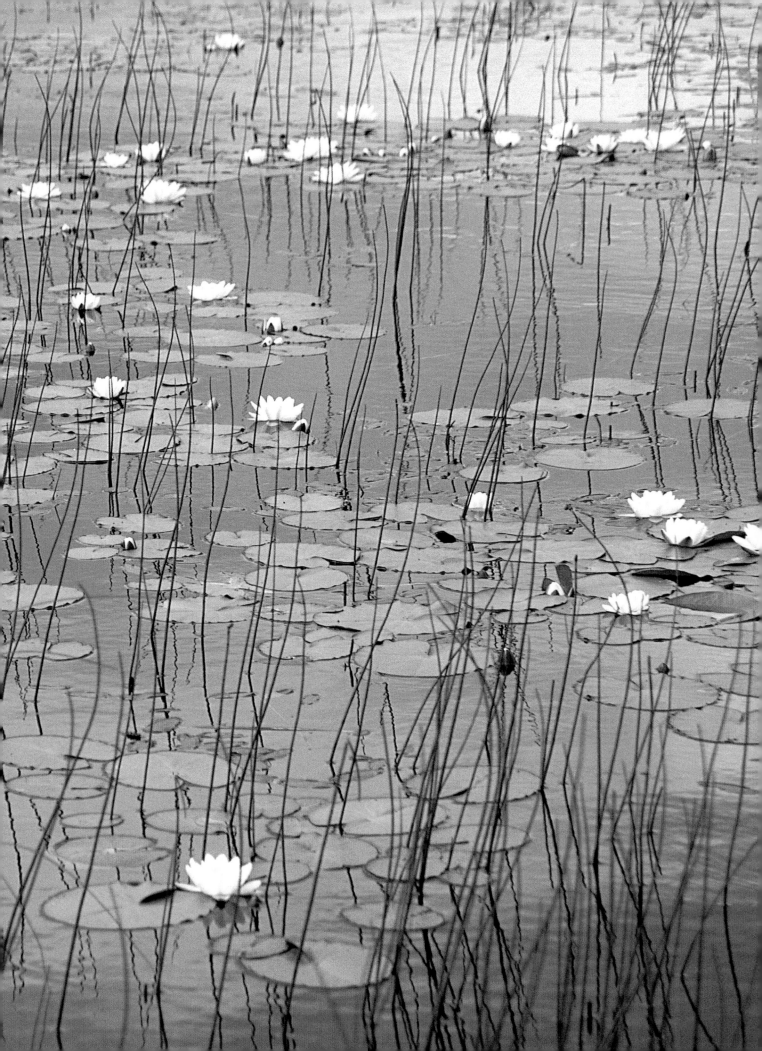

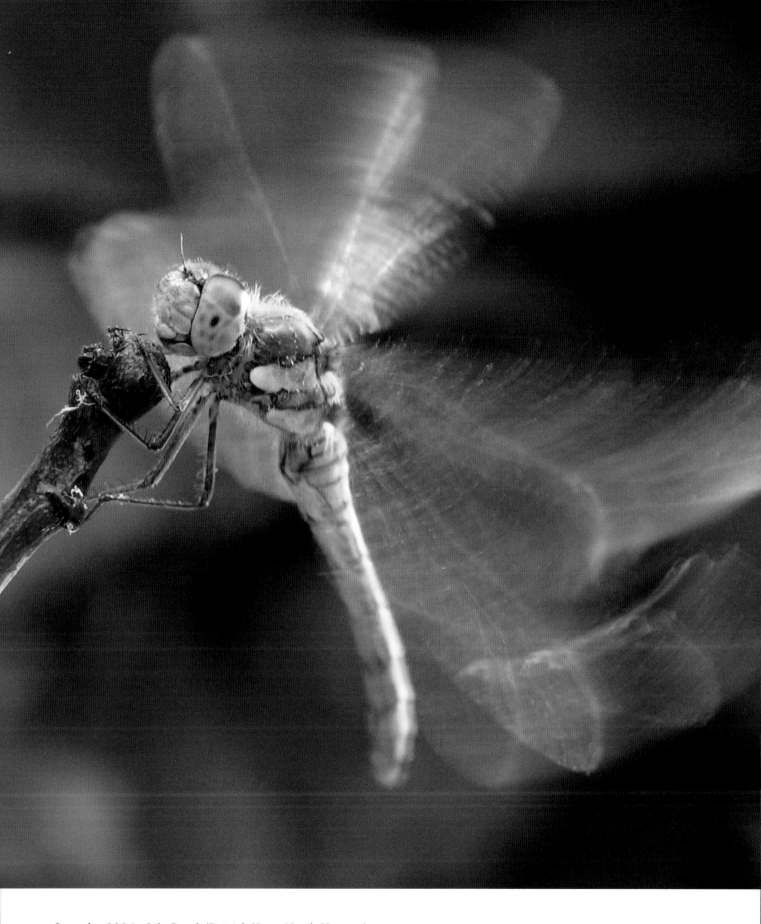

Opposite: **2004** – Lily Pond. (Patrick Kaye, North Harrow)

Above: **2005** – Dragonfly. **Judges' Favourite**. (Glyn Dring, Nottinghamshire)

Following spread: **2015** – Ruffled Feathers. (David Naylor)

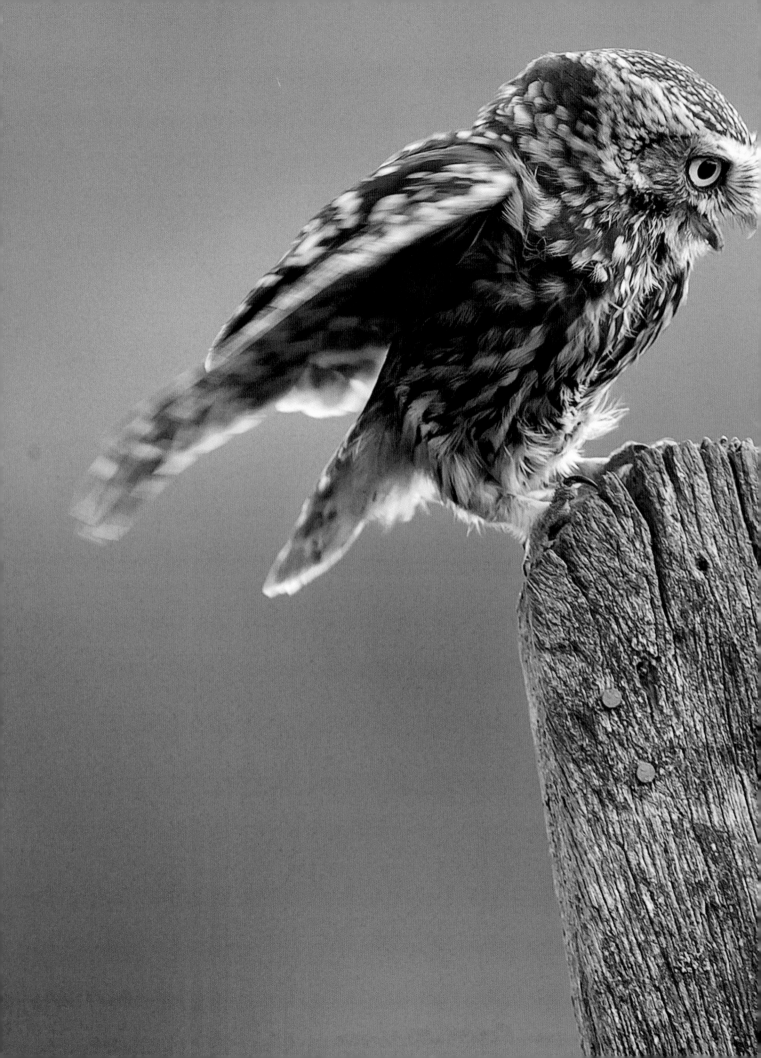

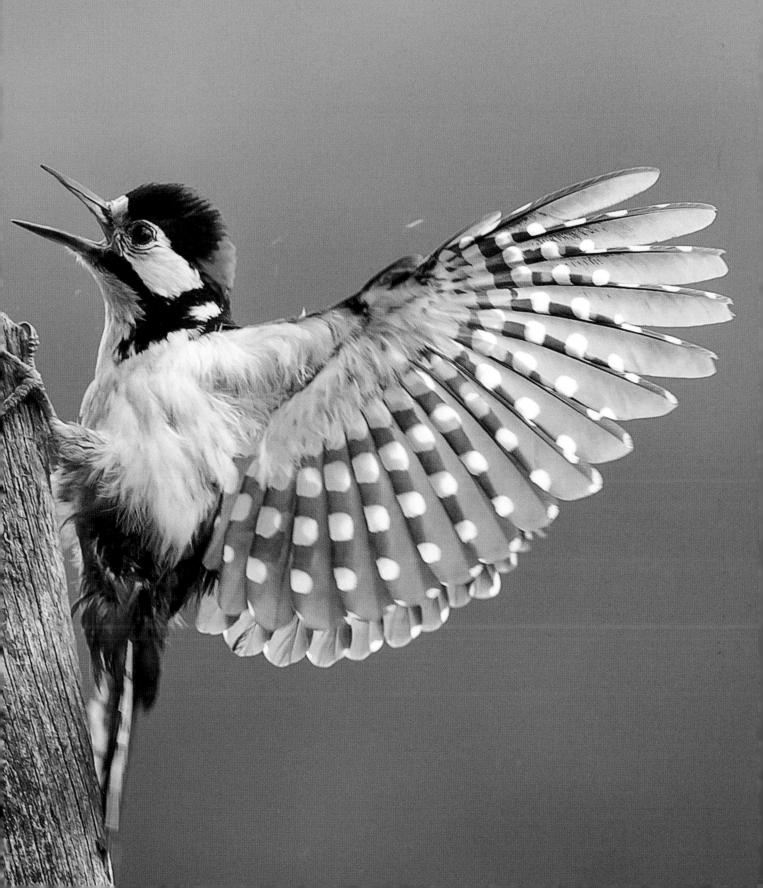

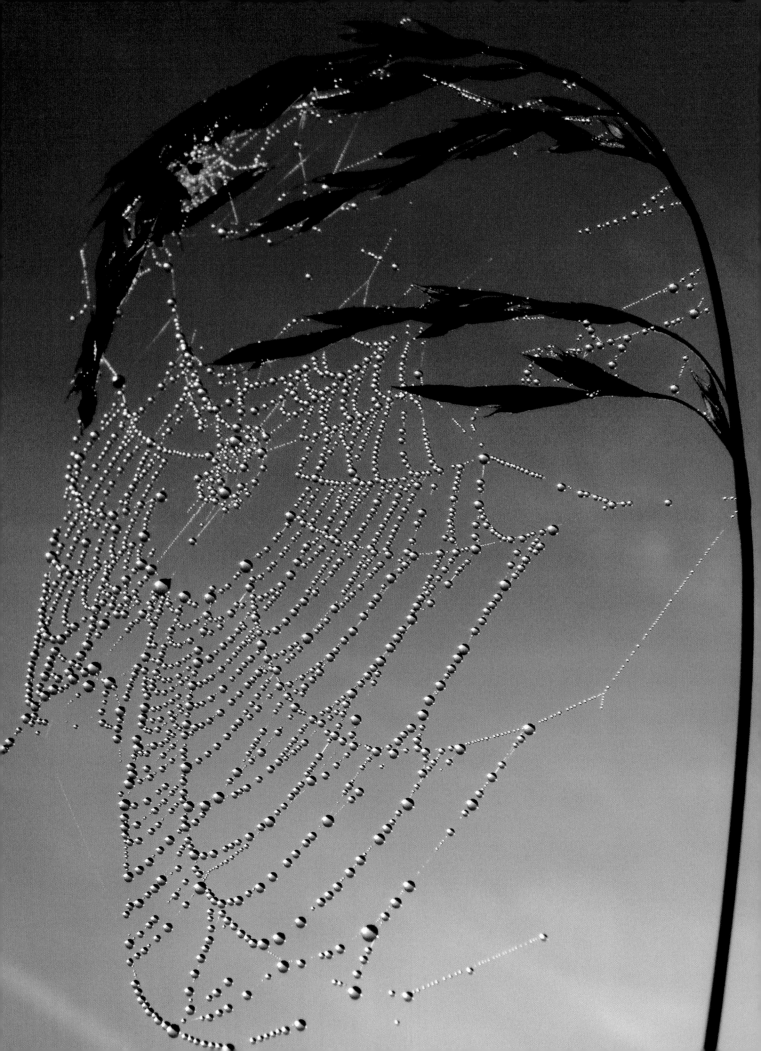

August

John Craven

***Opposite: 2017**
– Web of Pearls.
(Annie Durkan)

I like August. It's warm and sunny (though it can also be wet), it's the height of the holiday season and in the middle of the month it's my birthday! The first day of August is Lammas ('Loaf Mass') Day and in ancient times farmers made bread from newly gathered wheat and offered it to churches to mark the start of harvest. Henry VIII put a stop to that and harvest is now celebrated at the end of the season.

There are three contrasting beach scenes: Rosy Burke's monochrome bathers playfully contending with an incoming tide; Elaine Redman's cows doing a spot of sunbathing on vast and otherwise empty sands; and Graham Mealand's lone horserider silhouetted against the setting sun. Not a bucket and spade in sight.

Inland, canal holidays are increasingly popular – I travelled down the Llangollen canal with my two eldest grandsons and it was a brilliant experience. I regret that, unlike Sarah Williams, we didn't see a horse-drawn narrowboat to take us back to the early days of our inland waterways. Her photo drips with nostalgia.

Seabirds abound: an oystercatcher's view of the Northumbrian seaside town of Amble, the hypnotic rock patterns in the cliffs where fulmars nest and the inevitable puffin shot. We receive hundreds of puffin pictures every year – but what makes Jennifer Duncan's image stand out for me is the way all the other puffins are watching the one about to land. I wonder what their thoughts were.

Spiders' webs, bees and dragonflies are always popular subjects, but not slugs! Yet Raymond Alexander's close-up transforms this slithery, unloved creature into a thing of beauty … and an unlikely calendar star. It emphasises the belief, endorsed by the novelist and poet Thomas Hardy, that the lowliest life forms must never be dismissed. While writing late one August evening, Hardy recalled how a daddy longlegs, a bumblebee, a moth and a fly shared his desk:

"Thus meet we five, in this still place,/At this point of time, at this point in space./My guests besmear my new penned line/Or bang at the lamp and fall supine./"God's humblest, they!" I muse. Yet why?/They know Earth's secrets that know not I."

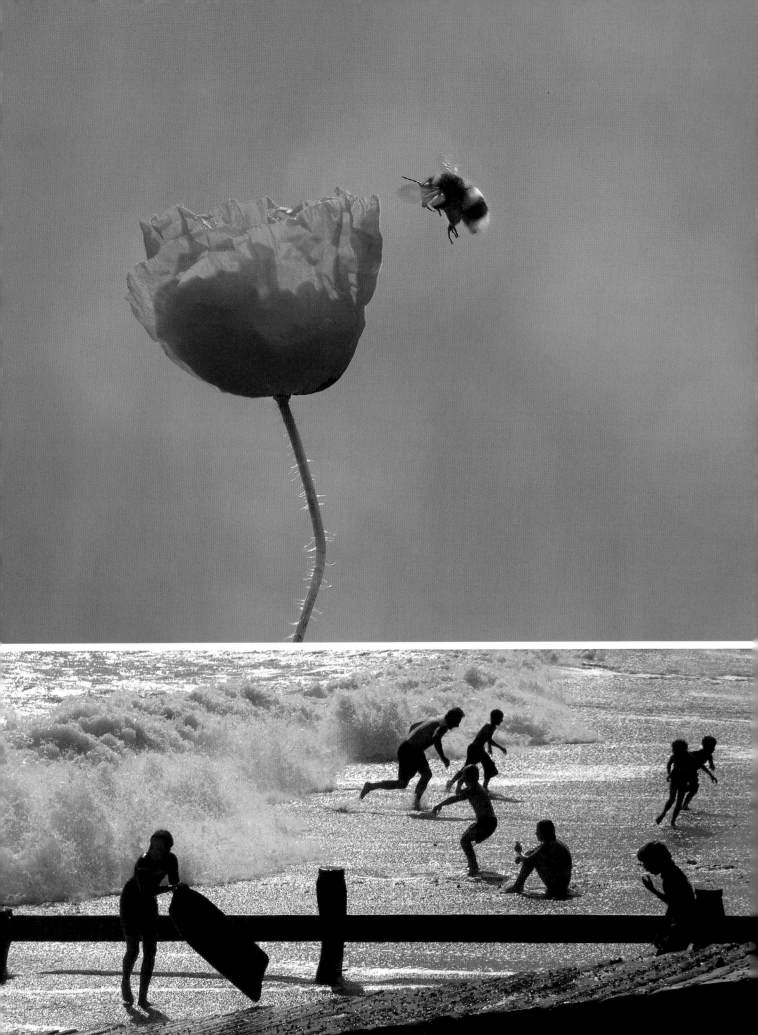

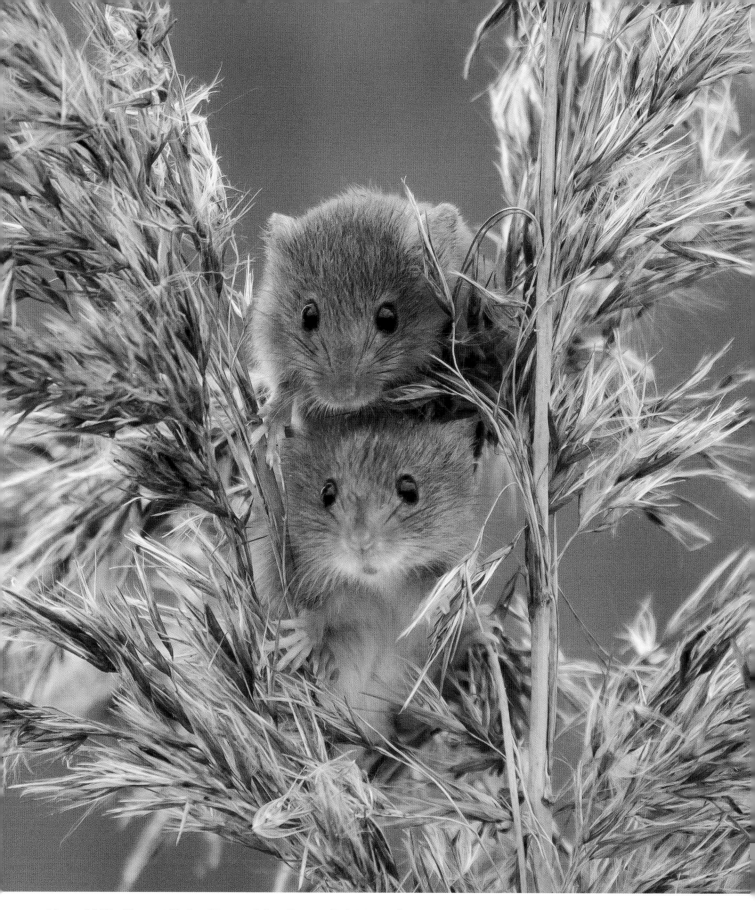

Above: **2017** – Harvest Twice, Harvest Mice, Devon. (Bob Morgan)

Opposite top: **2013** – Poppy Pit Stop. (Chris Miles)

Opposite bottom: **2006** – Fun in the Waves. **Judges' Favourite**. (Rosy Burke.)

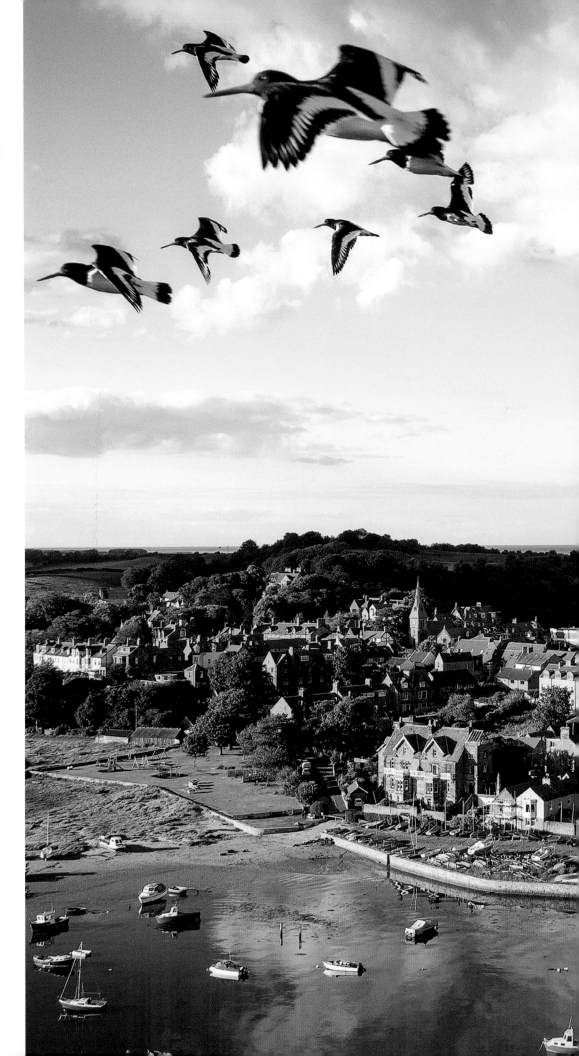

Right: **2020** –
Catchers in the
Sky, Alnmouth,
Northumberland.
(Richard Armstrong)

Following spread:
2008 – Beach Cows.
(Elaine Readman)

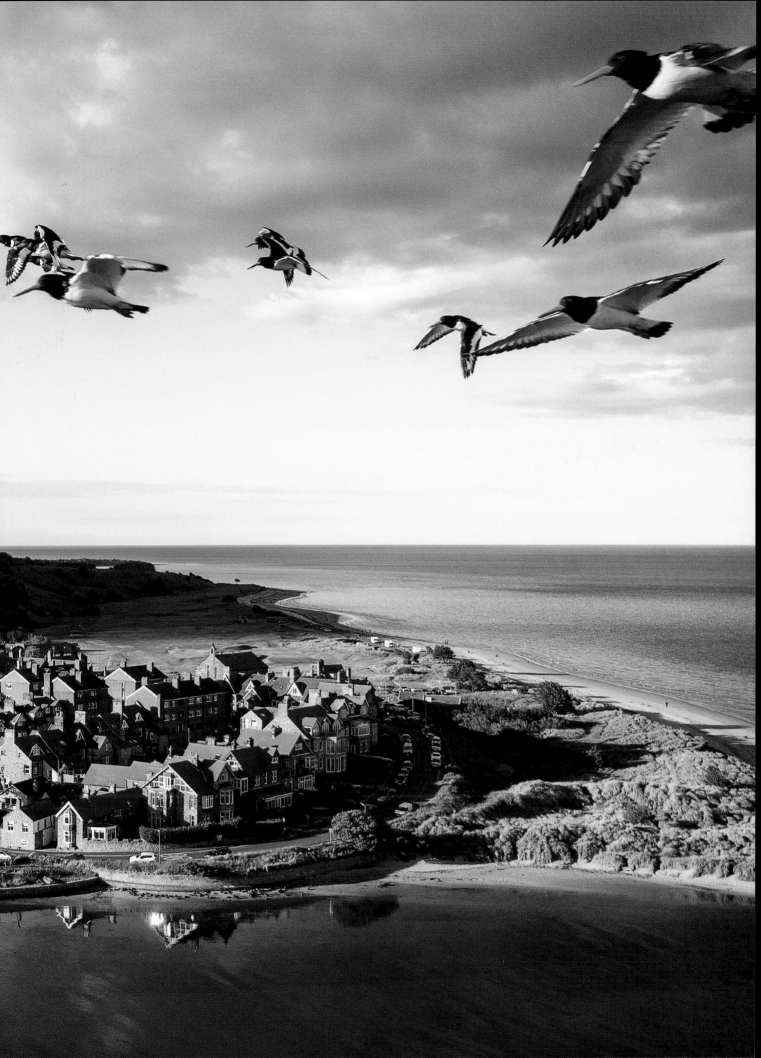

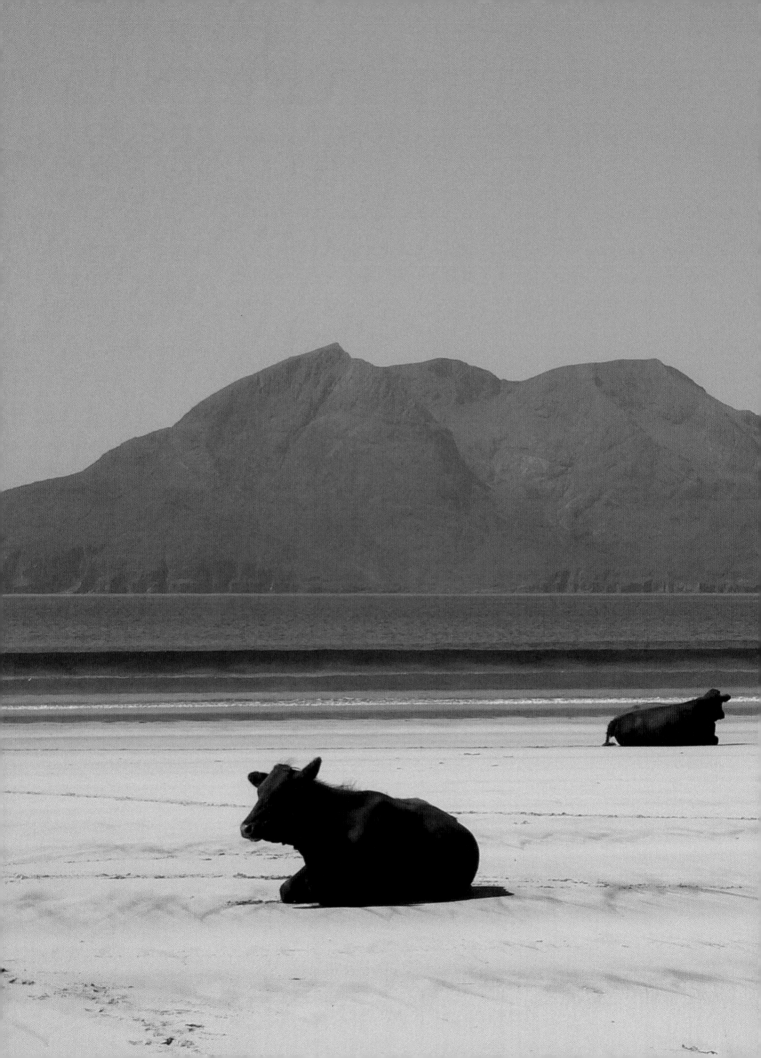

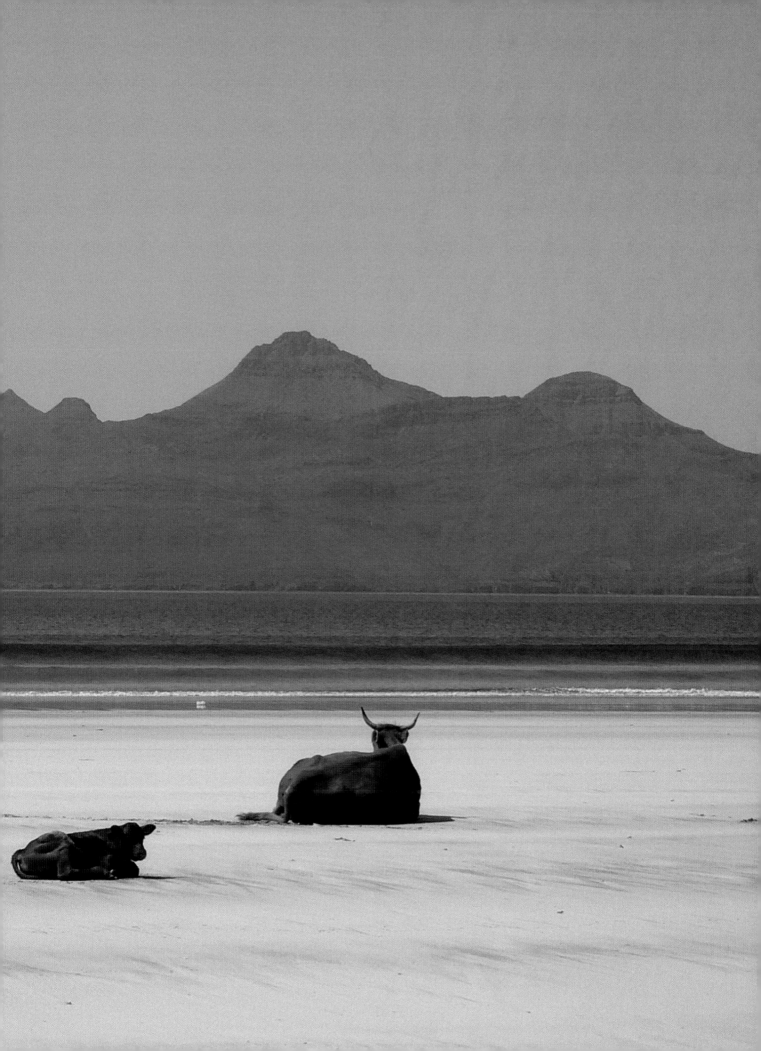

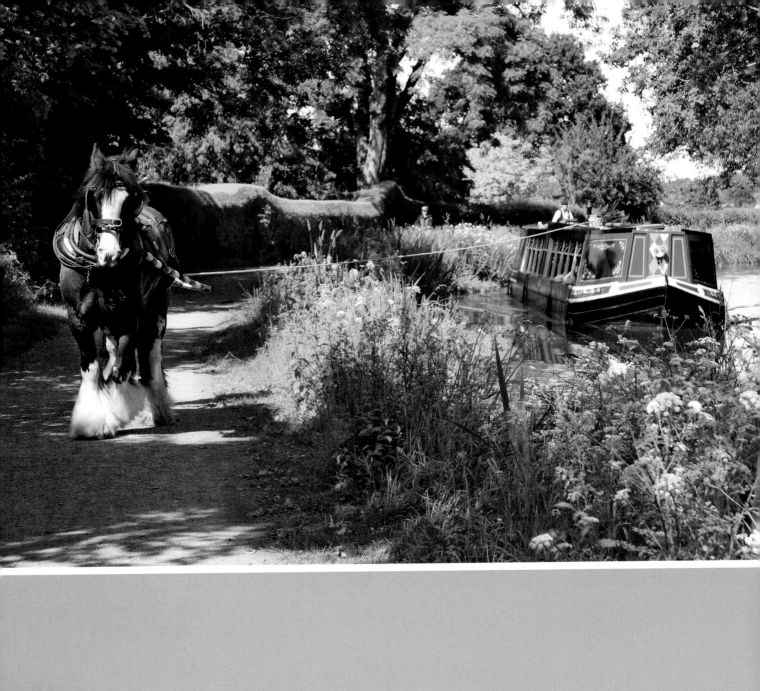
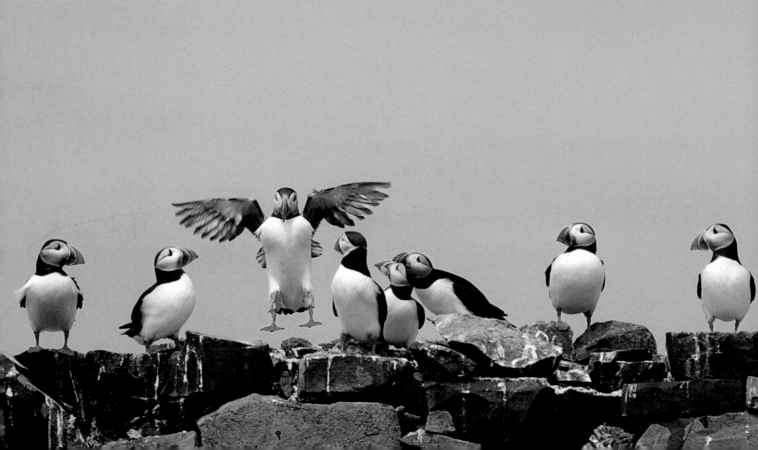

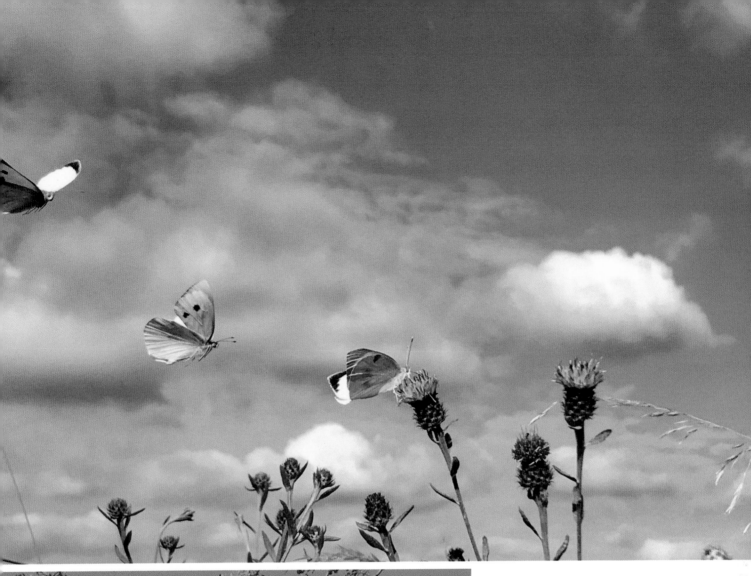

Above: **2018** – Flutter By, Oxfordshire. (Alison Rosum)

Opposite top: **2012** – Pulling Power. **Overall Winner**. (Sarah Williams)

Left: **2003** – Crossing the Severn, Bewdley. (Les Clarke, Malvern, Worcestershire)

Far left: **2011** – Huffing Puffin. (Jennifer Duncan)

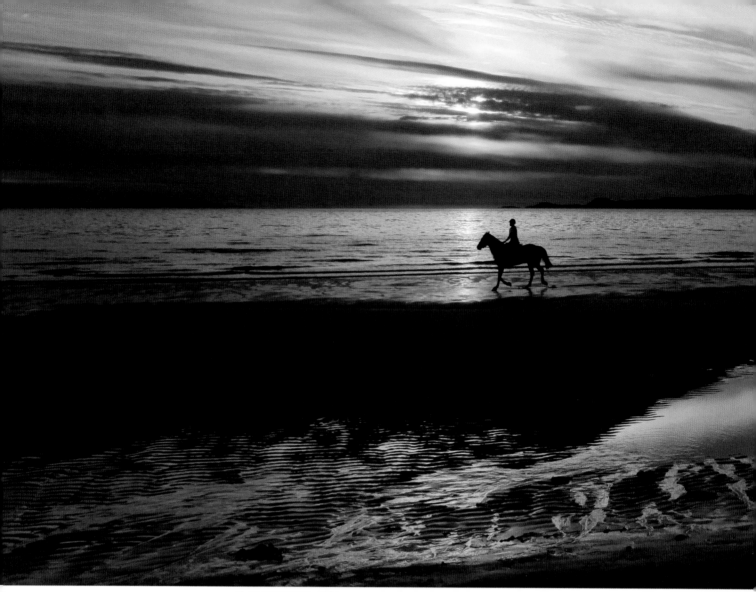

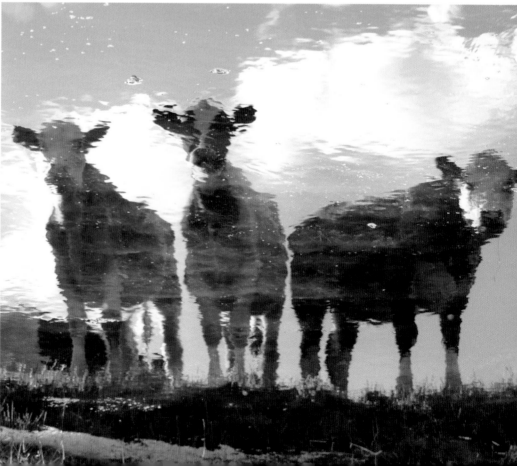

Above: **2016** – Coastline Canter. **Judges' Favourite**. (Graham Mealand)

Right: **2015** – Curious Cattle. **Judges' Favourite**. (Susie Mulhern)

Far right: **2005** – Willow Tit. (Paul Weston, Cheshire)

Following spread: **2014** – Fulmars Roost on Ancient Rocks. (Alfred Paladini)

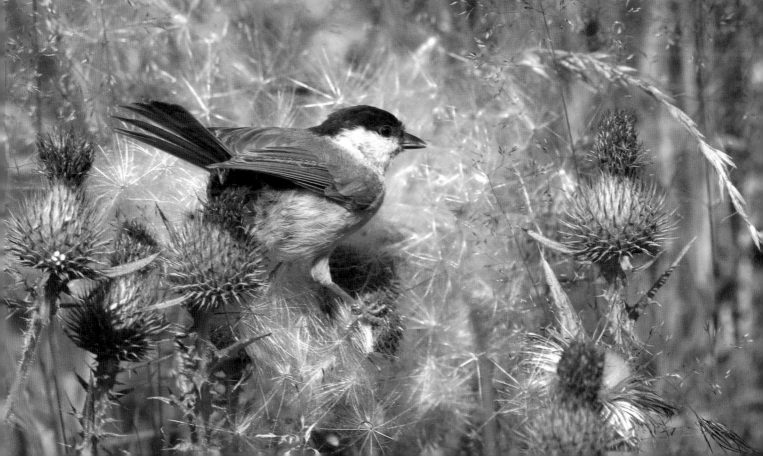

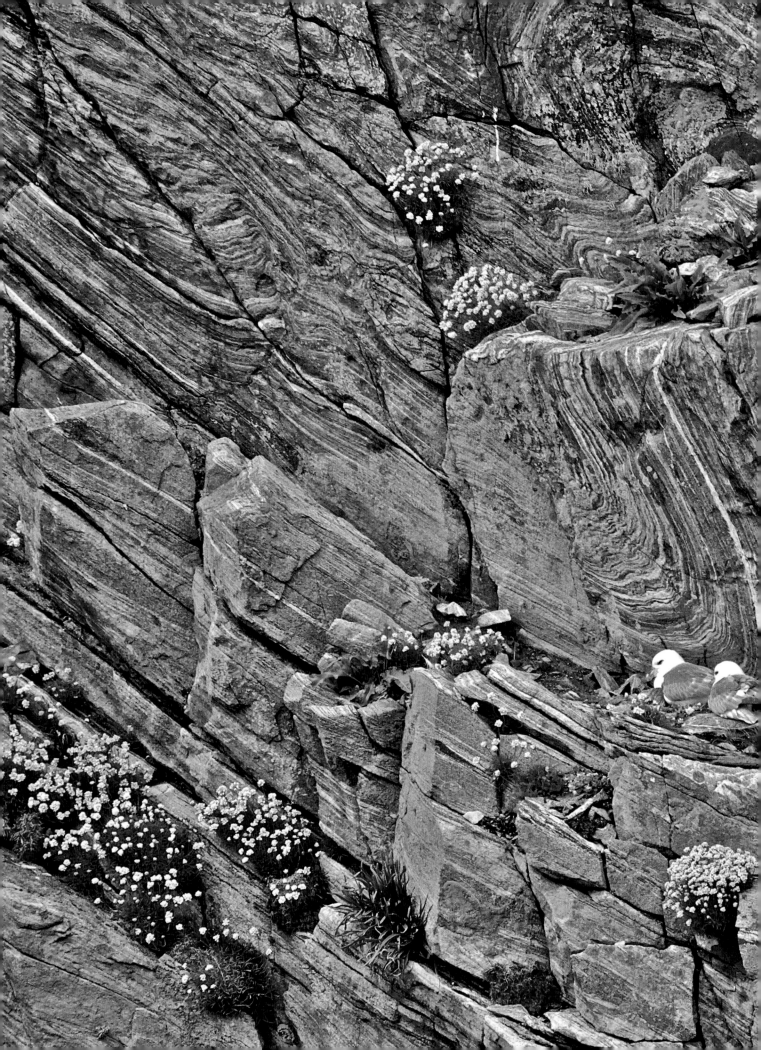

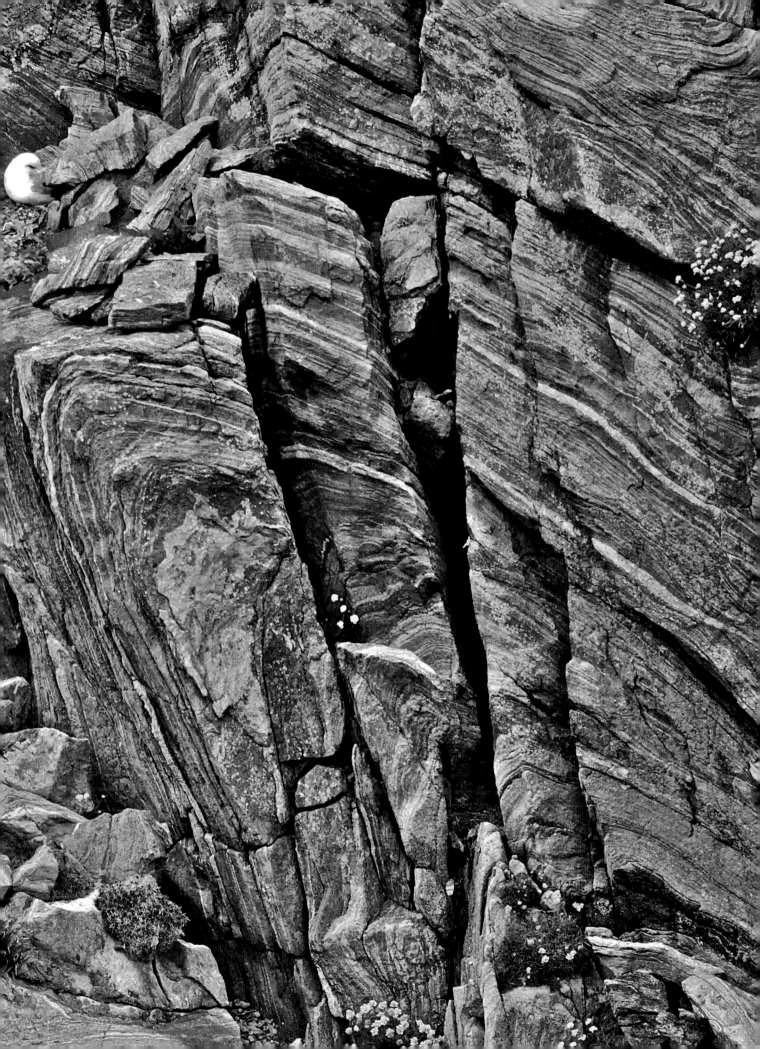

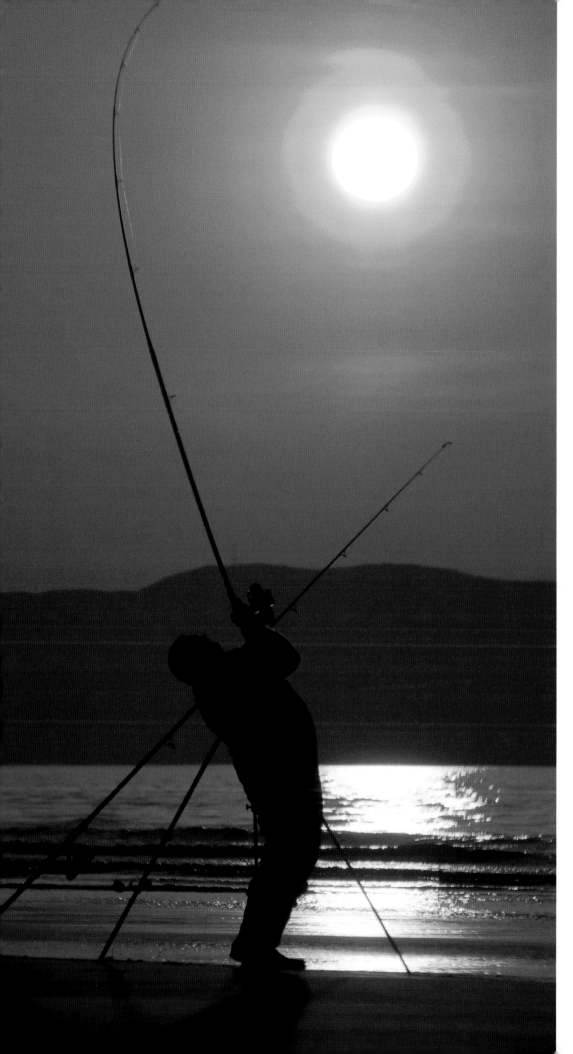

Opposite top: 2004 – Harvest Time. (Andrew White, Bridport, Dorset)

Opposite bottom: 2009 – Slippery Customer. (Raymond Alexander)

Left: 2007 – Angler, Northern Ireland. (Glenn Miles)

Following spread: 2019 – Fields of Gold, Woods Mill, West Sussex. (Sean Stones)

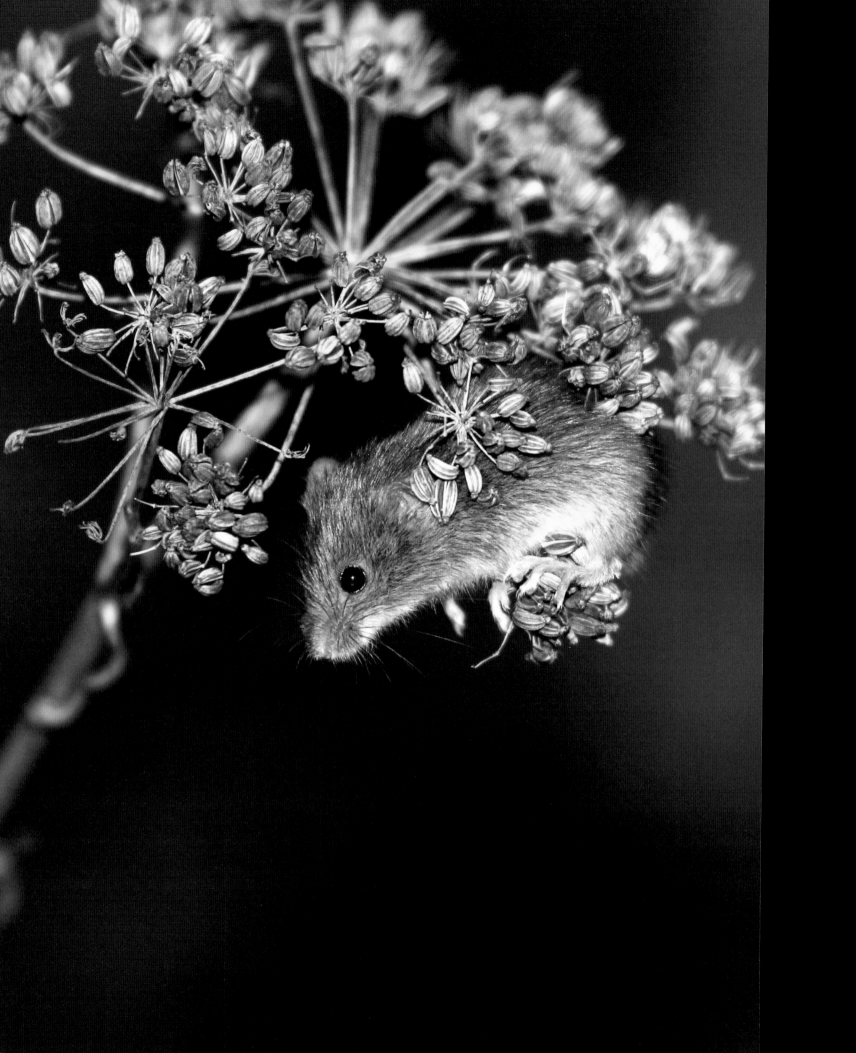

September

Matt Baker

September brings the autumn equinox when the nights become longer than the days, marking the start of autumn. It's the last chance for migrating birds to build up their reserves before their epic journeys to warmer winter destinations. Swallows will have been gathering together, chattering to each other in readiness for their departure this month; others, like swifts, will have already left. It's not only birds that head off for warmer climes: incredibly, some butterflies do too, with red admirals and painted ladies destined for the Mediterranean.

While some migrate, others hunker down. Dormice and hedgehogs are preparing for hibernation, busily trying to add on the last few reserves that will hopefully see them through the winter.

September's name comes from the Latin for seven – 'septem' – the 'seventh month'. Other months were renamed for Roman leaders, but the last few months of the year remained unchanged. September was sometimes called 'harvest month' in Old English before the Roman calendar came into use and the energy of harvest still lingers in the air, with farmers literally ploughing on with the next crop. Barley, yellow oil-seed rape and winter wheat will all be drilled into the soil.

Some of the September photos demonstrate this beautifully. In the photo of the field mouse with its ability to balance so delicately; the deer and the squirrel going about their business side by side; and the jackdaw balancing on the back of the fallow deer amazes me. The barn owl is wonderful as it's a very photogenic bird. It too will be making the most of the wealth of food before winter arrives making prey harder to find.

Elderberries are in abundance this month, with the blackthorn and hawthorn not far behind. Anyone who makes their own homebrews will know that September is the time to get out and gather sloes – the fruit of the blackthorn. As a family we make our own hedgerow brews and sloe gin is definitely a favourite. Blackberries are at their height too in September and it doesn't get much better than a homemade (and homegrown) blackberry and apple crumble washed down with a small sloe gin or two.

Opposite: **2017** – In the Balance. (Michael Mutimer)

Right: **2009** – Highland Fling. (John MacTavish)

Opposite bottom: **2007** – Ice Cream in the Rain, Lytham. (Chris Ogden)

Below: **2019** – Posing Puffin, Skomer Island, Pembrokeshire. (Philip Male)

Following spread: **2017** – Anglesey Dawn, Llanddwyn Lighthouse, Anglesey. (Gareth Mon Jones)

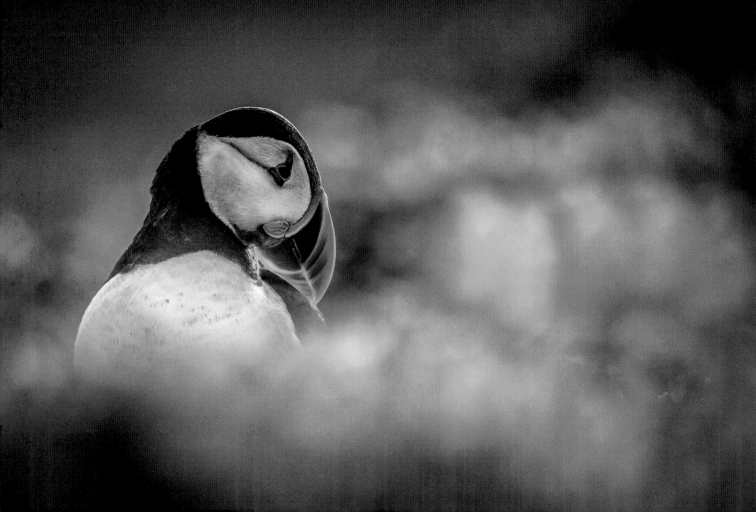

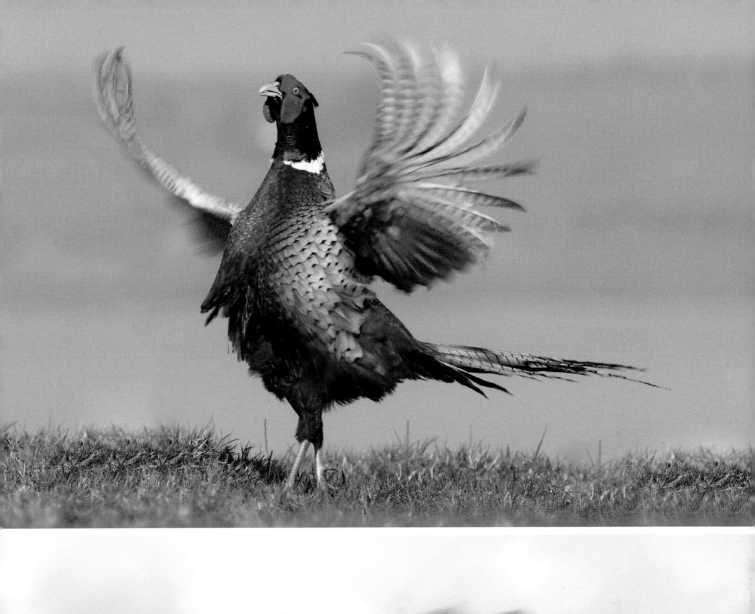

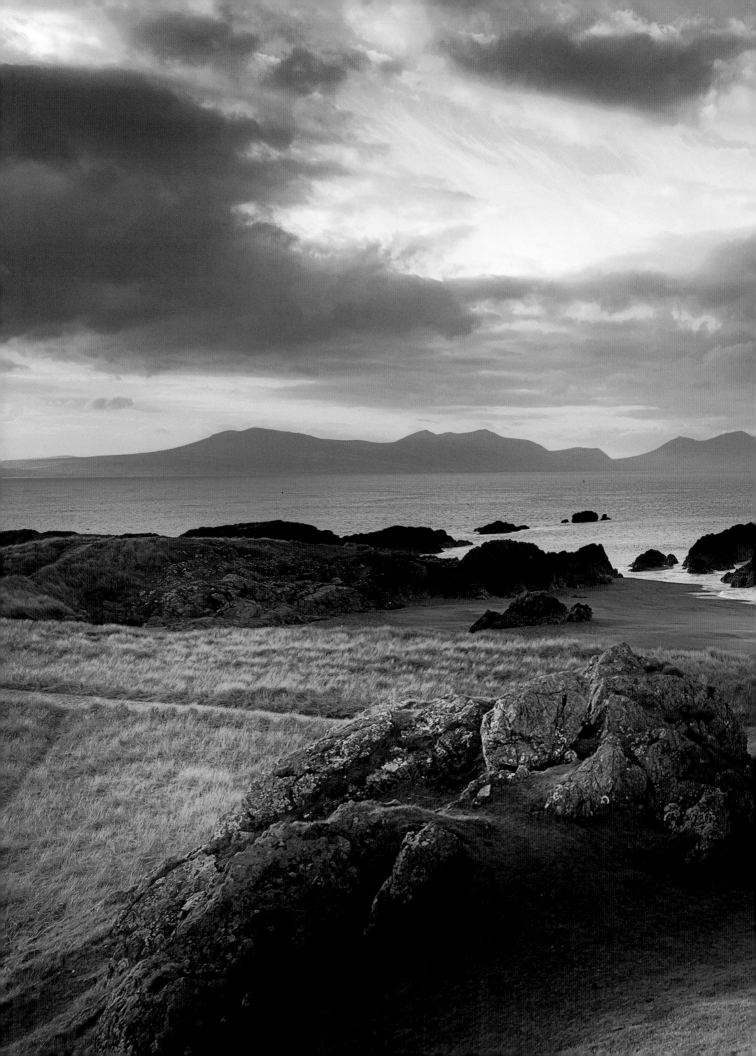

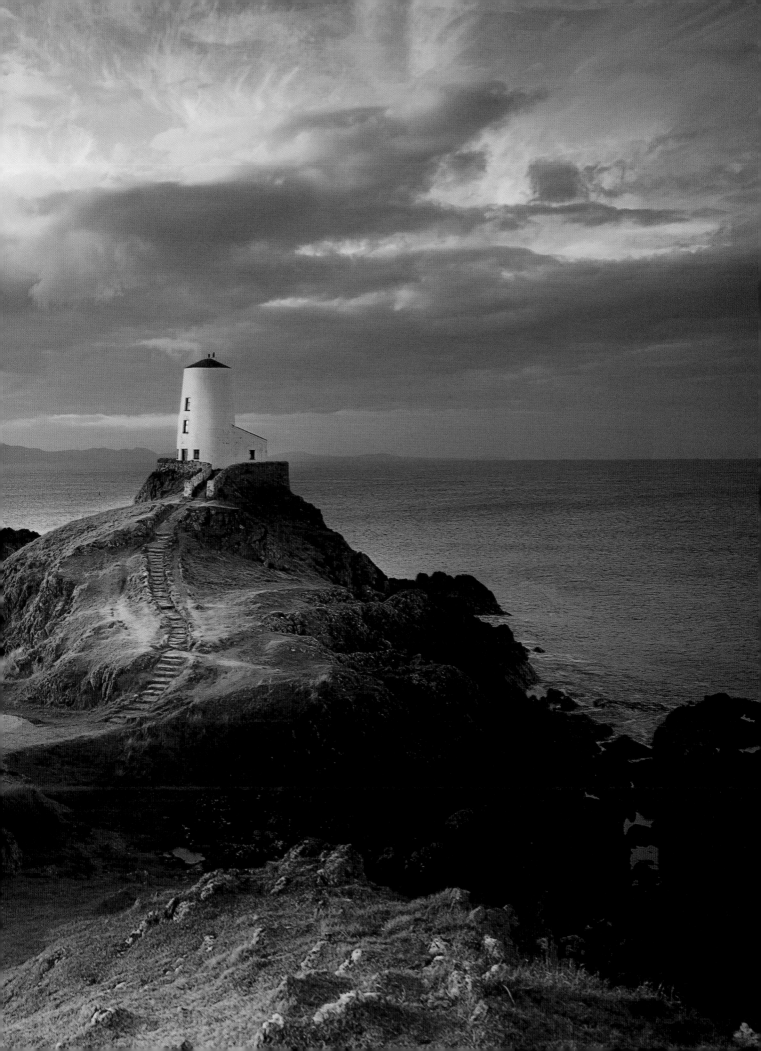

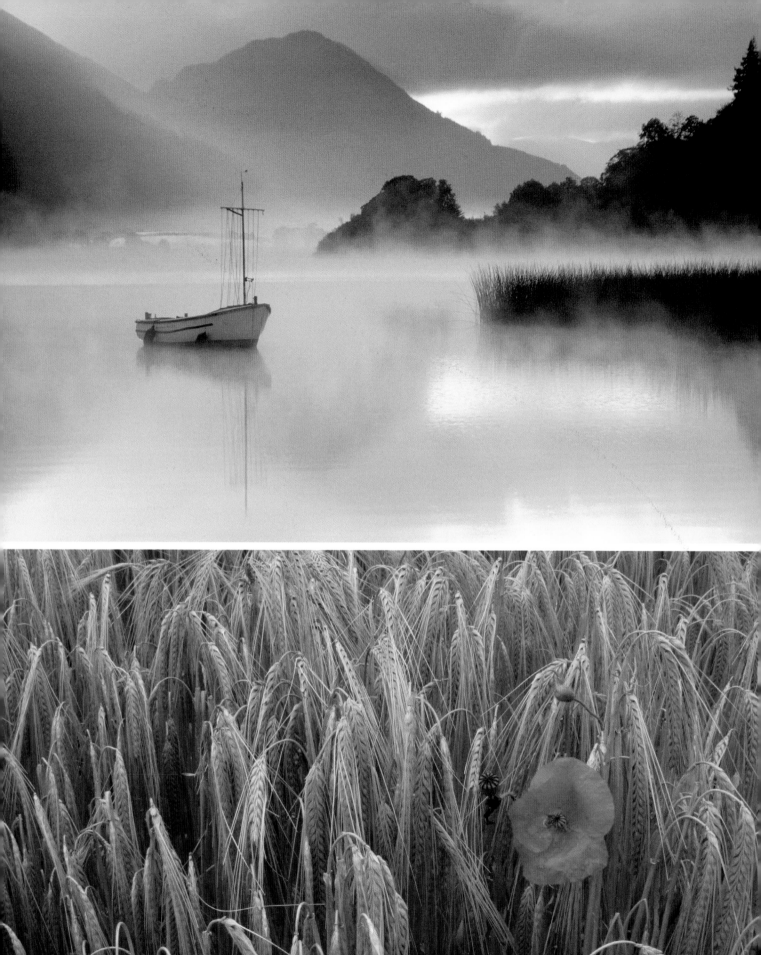

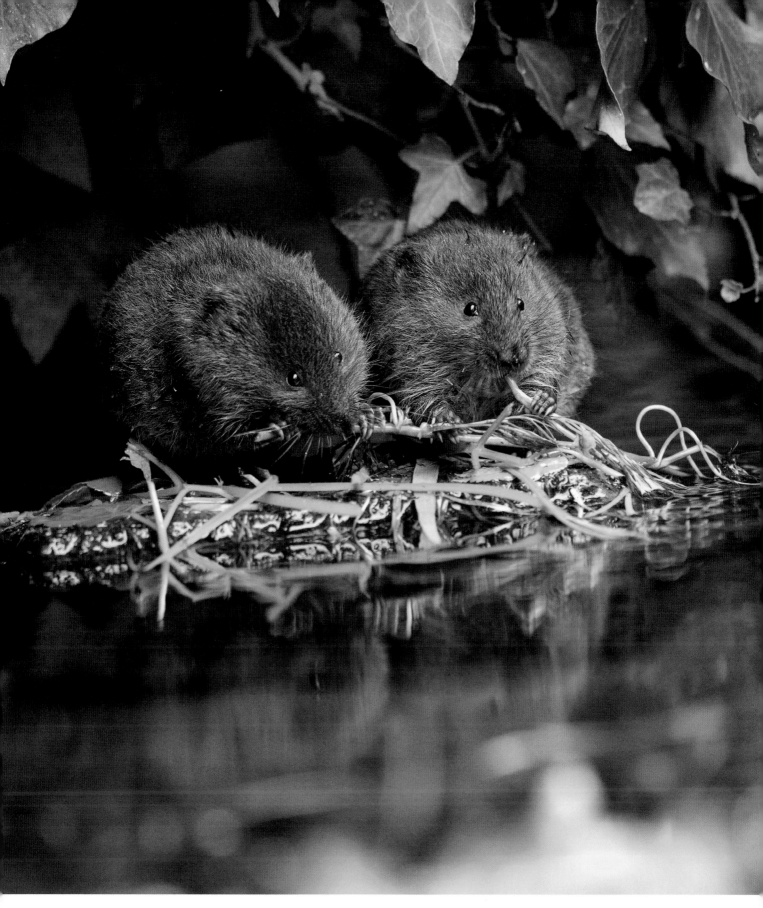

Above: 2016 – Dinner Date. (Jenny Hibbert)

Opposite top: 2004 – Morning Mist. (David Stephenson, Cockermouth, Cumbria)

Opposite bottom: 2005 – Lone Poppy. (Chris Ogden, West Yorkshire)

Following spread: 2010 – Morning Light. (Tony Lovell)

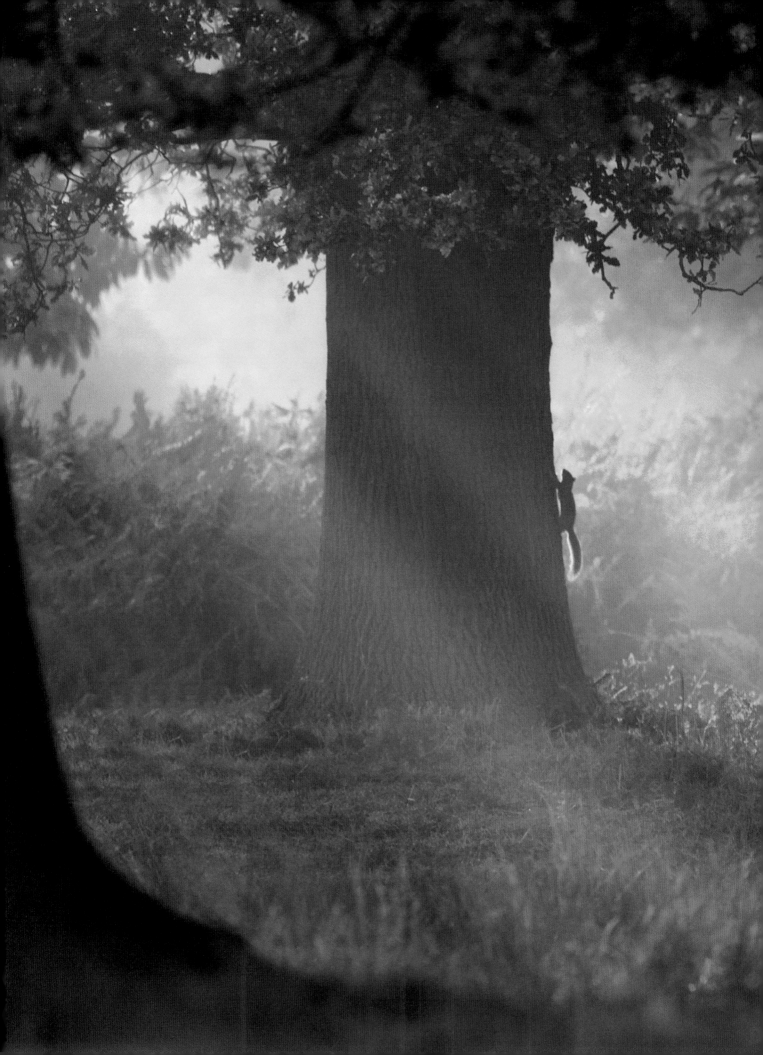

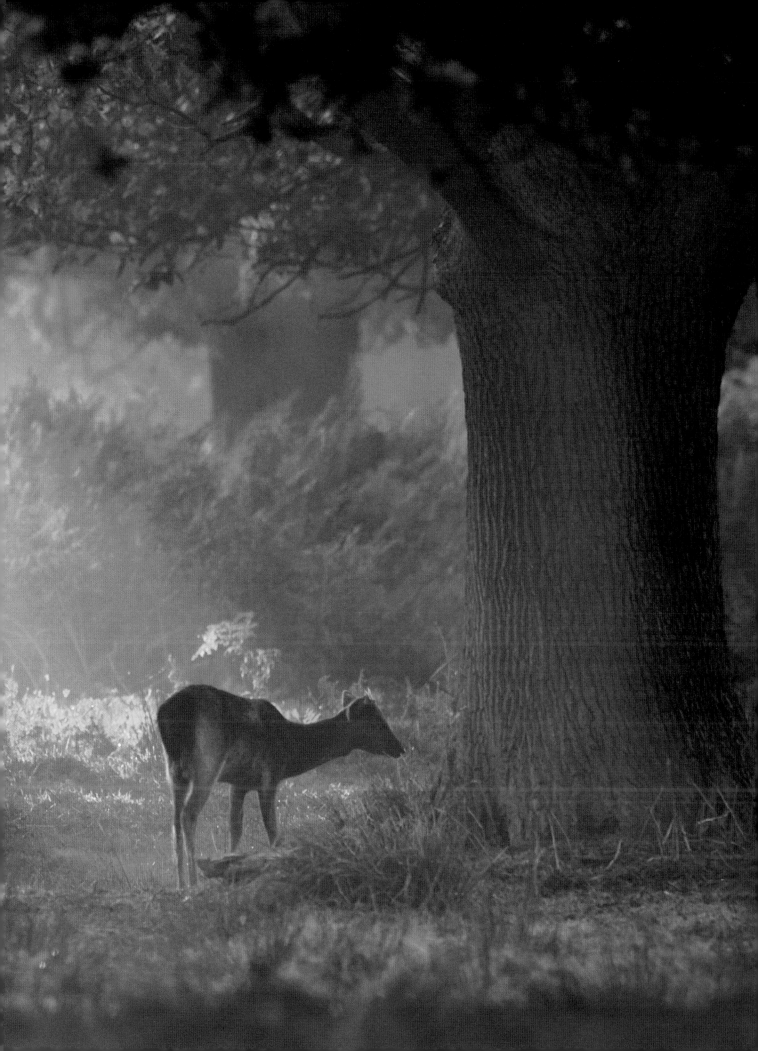

Above: 2012 – Happy Ever After. (Steve Felton)

Opposite: 2003 – Waterfall, Virginia Water. (Peter Davidson, Camberley, Surrey)

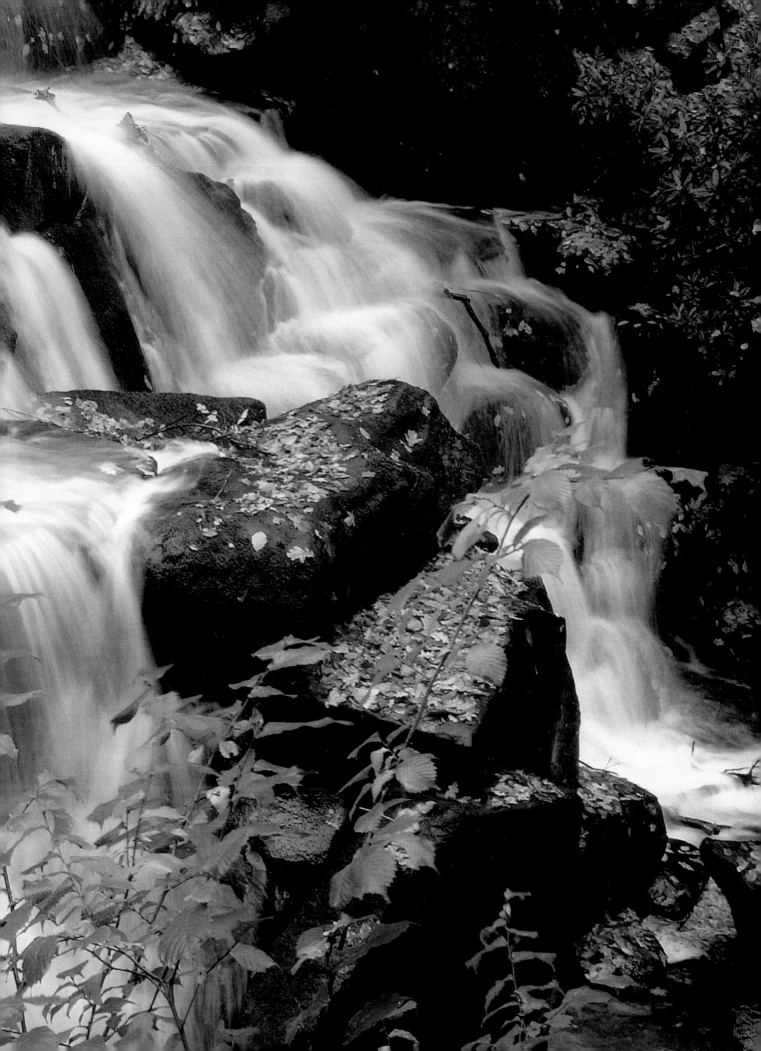

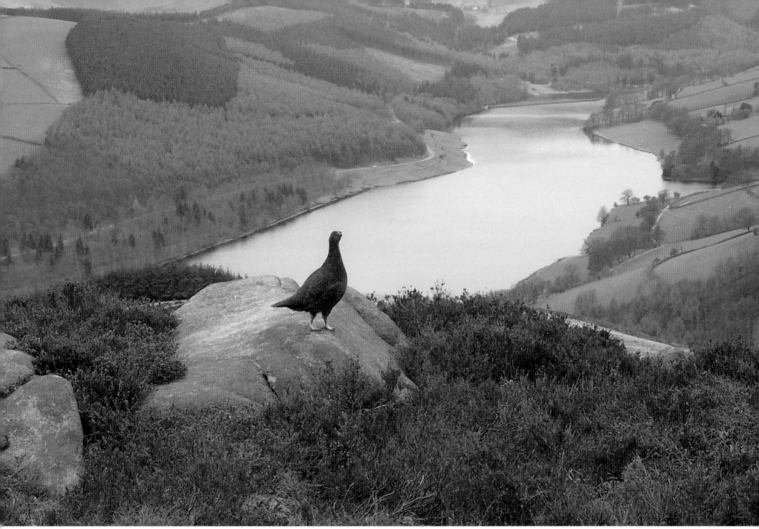

Above: 2006 – Grouse. (Peter Cheslett)

Opposite top: 2014 – Ailsa Craig. (John Lindsay)

Right: 2018 – Dark Horse, Molesey Heath. (Caroline Green)

Following spread: 2015 – Harvest Mouse. (Andrew McCarthy)

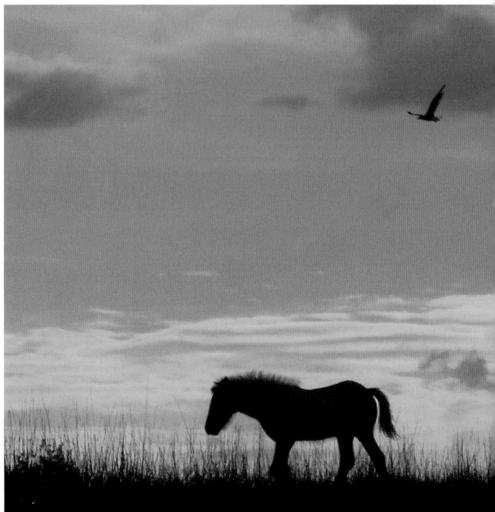

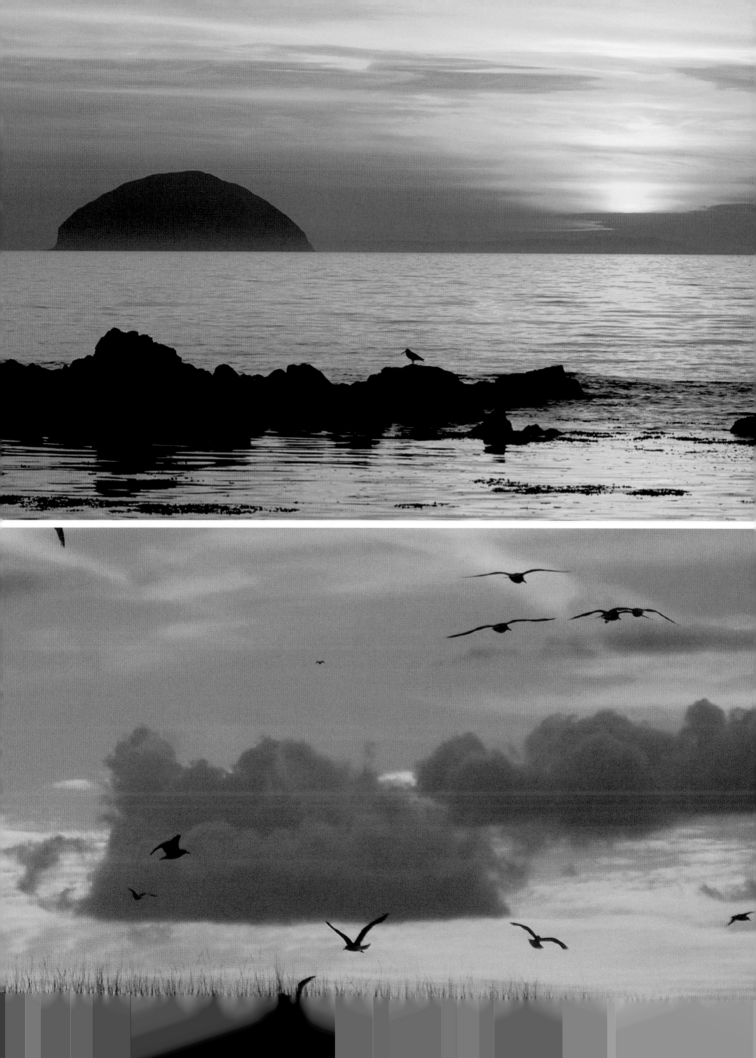

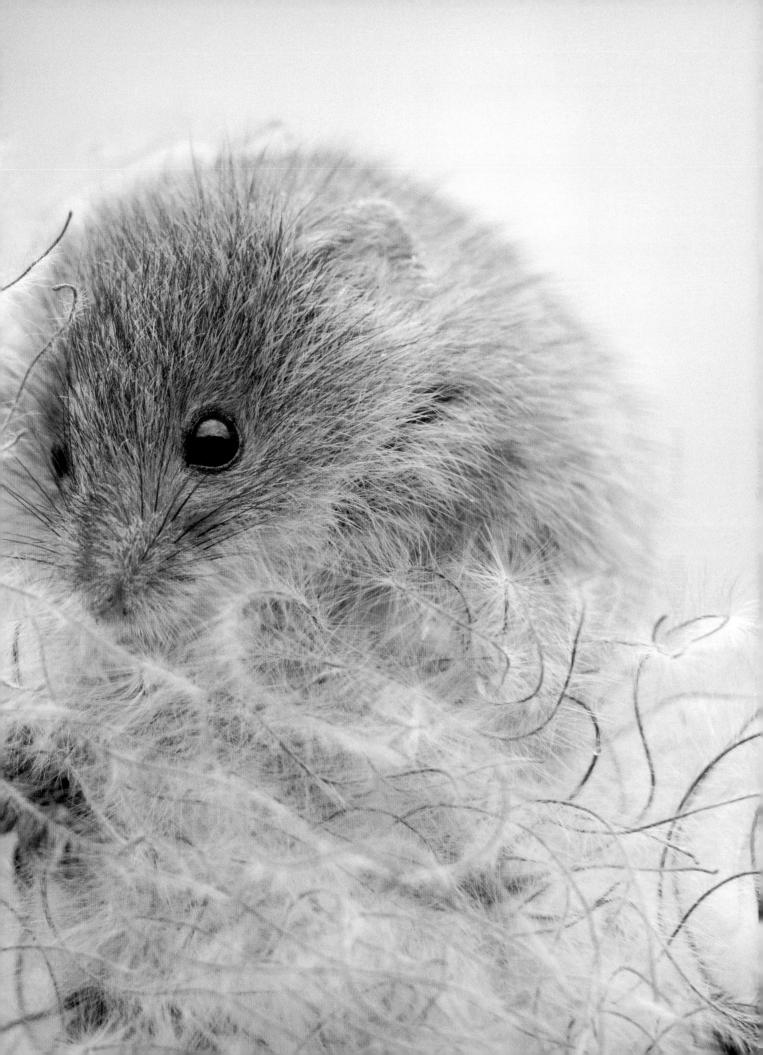

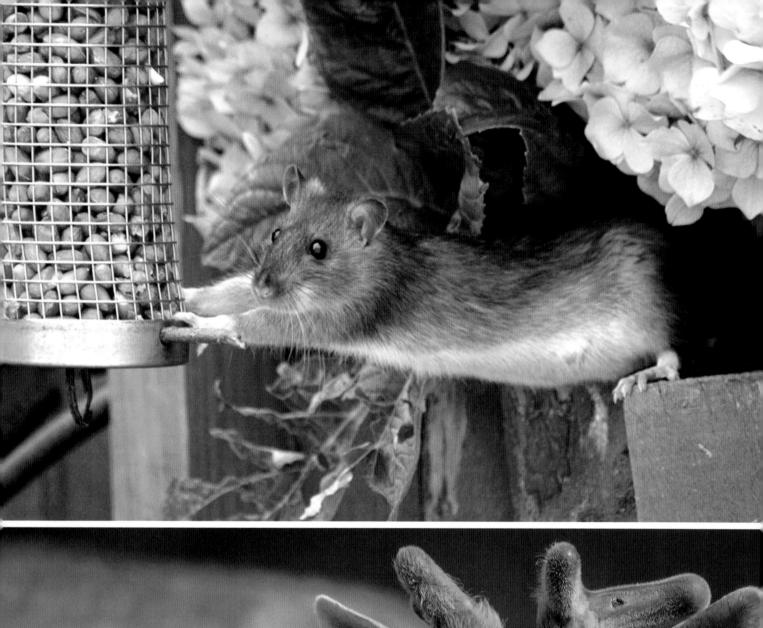
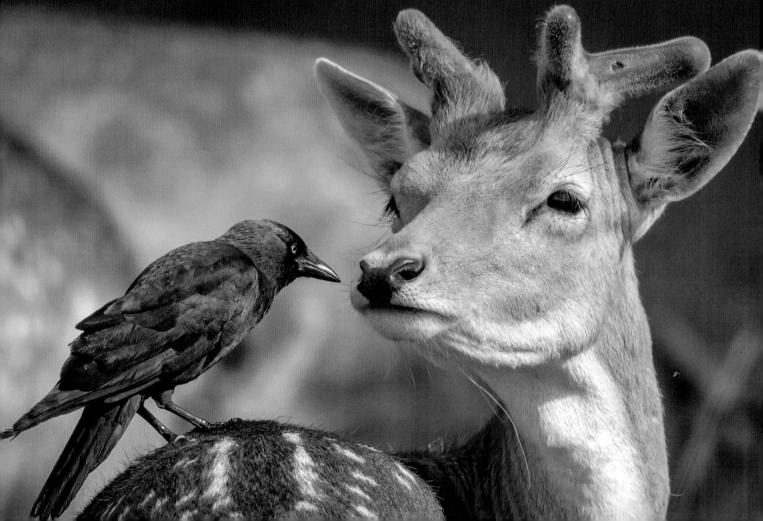

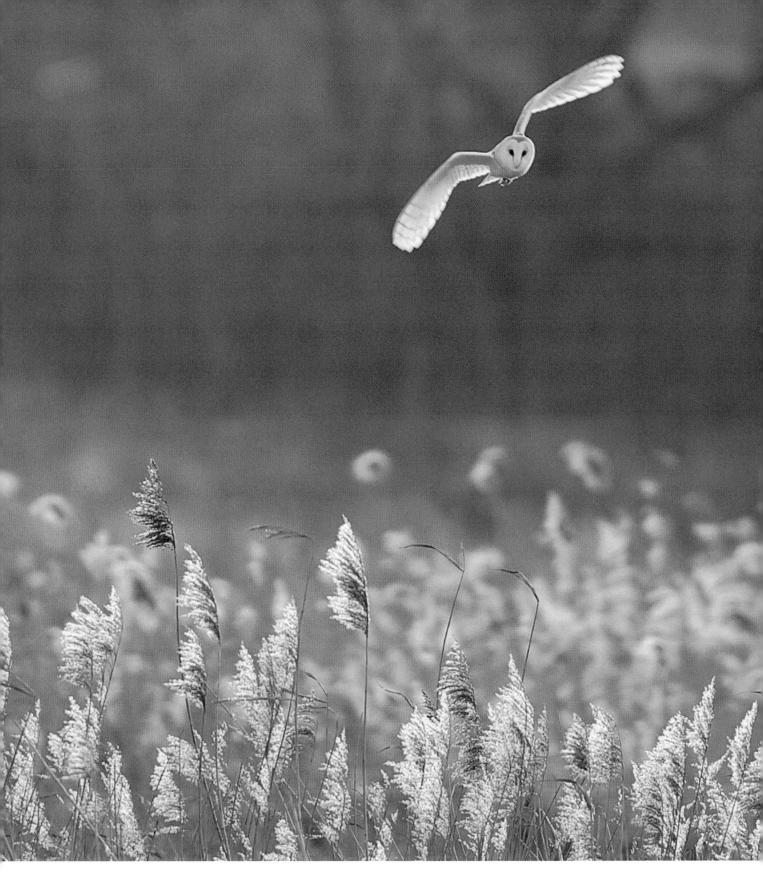

Above: **2013** – Owl on the Prowl. (Mark Bridger)

Opposite top: **2008** – Cheeky Rodent. (Jane Powell)

Opposite bottom: **2020** – Cheek to Beak, Bushy Park, London. (Paul Abrahams)

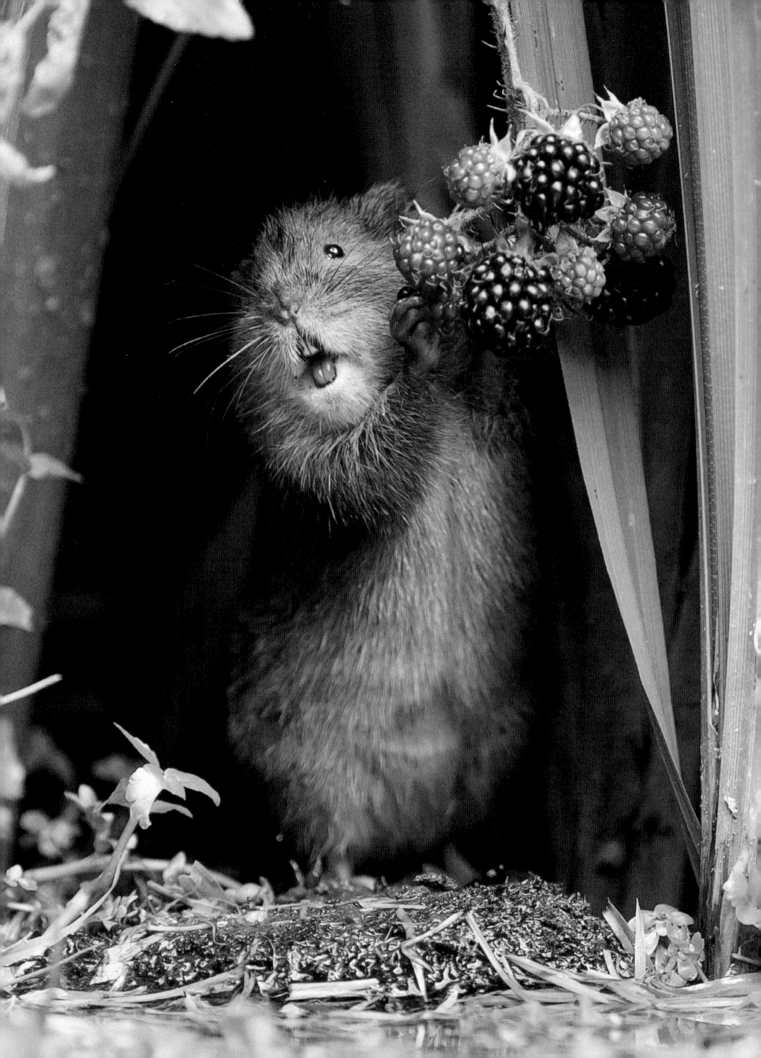

October

John Craven

This is the month when autumn really gets into its stride; when once-green leaves lose their chlorophyll and burst into vivid yellows and oranges, when harvest is brought home and hedgerow berries are ripe for plucking, when days begin to shorten, clocks go forward an hour and the sun's strength is sapped.

It is a time of abundance and transformation – and also one of the favourite months for overall winners of our competition, like Dean Mason. He spent many hours in rather uncomfortable conditions until he captured his photo of a water vole about to enjoy a feast of blackberries, an image which to me sums up the mood of October.

Autumn officially starts on 22 September and ends on 21 December, and this month has a lion's share of its glories. Perhaps the best-known evocation of the season was written by John Keats in 1819, shortly after a stroll along the banks of the River Itchen in Winchester, where the changing landscape inspired his 'Ode to Autumn' with its much-quoted opening line: 'Season of mists and mellow fruitfulness'.

On the 200th anniversary of the poem, I walked in Keats' footsteps along the river pathway and very little seemed to have changed. Winchester College was in the distance, the stubble stood in the fields and the sluice that has always controlled the water meadows was still in place – and still working. Sadly, it was the last English autumn that Keats would see and 'Ode to Autumn' was one of his last great poems. His died from tuberculosis in Rome 18 months later at the age of only 25.

Our October compilation features, I'm pleased to say, some of my favourite places; Bamburgh beach on the wild Northumberland coast, dominated by its fine castle; the Dark Hedges, an avenue of ancient beeches in County Antrim, made famous as the Kingsroad in *Game of Thrones*; and woodlands just waiting for us to wander through as the leaves fall around us.

Hedgehogs start thinking of hibernating, while harvest mice and squirrels stock up for winter. Stags begin rutting, grey seals have their pups and farmers round up their upland flocks and herds and bring them down to safer pastures. Country pubs light up their fires and people of all ages look forward to harvest festivals.

Opposite: **2017** – Berry Brunch, Water Vole, Kent. **Overall Winner**. (Dean Mason)

Following spread: **2004** – Hough Woods. (Philip Franklin, Drybrook, Gloucester)

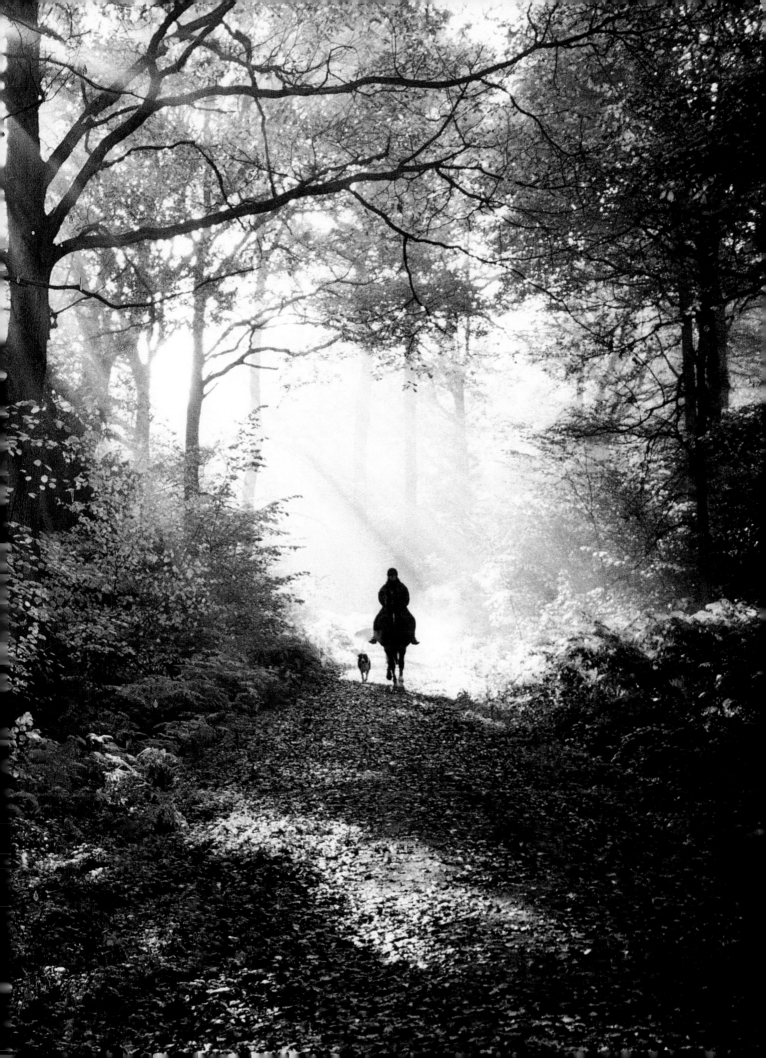

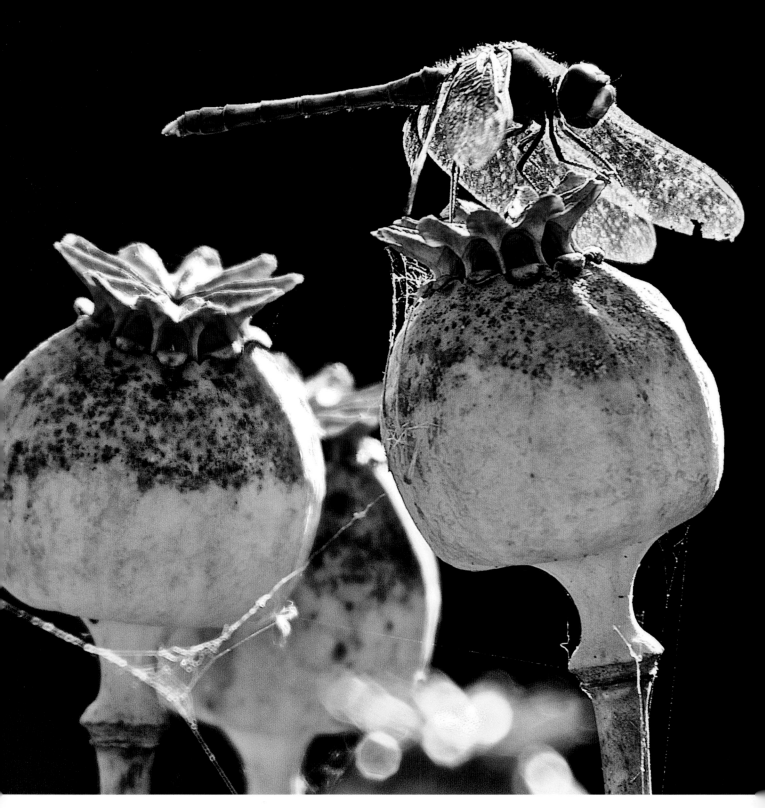

Above: **2011** – Magic Dragon. **Judges' Favourite**. (Matthew Thomas)

Opposite top: **2003** – Hill Farming, Upper Derwent Valley. (Eric Willoughby, Peak National Park)

Opposite bottom: **2005** – Fairy Glen. (Stuart Stevenson, County Armagh)

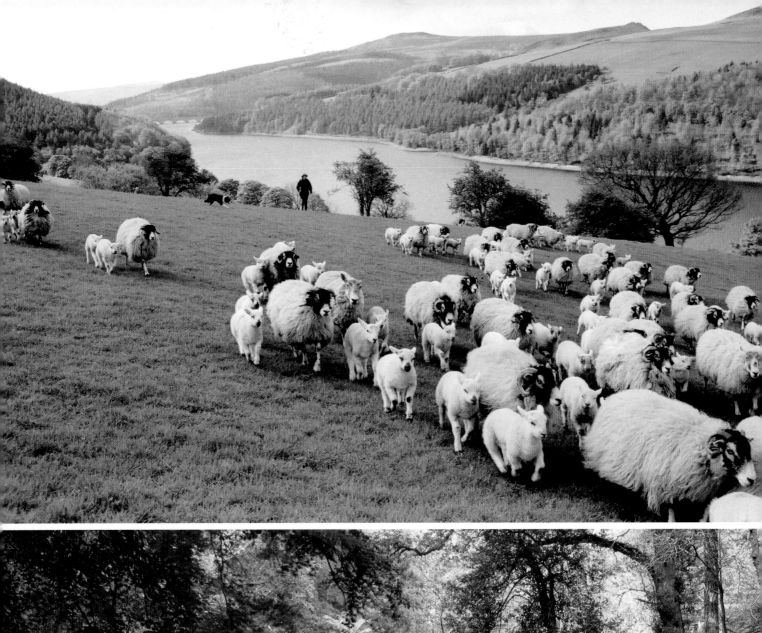

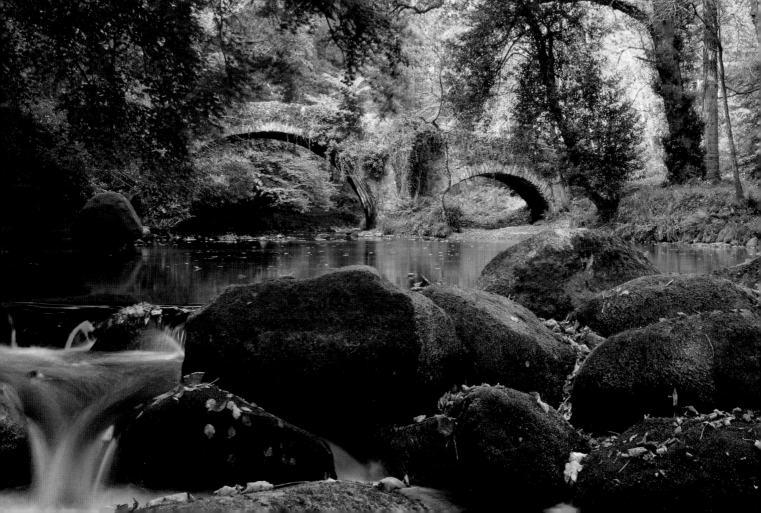

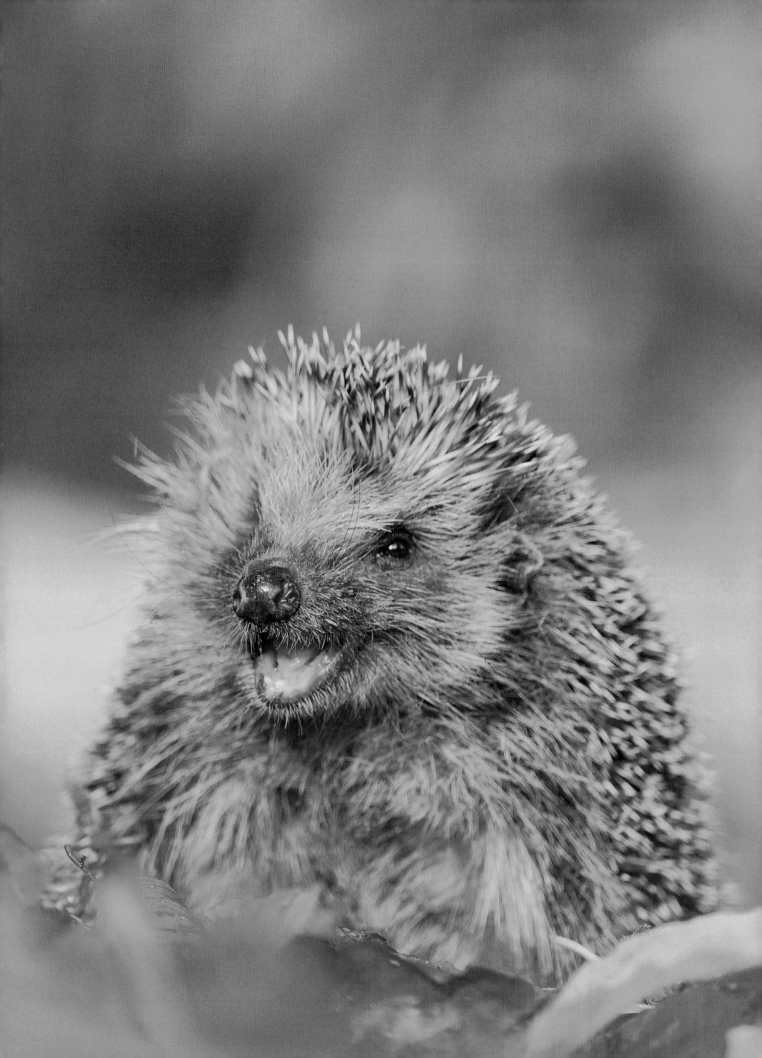

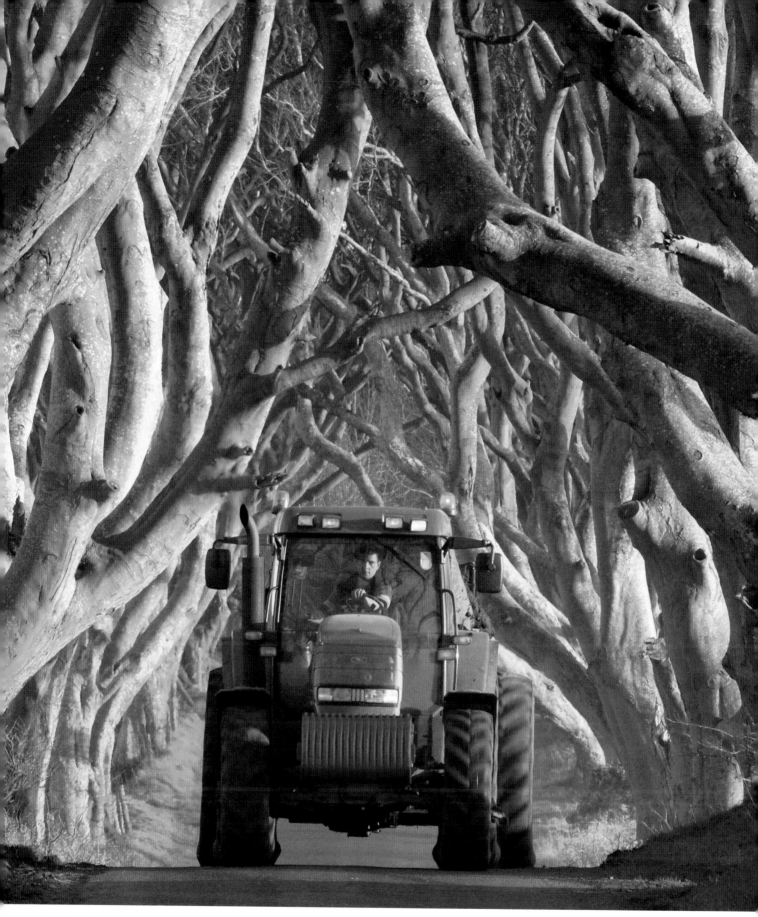

Above: **2012** – Guard of Honour. (Bob McCallion)

Opposite: **2016** – Happy Hedgehog. (Ben Andrew)

Following spread: **2006** – Seven Sisters Cliffs. (Henrietta Byrne)

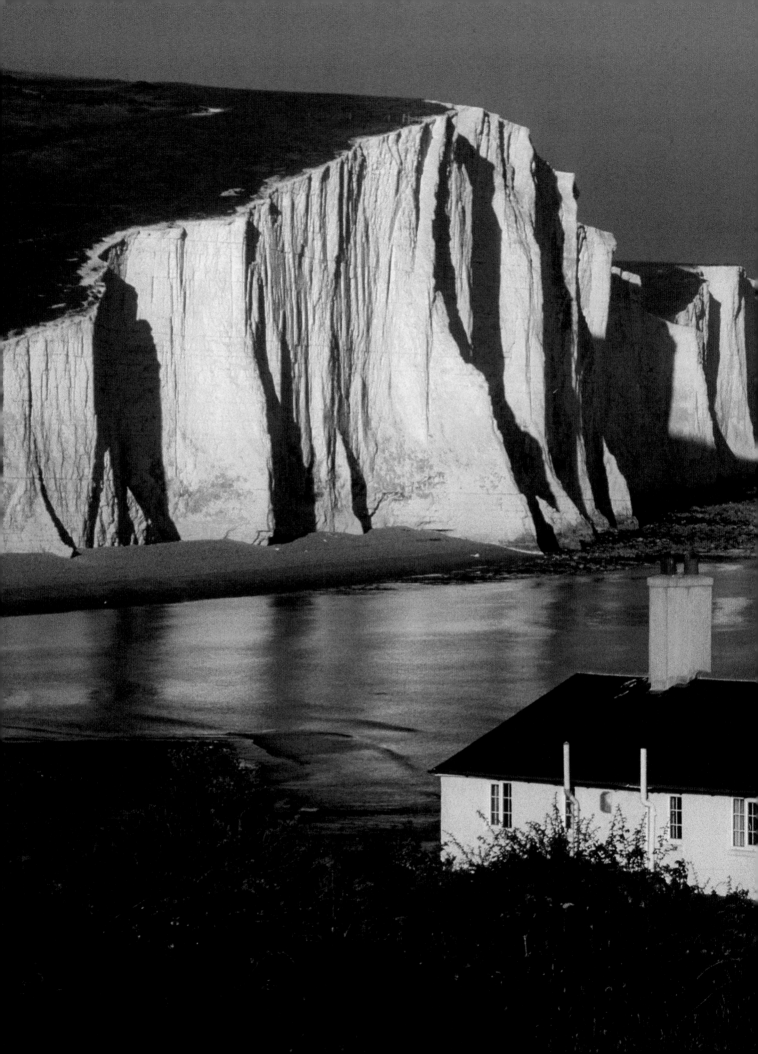

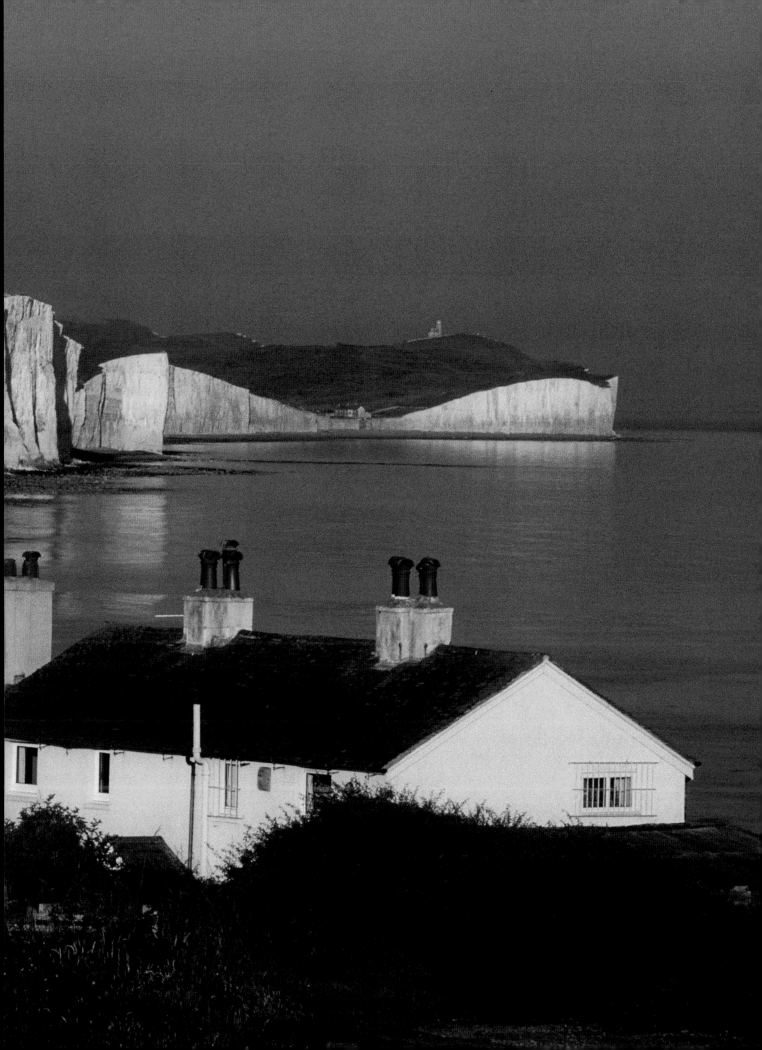

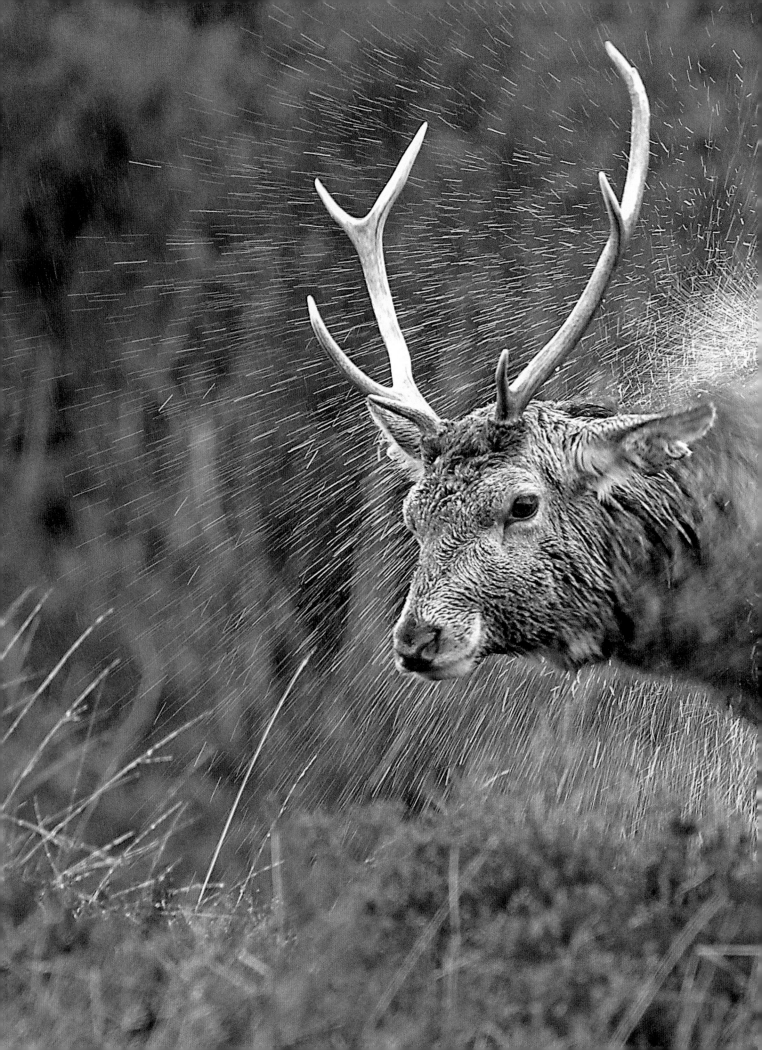

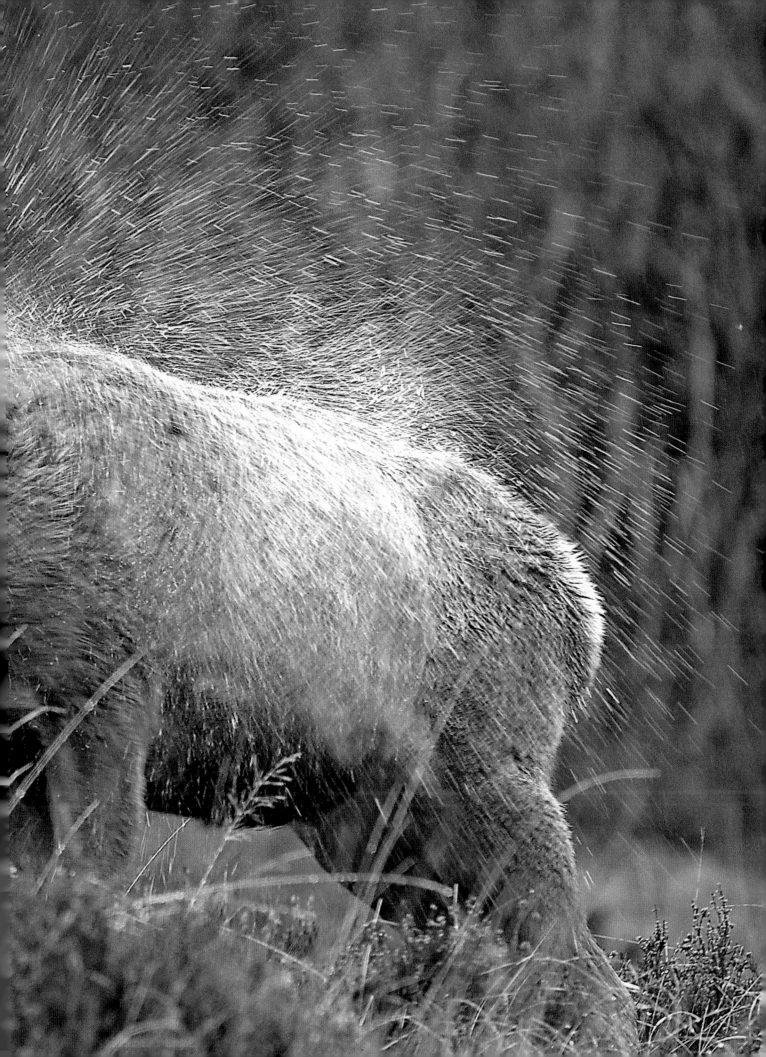

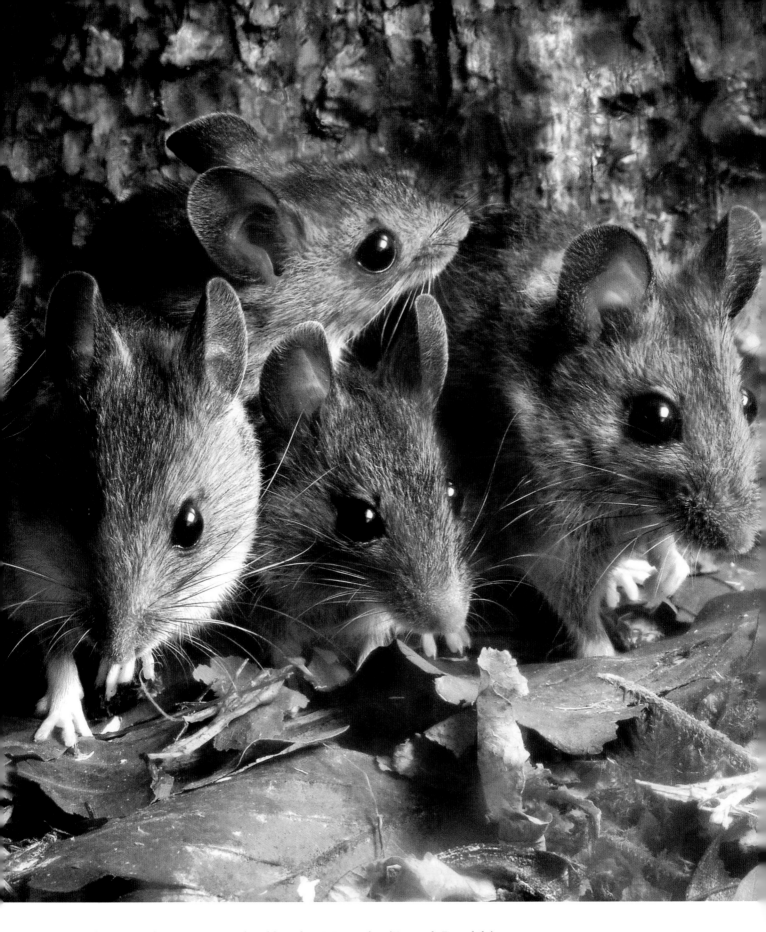

Previous spread: **2006** – Wet and Wild. **Judges' Favourite**. (Kenneth Drysdale)

Above: **2010** – Say Cheese! (Geoffrey Hill)

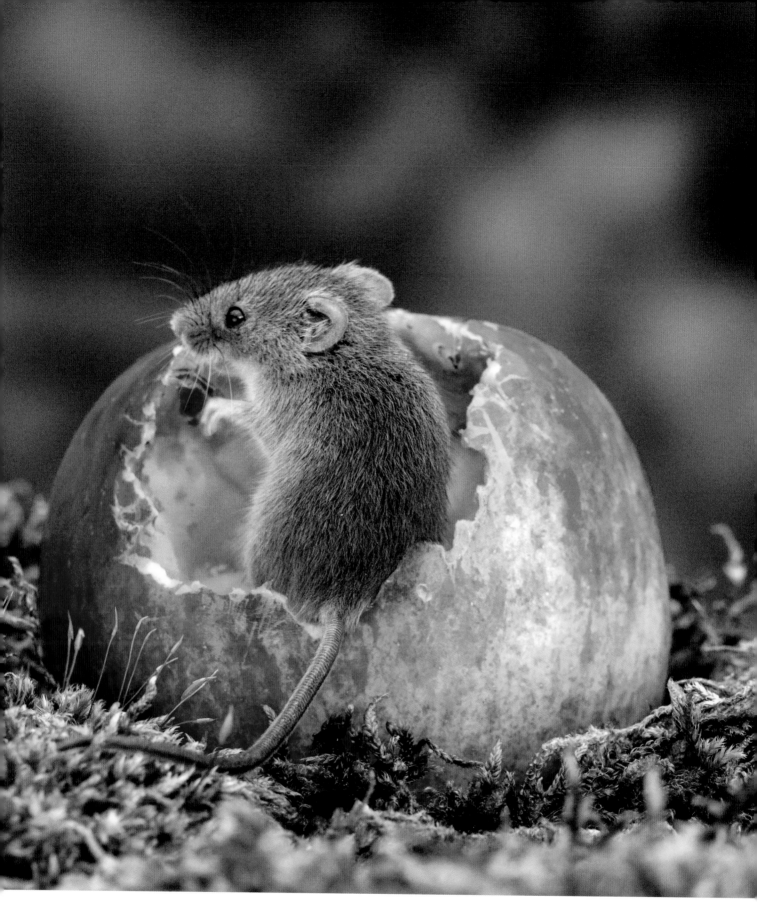

Above: **2020** – An Apple a Day, Scarborough, North Yorkshire. **Overall Winner**. (Michelle Howell)

Right: **2014** – Dinner for One. (Pui Hang Miles)

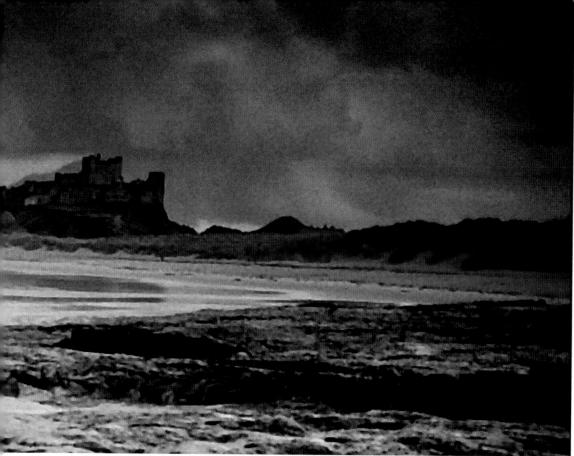

Left: **2007** –
Bamburgh Castle.
(Piers Fenwick)

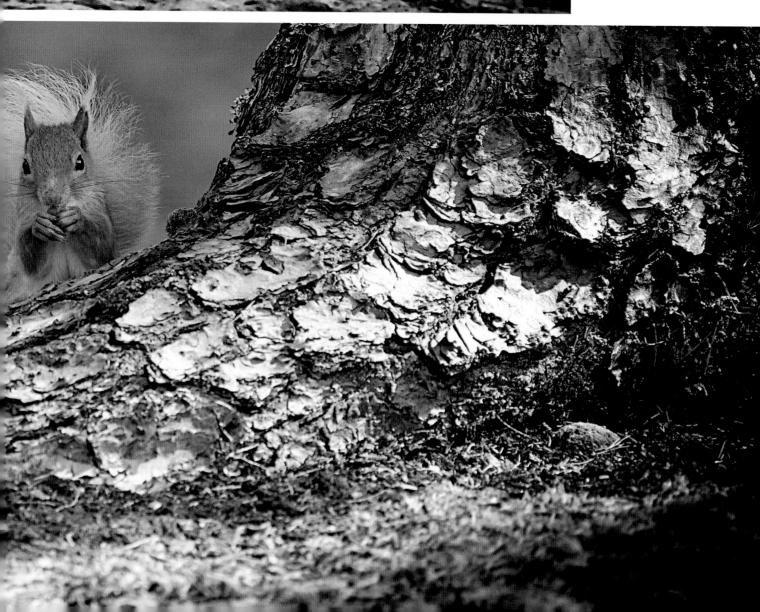

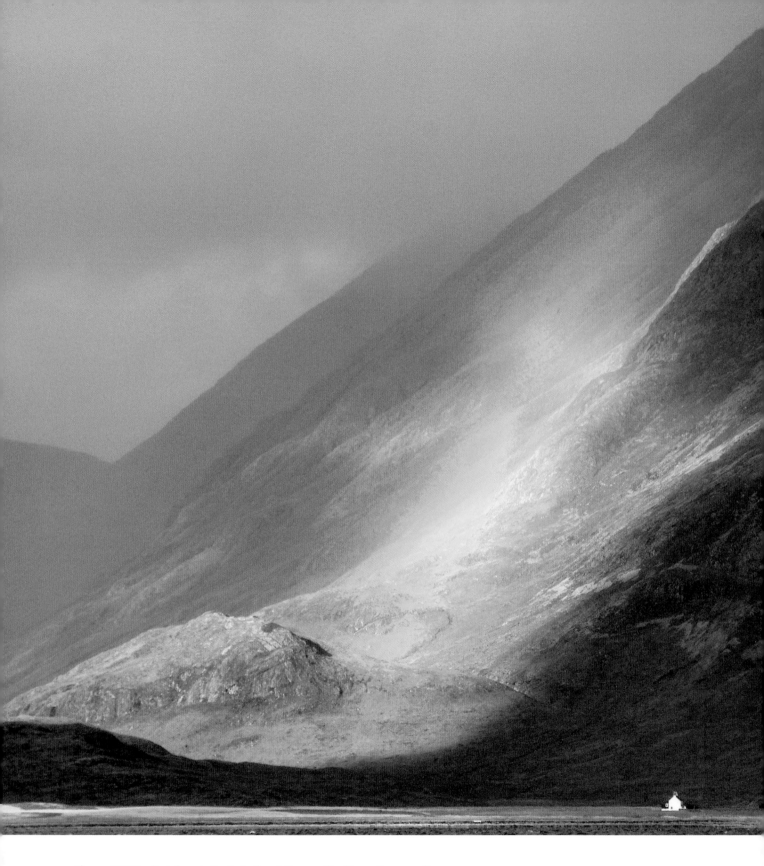

Above: **2013** – Rainbow's End. **Judges' Favourite**. (Jean Burwood)

Opposite top: **2009** – Pony Gathering. (Derrick Williams)

Opposite bottom: **2015** – Piglets on Parade. **Overall Winner**. (David Smith)

Following spread: **2018** – Highland Majesty, Loch Lomond. (Michael Cheetham)

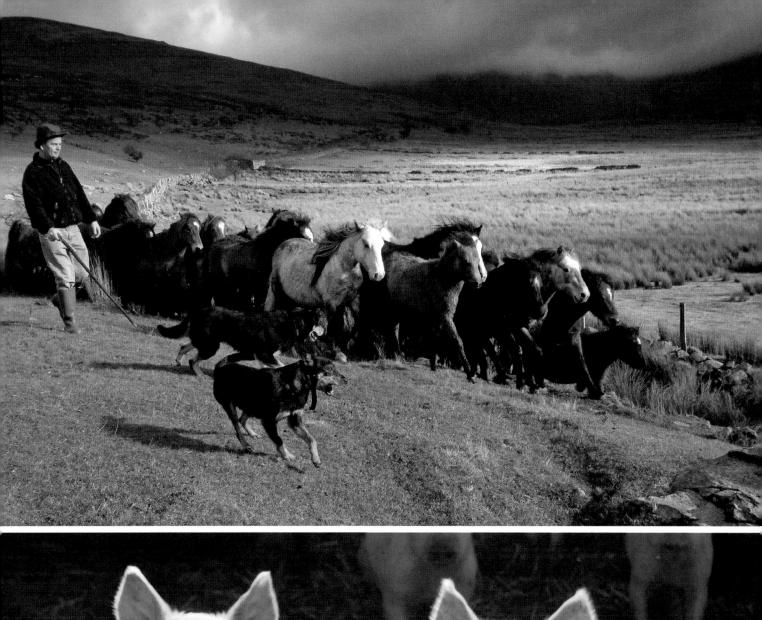

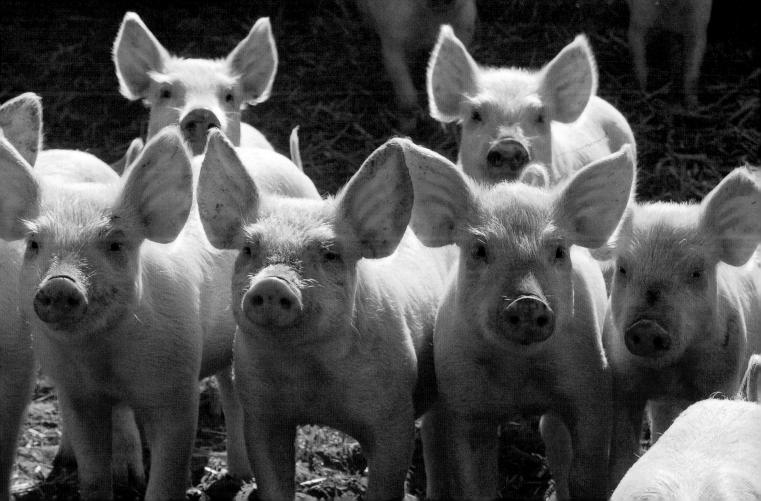

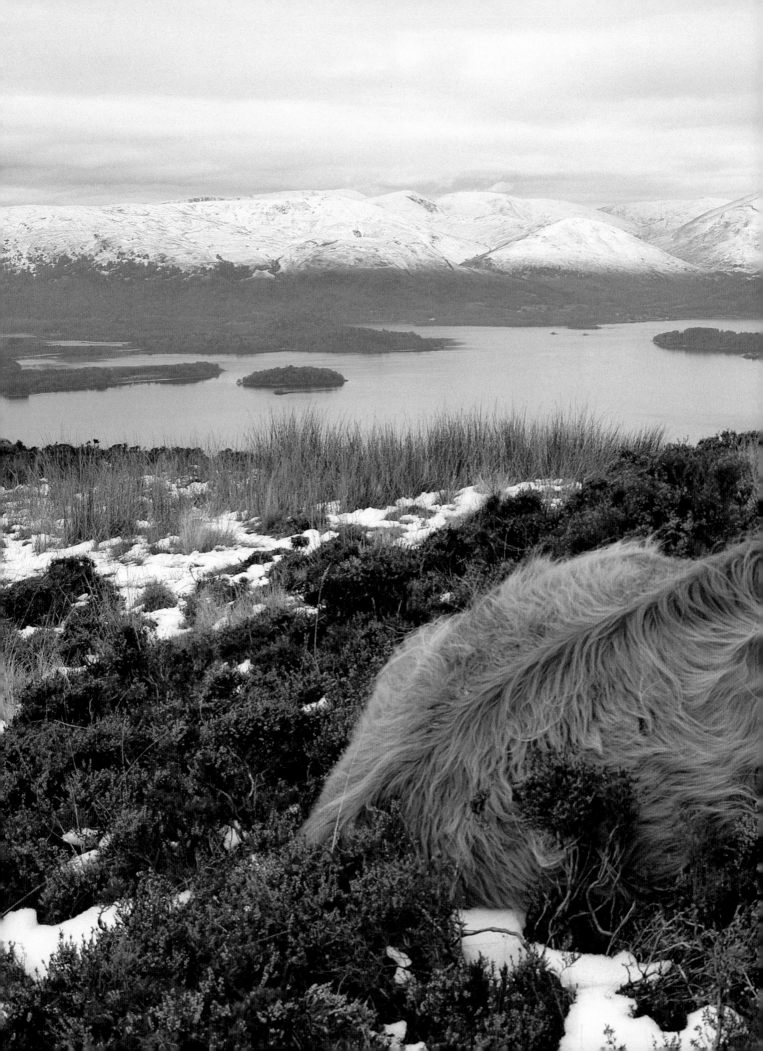

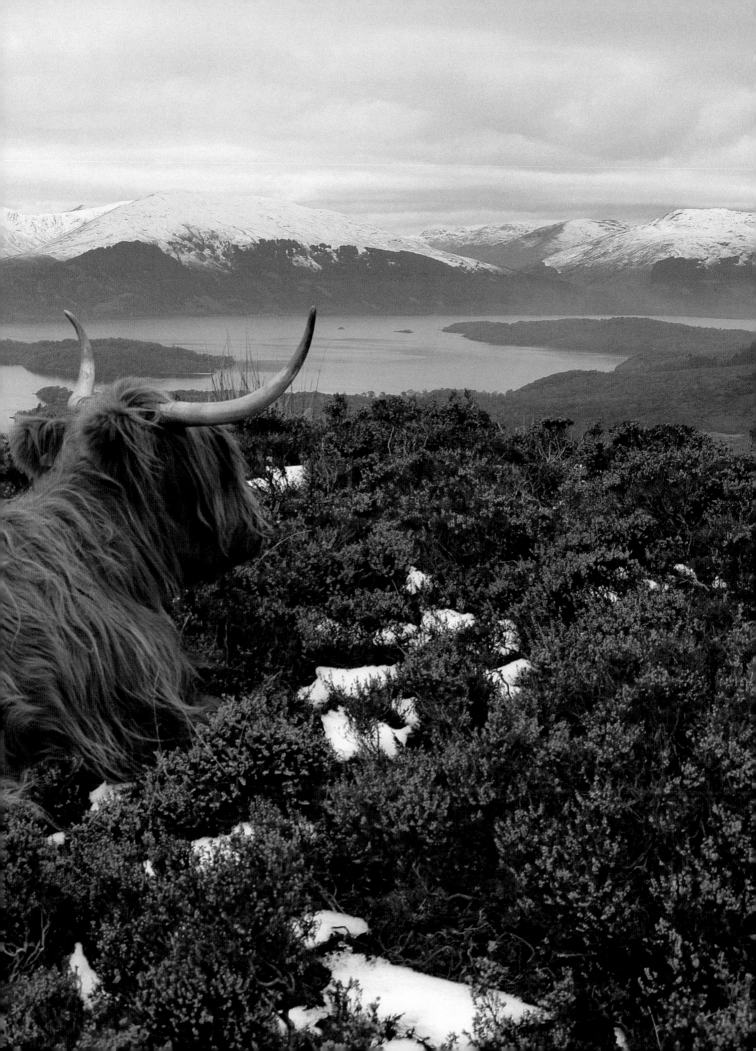

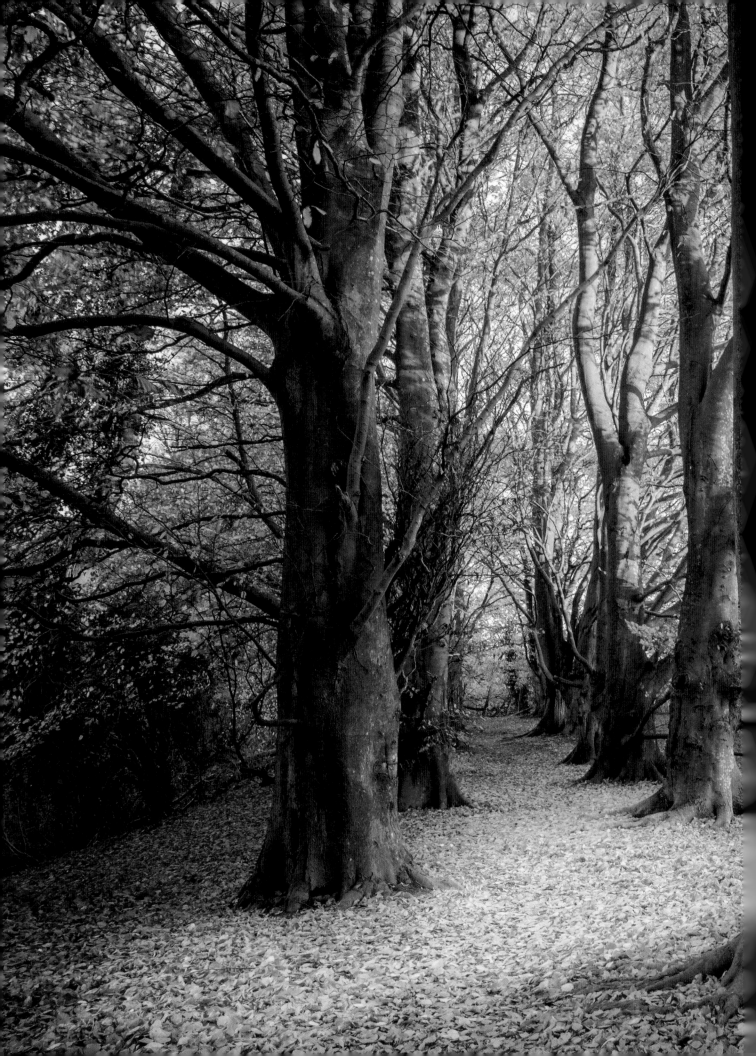

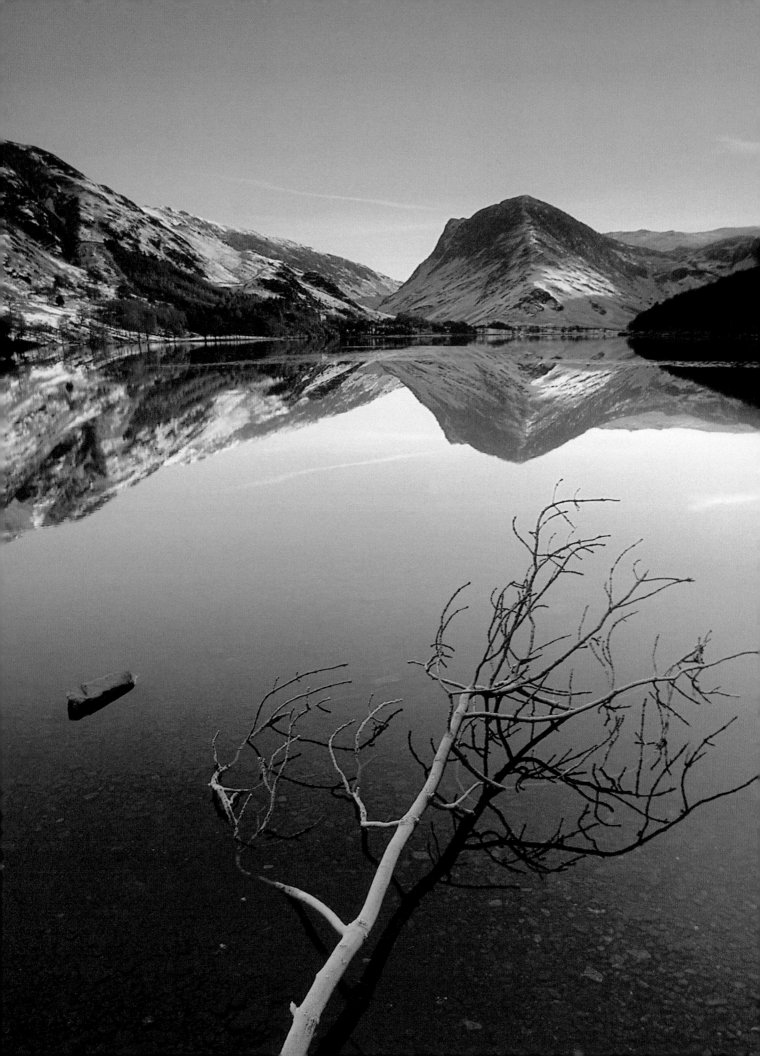

November

Matt Baker

This time of year signals the beginning of many a themed party! Halloween, Bonfire Night, Christmas and New Year. As a family we also have a fair few winter birthdays so the last couple of months of the year are full of get-togethers – just as well, with the days short, cold and gloomy. Shooting *Countryfile* is difficult at this time of year as there's not a lot of light in the day to film and the weather often isn't on our side. It becomes really important to pack the right clothing too, warm layers, waterproofs and the warmest socks you can lay your hands on.

November is a month of exploring during daytime but hunkering down at night, for both us and our wildlife. One of the most spectacular sights at dusk this time of year are the starling murmurations. Starlings generally form their autumn roosts by November, with more and more birds joining, creating flocks of up to 100,000 birds. An undulating mass of birds acrobatically rise and swoop through the air, before settling down for the night. Other animals begin to hibernate, hoping they've managed to build up enough reserves to last through the winter, as temperatures drop and food becomes scarce. Not all animals are winding down, though: grey seals give birth at this time of year, so the mothers are busy feeding their pups with milk that will triple the pup's birth weight before they leave them to fend for themselves a few weeks later.

November has always been a very important month for me as it's when I've done the Rickshaw Challenge for Children in Need. Cycling hundreds of miles with amazing youngsters is a real highlight of my year – despite the awful weather that gets thrown at us. There's a feel in the air now that seems to say 'long bike rides' as I spend most of November getting my bottom ready for the cycling challenge ahead!

The November photos show us winter setting in: the stormy sea crashing against the harbour wall; black grouse facing off against each other on snow-dusted ground. Although the countryside appears to be winding down for the winter, on the farm there's a glimpse of what's to come. We put the tup in with the sheep on Bonfire Night so we get lambs around 1 April. It's a reminder that winter doesn't last and that new life is just around the corner even on the darkest of days.

Previous spread: **2019** – Autumn Flame, Winchester, Hampshire. (Simon Garratt)

Opposite: **2003** – Buttermere: The Lake District. (Judith Clark, Long Eaton, Nottinghamshire)

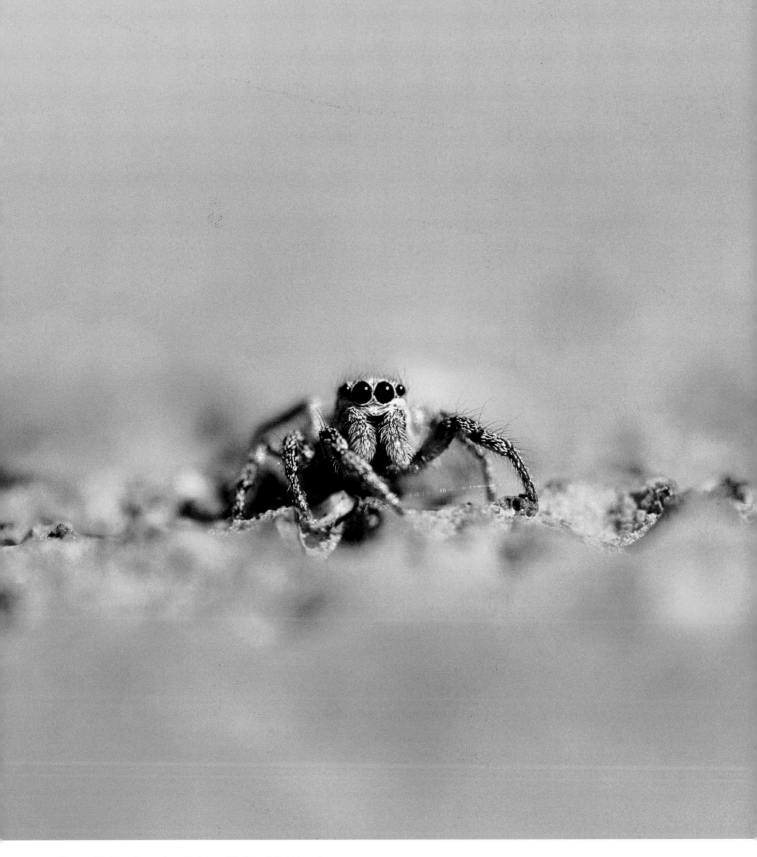

Above: **2008** – Jumping Spider. (Richard Pattison)

Opposite top: **2005** – Fungus. (David Stephenson, Cumbria)

Opposite bottom: **2015** – Sand Surfers. (Andrew Gordon)

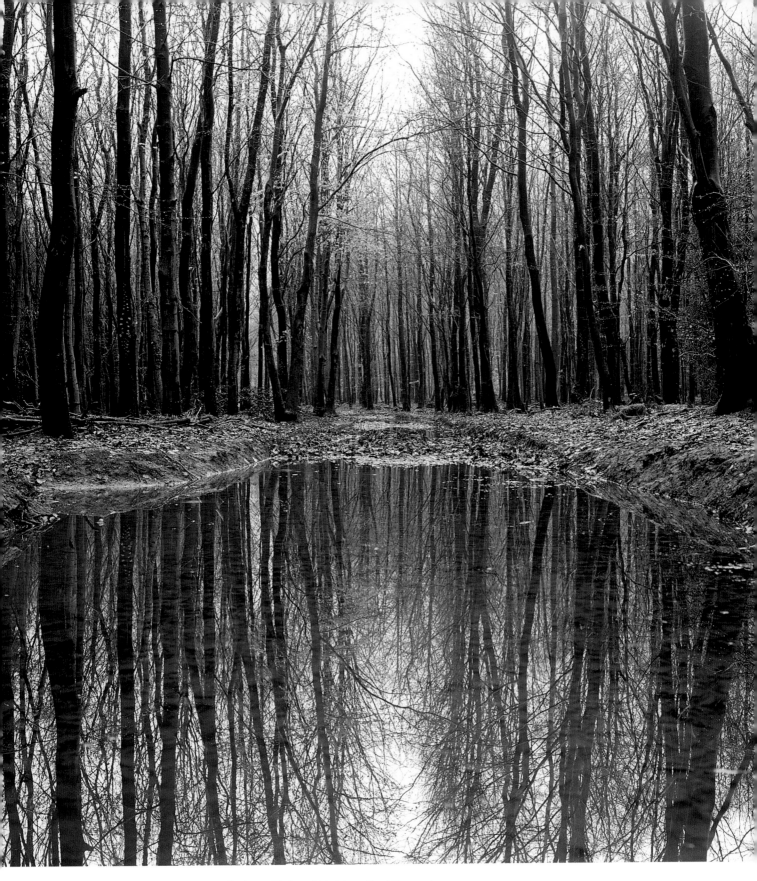

Above: **2004** – Burton Down. (Adrian Talbot, Brighton, East Sussex)

Opposite top: **2018** – Caught Napping, Donna Nook. (Geoffrey Baker)

Opposite bottom: **2010** – Waxwing in Winter. (David Hermon)

Following spread: **2013** – Storm Force. (Ian Thompson)

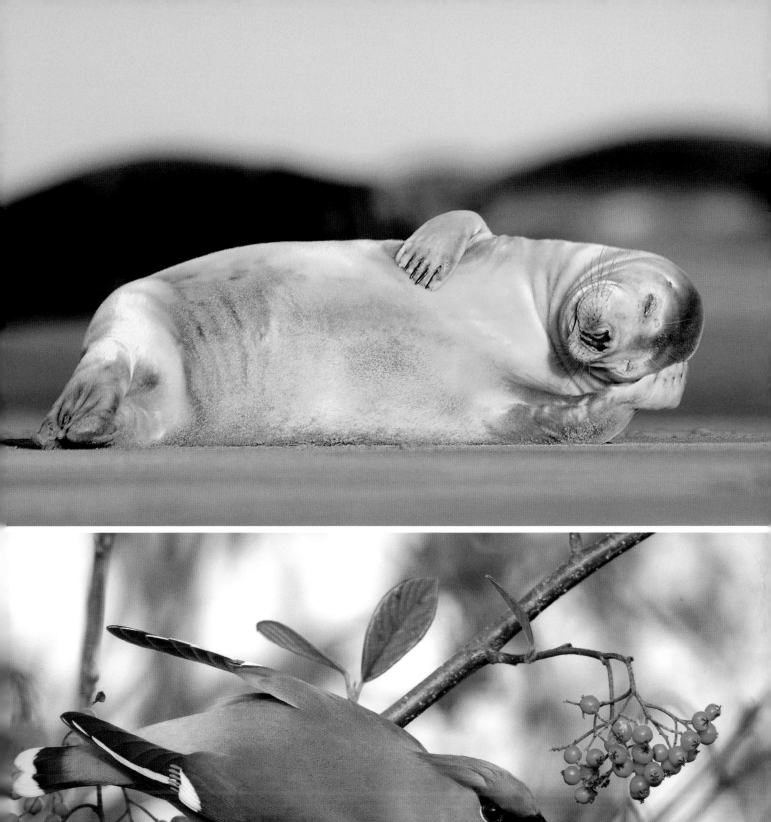
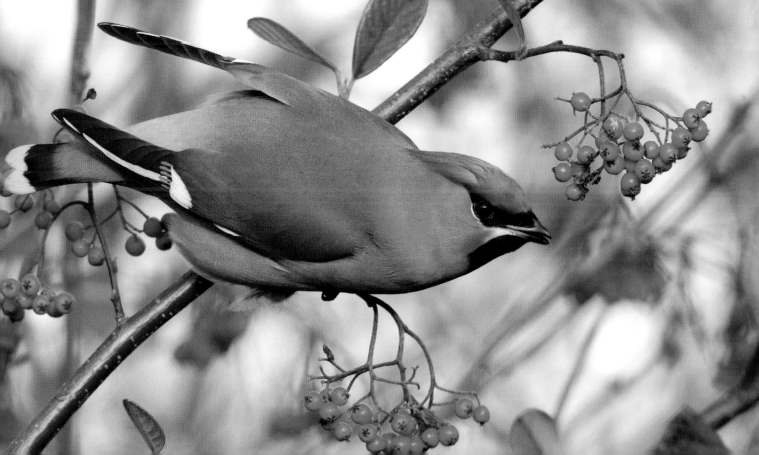

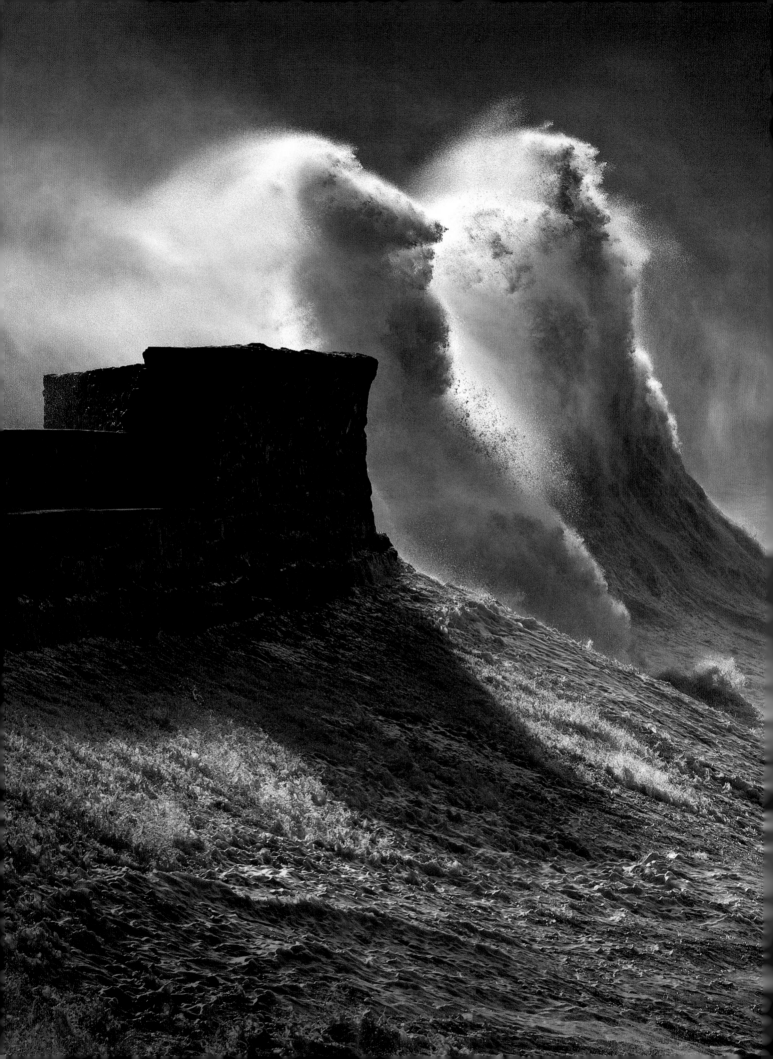

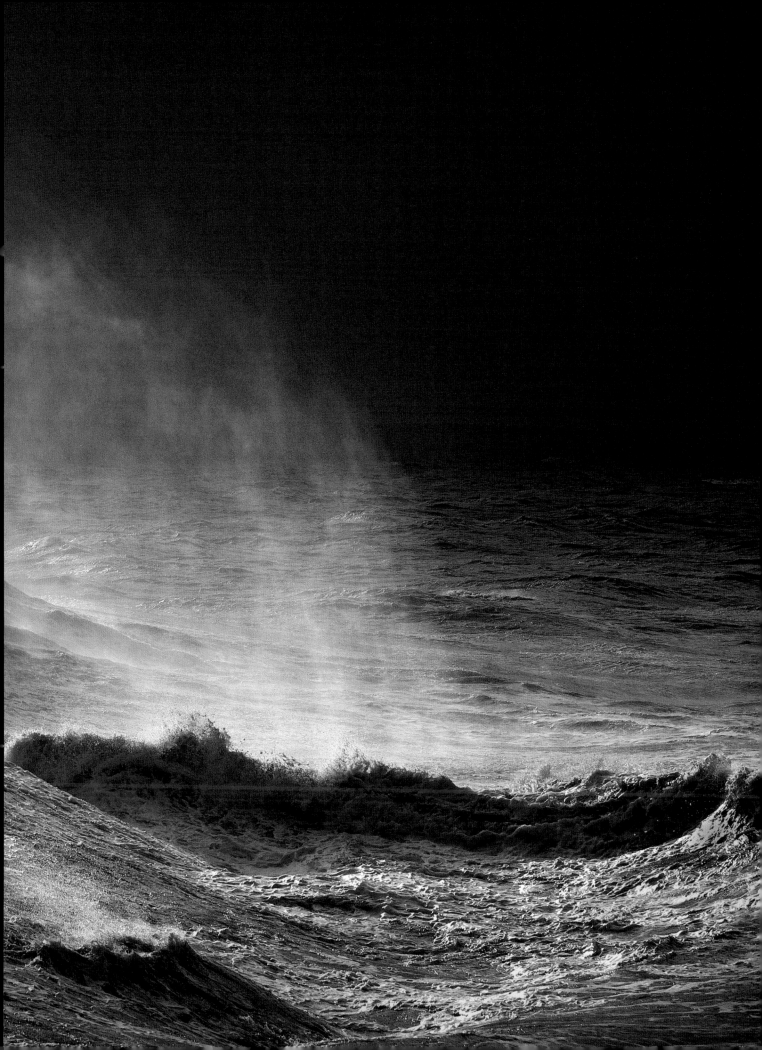

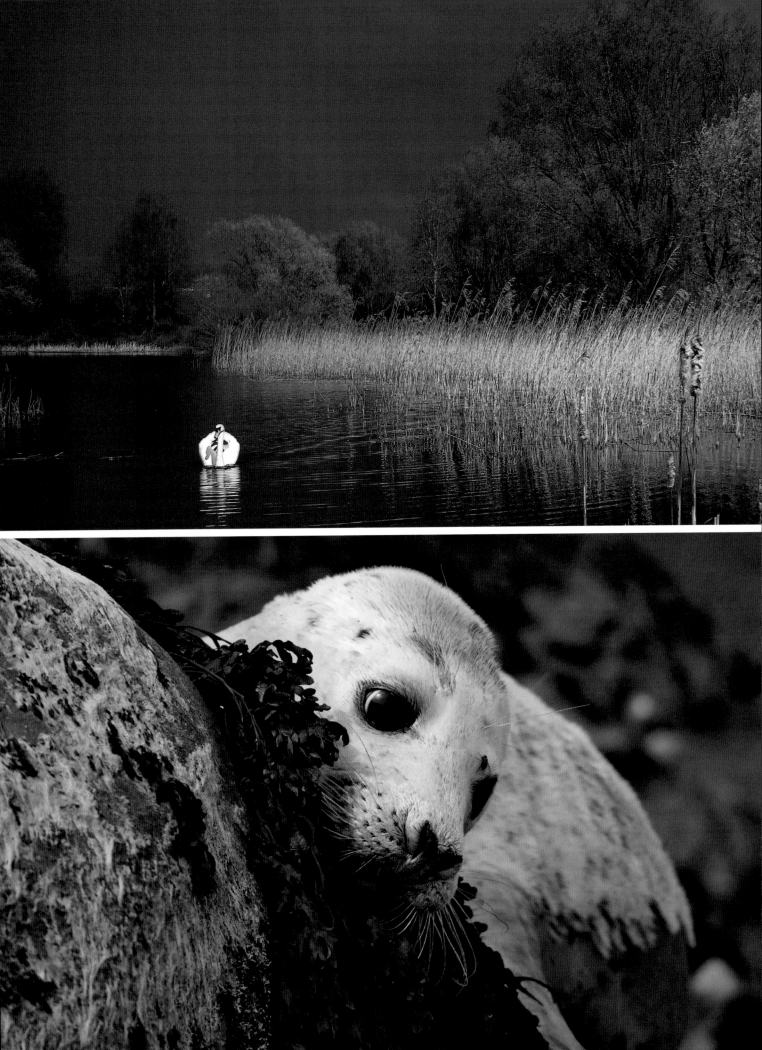

Left: **2014** –Swan Lake. (James Clapham)

Opposite bottom: **2020** – Solitary Seal, Ravenscar, North Yorkshire. (Mark R. Duffield)

Below: **2009** – Heading Home. (Anthony Elgey)

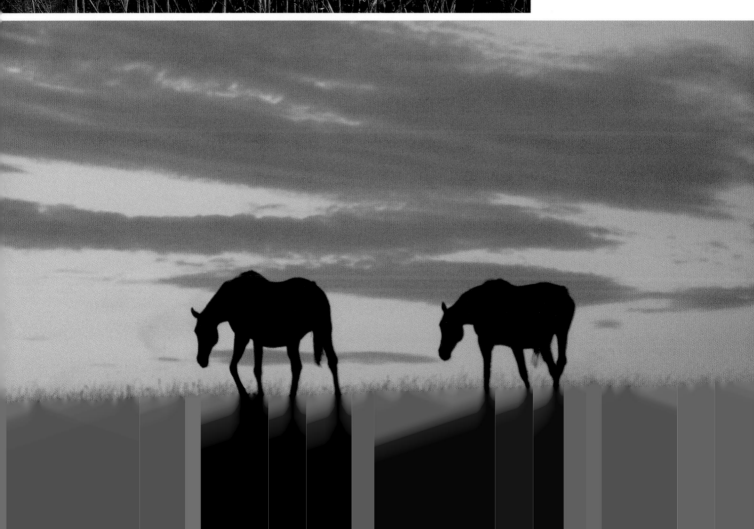

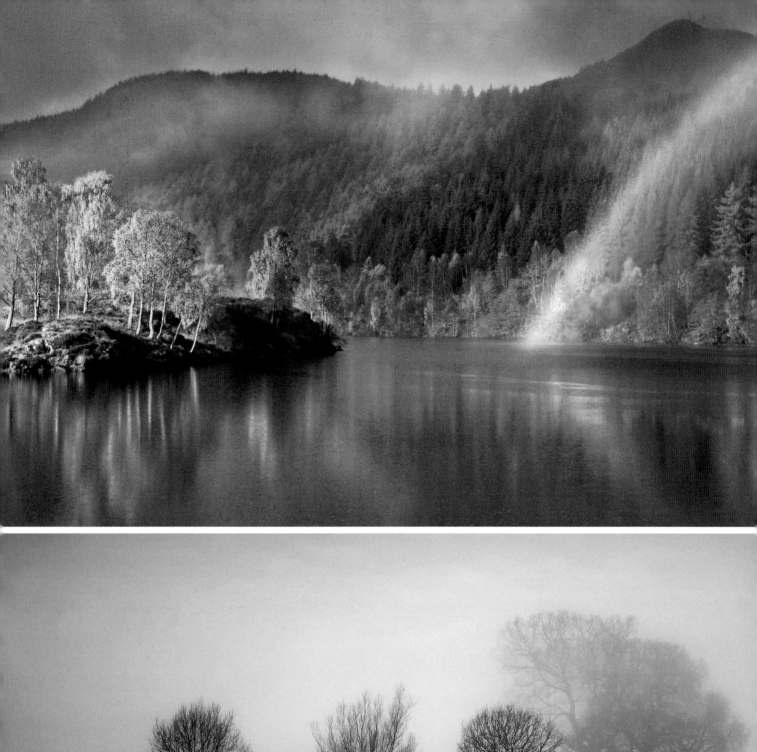
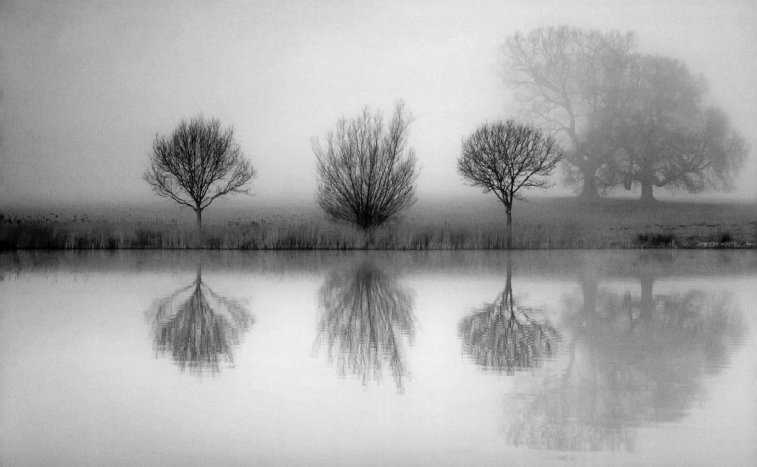

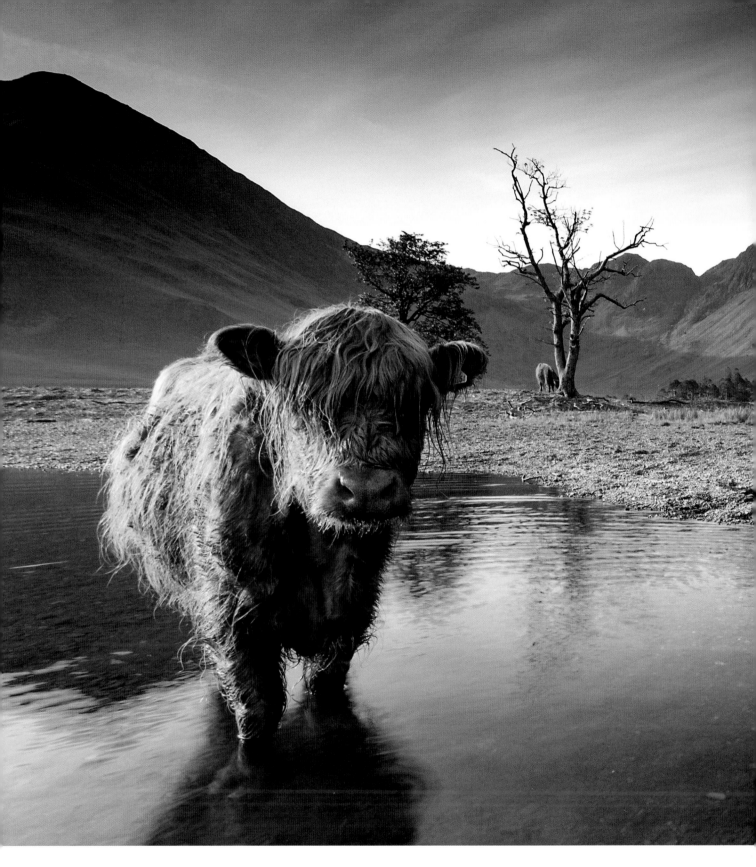

Above: **2019** – Big Dipper, Buttermere, Cumbria. (Peter Skillen)

Opposite top: **2011** – Pot of Gold. (Mike Cruise)

Opposite bottom: **2006** – Misty Dawn. **Overall Winner**. (Kate Barclay)

Following spread: **2012** – Right to Roam. (Robert Back)

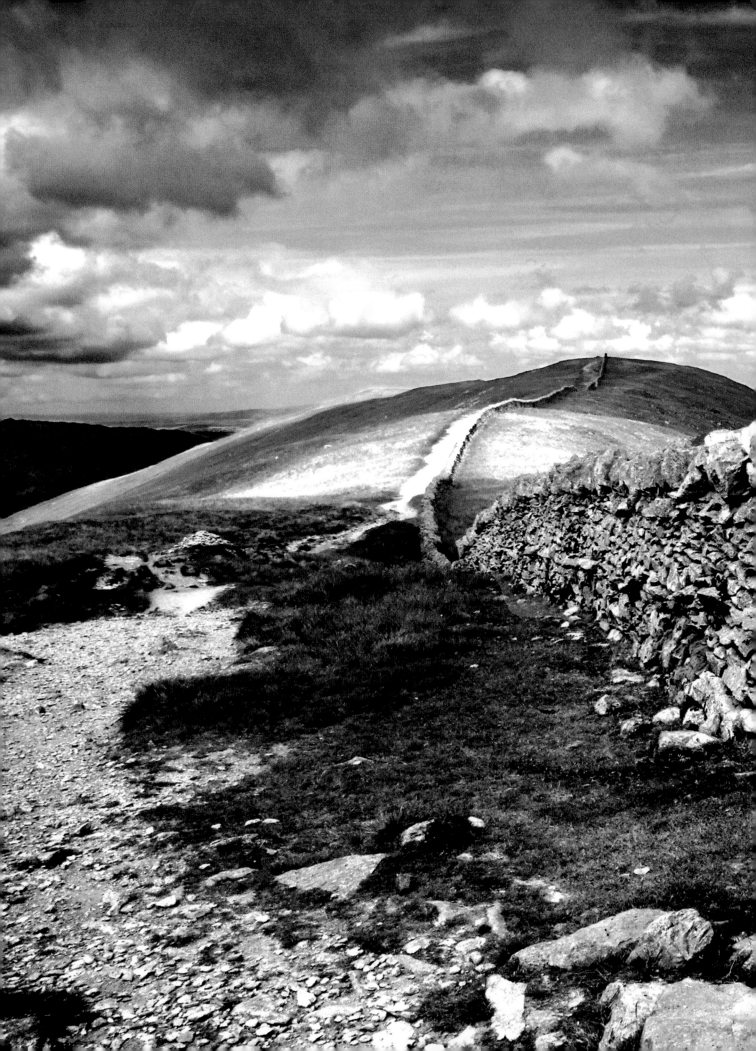

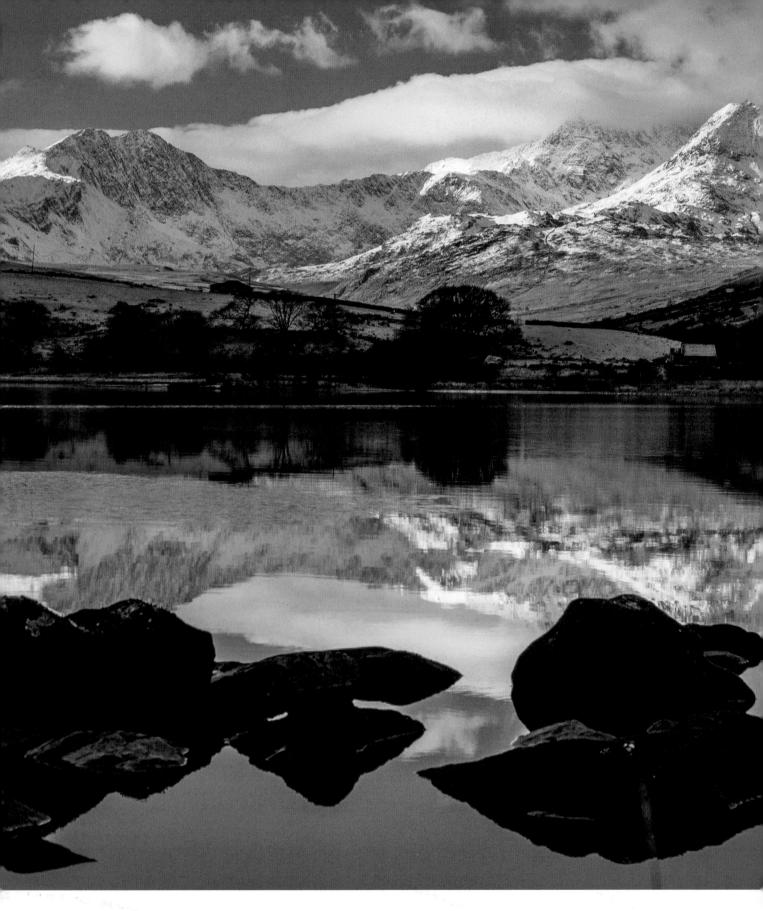

Above: **2016** – Mirrored Mountains. (Andy Morley)

Opposite top: **2017** – Sunrise Standoff, Black Grouse, Cairngorms. (Helena Spinks)

Opposite bottom: **2007** – Lone Stag, Ben Nevis. (Robin Bigwood)

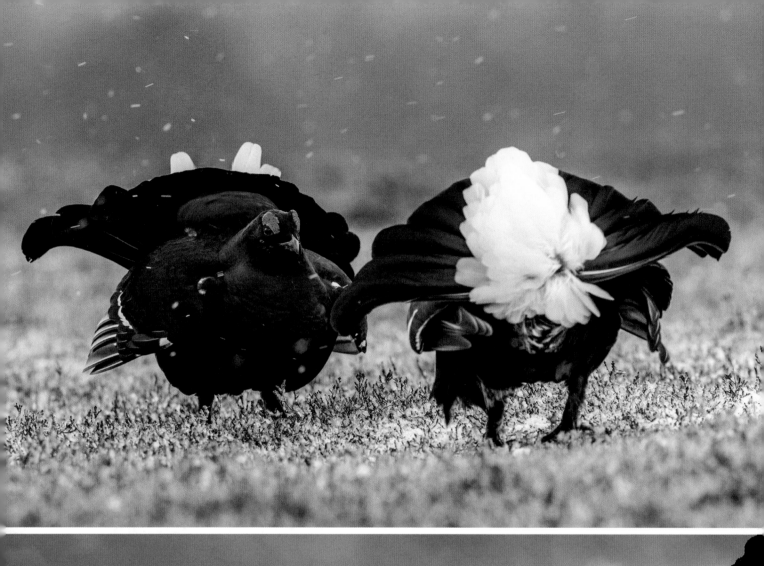

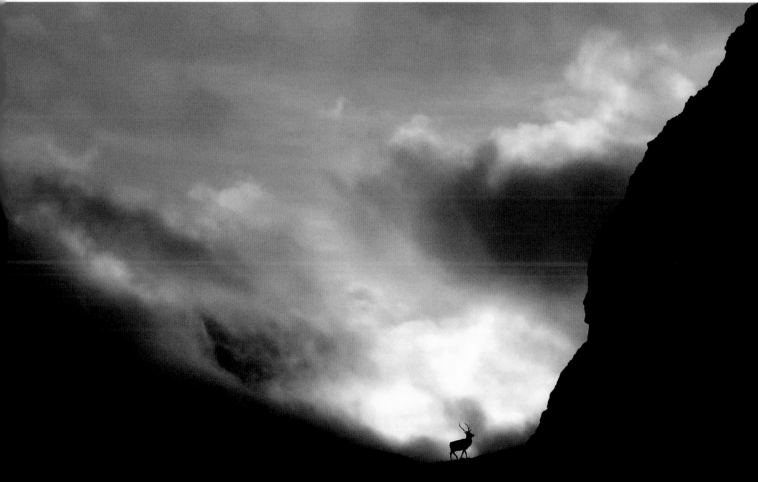

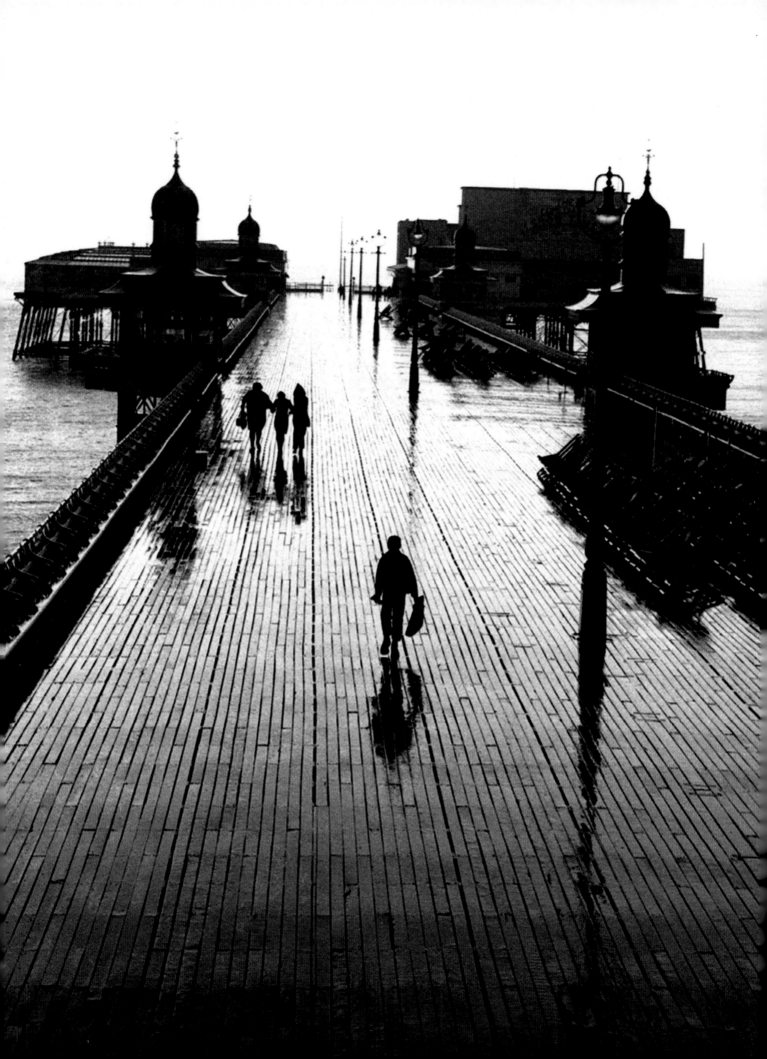

December

John Craven

Opposite: 2007 –
The Pier, Blackpool.
(Piers Fenwick)

Winter starts twice this month; the meteorological one always begins on 1 December because scientists like to have fixed dates when they record and compare climate data. The astrological one is based on the winter solstice – the year's shortest day when the Northern Hemisphere tips the furthest distance from the sun – between 21 and 22 December.

We always associate December with snow, especially with a White Christmas – but dream on, because the chances of that happening are in 1 in 10 in England and Wales and 1 in 6 in Scotland and Northern Ireland. In fact, December averages only about four days of snow. But that never stops a photo-based calendar from having lots of snowy shots to celebrate the month, as you can see on the following pages.

There's an arctic hare deep in snow and, ditto, a fox; a highland cow and later a squirrel with flakes falling gently on their foreheads; white ponies nuzzling up during a snowfall; a sledging scene (one of the few photos in this book featuring animals of the human variety) and, a favourite of mine, a long line of sheep making their symmetrical way through a snowdrift.

As the new year approaches, many writers and poets have expressed their admiration for this final month of the fading year, among them Emily Bronte, best known for her only novel, *Wuthering Heights*. Her poetry included these lines:

'Yet my heart loves December's smile as much as July's golden beam;
Then let us sit and watch the while the blue ice curdling on the stream.'

We hope you have enjoyed passing the time with our talented amateur photographers as the months and seasons unfurled and they revealed to us, through their individual perspectives, the incredible majesty of our countryside and its creatures.

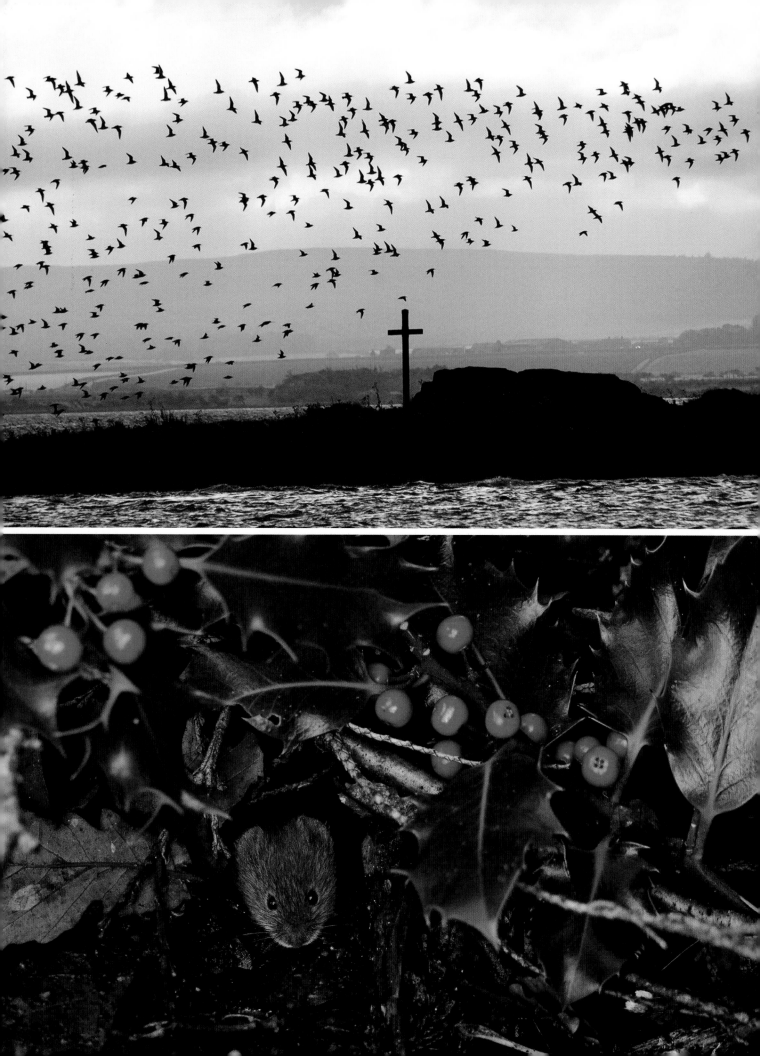

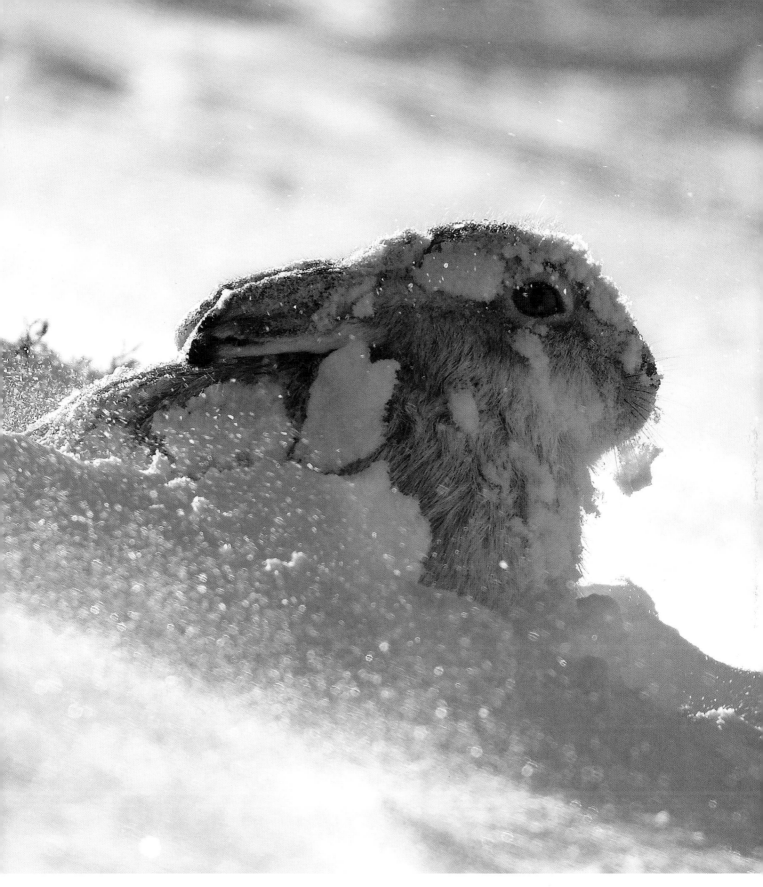

Above: **2020** – Winter's Hare, Cairngorms National Park. (Jane Deville)

Opposite top: **2009** – Knots in Flight. **Judges' Favourite**. (Terry Heath)

Opposite bottom: **2016** – Hide and Squeak. (Bernard Boyle)

Following spread: **2006** – Snowy Bench. (Brian Clark)

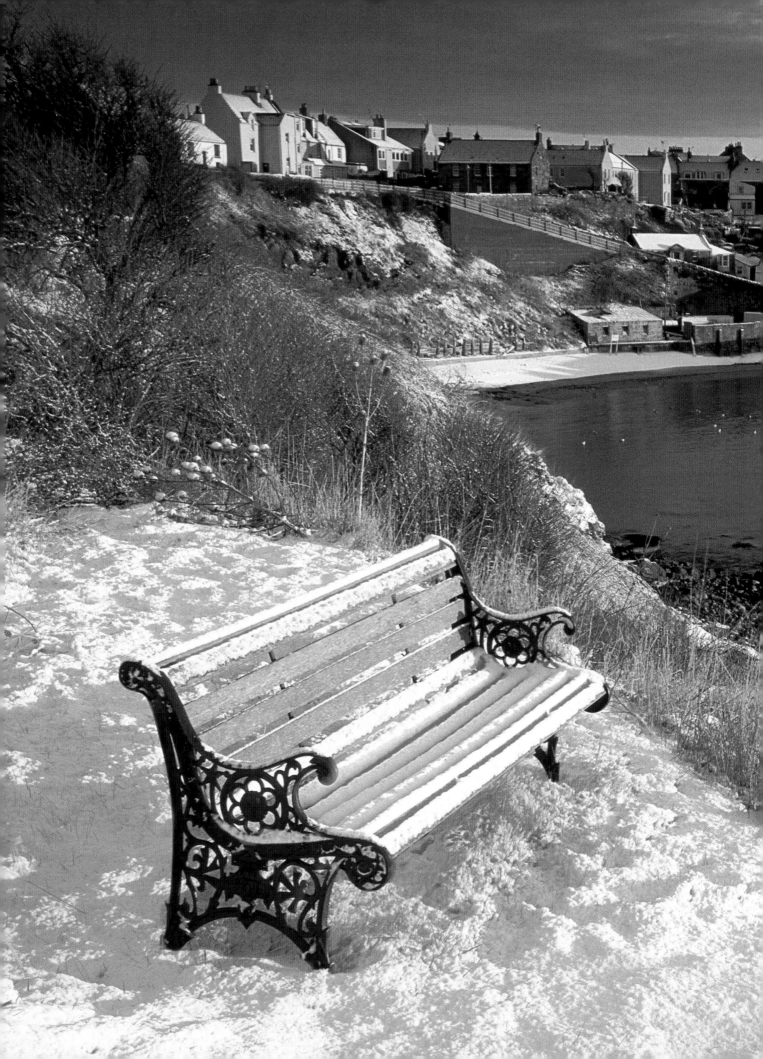

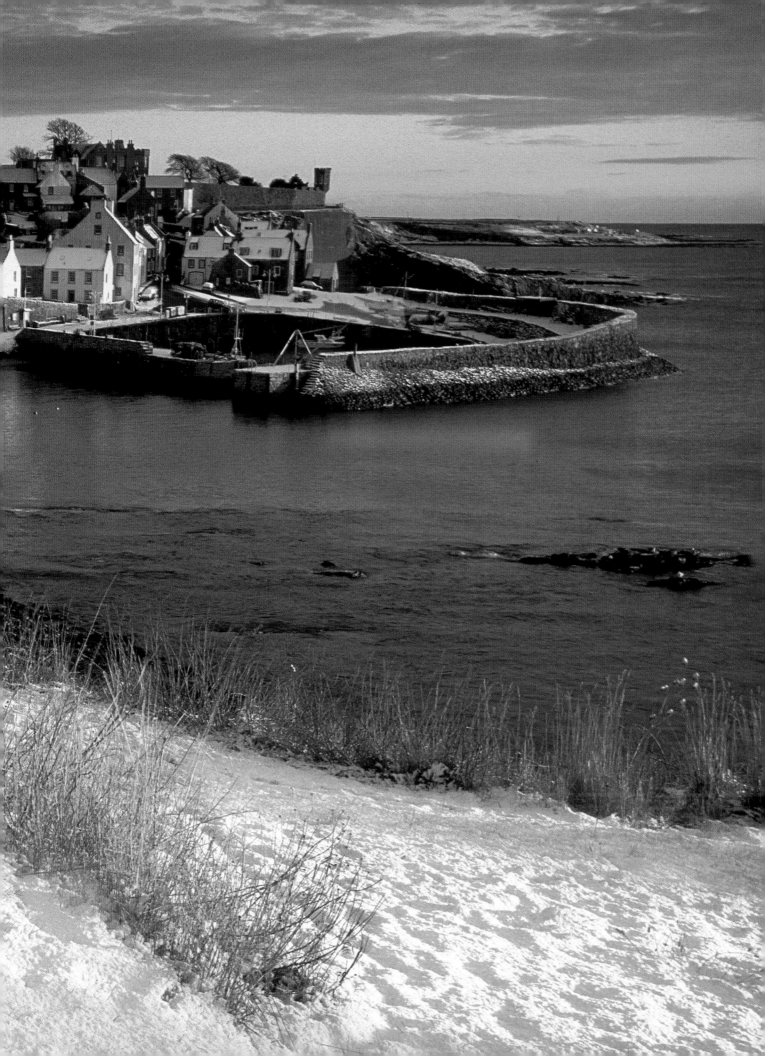

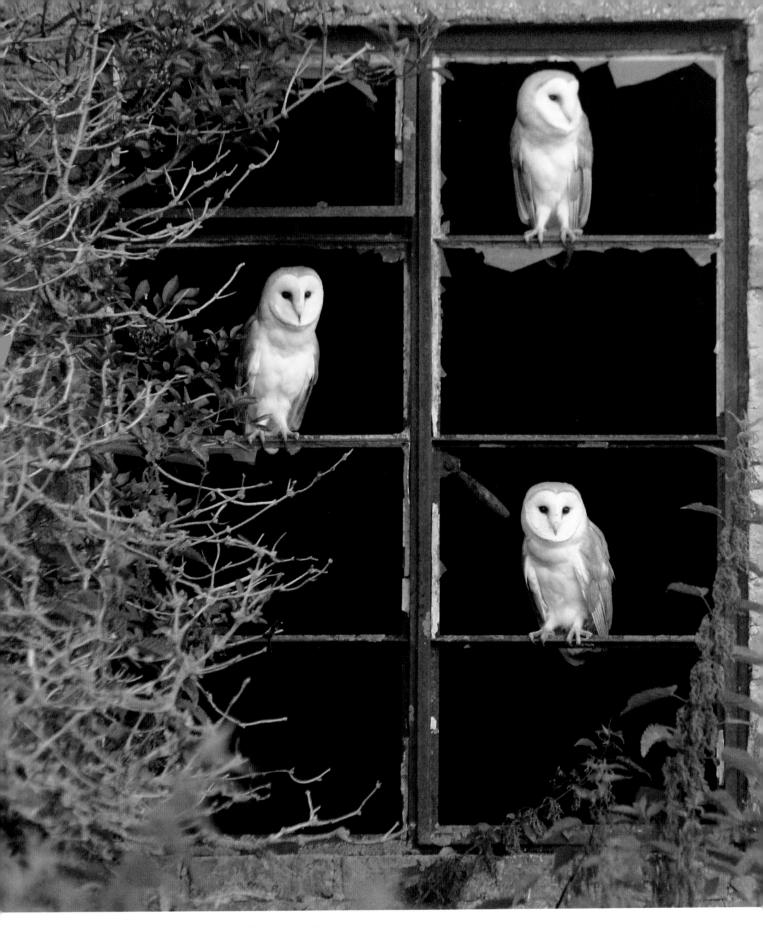

***Above:* 2008** – Three Wise Owls. (Edwin Frear)

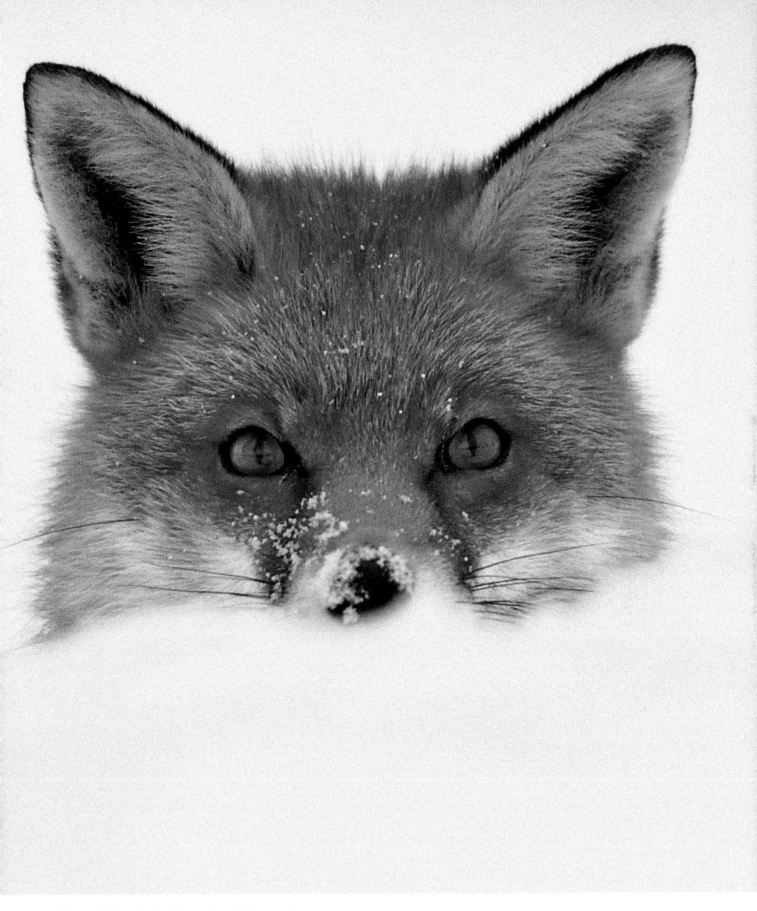

***Above:* 2012** – Fox in Snow. (Matt Binstead)

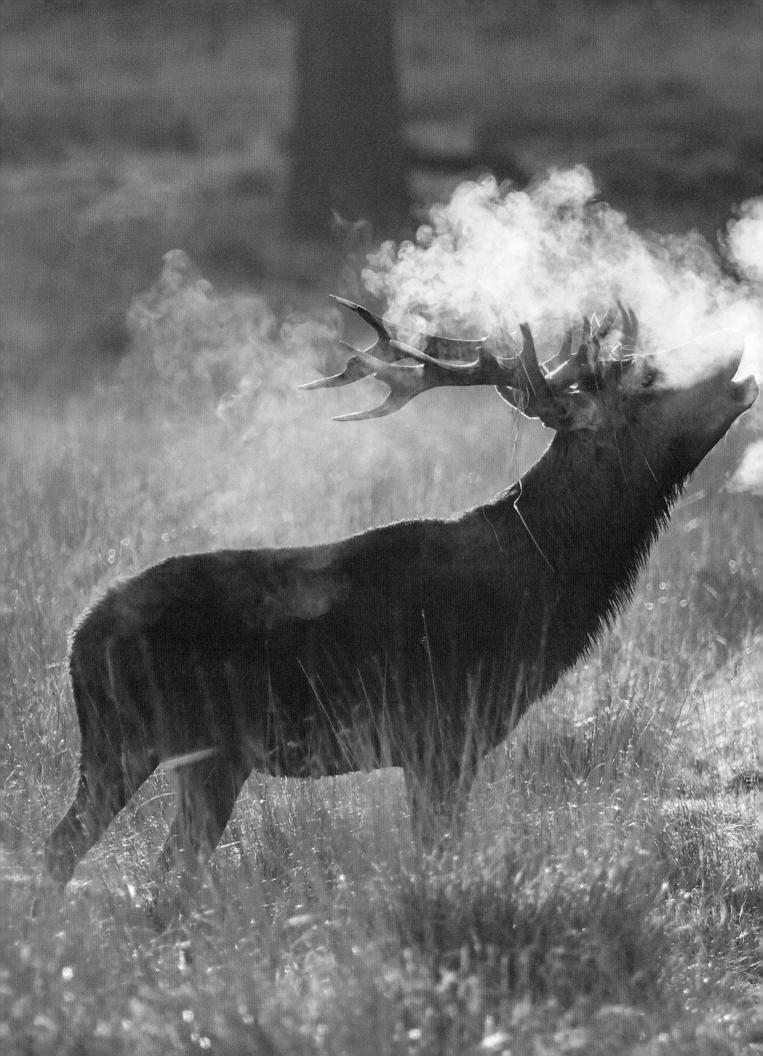

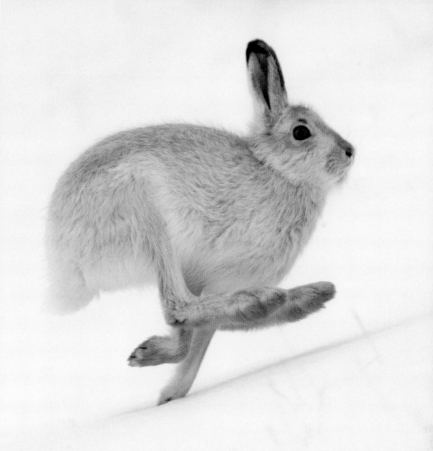

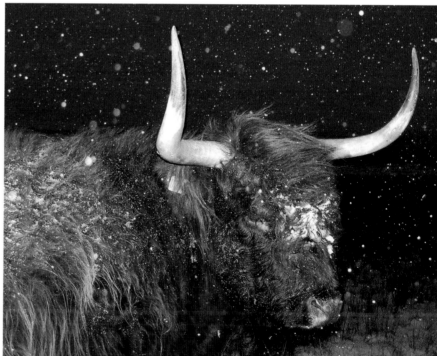

Top: **2015** – Hare in a Hurry. (Robert Cross)

Above: **2013** – Highland Flurry. (James Macdonald)

Left: **2017** – Monarch of the Morning, Richmond Park.
(David Hawkins)

Following spread: **2019** – Silver Shadows, Burley, Hampshire.
(Dawn Cotterell)

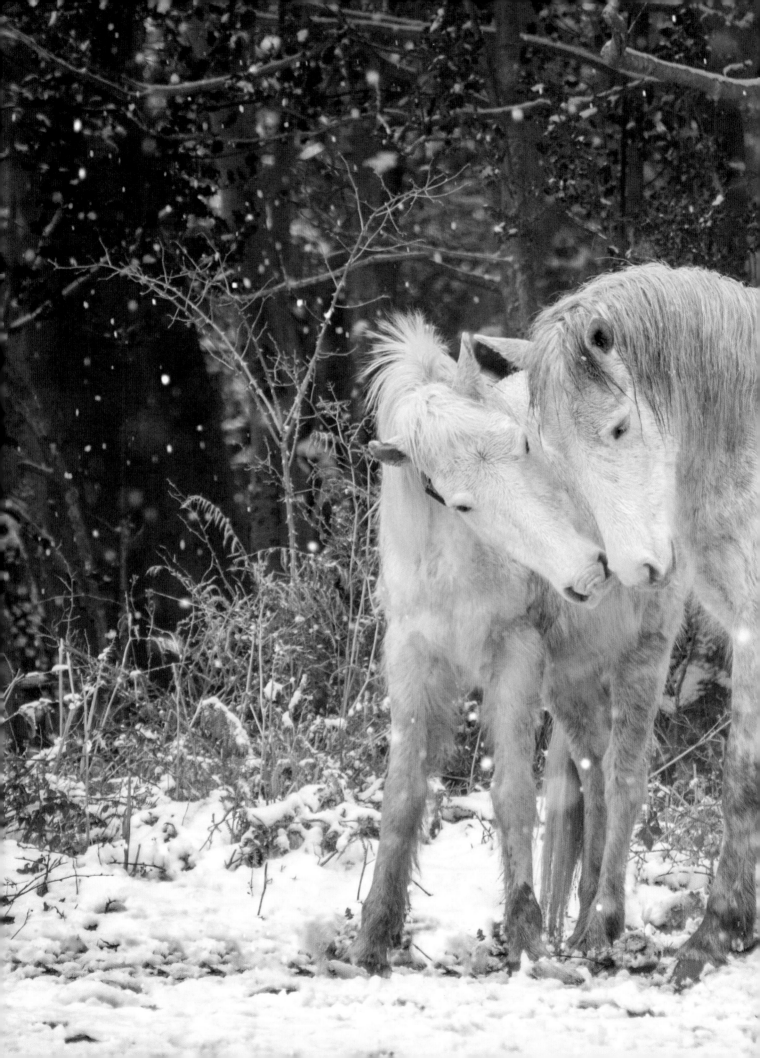

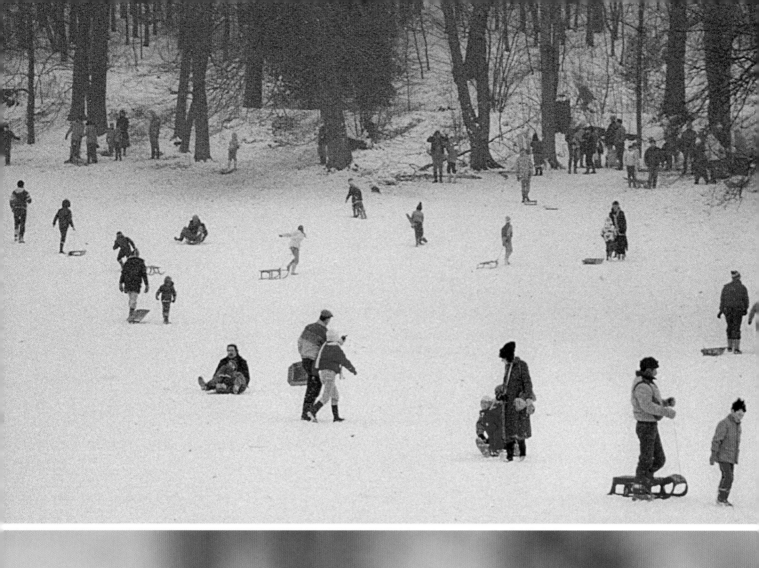

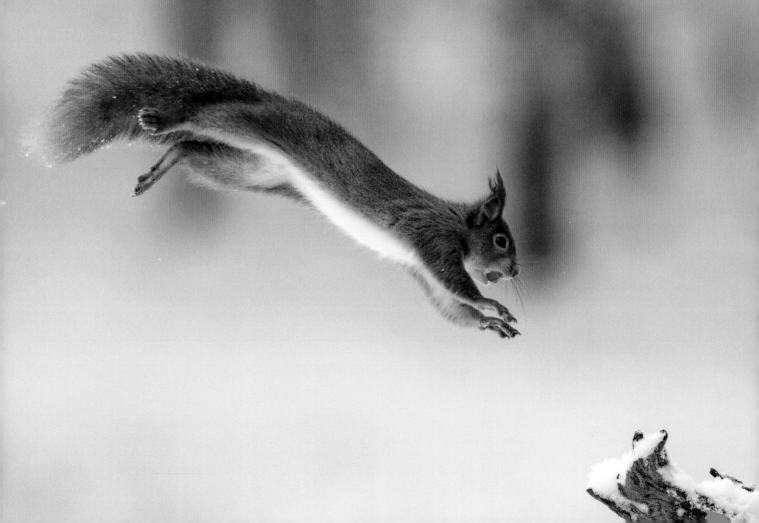

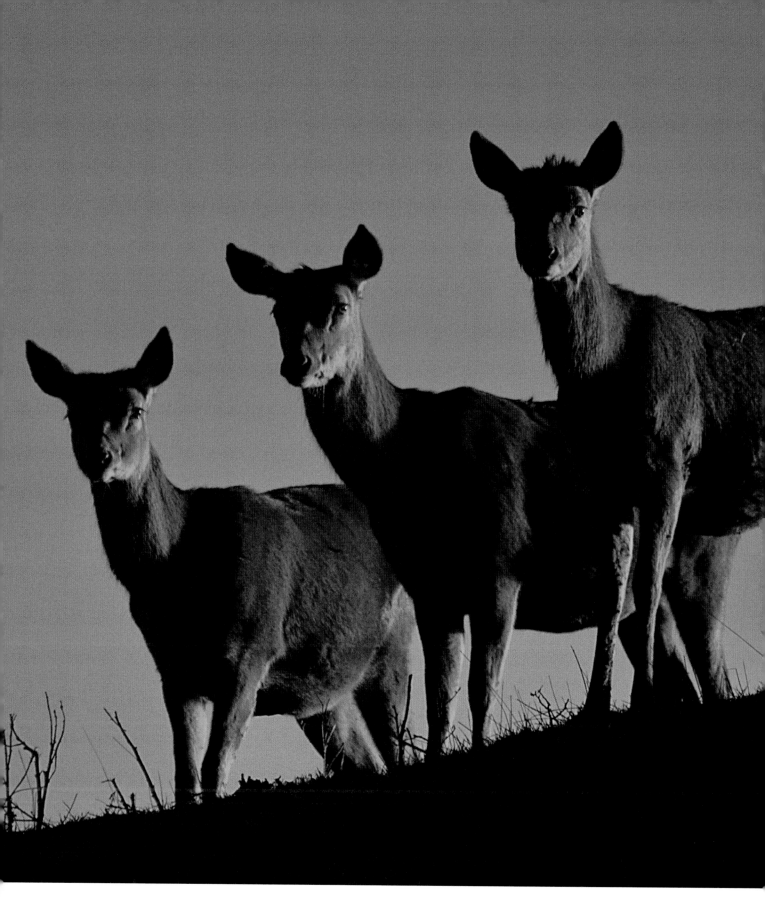

Above: **2005** – Three Red Deer. (Martin Roome, Derbyshire)

Opposite top: **2004** – Sledging. (Trevor Fry, Saffron Walden, Essex)

Opposite bottom: **2018** – Leap of Faith, Cairngorms. (Nick Carter)

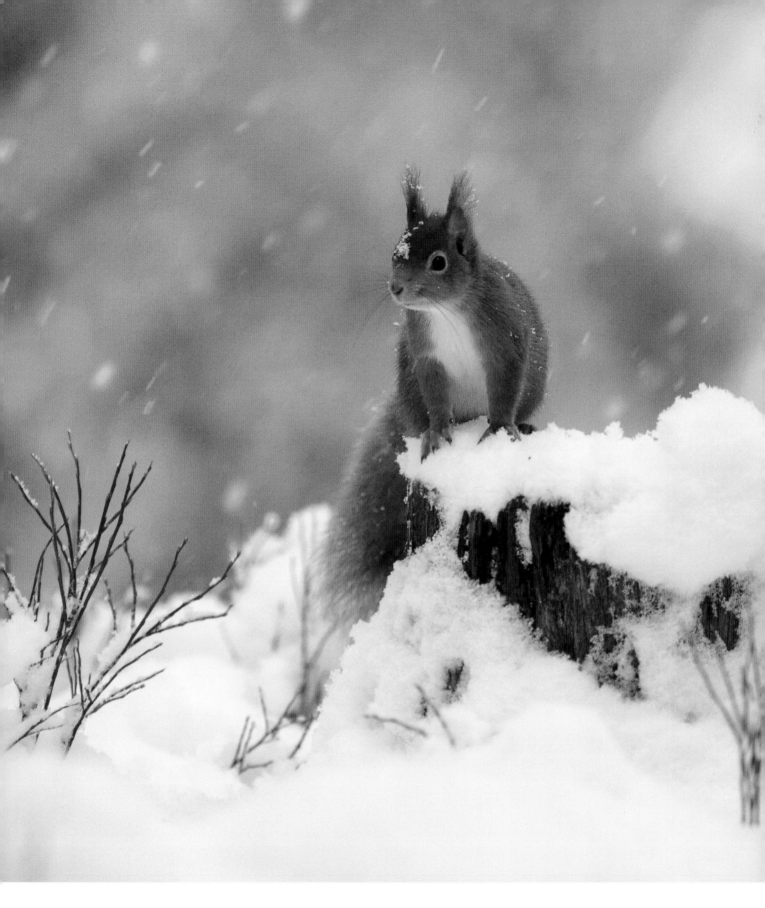

Above: **2010** – Snowy Squirrel. **Overall Winner**. (Cheryl Surry)

Opposite top: **2014** – Sheep Skyline. (Paul Cheeseman)

Opposite bottom: **2011** – Going Home. **Overall Winner**. (Pen Rashbass)

Following spread: **2003** – River Test, Wherwell, Hampshire. (John Eccles, Salisbury)

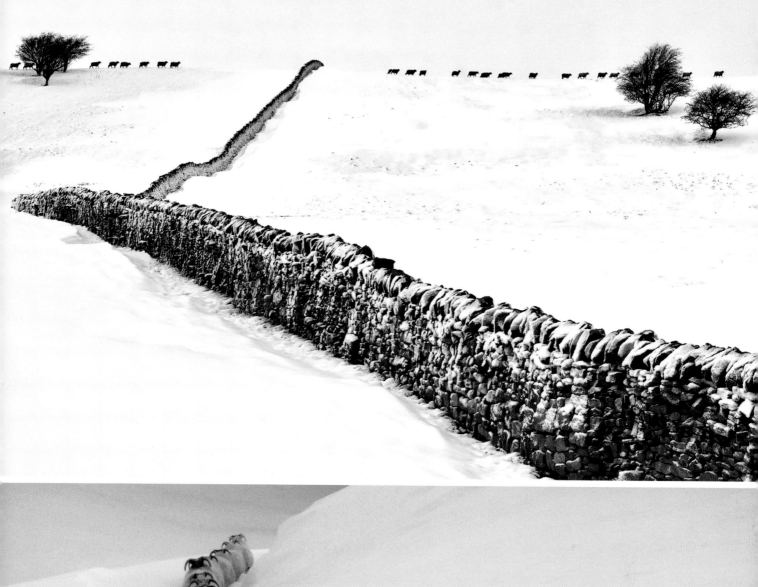

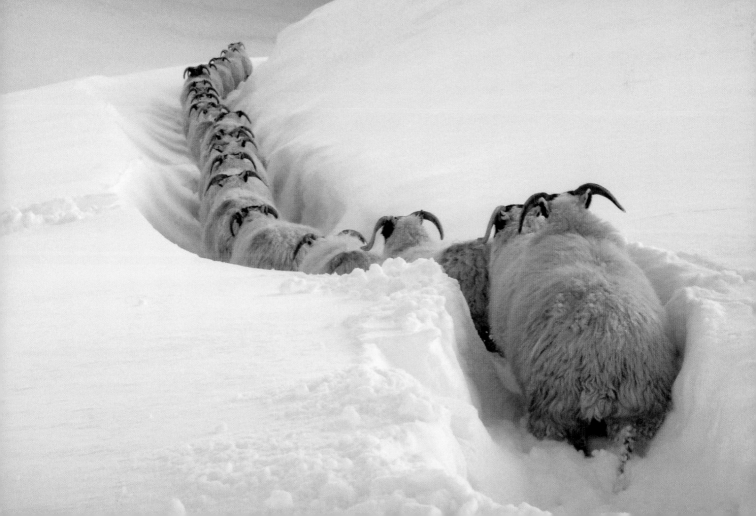

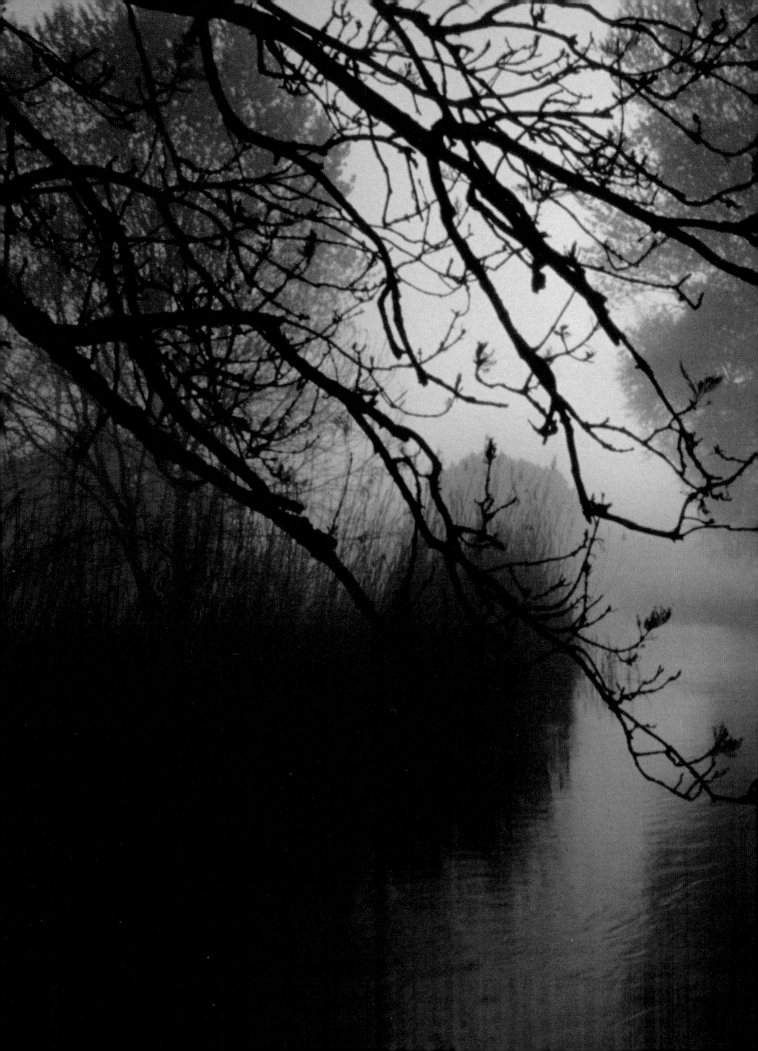

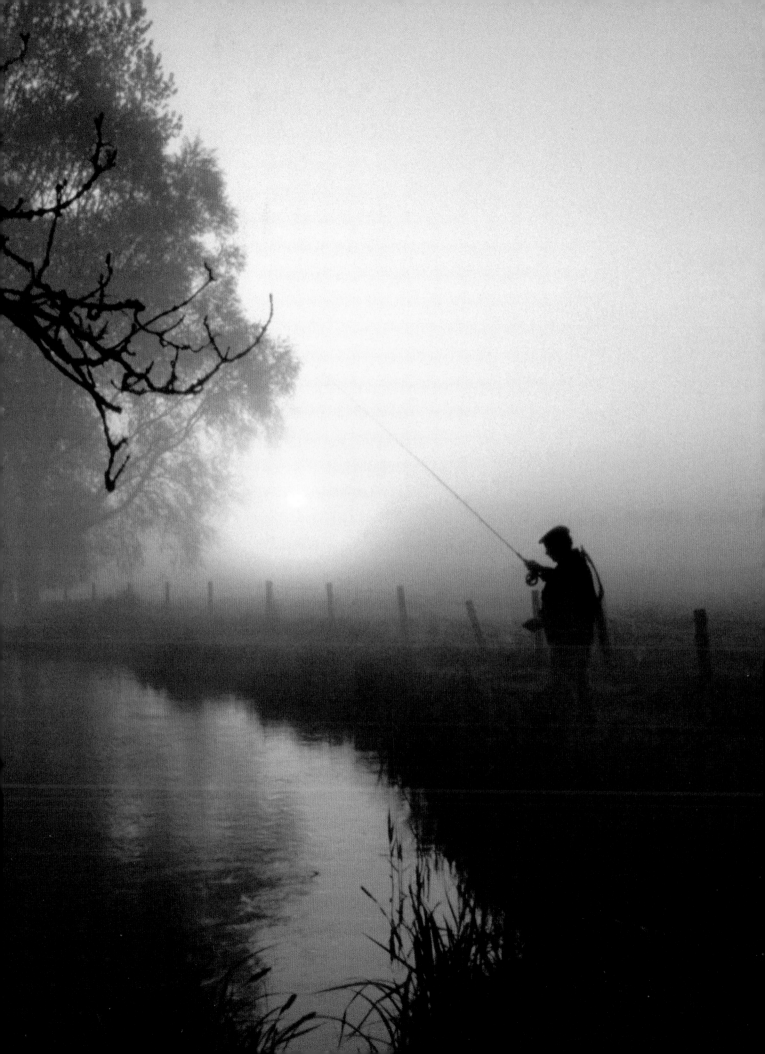

COUNTRYFILE Calendars (2003–20)

William Collins
An imprint of HarperCollins*Publishers*
1 London Bridge Street
London SE1 9GF

1st Floor, Watermarque Building, Ringsend Road
Dublin 4, Ireland

WilliamCollinsBooks.com

First published in Great Britain by William Collins in 2020

2023 2022 2021 2020
10 9 8 7 6 5 4 3 2

Designed and typeset by Tom Cabot/Ketchup
Printed by Graficas Estella in Spain